THE

Didascalicon

OF HUGH

OF SAINT VICTOR

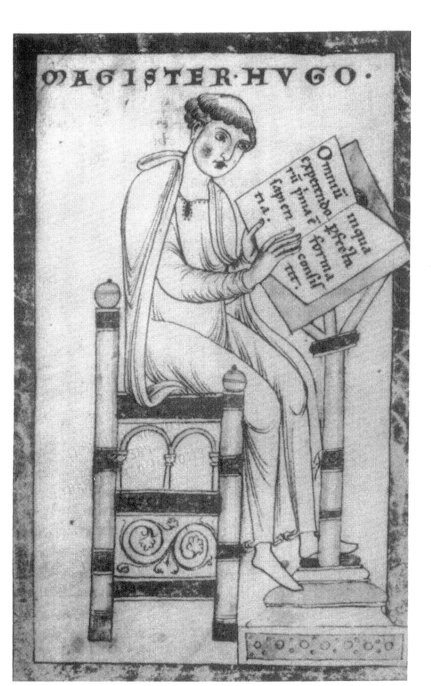

MAGISTER·HVGO·

O mniū inqua expetendo prctā rū prima ē formā sapien ti·ā· consistit·

THE
Didascalicon
OF HUGH
OF SAINT VICTOR

A MEDIEVAL GUIDE
TO THE ARTS

TRANSLATED FROM THE LATIN
WITH AN INTRODUCTION
AND NOTES BY

JEROME TAYLOR

COLUMBIA UNIVERSITY PRESS

NEW YORK

Frontispiece:

CONVENTIONALIZED REPRESENTATION OF
HUGH OF SAINT VICTOR
(Leiden, University Library, ms Vulcanianus 46, f. 130)

Produced at Fulda in 1176–77, it accompanies the text of Hugh's *Didascalicon*. On the open book appears the first sentence of the *Didascalicon: Omnium expetendorum prima est sapientia in qua (perfecti boni) forma. consistit* (Of all things to be sought, the first is that Wisdom in which the Form of the Perfect Good stands fixed).

Columbia University Press
New York Chichester, West Sussex
Copyright © 1961, 1991 Columbia University Press
All rights reserved

Library of Congress Cataloging-in-Publication Data

Hugh, of Saint Victor, 1096?–1141.
The didascalicon of Hugh of St. Victor : a medieval guide to the
arts / translated from the Latin with an introduction and notes by Jerome Taylor.
p. cm.—(Records of Western civilization)
Reprint. Originally published: 1961.
Includes bibliographical references and index.
ISBN 978-0-231-09630-0 (pbk.)

I. Title.
II. Series.
AE2.H83 1991
189'.4–dc20 91-6828
CIP

Casebound editions of Columbia University Press
books are printed on permanent and durable
acid-free paper.

Printed in the United States of America

RECORDS OF WESTERN CIVILIZATION is a series published under the auspices of the Interdepartmental Committee on Medieval and Renaissance Studies of the Columbia University Graduate School. The Western Records are, in fact, a new incarnation of a venerable series, the Columbia Records of Civilization, which, for more than half a century, published sources and studies concerning great literary and historical landmarks. Many of the volumes of that series retain value, especially for their translations into English of primary sources, and the Medieval and Renaissance Studies Committee is pleased to cooperate with Columbia University Press in reissuing a selection of those works in paperback editions, especially suited for classroom use, and in limited clothbound editions.

Committee for the Records of Western Civilization

Joan M. Ferrante
Carmela Vircillo Franklin
Robert Hanning
Robert Somerville, editor

TO

THEODORE SILVERSTEIN

CONTENTS

FOREWORD

The present translation, the first complete one in English, is based upon Brother Charles Henry Buttimer's critical edition of Hugh of Saint Victor's *Didascalicon: De studio legendi*. An effort has been made to meet the demands of technical accuracy by consistently adhering to a single rendering for philosophical and theological terms, despite the varying contexts in which these recur. It is hoped that readability has not been sacrificed thereby. Buttimer's text, excellent in the main, has not been above correction, and upwards of forty emendations of his text have been made. These vary from the correction of apparent misprints to recasting the punctuation of several passages in which unawareness of Hugh's source or of his meaning had produced confusion. Significant alterations of Buttimer's text are indicated in the footnotes.

The purpose of the notes is primarily to indicate new sources and to set Hugh's text in illustrative relief against the contrasting work of predecessors and contemporaries. Authors and works from classical, patristic, and Carolingian times, as well as from the twelfth century, are cited. At one extreme, the discoveries made involve minor curiosities like Hugh's inexplicable transference to geometry of a portion of the traditional definition of "topica" (II. xv. n. 55), or his use of a Hermetic prayer to conclude the *Didascalicon* (VI. xiii. n. 54); or they involve the identification of incidental phrases from Boethius, Chalcidius, Augustine, Jerome, and Gregory the Great—phrases which, precisely by their incidental character, suggest the extent to which Hugh's thought was penetrated by the very expressions of these authors. At the other extreme, the notes report the sources of whole chapters, e.g., the *Isagoge Johanitii ad Tegni Galiegni*, which provides the substance of the chapter on medicine (II. xxvi); or they elucidate complex relationships like those which chapters i, vi, vii, ix, and x of Book I bear to texts in the commentary traditions on Boethius's *De consolatione philosophiae*, Plato's *Timaeus*, and Macrobius's commentary on the *Somnium*

Scipionis of Cicero—relationships which reveal not merely Hugh's indebtedness to the traditions but, more significantly, his reservations in the use of heterodox cosmological texts and themes. The recent publication by Professor Theodore Silverstein of the "Liber Hermetis Mercurii Triplicis de VI rerum principiis" made it possible to identify a contemporary analogue of Book i, chapter vii, and perhaps to identify the source, in a pseudo-Pythagorean *Matentetraden*, of certain cosmological distinctions occurring in the same chapter. Professor A. van de Vyver's report of the existence of Hugh's personal copy of Remigius of Auxerre's commentary on Martianus Capella in the Bibliothèque Nationale led to the discovery of the source, in Remigius's commentary, of numerous details on the authors of the arts reported by Hugh in Book iii, chapter ii.

But the notes do more than indicate sources and analogues. They attempt, at times, to offer sketches in the history of an idea, a phrase, a definition, together with a selection of primary sources and recent secondary studies. Such, for example, are the notes on "nature" as the archetypal Exemplar of creation and as a cosmic fire (i. x. n. 69, 71), on the Boethian phrase "Form of the Good" (i. i. n. 1), on Hugh's definition of philosophy as "the discipline which investigates comprehensively the ideas of all things, human and divine" (i. iv. n. 27), on Hugh's curious use of the term "entelechy" (i. i. n. 7), on the literary practice of concealing inner meaning beneath a fabulous surface (*involucrum* or *integumentum*) (i. iv. n. 26), on the doctrine of the "three works" (i. ix. n. 59) and that of the "three manners of things" (i. vi. n. 34, 35, 38, 42), and on the "number 'four' of the soul" (ii. iv. n. 25–29).

The notes also call attention to not yet recognized citations or reminiscences of the *Didascalicon* in twelfth-century authors, as in John of Salisbury and Alanus de Insulis. Moreover, Hugh's dependence on John the Scot's translation of the pseudo-Dionysian *Celestial Hierarchy* in preparing his own commentary on that work, plus the appearance in the *Didascalicon* of certain terms frequently a sign of Scotist influence, raised the whole question of Hugh's relationship to John the Scot and made it desirable to call particular attention to differences or likenesses between Hugh and the Carolingian author as these were found

at various points (e.g. in 1. i. n. 16; 1. ii. n. 21; 1. vi. n. 42). Finally, the singular consistency and unity of Hugh's thought, often remarked upon by scholars, invited frequent citations from his other works to illustrate or expand his meaning in the *Didascalicon*.

The introductory essay attempts to go beyond what is currently said of the *Didascalicon* and to offer new suggestions regarding its date, its argument for a fourfold "philosophy," its peculiar use of cosmological lore, and its distinctiveness vis-à-vis the *De doctrina christiana* of Augustine and the *Institutiones divinarum et saecularium lectionum* of Cassiodorus. The aim has been to make some beginning, however slight, toward setting the originality and achievement of the *Didascalicon* in clearer light.

Several matters of editorial nature deserve notice. Biblical quotations are given in the Douay translation of the Latin Vulgate as revised by Bishop Challoner, and the names and numeration of the books of the Bible follow this version, as does the spelling of all proper names. Occasionally, however, as in Book v, chapter iv, the original Latin quotations are so disposed as to make it impossible to use the corresponding Douay-Challoner translation without alteration. Where terms such as "Truth," "Wisdom," "Nature," "Idea," "Pattern," and "Exemplar" are capitalized, the capital indicates that Hugh, in the translator's understanding, is referring to God, or, more specifically, to the Second Person of the Trinity. The terms "catholic," "catholic church," and "catholic faith" are not capitalized because to have capitalized these would have been to suggest the modern sense of "Catholic" as contrasted to "Protestant,"a distinction which could hardly have been in Hugh's thought. For him, it was still possible to refer simply to the universal belief of Christians and to the universal church.

Latin sources quoted in the footnotes have generally been translated, except when the original is a new source or analogue found in a manuscript or in a book hard to come by; in such cases, the Latin text has been reproduced for readers who may wish to compare it with Hugh's Latin in Buttimer's text. Names of twelfth-century authors have been modernized, except when identification of the place name has been disputed, as in the case of Honorius Augustodunensis and Alanus de Insulis, or when

the Latin form of the name has come into general usage, as in the case of Bernardus Silvestris and Clarenbaldus of Arras. However, the form "Abaelard" has been adopted in preference to the more common "Abelard" in order to indicate the proper pronunciation of the name, which seems to have been accented on the second syllable.

I am grateful to Professor Theodore Silverstein of the University of Chicago for first interesting me in Hugh of Saint Victor, and to Professors Blanche Boyer and Richard Peter McKeon of the same University, as well as to Professor Nicholas Häring of the Pontifical Institute of Mediaeval Studies, Toronto, for reading the translation, notes, and introduction and offering helpful criticisms and suggestions. I am indebted to the American Council of Learned Societies and to the Danforth Foundation for year-long fellowships which enabled me to work on the project, and to Dartmouth College and the University of Notre Dame for leaves of absence which made possible the acceptance of the fellowships; in the case of Notre Dame, I am indebted for a subsidy as well. Thanks are likewise due to Canon Astrik L. Gabriel, Director of the Institute of Mediaeval Studies of the University of Notre Dame, for assistance in obtaining microfilm materials from the Victorine collection of the Bibliothèque Nationale; to Doctor R. W. Hunt of the Bodleian for several helpful suggestions and for allowing me to read two as yet unpublished articles on the divisions of philosophy in the twelfth century; to Brother Charles Henry Buttimer for obtaining for me a copy of his edition of the *Didascalicon*, which has for some time been out of print; and, last but not least, to Professors Austin P. Evans and Jacques Barzun of Columbia University for encouraging me to submit the translation to the Records of Civilization series. To Professor Evans, I am above all indebted for his meticulous care and perceptive guidance in the final editing of the manuscript, and to Mr. Edward McLeroy, editor, Columbia University Press for expertly seeing the work through to final publication.

The University of Notre Dame JEROME TAYLOR
December 28, 1959

INTRODUCTION

INTRODUCTION

I. *General Nature, Date, Significance of the Didascalicon.* The *Didascalicon* of Hugh of St. Victor aims to select and define all the areas of knowledge important to man and to demonstrate not only that these areas are essentially integrated among themselves, but that in their integrity they are necessary to man for the attainment of his human perfection and his divine destiny. Composed at Paris in the late 1120's,[1] the book provided intellectual and practical orientation for students of varying ages and levels of attainment who came in numbers to the open school[2] of the newly founded Abbey of Saint Victor. To such, as they took up studies at their different levels, it offered a survey of all they should ultimately read, and of the order, manner, and purpose which should govern their reading, both in the arts or disciplines and in Sacred Scripture.

The very title of the work places it squarely in a long antecedent tradition of didascalic, or didactic, literature concerned in various ways with what arts or disciplines a man should study and why he should acquire them. In the Latin Christian West, such literature begins with Augustine and continues through Boethius, Cassiodorus, Isidore of Seville, Bede, Alcuin, Rhabanus Maurus, and the late Carolingian masters, including John the Scot. Before them, it is found in the writings of Cicero and Quintilian on the education of the orator; in the lost works of M. Terentius Varro on the arts; in the introductions to specialized treatises on particular arts, like that of Vitruvius on architecture or that of Galen on medicine; in certain moral epistles of Seneca; and in the allegory on the arts by Martianus Capella, Augustine's contemporary. Its roots reach far back to the ancient Greek conception of an ἐγκύκλιος παιδεία to the objections of Socrates to Sophist education in the fifth century B. C. and to the opposed views of education propounded in the next generation by Isocrates on the one hand and by Plato and Aristotle on the other.[3] In a sense, the *Didascalicon* can be regarded as both a summary and an extension of this tradition;

it is bound to it in most of its materials and in aspects of its form, yet it provides a new synthesis of the materials, a synthesis remarkable for its originality and its wholeness.

However, the *Didascalicon* is important not only because it recapitulates an entire antecedent tradition, but because it interprets that tradition in a special and an influential way at the very dawn of the twelfth-century renaissance. A crude index of its influence on its own and subsequent ages can be seen in its survival in nearly a hundred manuscripts of the twelfth through the fifteenth centuries, preserved in some forty-five libraries stretching across Europe from Ireland to Italy, from Poland to Portugal.[4] It appeared at a time when centers of education had moved from the predominantly rural monasteries to the cathedral schools of growing cities and communes; when education in the new centers was becoming specialized, hence unbalanced, according to the limited enthusiasms or capacities of particular masters; and when, in response to the flowering of secular life, learning itself was making secularist adaptations.[5] In contrast, for example, to the specializations in law, medicine, or the poetic arts at the schools of Bologne, Salerno, Montpellier, Tours, and Orléans; in contrast to the belletristic humanism of a John of Salisbury, a Bernardus Silvestris, or a Matthew of Vendôme; in contrast to the concern with a Platonized quadrivium and physics of the Chartrian masters, or the absorption in dialectic of an Abaelard, or the demand for a quick, money-making education by the Cornificians; in contrast, finally, to Cistercianism, which forbade "profane" learning and aimed to make of every monastery a "school of charity" only, the *Didascalicon* set forth a program insisting on the indispensability of a whole complex of the traditional arts and on the need for their scientific pursuit in a particular order by all men as a means both of relieving the physical weaknesses of earthly life and of restoring that union with the divine Wisdom for which man was made.

The *Didascalicon's* influence was immediate and penetrating. It provided on the one hand an outline of work partly fulfilled in Hugh's own scholarly production, continued in that of Andrew and Richard, his successors in the Victorine chair, and reflected in the philosophical poetry of Godfrey and the liturgical

sequences of Adam, so that the book forms a kind of key to the Victorine corpus. On the other hand, for twelfth- and thirteenth-century writers as different from the Victorines and from one another as John of Salisbury, Clarenbaldus of Arras, William of Conches (or his disciples), Peter Comestor, Stephen Langton, Robert Kilwardby, Saint Thomas Aquinas, Saint Bonaventure, and Vincent of Beauvais it served either as a source of references and extracts which they incorporated into their own writings or, more significantly, as a source of leading ideas to the guidance of which they submitted their thought and their work.

It is evident, then, that the *Didascalicon* can be approached from many different points of view. Considering it as a document in the didascalic tradition as a whole, one might seek to measure the extent to which it transmits and adapts the common materials of that ancient tradition.[6] More narrowly, one might compare and contrast its particular schematization of the sciences to earlier and later schematizations in the Christian tradition and attempt to trace the line of a developing scholastic *Wissenschafts-lehre*.[7] More narrowly still, one might study the relation it establishes between the arts and scriptural exegesis and ask how its program figured in the shift from positive to systematic theology which took place across the twelfth and thirteenth centuries.[8] Turning to educational history, one might center attention on what the work reveals of the teaching aims, methods, and materials of the schools of the same period.[9] Finally, one might examine the *Didascalicon's* treatment of the individual arts, following the previous history of their various terms in such fashion as to explicate their special significance in Hugh—a most important approach and one which, if followed through, would produce in effect a critical history of the arts in the middle ages.[10]

But if the variety and scope of these historical considerations, each of which would require a separate study or series of studies for its adequate development, suggest the importance of the *Didascalicon*, they imply its originality as well. Of the work's originality, in fact, there has never been doubt, though the grounds on which it has been advanced leave much to be desired. In part, the *Didascalicon* has been given a deceptive prominence because closely affiliated schematizations of knowl-

edge in its own time have been ignored.[11] In part, the attempt
to qualify its originality with greater accuracy has led to the
proposal of other schematizations, actually of later date, as its
antecedents, and to the irrelevant measurement of its achieve-
ment against theirs.[12] Again, it has been given a value borrowed
from Aristotle or Aquinas, and, brought into step with the
march of truth from the Stagirite to the Angelic Doctor, it has
been praised because it makes advances over the former and
almost, but not quite, achieves the perfection of the latter.[13]
Yet again, its purposeful and organic arrangement of twenty-one
arts has been contrasted to the listing, "encore rudimentaire,"
of the seven liberal arts by writers from Martianus Capella
through the Carolingians, and the causes of its great advance
over these sought (1) in the entrance into the West of new
Arabic learning, which, however, Hugh gives no evidence of
having known, (2) in the discovery of the new logic of Aristotle,
with which, however, Hugh seems to have been unacquainted,
and (3) in the actual state of development, by the twelfth century,
of each of the arts which Hugh mentions, a state not historically
verifiable and one which, even if shown to exist, would explain
only the material and not the formal aspects of Hugh's work.[14]
When the attempt has been made to place the *Didascalicon* with
respect to like works of its own time, it has been bracketed with
the *Heptateuchon* of Thierry of Chartres and with it made the
source of broad inferences concerning "le programme d'en-
seignement généralisée de son temps"; or it has been contrasted
with John of Salisbury's *Metalogicon*, which appeared more than
a quarter of a century later, in 1159, and therefore exercised no
influence upon it; or it has been balanced in general terms
against an assortment of twelfth-century "humanists," utili-
tarians, and scientists, as well as religious reformers and
dialecticians, a procedure which provides illuminating com-
parisons, to be sure, but which fails to shed particular light on
precisely those immediately antecedent authors, texts, and
problems to which the *Didascalicon* applies and to which many
features of the text seem a direct response.[15] In particular, the
work of William of Conches, which appears to have challenged
Hugh to a particular line of argument at many points in the
Didascalicon, and, together with that of Abaelard, to have

exercised a determining influence even upon his choice of certain authorities and terms, has not been examined from this point of view.16

Of the *Didascalicon's* relation to earlier works in its tradition, it has been said, for example, that it provides a "refonte complète" of the *De doctrina christiana*, adapting Augustine's ideas to the special needs of the twelfth century and calling a rebellious learning back to the scriptural basis posited by Augustine for Christian intellectual and spiritual formation.17 It has also been said that the *Didascalicon* was to its time what the *Institutiones divinarum et saecularium lectionum* of Cassiodorus were to the sixth century, the *Etymologiae* of Isidore to the seventh, and Rhabanus Maurus's *De institutione clericorum* to the ninth.18 Such comparisons are suggestive and, up to a point, true. Like all analogies, however, they ignore specific differences in order to stress general similarities; they do not pinpoint what is distinctive or original about the *Didascalicon*.19

If, then, by way of introduction to the *Didascalicon*, we wish to know something of the work's originality, it will be necessary to examine, if even on a severely limited scale, how the work compares in intention and structure, in its terms and its argument, and in its adaptation of source materials, with certain selected earlier and contemporary works in the didascalic tradition. Because Book I, and to a lesser extent, Books II and III, seem determined in many ways by problems peculiar to the early twelfth century, the contemporary relationships of the work will be discussed first. Because Books IV, V, and VI—and in particular the disputed connection of *divinitas* or *sacra pagina* with the arts and *philosophia*—are best discussed with reference to Augustine's *De doctrina christiana* and the *Institutiones divinarum et saecularium lectionum* of Cassiodorus, the relationship of the *Didascalicon* to earlier works will be treated last.

II. *The "Quaternary" of the Arts.* The first book of the *Didascalicon* provides a carefully articulated demonstration that philosophy must comprise four, and only four, master-categories of arts and disciplines—theoretical, practical, mechanical, and logical. The caption "De origine artium," which in the Buttimer edition is affixed only to the first chapter of the *Didascalicon*, must

therefore be taken as the title of the whole first book,[20] the "origin" in question being Hugh's reasoned derivation of these four categories from certain fundamental postulates concerning the divine Wisdom in relation to the postlapsarian state, but divinely ordained restoration, of man.

Hugh's fourfold scheme, Aristotelian in ultimate inspiration and character, stands in contrast to a threefold division of philosophy into physics, ethics, and logic, which, largely on the authority of Augustine, prevailed as Plato's division almost without exception in the West until the twelfth century.[21] Famous in his own time for his fidelity to Augustine,[22] Hugh has nonetheless been credited with taking unexplained leave of Augustine on this essential matter and with introducing an Aristotelian division of knowledge to the later middle ages. That the *Didascalicon* cooperated in spreading interest in the so-called Aristotelian division is evident from the book's wide dissemination and use. But that Hugh's originality did not consist in the initial rediscovery and rehabilitation, for his time, of the Aristotelian scheme is evident from the reappearance of the Boethian version of that scheme in William of Conches' glosses on the *De consolatione philosophiae*, datable between 1120 and 1125, or some years earlier than the *Didascalicon*, and possibly in the pre-1125 version of William's commentary on the *Timaeus* as well.[23] Moreover, that Hugh's departure from Augustine was strictly limited and that, paradoxically, it was motivated by his loyalty to Augustine in other and more basic respects, becomes clear when certain structural and material features of the first book of the *Didascalicon* are studied with reference to fuller expressions of Hugh's thought in others of his works and to contrasting points of view in his immediate contemporaries. His true originality then appears to lie in the adaptation of an already current Aristotelian division of philosophy within a system of thought and action radically Augustinian, attentively orthodox, and mystically oriented as against certain contemporaries, including William of Conches, who are heterodox in tendency and more concerned with disputation, the quadrivium, and physics than with the final end of man.

The argument of the first book of the *Didascalicon* may be summarized as follows:

Through knowledge, man's immortal mind is capable of containing all things, visible and invisible. As man recognizes this dignity of his nature by the light of the divine Wisdom, he turns from mere animal existence to pursuit of that same Wisdom, which deserves to be sought above all things (c. i). The name of this pursuit is "philosophy," and the divine Wisdom sought is the divine Mind, living primordial Pattern or Idea of things. Calling man back to Itself, It bestows Its own divinity on man's soul and restores human nature to proper force and purity through leading it to truth and to holiness of action (c. ii). Soul has three kinds of power: the first produces growth and nourishment and is found in plants; the second includes the first and adds sense perception—it is found in animals; the third includes the first two and adds reason—it is found exclusively in man, whom it prompts to seek out the natures of things and instruction in morals (c. iii). Because philosophy is the peculiar prerogative of human nature, it must extend not only to studying the natures of things and regulating conduct but to the ideas of all human acts and pursuits whatever (c. iv). But all human acts and pursuits are ordered either to restoring the likeness of man's soul to divine and supernal substances, or to relieving the weaknesses of man's body, which belongs to the lowest, or temporal category of things (c. v). There are three categories of things: *eternal*, in which existence and the existing individual are identical—such alone is the Begetter and Artificer of nature; *perpetual*, in which endless existence is conferred upon individuals by an extrinsic principle—such alone is nature, the twofold character of which is exemplified by the *ousiai* on the one hand and the superlunary bodies on the other; *temporal*, in which temporary existence is conferred by nature—such are the corporeal beings, or "works of nature," begotten upon the sublunary earth by an artifacting fire descending from above (c. vi). Astronomers have divided the world into superlunary, which they call "nature," and sublunary, which they call "the work of nature" because all living things in the lower world are nourished by emanations from above. They also call the upper world "time" because it governs movement in the lower world, and "elysium" because its order contrasts with the flux and confusion of the lower region, or "infernum." Man, who resembles the divine in his soul, is subject to necessity in his bodily or temporal part, which must be cherished and conserved in proportion to its weakness (c. vii). The contemplation of truth and the practice of virtue, divine actions because they restore the divine likeness in man, constitute "understanding," higher of the two parts of wisdom. Understanding is theoretical when it concerns truth, practical when it concerns morals. "Knowledge," lower of the two parts of wisdom, is properly called "mechanical," that is, adulterate (c. viii). For there are three works—the work of God, which is to create nature; the work of nature, which is to bring forth; and the work of the human artificer, adulterate because it only copies the work of nature, yet a tribute to man's reason by its ingenuity (c. ix). By "nature" men of former times have

meant (1) the archetypal Exemplar of all things in the divine Mind, pri-
mordial cause of each thing's existence and character; (2) the peculiar being of
each thing; and (3) an artificer fire coming forth with a certain power from
above and begetting sensible objects upon the earth (c. x). After the inven-
tion of the theoretical, the practical, and the mechanical sciences, the logical
sciences were invented because men became conscious of inconsistencies
and errors in their discussions. Though invented last, the logical sciences
should be studied first, for without them no philosophical explanation is
possible. The four branches of knowledge can be taken as that sacred
"four" which ancient authority attributed to the soul (c. xi).

The tightly knit, chapter-to-chapter sequence of the argument,
observed in passing by Baur but without attention to its
significance,[24] evinces the deliberateness with which Hugh
expands to four the two categories of theoretical and practical
science which Boethius, and William of Conches following him,
report in philosophy. The first three chapters, developing the
soul's capacity to know all things, its relationship with the
divine Wisdom, and its possession of vegetative and animal as
well as rational functions, prepare directly for chapters iv, v,
and viii, which contain the heart of the argument. The argu-
ment can be expressed in three propositions:

Philosophy, as the unique prerogative of human nature, must contain as
many parts as there are types of human action.
But of the types of human action, two restore human nature through
knowledge or virtue; a third aims to relieve the weaknesses of bodily life.
Therefore, philosophy, first of all, has three parts: theoretical, ordered to
truth; practical, ordered to virtue; mechanical, ordered to the relief of
physical existence.

The fourth part, last to be discovered and therefore left to
last by Hugh, is introduced in chapter xi as the indispensible
means of assuring clear and true conclusions in the other three.
The excursion into cosmology in chapters vi and vii, though
recognized as digressive by Hugh, is justified by him as making
clear the temporal, dependent, and fragile nature of bodily life,
and hence relates to the mechanical arts.[25] Chapters ix and x
may be similarly accounted for.

Hugh's management of three long extracts from Boethius in
Book i affords a second evidence of the care with which he
builds his argument for the fourfold division of philosophy.
The first passage, taken from Boethius's earlier commentary on

the *Isagoge* of Porphyry,[26] supplies the material on the divine Wisdom for the larger part of Hugh's chapter ii. It continues in the original source with a merely bipartite division of philosophy and suspends judgment on whether logic is part, or an instrument only, of philosophy. Suppressing this portion of the passage, which contradicts the fourfold division of philosophy he seeks to establish, Hugh selects for the continuation of his first extract a portion of Boethius's later commentary on the *Isagoge*. Selected to need no explanatory transition, this passage is placed immediately after the first extract and forms the last paragraph of Hugh's chapter ii and the entire content of chapter iii.[27] In Boethius, the passage provides the psychological basis for logic; in Hugh, by adroit alteration of context, it provides the psychological basis for his fourfold division of philosophy.[28] Again, in the original, this passage moves on at once to a discussion of the errors committed by Epicurus and other ancient philosophers through ignorance of logic, and to a clear pronouncement that logic is *both* instrument and part of philosophy. This discussion and pronouncement Hugh reserves for his chapter xi, where they form the third long extract from Boethius and serve to round out Hugh's quaternary of the arts.[29]

Hugh's concern to establish a fourfold division of philosophy derives from a view of fallen man which is peculiarly Augustinian even when, as in the *Didascalicon*, passages lifted from Boethius or reminiscent of Plato, are made to express certain of its aspects. The sense of a disaster primitively suffered by man pervades Book I, though never set forth in familiar religious or doctrinal terms. Thus, the divine Wisdom must *call man back* to Itself, must *restore* the proper force and purity of his nature.[30] The mind of man, "stupefied by bodily sensations and enticed outside itself by sensuous forms, *has forgotten* what it was, and, because it *does not remember* that it was anything different, believes that it is nothing but what is seen"; it is *restored* through instruction.[31] Finally, in the first chapter of book two: "This, then, is what the arts are concerned with, this is what they intend, namely, to *restore* within us the divine likeness... then there begins *to shine forth again* in us what has forever existed in the divine Idea or Pattern, coming and going in us but standing changeless in God."[32]

The relationship of the four branches of philosophy to the fall of man is made clear by the interlocutor in Hugh's dialogue, the *Epitome Dindimi in philosophiam*. Asked how philosophy arose, the interlocutor explains that its four branches presented necessary expedients against as many evils resulting from the fall:

Although, Sosthenes, a great chaos of forgetfulness cloud s human minds so that the hearts of mortals, submerged in an abyss of ignorance, cannot fully remember their origin, there nonetheless lives in men something of that eternal fire of Truth, which, gleaming in the midst of their darkness, enlightens them to see a little way in their search for Wisdom. Wisdom stirred our nature to that search by providing that we should neither know all we had lost nor be totally unaware of what we yet retained. For by that selfsame light gleaming within us we saw our darkness; our nature knew its evils and understood from them what opposed goods to seek. It knew to what evils mortal life lay subject and what things hostile to its original goodness it sustained, both interiorly and exteriorly, when it became corrupted. Three were the sources of all those evils which infected human nature interiorly and exteriorly when the pestilence passed over it. Ignorance of good and desire for evil beset the mind of man; the weakness of mortality sickened his flesh. And man knew of his change because he was aware of his inability to approve the evils he now desired or to hate the things which had once been his goods. Therefore, with what strength he could summon, he began to strive for his liberation—to avoid his evils and obtain his goods. And so arose the pursuit of that Wisdom we are required to seek—a pursuit called "philosophy"—so that knowledge of truth might enlighten our ignorance, so that love of virtue might do away with wicked desire, and so that the quest for necessary conveniences might alleviate our weaknesses. These three pursuits first comprised philosophy. The one which sought truth was called theoretical; the one which furthered virtue men were pleased to call ethics; the one devised to seek conveniences custom called mechanical. Art had not yet joined logic to philosophy; crude discourse handled the secrets of Wisdom with common and vulgar simplicity until finally a more skilled teaching, setting up the form of polished discourse, added logic last of all and completed the quaternary.[33]

That Hugh's conception of philosophy should be rooted in Genesis reflects on the one hand Augustine's own preoccupation with that book,[34] and on the other a twelfth-century preoccupation with the creation account as part of a larger concern with the relationship of the entire order of nature to the divine.[35] Hugh's interest in Genesis, however, true to the spirit of Augustine's thought, is man-centered; he seeks in it the antecedents of the present human condition and a norm of human nature to which man may return. His historical approach,

careful to preserve the literal features of the biblical text, stands in contrast to that of William of Conches, who, approaching Genesis primarily as a physicist, seeks to reconcile revelation with the science of the day, particularly with the cosmogony of Plato's *Timaeus*. To do so, William is willing to interpret key features of the text allegorically and, from Hugh's point of view irresponsibly. Thus, whereas William of Conches denies the existence of initial chaos and holds that the six days of creation must be taken figuratively, Hugh insists that chaos literally existed and that its ordering in an equally literal six-day period is a mystery, a "sacrament," through which the Creator determined to teach the rational creature that it must rise from the disorder of its initial and untaught existence to an intellectual and moral beauty of form conferred by the divine Wisdom.[36] Differences between Hugh and the Chartrians in matters of cosmology and cosmogony, as these relate to the *Didascalicon*, will be further examined in the next section of the introduction. The interest here is to note that Hugh's approach to the materials of Genesis focuses upon their relation to the spiritual perfectibility of man—a concern which dominates the whole of his theology.[37]

The conception of the divine Wisdom as archetypal Exemplar of creation, elaborated in patristic and especially in Augustinian exegesis of Genesis, is one of the most important of such materials. The sources of the conception as it appears in twelfth-century writers are, to be sure, many and complex.[38] It recurs in various forms in the Platonic, Neoplatonic, Stoic, and Hermetic texts which interested Abaelard and fascinated the Chartrians—in Chalcidius's translation of and commentary on the *Timaeus*, in Macrobius's commentary on Cicero's *Somnium Scipionis*, in Boethius's *De consolatione philosophiae*, in the Latin *Asclepius*. It is implicit in the Bible, not only in Genesis but in the sapiential books, in the Joannine prologue, in scattered verses of the psalms; and it finds full elaboration in the commentaries upon all of these by the Fathers, in whom Neoplatonic influences and Christian teaching meet. From his contemporaries Hugh parts ways to expose, following Augustine, not the cosmological nor even the Trinitarian, but especially the moral implications of this concept and these texts.

Thus, in his *De sapientia animae Christi*, Hugh transmits in detail, and in the *Didascalicon* he echoes, Augustine's doctrine that there are not many wisdoms, but only one Wisdom which makes men wise, and this Wisdom is God—the Wisdom begotten from all eternity by the Father.[39] In holding further that the rational creature's wisdom is a participation in the "ideas and causes, likenesses and forms, dispositions and foreseeings" of all things begotten in the divine Wisdom, Hugh follows Augustine in such manner as to remove the ambiguity and paradox of the teaching of John the Scot and the twelfth-century Bernard of Chartres on the nature and location of the *ousiai*—the "essences" or "substances" of all things.[40] According-ing to John and Bernard, these "essences," primordial exemplars of all created realities, subsisted in the Mind of God, yet were created; though one with God, they were distinct from Him, and though eternal, they were not quite coeternal with Him. Hugh, who likewise believes that the primordial exemplars of created realities subsist in the Mind of God, simply identifies them with the divine Mind or Wisdom, uncreated and coeternal with God. The term *ousiai* he reserves for the participated knowledge of the primordial exemplars on the part of the rational creature—angels and the mind of prelapsarian man, who enjoyed such participation in the divine Wisdom "not through study or any teaching over periods of time, but simultaneously and immediately from the first moment of his creation, by a single and simple illumination of divine imparting."[41]

What man saw before the fall, what he lost by it, and what he must do to restore the loss, Hugh expresses by the pseudo-Dionysian figure of the three eyes.[42] Before the fall man saw the physical world with the eye of flesh; with the eye of reason he saw himself and what he contained; with the eye of con-templation he saw within himself God and "the things which are within God" (primordial exemplars). By the fall the eye of flesh was left unimpaired, the eye of reason and self-knowledge bleared, and the eye of contemplation blinded. Philosophy must therefore perfect man's self-knowledge (eye of reason) through the practical arts, which "cleanse the heart by the study of virtue so that it may thereafter see clearly for the investigation of truth in the theoretical arts."[43] And it must then renew the know-

ledge of God and "the things which are within God," that is, must renew man's eye of contemplation, through the theoretical arts, which, because they are specifically restorative of the divine Wisdom's image in man, are "wisdom" in a preeminent sense, while the remaining arts, though necessary parts of philosophy, are "more precisely spoken of as prudence or knowledge."[44] The first stage in the restoration of man which philosophy effects is *lectio*, or study, with which alone the *Didascalicon* is concerned,[45] though the book points beyond *lectio* to the meditation, prayer, performance, and finally contemplation, "foretaste even in this life of what the future reward of good work is,"[46] in which the task of philosophy is consummated.

In such a view as this, the pursuit of the arts becomes, in effect, convertible with religion—an equivalence explicitly stated by John the Scot but asserted before him by Augustine, who, rather than John, inspires Hugh.[47] Hugh's consciousness of the need to justify the view in his own time is reflected in his statement that the etymology of "philosophy" requires explanation because, though the verbal components of the term are commonly known, not all men understand the same thing by "love" and "Wisdom," or "the True."[48] Granted Hugh's integration of the four parts of philosophy in the task of man's relief and restoration, his attack, in the *Epitome*, upon "the commonly bruited opinion of many persons" who "try to eliminate certain of the arts from philosophy by an excessively rigid test"[49] is understandable. "In fact," Hugh observes, "one may not deny that the things in which the practice of philosophy *consists* belong to it first; but second, so do the things which further that practice." Of the arts, he says:

...certain ones are both *in* the search for the True and *for* the search for the True, and no one denies that these must be thought parts of philosophy, as authority declares. But others, because they are *for* that search only, and are not found *in* it, certain men have condemned.[50] I mean grammar and the mechanical arts. Grammar is *for* philosophy only, not about philosophy nor developed philosophically; the mechanical arts are developed philosophically, but they are not *about* philosophy nor are they *for* it. Some wish to exclude the whole of logic from philosophy, but this makes little sense, since obviously the theory of argument is not only *for* philosophy but *about* philosophy. In my opinion, men of greater discrimination hold that it is not

only philosophizing which ought to be called philosophy, but also what-
ever has been established for the sake of philosophizing, whether *for*
philosophy or whether philosophically developed in itself.[51]

Held up to scorn are those who, apparently forgetting phi-
losophy altogether, become lost in disputes about disputations:

> In former times, seekers who did not know how to philosophize disputed
> about philosophy. Now another generation has succeeded them, and these
> do not even know for sure how one ought to conduct a dispute about
> philosophy. They have gone one step back beyond those who were already
> backward enough, in order to learn how to dispute about disputations, and
> they can't figure out where to classify[52] the very disputations they dispute
> about. For if philosophy is an art, and to dispute *about* philosophy is an art,
> to what art do we leave it to dispute about disputations?[53]

Against those who separate the arts of speech from phi-
losophy and, devoting themselves to the former, shamelessly
ignore the latter, William of Conches also writes.[54] The reverse
pretension that the arts of speech are useless because no part of
philosophy, John of Salisbury, looking back toward the third
decade of the century, attributes to the Cornificians.[55] He
observes in passing that this sect had small reverence for Hugh,[56]
and he praises William of Conches, along with Abaelard,
Thierry of Chartres, and Gilbert of Porrée, for active resistance
to the Cornifician "madmen." Yet he notes that not all of these
masters resisted successfully, but succumbed instead to the very
foolishness they combatted.[57] Whether John has William of
Conches in mind here or not, William himself maintains the
distinctness of *eloquentia* and *philosophia* in his commentary on
the *De consolatione philosophiae*, and does so in terms suggestive
of Hugh's statement quoted just above:

> ...neither *eloquentia* nor any part of it is *about* philosophy. This is con-
> firmed by the authority of Tully, who, in the prologue to the *Rhetoric* [*De
> inventione*], says: 'Wisdom without eloquence is helpful, but not much;
> eloquence without wisdom not only is not helpful—it is harmful; eloquence
> and wisdom together are truly helpful.' So Tully wanted eloquence and
> wisdom to be distinct. Likewise Sallust, who in his description of Catiline
> says: 'He had eloquence enough but small wisdom.'[58]

The persistence of William's point of view is evident in the
reviser of William's *De philosophia mundi*, who, writing con-
siderably later, makes unmistakable references to the *Didascalicon's*

conception of a fourfold philosophy as something that should not disturb his readers if they encounter it, and himself maintains, following William, that the theoretical and practical arts are "*about* philosophy itself," the arts of speech only "*for* philosophy" ("its appendages and tools"), and the mechanical arts its mere "menials."[59]

In standing against such positions, Hugh is not seeking agreement on the meaning of a word—"philosophy":

> If anyone thinks that the term 'philosophy' should be reserved to philosophizing-proper and to the search for the True which I have put in first place, I will not argue with him about a name. What good is that? As anyone is free to use words in a plausible manner as it pleases him, so I judge a teaching and its utility by one same standard of truth.[60]

Hugh's one standard is the necessity for so pursuing all knowledge, all human activity, that human restoration to beatitude in the knowledge and love of God will result.

The starting-point of a division of philosophy, the term initially divided, is above all what determines the whole character of the result. Hugh begins with a conception of man's fall and divides man's pursuit of restoration into parts which reflect the effects of that fall. By contrast, William of Conches begins simply with natural knowledge, *scientia*. Borrowing an Augustinian distinction, but a subordinate one, between *res* (things) and *verba* (words), he divides knowledge into "wisdom," or knowledge of things, and "eloquence," or knowledge of how to state one's knowledge of things decorously. Wisdom he equates with philosophy; the sole difference between "wisdom" and "philosophy" for him is that one name is Latin, the other Greek.[61] From such naturalistic rationalism Hugh's thought is poles apart. For Hugh, Wisdom is the second person of the trinitarian Godhead, and philosophy is pursuit of that Wisdom; secondarily, from the standpoint of the intellectual creature, wisdom is a participation in the divine Wisdom. Without such orientation, without the divine root and end, knowledge is fruitless: "Logic, mathematics, and physics teach a sort of truth, but they do not attain to that Truth in which the salvation of the soul lies and without which everything that is, is vain";[62] and again, "Behold, we have shown... the cause of our disease, namely love of the world, and the cure of that disease, namely

love of God... without which to have known all other things avails either little or nothing."[63]

Against Haureau's misconception of Hugh as one who had "pris en dégoût la science elle-même" or against the textual misrepresentation by Ueberweg and Heinze to the same effect,[64] Hugh's stress upon knowledge has been exaggerated to the level of an absolute and his "Learn everything... A skimpy knowledge is not a pleasing thing"[65] quoted without the qualification afforded by its context, where it forms part of an exhortation to learn perfectly the letter or *historia* of Scripture and the arts that will make that letter clear. Hugh, unlike William of Conches and others of his time, will not allow study to be the *propositum* (objective) or *occupatio* (preoccupation) of his students.[66] One thinks of Abaelard's complaint that his enemies kept objecting to him "quod scilicet proposito monachi valde sit contrarium saecularium librorum studio detineri" ("that it is altogether contrary to a monk's objective to be seduced by worldly books").[67] Not against natural science, Hugh nonetheless teaches that the man engrossed in the investigation of temporal things "not only forgets his Creator, but neglects himself, and becomes preoccupied in the lowest order of things—things without relevance for salvation"[68]—one thinks of William of Conches' grouchy remonstrance against those who, "ignorant themselves of the forces of nature, don't want others to find out anything about them either, so that they may have everyone as companions in their ignorance."[69]

Differing from, and, it seems, in part replying to, the naturalistic conception of philosophy of William of Conches or the interest in disputation of Abaelard; differing equally from such ingenious but fictive conceptions as that of Honorius Augustodunensis, who sees philosophy as a highway and the arts as cities strung along it, leading the soul from ignorant exile to scriptural wisdom;[70] more profound, finally, than Adelard of Bath, who sees the arts as "liberal" because they liberate the soul from the chains of worldly love which bind it within the prison-house of the body[71]—Hugh presents philosophy as the instrument of a literal return to the divine Wisdom from the literal exile of the fall; as the means of restoring to man an ontological perfection which he knows, through experience,

that he lacks; which by faith he believes he lost in Adam; which by philosophy he struggles toward in time; and which by grace he receives abundantly in eternity.

III. *The Readaptation of Heterodox Cosmological Texts and Themes.* It is not only in the adaptation of an Aristotelian division of knowledge to an Augustinian view of man's fall and redemption through "philosophy" that Hugh, as it were, confronts and reorients contemporary interests. In the first book of the *Didascalicon*, and to a smaller extent in the second, he has chosen to express and support his argument by allusions to Platonic, Neoplatonic, and Hermetic texts and themes which reflect, not directly through uncritical repetition of them, but obliquely and correctively through implicit alteration of their meaning, certain dominant cosmological concerns of the early twelfth century. One such concern deals with the divine Wisdom, formal cause or Exemplar of the created universe, and with the specific agency by which the prototypes therein contained are transferred to the material world. Directly related to the latter is also the concern for "nature," conceived not only as the primordial form of each thing residing in the divine Mind or as the form inhering in the actualized thing itself, but also as an intermediary of uncertain character presiding in one way or another over creation.

It seems to have been Abaelard who, zealous to refute the Sabellianism of Roscelin with a great show of authority as well as of dialectic, first marshaled for the twelfth century those *loci* from Plato, Chalcidius, Macrobius, "Mercury," Vergil, the Sybil, and others, by which he intended to show that even the pagans had knowledge of the three divine persons and which, for a quarter of the century and partly through the influence of Abaelard upon the Platonizing cosmologists of Chartres, were to become involved in the heated disputes over the existence and identity of the world-soul and over the role of the Son and of the Holy Spirit in creation.[72] At the same time, the *De consolatione philosophiae* of Boethius, orthodox and congenial to the Victorine outlook by the quest for the *Summum Bonum* which forms its central subject matter but suspect and alien to the Victorines in the *Timaean* cosmology of the celebrated Book III, metre ix,[73]

attracted renewed interest after a century of disfavor and neglect, and the twelfth century saw the production of at least the four new commentaries reported by Courcelle,[74] including that by William of Conches, which was destined to a diffusion surpassing even that of Remigius of Auxerre's commentary, on which it relies heavily but over which it makes numerous original advances. Led constantly back to the *Timaeus* in his efforts to gloss the *De consolatione philosophiae*, William ultimately produced a full-length commentary on the Platonic dialogue as well. Both commentaries are replete with cosmological, cosmogonal, and other themes widely circulated throughout the century and reflected, with careful selection and adaptation, in the *Didascalicon*.[75] Finally, the Hermetic tradition not only provided the concepts of *Nous* or *secundum Dominum*, of a generating celestial *natura*, and of the divine stars as found in the Latin *Asclepius*, known to and even quoted by Hugh in the *Didascalicon*,[76] but it served as a cover for pseudepigraphous concoctions like the "Liber Hermetis Mercurii Triplicis de VI rerum principiis," through which a broader selection of cosmological materials from sources like Firmicus Maternus, Alcabitius, and Zahel ben Bischr were diffused in the twelfth century.[77] The "Liber Hermetis" is of particular interest because, by a passage having close verbal resemblance to the *Didascalicon*, it suggests the existence of a further cosmological pseudepigraph, a *Matentetrade* ascribed to Pythagoras, which is possibly a source common to Hugh and the "Liber Hermetis" author.[78]

The *Didascalicon* bears evidence of Hugh's intimate knowledge of these works through direct quotations, through unmistakable allusions, and, perhaps more telling than both of these, through incidental phrases which are not easy to recognize and which were introduced, it seems, rather by the unconscious prompting of Hugh's memory than by his deliberate intention.[79] That Hugh should have studied these works with the attentiveness suggested by his use of them, however, or that knowing them he should have employed them in his own work, seems at first sight inconsistent with attitudes he abundantly expresses elsewhere. Unlike Remigius of Auxerre, whose commentaries on Statius, Cato, Persius, Juvenal, Martianus Capella, Prudentius, Sedulius, and the *De consolatione philosophiae* mark him as "un

humaniste qui ne veut rien perdre de l'héritage antique, rien condamner";[80] unlike William of Conches, whose creationist interpretation of the *De consolatione philosophiae* and the *Timaeus* marks him as "un humaniste nourri de culture antique et convaincu de ses secrètes harmonies avec la foi,"[81] Hugh, though a voluminous commentator, has no commentary on texts other than scriptural or religious,[82] and never recommends such texts as those under discussion, or any commentary on them, to his students. In the *Didascalicon* itself, purely literary or poetic works are classified as the mere *appendicia artium*, "which touch in scattered and confused fashion upon some topics lifted out of the arts";[83] the writings of philosophers are described as so many "whitewashed walls of clay," shining with eloquence on their verbal surface but concealing the clay of error and falsehood underneath.[84]

In others of his works, Hugh deplores the number of contemporary men of letters who think more often of pagan lore, of Socrates, Plato, and Aristotle, than of Christ and his saints; who delight in the trifles of poetry and contemn Scripture; who know truth but love falsehood.[85] To the "philosophers of the gentiles," whom he characterizes as peering toward Wisdom with "an alien love that comes seeking from afar," he ascribes three types of false opinion, of groundless teaching, on the origin and continuing existence of the world:

Some say that nature alone exists and nothing else, and that God is nothing but the invention of empty fear, and that things were always as they are, from the beginning, before the beginning, without beginning. And the ages roll by, and nature produces and renews itself, and nothing can be different from what it has always been. Others declare the contrary and fight because of such insults to the Creator, and think that they are defending him, when in fact they too are attacking him with their lies. They say that there is an "opifex," who shaped all things out of matter coeternal with himself, giving matter an improved form. These do not know the power of the Creator; they deny that anything has been made from nothing or can fall back into nothingness, and they make the work of the Creator consist only in shifting things about.[86]

The third group, Hugh continues, admit that all things were made from nothing, that once nothing was yet created, that then the Maker of all things existed and has always existed. But from this promising beginning they come to a bad end:

Seeming to perceive the truth about creation, they fall into countless lies about the subsistence of things. They invent essences and forms and atoms and 'ideas of the principal constitutions' and numerous elements and infinite births and invisible motions and procreative agencies. And in all these things they multiply mere shadows of thought...and the truth is in none of them.[87]

Repeatedly Hugh remarks upon the disparity between the cosmogony of the *Timaeus* and the truth taught by Christian authors according to the true faith.[88] Since the basic truth about the creation and subsistence of the world is known, continued disputes over its constitution are "the disputes of men who, out of vain curiosity, pry into the hidden things of God's works— disputes which they multiply by making up for themselves lies about things of which they are ignorant."[89]

For Hugh, philosophy is essentially Christian philosophy. The pagan philosophers, to be sure, wished to find Wisdom, but not believing in Christ, they did not know the Way. Serving as their own guides, they explored moon, sun, the stars of heaven, heaven itself, and beyond heaven, the firmament. There was nothing higher toward which they could reach in their search for Wisdom. But that Wisdom which is above all things lies in none of the physical things He has made. He resides within man—and these philosophers sought him in the outside world![90] In the arts of the trivium and quadrivium—wherever they were not dealing with God, whether taken in himself, or as Creator, or as the final end of man—Hugh concedes that the ancients were preeminent. But even here he minimizes their role by asserting their subservience to the Christian philosophers who were to follow them. If for Bernard of Chartres the ancients were giants on whose shoulders the moderns perched like dwarfs, for Hugh the ancients were but laborers upon an inferior truth, while to Christians, to the sons of Life, was reserved the consummation of truth.[91]

Heterodox and inconsistent with the general tenor of Hugh's thought, the cosmological texts and allusions found in the *Didascalicon* seem at first sight not only out of place but peculiarly gratuitous. While they appear in the opening chapter of Book i, they are above all centered in chapters vi and vii, and ix and x, the digressive and inessential character of which,

from the standpoint of the argument of Book I, has been noted above.[92] It is only when Hugh's use of such texts and allusions in the *Didascalicon* is examined in some detail that they are found carefully altered in meaning and thus made consistent with his thought as elsewhere expressed. Further, once their adaptation is recognized, their introduction into the *Didascalicon* ceases to seem gratuitous and assumes instead a rhetorical value. Given new currency by revived interest in the works which embody them, propounded by teachers as dynamic and contentious as Abaelard and William of Conches, receiving added importance by the very notoriety of Abaelard's condemnation at Soissons in 1121, such texts and ideas would be well known to readers of the *Didascalicon*. By using them, Hugh spoke to his contemporaries in terms significant in their times; by adapting their meaning, he made them promote a point of view actually alien, as we have seen, to the borrowed texts themselves, and hence gave, even to those who might disagree with him, an attractive proof of ingenuity.

The opening, or keynote, sentence of the *Didascalicon*, with its Boethian "Form of the Perfect Good," at once evokes a commentary tradition which, from as far back as John the Scot and Remigius of Auxerre, risked heterodoxy in order to give Christian accommodation to *Timaean* concepts of the world and its origin.[93] While the over-all phraseology of the opening sentence derives from the *De consolatione philosophiae*, Book III, prose x, and from Boethius's inquiry there into the existence and identity of the Perfect Good, source of human felicity, the term "perfecti boni forma" looks back also to the "insita summi forma boni," "ratio perpetua," "supernum exemplum," "mens," "lux," and "fons boni" of the *De consolatione philosophiae*, Book III, metre ix. Consistently identifying these terms with the Joannine Creator-Logos, with the Pauline "Christ, Wisdom of the Father," or "Christ, form of God," commentators from the ninth century onward were led into a variety of stratagems in their efforts to give comparable Christian naturalization to Platonic teaching on the perpetuity of matter, on God as the mere shaper of a preexistent material chaos, on the descent through the cosmos of souls created on stars, or on the stars themselves as living divine beings sharing with the "anima

mundi" a superintendence over life and motion in the inferior reaches of the cosmos.

Hugh's acceptance of the Christianized Platonic *Nous* in its cosmic and creationist role is explicit in his mention of "that archetypal Exemplar of all things which exists in the divine Mind, according to the idea of which all things have been formed."[94] The opening words of the *Didascalicon*, however, present the divine Wisdom not as exemplary cause of creation at large, but specifically as instigator and term of *man's* illumination and restoration; not as a general ontological cause, but as a moral objective, as something to be sought, and sought first, by man. By reminding man of his origin, the divine Wisdom, Hugh says, keeps man from being like the other animals.[95] The "tripod" of Apollo, with its superscription "Know theyself" is actually the threefold sense of Scripture, inspired by the divine Wisdom to teach man self-knowledge.[96] Further relations between the divine Wisdom and man are detailed in the Boethian definition of philosophy in chapter ii, which extends the materials of the opening paragraph of chapter i. Thus, with an emphasis wholly different from that of Chartrian contemporaries who were preoccupied with the role of the divine Wisdom in the genesis of the cosmos—from Bernard of Chartres, who became entangled in the paradoxes of John the Scot's "natura quae et creatur et creat";[97] or from William of Conches, bent upon eliciting an Augustinian creationism from the *Timaeus*;[98] or from Thierry of Chartres, who drew upon Neopythagorean arithmology to explain how the created many derive from the creating One[99]—Hugh begins, in his very opening words, to lead toward the expression of his belief, following Augustine, that the human mind is made in the image of the divine Wisdom, and that this image, damaged by the fall, is to be restored through the arts, in cooperation with grace.[100]

Arresting, however, is the sudden reference to the *Timaeus*, and thus, ostensibly, to the world-soul, in the second paragraph of the first chapter.[101] Plato's *Timaeus*, we are told,

...formed the entelechy out of substance which is 'dividual' and 'individual' and mixed of these two; and likewise out of nature which is 'same' and 'diverse' and a mixture of this pair, by which the universe is defined.[102]

We are told further, in a passage lifted from the Chalcidian elucidation of the "anima mundi," that the entelechy grasps "not only the elements but all things that are made from them,"[103] and to substantiate this capacity certain Empedoclean verses, found also in Chalcidius and also in connection with the "anima mundi" (though a second time in connection with man's soul), are cited.[104] Lastly, a verse from the *De consolatione philosophiae*, Book III, metre ix("Quae cum secta duos motum glomeravit in orbes"— line 15), a verse alluding to the two circles into which the world-soul is arranged in *Timaeus* 36 B-C, is closely paraphrased.[105]

Interpretations of these passages current at the time the *Didascalicon* was written were associated with heretical points of view and were, in fact, abandoned by their authors within a decade or a little after the appearance of the *Didascalicon*. To Abaelard, the *Timaean* passage on the world-soul referred "per pulcherrimum involucrum" to the Holy Spirit, "same" in nature with Father and Son, "diverse" in person; "individual," that is, indivisible, because the divine substance is simple, "dividual" because it divides its gifts among many.[106] To William of Conches, who also identified the world-soul with the Holy Spirit[107] but who explained Plato's terms with a typical cosmological emphasis, the world-soul is "individual" because, as spirit, it lacks parts, "dividual" because of the different grades of vital power it bestows upon plants, upon animals, upon men; "same" as productive of reason and intellect, which are unchanging, "diverse" as productive of sense and opinion, which change and err.[108] Following Chalcidius, William cited the Empedoclean verses in his commentary on the *Timaeus* as showing why the world-soul, if it was to discern as well as to vivify all things, would have, in some fashion, to be composed of them.[109] The "Quae cum secta duos" verse from the *De consolatione philosophiae* he interpreted as referring to the spheres of the planets and the firmament, which, contrary in movement, exercise different influences upon the corporeal world.[110] The term "entelechy," moreover, was reported by John the Scot and Remigius of Auxerre to be Plato's name for the "anima mundi," and its use in this sense in Bernardus Silvestris's *De mundi universitate* testifies to the currency of this mistaken identification in the twelfth century.[111]

But by all these terms—"entelechy," the "same and diverse" and "dividual and individual" of the *Timaeus* passage, the Empedoclean verses, and the terms taken from the "Quae cum secta duos" line of the *De consolatione philosophiae*, Book III, metre IX—Hugh intends not the "anima mundi" but the human soul. That "entelechy" was not Plato's but Aristotle's term for "the first perfection of a natural organic body" he might have learned from Chalcidius, who makes the point in a context dealing with man;[112] and one notes that Hugh endows his entelechy with senses and sense perceptions, explicitly denied to the animate world by Plato in *Timaeus*, 33. That "persons of better judgment" apply the *Timaeus* passage to man, to the microcosm rather than to the macrocosm, he might also have read in John the Scot and Remigius,[113] and John the Scot supplies the psychological interpretation of the "Quae cum secta duos" verse which, rather than William of Conches' astrological one, Hugh follows; the "two spheres" being those of sensory and intellectual cognition.[114]

The bases for Hugh's application of these materials to man thus exist in aspects of the commentary tradition ignored by William of Conches. But beyond this, the opening chapter's concluding references to the dignity, fall, and restoration of human nature make it unmistakable, should one have missed Hugh's meaning earlier in the chapter, that he has been speaking of the human soul. Similarly, the title of chapter iii, "Concerning the threefold power of the soul, and the fact that *man alone* is endowed with reason," excludes the common attribution of reason to the world-soul, just as the chapter itself, by presenting vegetative, sensitive, and rational life with reference to terrestrial beings alone, stands pointed against the current interpretation of the world-soul as threefold in nature because of the source of these three forms of life.[115] In his *De tribus diebus*, Hugh admits that God fills the universe as source of vitality and motion, but he denies that "the Creator Spirit" can be present to the universe as a soul.[116] Finally, the *brano* revision of William of Conches' *De philosophia mundi* lists several contemporary interpretations of the *Timaean* "dividual and individual substance" and "same and diverse nature"; one of these, agreeing in all particulars with various passages in the

Didascalicon, refers entirely to the human soul and may safely be concluded to be Hugh's.[117]

In later chapters Hugh makes further modifications in current cosmological teachings. Among the commonest current synonyms for "world-soul" was the term "nature."[118] Hugh first of all uses "nature" to indicate the whole of creation, intellectual and material, viewed as a perpetual ordinance of God.[119] Second, he uses "nature" to indicate the superlunary world, following the pseudepigraphous "Liber Hermetis" in strictly astronomical details but no farther. He does not, like that work, make the celestial "nature" an offspring of the divine Cause or Good ("Tugaton") and the *Nous* or *Ratio*, a generative hierarchy uncomfortably suggestive of the Trinity; he does not, like that work, make the celestial "nature" distributor to the inferior world of those essences of which *Nous* is the source, but reserves that function to the divine Exemplar itself, in accordance with a more orthodox view of Providence.[120] Last, in a brief survey of three basic meanings of "nature" among the ancients, he limits himself to recording the term's extension to the archetypal Exemplar, to the "proprium esse" of each created thing, and to a certain cosmic fire, which, as we learn from his homilies on Ecclesiastes, he would locate not in a world-soul, but in nothing more mysterious than the sun, William of Conches' objections to this view notwithstanding.[121]

The distinction among "the work of God," "the work of nature," and "the work of the artificer, who imitates nature," Hugh borrows from Chalcidius, but with basic modifications in meaning.[122] Both the title of *Didascalicon* I. vi ("Concerning the three 'manners' of things") and that chapter's differentiation among "eternal," "perpetual," and "temporal" can be traced to William of Conches' commentaries on the *De consolatione philosophiae* and the *Timaeus*,[123] but Hugh includes the chapter, as he includes *Didascalicon* I. x, not for its intrinsic cosmological interest but to identify precisely the temporal nature of the needs served by the mechanical arts and the "adulterate" character of their products.[124] The chapter "Concerning the three subsistences of things,"[125] possibly intended for interpolation after *Didascalicon* I. vi,[126] presents the angels not in Chalcidian terms as cosmically localized fiery intermediaries between God and

man, as do William of Conches and numerous contemporaries,[127] but as participants, through knowledge, in the primordial causes subsisting in the divine Mind and in this sense as containing the exemplars according to which material creation was made.[128]

The reactivation of the *Timaean,* Boethian, and Hermetic cosmological materials in the twelfth century did not spring from a simple desire to bring these to light for their own sakes, from what Chenu has called "une curiosité de bibliothécaire en mal de souvenirs antiques."[129] Chartres had its own immediate interests and purposes in regard to these materials, and so did Abaelard, as Parent and others have long ago shown. Perhaps we can now see as well the reason for the interest which Hugh displays in the same materials in the *Didascalicon.* If he used them there at all, it was because others had misused them first; if he was interested in them, it was because others were excessively interested in them. He used them in an altered sense, and he reapplied and absorbed them into the ethico-mystical objective which governs the program of study set forth in the *Didascalicon.*

IV. *The Didascalicon and Earlier Works in the Didascalic Tradition.* Original in its own time for its argument for a fourfold "philosophy" oriented toward the perfecting of fallen man, and for its distinctive adaptation of currently fashionable cosmological texts and themes within the line of that argument, the *Didascalicon* is original in relation to traditional Christian didascalic works as well. Thus, though it has been likened to the *De doctrina christiana* of Augustine, the *Institutiones divinarum et saecularium lectionum* of Cassiodorus, the *Etymologiae* of Isidore, and the *De institutione clericorum* of Rhabanus Maurus, as we have seen,[130] it is essentially different from all four.

The *Didascalicon,* in the first place, is not rhetorical in aim, like the *De doctrina christiana;* it is not, like it, a manual for Christian indoctrination, showing first how to discover truth from Scripture and then how to teach, please, and persuade in presenting the discovered truth to others. In short, it is not conceived by a bishop for the preparation of preachers. Nor is it a manual of clerical, much less of monastic formation, and in this it differs from the work of Rhabanus, written to form a

clergy for the German missions, and of Cassiodorus, who out-
lined a plan of study and work peculiarly adapted to the re-
sources and aims of his new monastic foundation at Vivarium.
Finally, the *Didascalicon* is not an impersonal digest of universal
knowledge, an encyclopedic source book, and in this it differs
from the *Etymologiae* of Isidore.[131]

But since Hugh was undoubtedly inspired by Augustine more
than by any other single authority, it will be particularly in-
structive to compare the *Didascalicon* and the *De doctrina
christiana* in greater detail.

The orientation of the *Didascalicon* is toward the restoration
within the individual *lector*, or student, of the image of the
divine Wisdom, the second person of the trinitarian Godhead,
through whom, as through the primordial Idea or Pattern of all
things, the Father has established the universe and through
whose mysteries, from the fall to the end of time, he accomplish-
es the work of restoration. The orientation of the *Didascalicon*
is therefore, in a sense, mystical, since it looks toward man's
union with the divine Wisdom, or Son. It must also be called
noetic and ethical, since the mystical union is to be promoted
through the pursuit and contemplation of truth on the one hand
and the practice of virtue on the other. It must also be called
"philosophical," not only because of the love of the divine
Wisdom which motivates the pursuit but because of the full
complement of arts and disciplines which effects that pursuit.
Lastly, it must be called universal, intended for all men, partly
because in the preface to the *Didascalicon* Hugh exhorts all men
to study at the cost even of great efforts should they lack ability
and of keen physical sufferings should they lack material means,
partly because the program itself is postulated upon a catastrophe
which Hugh accepts as universal for the race, but finally because
he teaches expressly that no man may excuse himself from the
obligation to construct within his own soul the "arca Sapientiae"
—a dwelling place for the divine Wisdom.[132] The result of the
philosophic quest is the restoration in man of that form of the
divine nature or Wisdom, lost to him through the fall:

This, then, is what the arts are concerned with, this is what they intend,
namely, to restore within us the divine likeness, a likeness which to us is a
form but to God is his nature. The more we are conformed to the divine

nature, the more do we possess Wisdom, for then there begins to shine forth again in us what has forever existed in the divine Idea or Pattern, coming and going in us but standing changeless in God.[133]

It cannot be doubted that for Augustine, as for Hugh, the philosophic quest had a religious importance, that he valued at least certain of the arts as assisting man to the divine Wisdom, and that he regarded the restoration of the divine likeness in man as man's destined end. But beyond this point qualifications accumulate. For Augustine, the restoration of the divine likeness in man is altogether reserved to the perfect vision of God in glory to come;[134] it is not, as in Hugh, a process which begins with a study of the arts in this life. The arts render a man "quicker, more persevering, and better equipped for the truth he should embrace,"[135] but they are not themselves integral parts of that truth, increments of a growing divine likeness in man, as Hugh would have them; philosophy, whatever its part in Augustine's own spiritual growth, is not the normal avenue of Christian intellectual development as he finally conceives it in the *De doctrina christiana*.[136]

The *De doctrina christiana* holds up the study of Scripture as the exclusive source of normal Christian intellectual development; the result immediately intended is charity, not Wisdom. The opening book of the *De doctrina christiana* is devoted, not like that of the *Didascalicon*, to elucidating the relationship between the arts and man's pursuit of the divine Wisdom, but to elucidating the twofold law of love which directs that God alone be enjoyed and one's fellow-man well used in reference to God as man's end. For Augustine, all knowledge is reducible to charity, or love. Whatever a man has learned outside of Scripture, if it is harmful, is condemned in Scripture; if it is useful, is found in Scripture in greater abundance along with much that can be found nowhere else;[137] yet Scripture teaches nothing but love in all that it says.[138] To be sure, Augustine speaks of the knowledge gained from Scripture as the third step in a sevenfold ascent to Wisdom:[139] but the "knowledge" of which Augustine here speaks has nothing in common with the knowledge Hugh seeks from the arts; it is man's "knowledge" that he is entangled in temporal things, that he lacks the great love Scripture enjoins, and that he has good hope of deliverance;

and "Wisdom" in this context is not specifically identified, as in Hugh, with the divine Idea or Pattern of all things, source and object of truth and virtue even in the secular arts.

Of the arts, the *De doctrina christiana* offers a scheme radically different from that of the *Didascalicon*. Hugh elaborates a division of philosophy containing twenty-one distinct arts, with further subdivision possible.[140] While seven of these are singled out for special attention,[141] all constitute "divisive parts of philosophy" and are integral to its pursuit. Augustine, on the other hand, interpolates his analysis of the arts into a discussion of what pagan learning a Christian intellectual may not improperly acquire. His analysis is not presented as a division of philosophy but, more loosely, as a critical survey of the kinds of teachings practiced among the pagans.[142] Pagan knowledge he classifies thus:

I. Knowledge of things men have instituted:
 A. In cooperation with demons: magic, soothsaying, omens, superstitious practices.
 B. Among themselves:
 1. Unnecessarily and excessively: acting, dancing, painting, sculpture, fiction.
 2. Usefully and indispensably: weights, measures, coins, uniforms, written notations, and various arrangements necessary for the management of society.

II. Knowledge of things done through time or divinely instituted:
 A. Pertaining to the senses:
 1. History.
 2. Natural history.
 3. Astronomy.
 4. Useful corporeal arts:
 a. Those producing enduring effects like a house, a bench, or a dish.
 b. Those assisting God in his works, like medicine, agriculture, government.
 c. Those terminating in an action, like leaping, running, wrestling.
 B. Pertaining to the reason:
 1. The science of conclusions, definitions, and divisions.
 2. Eloquence.
 3. The science of number considered in itself or applied to figures, sounds, and motions.[143]

Having outlined pagan knowledge, Augustine classifies as unsuitable for Christians various parts of it which Hugh accepts as necessary. Of things instituted by men, Augustine countenances only those useful and indispensable for the management of society (I. B. 2.). He disallows dramatics and fiction (I. B. 1.), the former of which finds a place in Hugh's scheme as one of the mechanical arts,[144] and the latter of which Hugh recommends for recreation though not for serious study.[145] On the condemnation of magic both men agree.[146] Of things done through time or divinely instituted, Augustine dismisses astronomy (II. A. 3.) as useless[147] and depreciates the importance of formal study of eloquence (II. B. 2.),[148] both of which Hugh finds essential. Of all the teachings of the pagans, none are useful, Augustine thinks, except history, natural history (II. A. 1 and 2.), corporeal arts (II. A. 4.), and the sciences of reasoning and number (II. B. 1 and 3.).[149] His criterion is the immediate value of every branch of knowledge in the interpretation of Scripture. The limits of study as Augustine conceives it appear in the projects he recommends: histories to supplement scriptural history; handbooks to explain scriptural names, places, animals, plants, trees, stones, metals, numbers, and, if possible, types of reasoning.[150] Hugh, too, regards secular learning as of value for scriptural exegesis, but he requires a broader base of secular arts as preparation for this purpose than Augustine does, and he groups the secular arts according to their service to particular levels of scriptural interpretation.[151] Finally, while Hugh is faithful to Augustine in the concept of the divine Wisdom's relation to the rational creature, a concept which underlies the *Didascalicon*, it must be said that he draws from this concept, in his fourfold "philosophy" and his web of twenty-one arts, a program of study which exceeds anything that Augustine thought necessary.

But it has also been claimed that the *Didascalicon* bears closer resemblance to the *Institutiones divinarum et saecularium lectionum* of Cassiodorus than to any other previous work.[152] The comparison, whatever its truth, obscures differences at least as radical as those distinguishing the *Didascalicon* from the *De doctrina christiana*. Written "for the instruction of simple and unpolished brothers in order that they may be filled with an

abundance of Heavenly Scriptures," the *Institutiones* outlines for the cenobites of Vivarium a reading course in the Bible and the Fathers.[153] A compendium of secular arts is added only because these arts, though they do not promote spiritual advancement and can even be dangerous, are useful for interpreting Scripture, and because those already instructed in this sort of knowledge may wish a brief review, while those who are not, may profit by a few rudiments.[154] The arts treated are only the seven of the trivium and quadrivium; missing are theology and physics, the three branches of ethics, and the seven mechanical arts, all integral to Hugh's scheme. A division of philosophy into "inspective" and "actual" arts, prefixed to the chapter on dialectic in obedience to a custom set by commentators on Porphyry's *Isagoge*,[155] is analogous to Hugh's divisions of the theoretical and practical arts, different, however, in terminology[156] and without organic relevance to Cassiodorus's total presentation. Of Hugh's mechanical arts, agriculture, fishing, and medicine appear, but the first is a last resort for brethren too simple for instruction in letters, the last two are praised as works of mercy, especially to strangers;[157] there is no vision of a complex of mechanical arts serving the philosophic quest by repairing physical weaknesses sustained by man in the fall. In fact, Hugh is indebted to the *Institutiones* principally for a definition of theology which he enriches by associating it with concepts found in Boethius,[158] and possibly for a definition of philosophy, in which, however, he modifies the words and the meaning.[159]

Responsible for the notion that Hugh resembles Cassiodorus is the bipartite division of the *Didascalicon* into the first three books, which deal, as some have alleged, with philosophy or the profane sciences, and the last three, which deal, according to the same view, with theology or sacred science.[160] The bipartite division into two groups of three books each cannot be denied; but to infer that it represents a cleavage between sacred and profane like that in Cassiodorus, or a distinction between philosophy and theology like that common from the thirteenth century onwards is to misread the *Didascalicon* and do violence to Hugh's thought as there and elsewhere expressed. For Hugh, philosophy is the pursuit of the divine Wisdom;[161] it is the only

wisdom a man can have in this life;[162] it governs all human actions or occupations;[163] it comprehends all knowledge whatever.[164] Philosophy is simply the whole of human life pursued in proper relation to its final cause, or, one may also say, its formal cause.[165] Its all-inclusive divisions are outlined in the first part of the *Didascalicon* without concern for the sources of the knowledge, whether in reason or faith, in the created world or the mysteries of revelation, in secular writings or in Sacred Scripture. The last three books, then, do not "add" theology to the first three. Theology, the science of intellectible being, however that science be obtained, has its place among the disciplines outlined in the first three books, and a different explanation must be found for the bipartite division of the work.

The explanation lies in the divine Wisdom's double manifestation of itself in the works of creation and the works of salvation, the former constituting the matter of secular writings, the latter constituting the matter of Sacred Writings.[166] The existence of the Sacred Scripture alters the character of philosophy for Hugh, and no adequate grasp of his thought is possible without clear understanding of the reciprocal role he assigns to secular writings and Scripture in the one pursuit of the one Wisdom, the one philosophy.

Scripture, in the first place, is the primary "documentum," or evidence, in the theological art. A false "worldly theology" was elaborated by the ancients, who, first ignoring, then proudly rejecting the works of salvation, restricted themselves to the indistinct natural evidences of the created world. The terms in which Hugh speaks of "worldly theology" are almost vituperative: "dense gloom," "deep darkness of ignorance," "a trap of error to ensnare the proud," "foolishness," "lying fictions of their own fashioning."[167] Clearly, he does not think of *mundana theologia* as, in the thirteenth century and later, men were to think of natural theology. It can hardly be "worldly theology," so characterized and, moreover, a purely natural theology, which is meant by "theology" in the first three books of the *Didacalicon*. The great mistake of non-Christian theologians, Hugh teaches, was precisely that they reasoned exclusively from natural evidences and so became fools:

Invisible things can only be made known by visible things, and therefore the whole of theology must use visible demonstrations. But worldly theology adopted the works of creation and the elements of this world that it might make its demonstration in these... And for this reason, namely, because it used a demonstration which revealed little, it lacked ability to bring forth the incomprehensible truth without the stain of error... In this were the wise men of this world fools, namely, that proceeding by natural evidences alone and following the elements and appearances of the world, they lacked the lessons of grace.[168]

True theology, divine because it bases itself primarily on the works of restoration, on the humanity of Jesus and his mysteries from the beginning of the world, does not ignore the works of creation altogether, however; it "adds natural considerations in due measure, in order that it may fashion instruction from them."[169] In part these "natural considerations" are demonstrations of the existence and even the trinitarian nature of God drawn from the immensity, beauty, and utility of the external world as well as from introspective examination of the rational creature in operation.[170] In part, they are the "natural arts" or "lower wisdom"—the arts of the trivium, the quadrivium, and physics—needed for the interpretation of Scripture. For the Sacred Text "excels all other writings in subtlety and profundity, not only in its subject matter but also in its method of treatment, for whereas in other writings words alone convey the meaning, in it things as well as words are significant."[171] Hence, the arts of the trivium are needed to illuminate the verbal surface of the Sacred Writings as of non-sacred; while physics and the arts of the quadrivium are uniquely needed to illuminate the meaning of scriptural *things*, which, allegorically interpreted (*facta mystica*), lead to truth, tropologically interpreted (*facienda mystica*), lead to virtue.[172]

Scripture, then, is the source *par excellence*, but not the only source, of theology; and theology in turn is the "peak of philosophy and the perfection of truth."[173] Scripture is likewise, though again not exclusively, the source *par excellence* for ethics.[174] All the other arts, apart from their intrinsic value, serve to explain Scripture. Because Scripture exists as a distinct corpus, having its own history and canon and requiring its own bibliographical approach, and because it has unique properties demanding specialized techniques of interpretation and fitting it

for varied uses at different points in the spiritual and intellectual development of man, it is given special attention in the latter half of the *Didascalicon*.

The originality of the *Didascalicon* does not extend, then, to an anticipation of the Thomistic distinction between philosophy and theology, as Hugonin, Mignon, Mariétan, Manitius, Kleinz, Vernet, and others have believed. On the contrary, the *Didascalicon* is true to Augustine, as to its own time, in adhering to a conception of philosophy as coterminous with all knowledge whatever, including revealed or scriptural knowledge, and as consisting essentially in man's search for reunion with the God by and for whom he was made and without whom he can have neither peace nor profit in any earthly pursuit. It is true to Augustine in its independent rehandling of an Aristotelian division of knowledge, grouping the arts into a fourfold remedy for the needs of fallen man. It is true to its time as well, though in a different sense, by endeavoring, as it seems, to stand against secularist adaptations of learning everywhere current, but especially among the Chartrians, and by reclaiming even suspect cosmological texts and themes for its divinely oriented formulation of the intellectual life. And finally, in the very vigor of its response to the interests of its time, in its very willingness to formulate its Augustinian viewpoint in terms currently vital, it is led beyond the achievement of Augustine, as it is led beyond that of Cassiodorus, and cannot adequately be described as a refurbishment either of the *De doctrina christiana* or the*Institutiones divinarum et saecularium lectionum*.

V. *The Author of the Didascalicon.* Hugh is an author who is, as de Ghellinck has remarked, "très discret quand il parle de lui-même."[175] In all his writings, only three passages shed light upon his origin and early life. Two of these appear in the *Didascalicon*. The first, in *Didascalicon* III. xix, occurs in connection with Hugh's observation that the perfect lover of Wisdom considers all the world a place of exile. The unpracticed beginner, he remarks, must try little by little to withdraw himself from love of the world. He must separate himself first of all from those tender ties which bind him to his homeland, extending his love to all lands equally. Later he can withdraw

his love even from these. Then he adds: "From boyhood I have dwelt on foreign soil, and I know with what grief the mind takes leave of the narrow hearth of a peasant's hut, and I know too how frankly it afterwards disdains marble firesides and panelled halls." Apart from the reference to dwelling abroad since early life, the statement seems to be largely rhetorical, a tissue of allusions to Vergil, Horace, Cicero.[176] In the second passage, in *Didascalicon* vi. iii, Hugh reminisces on his love of learning, specifically his experimental curiosity in the arts of the trivium and quadrivium, while still a schoolboy.[177] The third, which comprises the dedicatory epistle to the *De arrha animae*,[178] shows a fondness for and a familiarity with the brethren of the small Augustinian priory of St. Pancras, Hamersleben, which have led to the identification of that far-off Saxon house as the scene of Hugh's early religious life and his schoolboy pursuits.

To these passages from Hugh's works must be added several items from the Victorine archives. The Victorine necrology for February 11 records the "anniversarium solemne" of Master Hugh, "who, yielding himself to the service of God in this our house from the first flower of his youth, so outstandingly took to himself the gifts given him by the heavenly Wisdom from above that in all the Latin Church, no man can be found to compare with him in wisdom." The necrology goes on to mention relics of the martyr St. Victor which Hugh brought to the Abbey from Marseilles, having "sought them with much effort and begged them with great difficulty." For May 5, the necrology mentions Hugh's uncle, also named Hugh, whom it identifies as "an archdeacon of the church of Halberstadt, who came to us from Saxony, following in the footsteps of Master Hugh, his nephew." It observes that he "enriched our establishment magnificently with gold, silver, precious vestments, carpets, draperies, and other furnishings from his own goods" and that he supplied funds for the building of the Abbey church. For June 17, the day on which the Abbey celebrated the feast of its reception of the relics of St. Victor, the necrology and ordo prescribe that mass be celebrated for the soul of Hugh, their donor. Adam of St. Victor's twelfth-century sequence for this feast likewise records the story of the relics having been brought from Marseilles.

These records, plus a variety of references to Hugh in chronicles from the region of Halberstadt, lie at the basis of the account of Hugh's life which the Victorines prefixed to the Rouen, 1648, edition of Hugh's works and of the comparably circumstantial version of his life found in the mid-sixteenth-century *Halberstädter Bischofschronik* of Johann Winnigstedt. If the complementary data of these two accounts are combined, the following story emerges: Hugh was born a lord of Blankenburg in the diocese of Halberstadt toward the end of the eleventh century. His parents sent him to the newly founded Augustinian house of St. Pancras, Hamersleben, in the same diocese, to learn letters. There, captivated by love of learning, he chose to become a novice, despite the unwillingness of his parents. His uncle, Reinhard, was bishop of Halberstadt. When he was eighteen years of age, Bishop Reinhard, his diocese about to be devastated by the Emperor Henry V, sent Hugh to Paris accompanied by his uncle and namesake, the Archdeacon Hugh. The two Hughs traveled first to Marseilles, where they obtained relics of St. Victor from the monastery of that name. Subsequently, they went to Paris, where, on June 17 in approximately the year 1115, they offered both the relics and their vows to Gilduin, first abbot of the Paris Abbey of St. Victor. When, after a time, Hugh had confirmed his vows, he was placed in charge of studies in the trivium and quadrivium, and finally made master of the school. After twenty-five years of life at the Abbey, he died on February 11, 1140 or 1141. An eye-witness account of his death, written by the infirmarian Osbert, is extant.[179]

Belief in this story of Hugh's life is not universal, but for reasons set forth in detail elsewhere, it seems to the present writer to be dependable in main outline.[180] Significant is Hugh's early contact with the canonical movement, which sought to make available to men living in the world the life of primitive Christian perfection—the *vita apostolica et canonica primitivae ecclesiae*—formerly confined to the monasteries.[181] To this aim of the canonical movement in general may perhaps be traced Hugh's interest in a view of "philosophy," that is, of education and life, which is directed to all men; to it may also be traced, in part, his desire to incorporate the mechanical arts, beginning to

flourish in the rising centers of urban life, into "philosophy" so conceived. Apart from this, it is difficult to see what influence the facts of his life, meager as we know them, exercised upon his work.

DIDASCALICON

On the Study of Reading

by Hugh of Saint Victor

PREFACE

There are many persons whose nature has left them so poor in ability that they can hardly grasp with their intellect even easy things, and of these persons I believe there are two kinds. There are those who, while they are not unaware of their own dullness, nonetheless struggle after knowledge with all the effort they can put forth and who, by tirelessly keeping up their pursuit, deserve to obtain as a result of their will power what they by no means possess as a result of their work. Others, however, because they know that they are in no way able to compass the highest things, neglect even the least, and, as it were, carelessly at rest in their own sluggishness, they all the more lose the light of truth in the greatest matters for their refusal to learn those smallest of which they are capable. It is of such that the Psalmist declares, "They were unwilling to understand how they might do well."[1] Not knowing and not wishing to know are far different things. Not knowing, to be sure, springs from weakness; but contempt of knowledge springs from a wicked will.

There is another sort of man whom nature has enriched with the full measure of ability and to whom she shows an easy way to come at truth. Among these, even granting inequality in the strength of their ability, there is nevertheless not the same virtue or will in all for the cultivation of their natural sense through practice and learning. Many of this sort, caught up in the affairs and cares of this world beyond what is needful or given over to the vices and sensual indulgences of the body, bury the talent of God in earth,[2] seeking from it neither the fruit of wisdom nor the profit of good work. These, assuredly, are completely detestable. Again, for others of them, lack of family wealth and a slender income decrease the opportunity of learning. Yet, we decidedly do not believe that these can be

altogether excused by this circumstance, since we see many laboring in hunger, thirst, and nakedness attain to the fruit of knowledge. And still it is one thing when one is not able, or to speak more truly, when one is not easily able to learn, and another when one is able but unwilling to learn. Just as it is more glorious to lay hold upon wisdom by sheer exertion, even though no resources support one, so, to be sure, it is more loathsome to enjoy natural ability and to have plenty of wealth, yet to grow dull in idleness.[3]

The things by which every man advances in knowledge are principally two—namely, reading and meditation. Of these, reading holds first place in instruction, and it is of reading that this book treats, setting forth rules for it. For there are three things particularly necessary to learn for reading: first, each man should know what he ought to read; second, in what order he ought to read, that is, what first and what afterwards; and third, in what manner he ought to read. These three points are handled one by one in this book. The book, moreover, instructs the reader as well of secular writings as of the Divine Writings. Therefore, it is divided into two parts,[4] each of which contains three subdivisions. In the first part, it instructs the reader of the arts, in the second, the reader of the Sacred Scripture. It instructs, moreover, in this way: it shows first what ought to be read, and next in what order and in what manner it ought to be read. But in order to make known what ought to be read, or what ought especially to be read, in the first part it first of all enumerates the origin of all the arts, and then their description and division, that is, how each art either contains some other or is contained by some other, thus dividing up philosophy from the peak down to the lowest members. Then it enumerates the authors of the arts and afterwards makes clear which of these arts ought principally to be read; then, likewise, it reveals in what order and in what manner. Finally, it lays down for students their discipline of life, and thus the first part concludes.

In the second part it determines what writings ought to be called divine, and next, the number and order of the Divine Books, and their authors, and the interpretations of the names of these Books. It then treats certain characteristics of Divine Scripture which are very important. Then it shows how Sacred

Scripture ought to be read by the man who seeks in it the correction of his morals and a form of living. Finally, it instructs the man who reads in it for love of knowledge, and thus the second part too comes to a close.

BOOK ONE

Chapter One: Concerning the Origin of the Arts

Of all things to be sought, the first is that Wisdom in which the Form of the Perfect Good stands fixed.[1] Wisdom illuminates man so that he may recognize himself;[2] for man was like all the other animals when he did not understand that he had been created of a higher order than they.[3] But his immortal mind, illuminated by Wisdom, beholds its own principle and recognizes how unfitting it is for it to seek anything outside itself when what it is in itself can be enough for it. It is written on the tripod of Apollo: γνῶθι σεαυτον, that is, "Know thyself,"[4] for surely, if man had not forgotten his origin, he would recognize that everything subject to change is nothing.[5]

An opinion approved among philosophers maintains that the soul is put together out of all the parts of nature. And Plato's *Timaeus*[6] formed the entelechy[7] out of substance which is "dividual" and "individual" and mixed of these two; and likewise out of nature which is "same" and "diverse" and a mixture of this pair, by which the universe is defined.[8] For the entelechy grasps "not only the elements but all things that are made from them,"[9] since, through its understanding, it comprehends the invisible causes of things and, through sense impressions, picks up the visible forms of actual objects. "Divided, it gathers movement into twin spheres"[10] because, whether it goes out to sensible things through its senses or ascends to invisible things through its understanding, it circles about, drawing to itself the likenesses of things; and thus it is that one and the same mind, having the capacity for all things, is fitted together out of every substance and nature by the fact that it represents within itself their imaged likeness.

Now, it was a Pythagorean teaching that similars are comprehended by similars: so that, in a word, the rational soul

could by no means comprehend all things unless it were also composed of all of them; or, as a certain writer puts it:

> Earth we grasp with the earthly, fire with flame,
> Liquid with moisture, air with our breath.[11]

But we ought not to suppose that men most familiar with all the natures of things thought that simple essence was in any way distended in quantitative parts.[12] Rather, in order to demonstrate the soul's marvelous power more clearly did they declare that it consists of all natures, "not as being physically composed of them, but as having an analogous type of composition."[13] For it is not to be thought that this similitude to all things comes into the soul from elsewhere, or from without; on the contrary, the soul grasps the similitude in and of itself, out of a certain native capacity and proper power of its own. As Varro says in the *Periphysion*:[14] Not all change comes upon things from without and in such a way that whatever changes necessarily either loses something it had or gains from the outside some other and different thing which it did not have before. We see how a wall receives a likeness when the form of some image or other is put upon it from the outside. But when a coiner imprints a figure upon metal, the metal, which itself is one thing, begins to represent a different thing, not just on the outside, but from its own power and its natural aptitude to do so. It is in this way that the mind, imprinted with the likenesses of all things, is said to *be* all things and to receive its composition from all things and to contain them not as actual components, or formally, but virtually and potentially.[15]

This, then, is that dignity of our nature which all naturally possess in equal measure,[16] but which all do not equally understand. For the mind, stupefied by bodily sensations and enticed out of itself by sensuous forms, has forgotten what it was, and, because it does not remember that it was anything different, believes that it is nothing except what is seen. But we are restored through instruction, so that we may recognize our nature and learn not to seek outside ourselves what we can find within. "The highest curative in life,"[17] therefore, is the pursuit of Wisdom: he who finds it is happy, and he who possesses it, blessed.[18]

[handwritten note:] Hugh establishes man's fundamental being as that which is made to know and receive wisdom — The thing for which his nature is suited. Bodily passions and appetites "stupefy" us and cause us to assume there is nothing else.

Chapter Two: That Philosophy is the Pursuit of Wisdom

"Pythagoras was the first to call the pursuit of Wisdom philosophy"[19] and to prefer to be called *philosophos*: for previously philosophers had been called *sophoi*, that is, wise men. Fitly indeed did he call the seekers of truth not wise men but lovers of Wisdom, for certainly the whole truth lies so deeply hidden that the mind, however much it may ardently yearn toward it or however much it may struggle to acquire it, can nonetheless comprehend only with difficulty the truth as it is. Pythagoras, however, established philosophy as the discipline "of those things which truly exist and are of themselves endowed with unchangeable substance."[20]

"Philosophy, then, is the love and pursuit of Wisdom, and, in a certain way, a friendship with it: not, however, of that 'wisdom' which is concerned with certain tools and with knowledge and skill in some craft, but of that Wisdom which, wanting in nothing, is a living Mind and the sole primordial Idea or Pattern of things. This love of Wisdom, moreover, is an illumination of the apprehending mind by that pure Wisdom and, in a certain way, a drawing and a calling back to Itself of man's mind, so that the pursuit of Wisdom appears like friendship with that Divinity and pure Mind. This Wisdom bestows upon every manner of souls the benefit of its own divinity, and brings them back to the proper force and purity of their nature. From it are born truth of speculation and of thought and holy and pure chastity of action."[21]

"But since this most excellent good of philosophy has been prepared for human souls, we must begin with those very powers of the soul, so that our exposition may follow an orderly line of progression."[22]

Chapter Three: Concerning the Threefold Power of the Soul, and the Fact that Man Alone is Endowed with Reason

"Altogether, the power of the soul in vivifying bodies is discovered to be of three kinds: one kind supplies life to the body alone in order that, on being born, the body may grow and, by being nourished, may remain in existence; another

provides the judgment of sense perception; a third rests upon
the power of mind and reason.

"Of the first, the function is to attend to the forming, nour-
ishing, and sustaining of bodies; its function is not, how-
ever, to bestow upon them the judgment either of sense
perception or of reason. It is the vivifying force seen at work in
grasses and trees and whatever is rooted firmly in the earth.

"The second is a composite and conjoint power which sub-
sumes the first and makes it part of itself, and which exercises
judgment of several different kinds upon such objects as it can
compass; for every animal endowed with sense perception is
likewise born, nourished, and sustained; but the senses it
possesses are diverse and are found up to five in number. Thus,
whatever receives nutriment only, does not also have sense
perception; but whatever has sense perception does also receive
nutriment, and this fact proves that to such a being the first
vivifying power of the soul, that of conferring birth and
nourishment, also belongs. Moreover, such beings as possess
sense perception not only apprehend the forms of things that
affect them while the sensible body is present, but even after the
sense perception has ceased and the sensible objects are removed,
they retain images of the sense-perceived forms and build up
memory of them. Each animal retains these images more or less
enduringly, according to its ability. However, they possess them
in a confused and unclear manner, so that they can achieve
nothing from joining or combining them, and, while they are
therefore able to remember them all, they cannot do so with
equal distinctness; and, having once forgotten them, they are
unable to recollect or re-evoke them. As to the future, they have
no knowledge of it.

"But the third power of the soul appropriates the prior
nutritional and sense-perceiving powers, using them, so to
speak, as its domestics and servants. It is rooted entirely in the
reason, and it exercises itself either in the most unfaltering grasp
of things present, or in the understanding of things absent, or
in the investigation of things unknown. This power belongs to
humankind alone. It not only takes in sense impressions and
images which are perfect and well founded, but, by a complete
act of the understanding, it explains and confirms what imagi-

nation[23] has only suggested. And, as has been said, this divine nature is not content with the knowledge of those things alone which it perceives spread before its senses, but, in addition, it is able to provide even for things removed from it names which imagination has conceived from the sensible world, and it makes known, by arrangements of words, what it has grasped by reason of its understanding. For it belongs to this nature, too, that by things already known to it, it should seek after things not known, and it requires to know of each thing not only whether it exists, but of what nature it is, and of what properties, and even for what purpose.

"To repeat, this threefold power of soul is the exclusive endowment of human nature, whose power of soul is not lacking in the movements of understanding. By this power it exercises its faculty of reason properly upon the following four heads: either it inquires whether a thing exists, or, if it has established that it does, it searches out the thing's nature; but if it possesses reasoned knowledge of both these things, it investigates the properties of each object, and sifts the total import of all other accidents; and knowing all these things, it nevertheless further inquires and searches rationally why the object exists as it does.

"While the mind of man, then, so acts that it is always concerned with the apprehension of things before it or the understanding of things not present to it or the investigation and discovery of things unknown, there are two matters upon which the power of the reasoning soul spends every effort: one is that it may know the natures of things by the method of inquiry; but the other is that there may first come to its knowledge those things which moral earnestness will thereafter transform into action."[24]

Chapter Four: What Matters Pertain to Philosophy

But, as I perceive, the very course of our discussion has already led us into "a trap from which there is no escape."[25] However, it is not involved words but an obscure subject matter that gives rise to our difficulty.[26] Because we have undertaken to speak of the pursuit of Wisdom, and have affirmed

that this pursuit belongs to men alone by a distinct prerogative of their nature, we must consequently seem committed now to the position that Wisdom is a kind of moderator over *all* human actions. For while the nature of brute animals, governed by no rational judgment, produces movements guided only by sense impressions and in pursuing or fleeing anything uses no discretion born of understanding but is driven by a certain blind inclination of the flesh: it remains true that the actions of the rational soul are not swept away by blind impulse but are always preceded by Wisdom as their guide. If this is settled as true, then we shall say that not only such studies as are concerned with the nature of things or the regulation of morals but also those concerned with the theoretical consideration of *all* human acts and pursuits belong with equal fitness to philosophy. Following this view, we can define philosophy thus: Philosophy is the discipline which investigates comprehensively the ideas of all things, human and divine.[27] *(AND ACTS ON TRUTH)*

And yet we ought not to retract what we said at the outset, namely, that philosophy is the love and the pursuit of Wisdom, not, however, of that "wisdom" which is deployed with tools, like building and farming and other activities of this kind, but of that Wisdom which is the sole primordial Idea or Pattern of things. For the same action is able to belong to philosophy as concerns its ideas and to be excluded from it as concerns its actual performance. For example, to speak in terms of instances already before us, the theory of agriculture belongs to the philosopher, but the execution of it to the farmer. Moreover, the products of artificers, while not nature, imitate nature,[28] and, in the design by which they imitate, they express the form of their exemplar, which is nature.

You see, then, for what reason we are compelled to extend philosophy to all the actions of men, so that necessarily the parts of philosophy are equal in number to the different types of those things over which its extension has now been established.[29]

Chapter Five: Concerning the Rise[30] of the Theoretical, the Practical, and the Mechanical

Of all human acts or pursuits, then, governed as these are by Wisdom, the end and the intention ought to regard either the

restoring of our nature's integrity, or the relieving of those weaknesses to which our present life lies subject. What I have just said, let me more fully explain.

In man are two things—the good and the evil, his nature and the defective state of his nature. The good, because it is his nature, because it has suffered corruption, because it has been lessened, requires to be restored by active effort. The evil, because it constitutes a deficiency, because it constitutes a corruption, because it is not our nature, requires to be removed, or, if not able to be removed completely, then at least to be alleviated through the application of a remedy. This is our entire task—the restoration of our nature and the removal of our deficiency.

The integrity of human nature, however, is attained in two things—in knowledge and in virtue, and in these lies our sole likeness to the supernal and divine substances.[31] For man, since he is not simple in nature but is composed of a twofold substance, is immortal in that part of himself which is the more important part—that part which, to state the case more clearly, he in fact *is*.[32] In his other part, however—that part which is transitory and which is all that has been recognized by those too ignorant to give credit to anything but their senses[33]—he is subject to death and to change. In this part man must die as often as he loses concrete substantiality. This part is of that lowest category of things, things having both beginning and end.

Chapter Six: Concerning the Three "Manners" of Things[34]

Among things there are some which have neither beginning nor end, and these are named eternal; there are others which have a beginning but are terminated by no end, and these are called perpetual; and there are yet others which have both beginning and end, and these are temporal.[35]

In the first category we place that in which the very being (*esse*) and "that which is" (*id quod est*) are not separate, that is, in which cause and effect are not different from one another,[36] and which draws its subsistence not from a principle distinct from it but from its very self. Such alone is the Begetter and Artificer of nature.

But that type of thing in which the very being (*esse*) and "that which is" (*id quod est*) are separate, that is, which has come into being from a principle distinct from it,[37] and which, in order that it might begin to be, flowed into actuality out of a preceding cause—this type of being, I say, is nature, which includes the whole world, and it is divided into two parts:[38] it is that certain being which, in acquiring existence from its primordial causes,[39] came forth into actuality not as moved thereto by anything itself in motion, but solely by the decision of the divine will,[40] and, once in existence, stood[41] immutable, free from all destruction or change (of this type are the substances of things, called by the Greeks *ousiai*)[42] and it is all the bodies of the superlunary world, which, from their knowing no change, have also been called divine.[43]

The third type of things consists of those which have both beginning and end and which come into being not of their own power but as works of nature. These come to be upon the earth, in the sublunary world, by the movement of an artifacting fire which descends with a certain power to beget all sensible objects.[44]

Now, of the second sort it is said, "Nothing in the world perishes,"[45] for no essence suffers destruction.[46] Not the essences but the forms of things pass away.[47] When the form is said to pass away, this is to be understood as meaning not that some existing thing is believed to have perished altogether and lost its being, but rather that it has undergone change, perhaps in one of the following ways: that things once joined are now apart, or once apart are now joined; or that things once standing here now move there; or that things which now are only "have-beens" once subsisted; in all these instances the being of the things suffers no loss. Of the third sort it is said, "All things which have arisen fall, and all which have grown decline":[48] for all the works of nature, as they have a beginning, so have they an end. Of the second sort, again, it is said, "Nothing comes from nothing, and into nothingness can nothing revert,"[49] from the fact that all of nature has both a primordial cause and a perpetual subsistence. And of the third sort, once more, "That which before was nothing returns again thereto":[50] for just as every work of nature flows temporarily into actuality out of its

hidden cause, so when its actuality has temporarily been destroyed, that work will return again to the place from which it came.

Chapter Seven: Concerning the Superlunary and Sublunary World

Because of these facts,[51] astronomers (*mathematici*) have divided the world into two parts: into that, namely, which stretches above the sphere of the moon and that which lies below it.[52] The superlunary world, because in it all things stand fixed by primordial law, they called "nature,"[53] while the sublunary world they called "the work of nature,"[54] that is, the work of the superior world, because the varieties of all animate beings which live below by the infusion of life-giving spirit, take their infused nutriment through invisible emanations from above, not only that by being born they may grow but also that by being nourished they may continue in existence. Likewise they called that superior world "time" because of the course and movement of the heavenly bodies in it, and the inferior world they called "temporal" because it is moved in accordance with the movements of the superior.[55] Again, the superlunary, from the perpetual tranquility of its light and stillness, they called *elysium,* while the sublunary, from the instability and confusion of things in flux, they called the underworld or *infernum.*[56]

Into these things we have digressed somewhat more broadly in order to explain how man, in that part in which he partakes of change, is likewise subject to necessity, whereas in that in which he is immortal, he is related to divinity. From this it can be inferred, as said above, that the intention of all human actions is resolved in a common objective: either to restore in us the likeness of the divine image or to take thought for the necessity of this life, which, the more easily it can suffer harm from those things which work to its disadvantage, the more does it require to be cherished and conserved.

Chapter Eight: In What Man Is like unto God

Now there are two things which restore the divine likeness in man, namely the contemplation of truth and the practice of

virtue. For man resembles God in being wise and just—though, to be sure, man is but changeably so while God stands changelessly both wise and just. Of those actions which minister to the necessity of this life, there are three types: first, those which take care of the feeding of nature; second, those which fortify against harms which might possibly come from without; and third, those which provide remedy for harms already besieging us. When, moreover, we strive after the restoration of our nature, we perform a divine action, but when we provide the necessaries required by our infirm part, a human action. Every action, thus, is either divine or human. The former type, since it derives from above, we may not unfittingly call "understanding" (*intelligentia*); the latter, since it derives from below and requires, as it were, a certain practical counsel, "knowledge" (*scientia*).[57] UNDERSTANDING = DIVINE Things knowledge = earthly.

If, therefore, Wisdom, as declared above, is moderator over all that we do deliberately, we must consequently admit that it contains two parts, understanding and knowledge. Understanding, again, inasmuch as it works both for the investigation of truth and the delineation of morals, we divide into two kinds—into theoretical, that is to say speculative, and practical, that is to say active. The latter is also called ethical, or moral. Knowledge, however, since it pursues merely human works, is fitly called "mechanical," that is to say adulterate.[58]

KNOWLEDGE only MECHANICAL.

Chapter Nine: Concerning the Three Works

"Now there are three works—the work of God, the work of nature, and the work of the artificer, who imitates nature."[59] The work of God is to create that which was not, whence we read, "In the beginning God created heaven and earth";[60] the work of nature is to bring forth into actuality that which lay hidden, whence we read, "Let the earth bring forth the green herb,"[61] etc.; the work of the artificer is to put together things disjoined or to disjoin those put together, whence we read, "They sewed themselves aprons."[62] For the earth cannot create the heaven, nor can man, who is powerless to add a mere span to his stature,[63] bring forth the green herb.

Among these works, the human work, because it is not

nature but only imitative of nature, is fitly called mechanical, that is adulterate, just as a skeleton key is called a "mechanical" key.[64] How the work of the artificer in each case imitates nature is a long and difficult matter to pursue in detail. For illustration, however, we can show the matter briefly as follows: The founder who casts a statue has gazed upon man as his model. The builder who has constructed a house has taken into consideration a mountain, for, as the Prophet declares, "Thou sendest forth springs in the vales; between the midst of the hills the waters shall pass";[65] as the ridges of mountains retain no water, even so does a house require to be framed into a high peak that it may safely discharge the weight of pouring rains. He who first invented the use of clothes had considered how each of the growing things one by one has its proper covering by which to protect its nature from offense. Bark encircles the tree, feathers cover the bird, scales encase the fish, fleece clothes the sheep, hair garbs cattle and wild beasts, a shell protects the tortoise, and ivory makes the elephant unafraid of spears. But it is not without reason that while each living thing is born equipped with its own natural armor, man alone is brought forth naked and unarmed.[66] For it is fitting that nature should provide a plan for those beings which do not know how to care for themselves, but that from nature's example, a better chance for trying things should be provided to man when he comes to devise for himself by his own reasoning those things naturally given to all other animals. Indeed, man's reason shines forth much more brilliantly in inventing these very things than ever it would have had man naturally possessed them. Nor is it without cause that the proverb says: "Ingenious want hath mothered all the arts." Want it is which has devised all that you see most excellent in the occupations of men. From this the infinite varieties of painting, weaving, carving, and founding have arisen, so that we look with wonder not at nature alone but at the artificer as well.

Chapter Ten: What "Nature" Is

But since we have already spoken so many times of "nature," it seems that the meaning of this word ought not to be passed

over in complete silence, even though as Tully says, "'Nature' is difficult to define."[67] Nor, because we are unable to say of it all we might wish, ought we to maintain silence about what we can say.

Men of former times, we find, have said a great deal concerning "nature," but nothing so complete that no more should seem to remain to be said. So far as I am able to conclude from their remarks, they were accustomed to use this word in three special senses, giving each its own definition.[68]

In the first place, they wished by this word to signify that archetypal Exemplar of all things which exists in the divine Mind, according to the idea of which all things have been formed; and they said that nature was the primordial cause of each thing, whence each takes not only its being (*esse*) but its "being such or such a thing" (*talis esse*) as well.[69] To the word in this sense they assigned the following definition: "Nature is that which gives to each thing its being."

In the second place they said that "nature" meant each thing's peculiar being (*proprium esse*), and to "nature" in this sense they assigned this next definition: "The peculiar difference giving form to each thing is called its nature."[70] It is with this meaning in mind that we are accustomed to say, "It is the nature of all heavy objects to tend toward the earth, of light ones to rise, of fire to burn, and of water to wet."

The third definition is this: "Nature is an artificer fire coming forth from a certain power to beget sensible objects."[71] For physicists tell us that all things are procreated from heat and moisture.[72] Therefore Vergil calls Oceanus "father,"[73] and Valerius Soranus, in a certain verse which treats Jove as a symbol of aethereal fire, says:

> Jupiter omnipotent, author of things as of kings,
> Of all true gods the father and womb in one![74]

Chapter Eleven: Concerning the Origin of Logic

Having demonstrated the origin of the theoretical, the practical, and the mechanical arts, we must now therefore investigate as well the derivation of the logical; and these I have left to the end because they were the last to be discovered. All

1. ESSE → Is-ness
2. Talis Esse → What it is
3. Proprium Esse → Its properties

the other arts were invented first; but that logic too should be invented was essential, for <u>no man can fitly discuss things unless he first has learned the nature of correct and true discourse</u>. For, as Boethius declares, when the ancients first applied themselves to searching out the natures of things and the essentials of morality, they of necessity erred frequently, for they lacked discrimination in the use of words and concepts: "This is frequently the case with Epicurus, who thinks that the universe consists of atoms, and who falsely maintains that pleasure is virtue. Clearly, such errors befell Epicurus and others because, being unskilled in argument, they transferred to the real world whatever conclusion they had reached by reasoning. This is a great error indeed, for real things do not precisely conform to the conclusions of our reasoning as they do to a mathematical count. In counting, whatever result obtains in the figures of one who computes correctly is sure to obtain in reality as well, so that if a count of one hundred is registered, one hundred objects will also necessarily be found as the basis for that count. In argument, however, such a relationship does not obtain with equal force, and whatever emerges in the course of a discussion does not find a fixed counterpart in nature, either. Thus it is that the man who brushes aside knowledge of argumentation falls of necessity into error when he searches out the nature of things. For unless he has first come to know for certain what form of reasoning keeps to the true course of argument, and what form keeps only to a seemingly true course, and unless he has learned what form of reasoning can be depended upon and what form must be held suspect, he cannot attain, by reasoning, the imperishable truth of things.

"Since, therefore, the ancients, having fallen often into many errors, came to certain conclusions and arguments which were false and contrary to each other; and since it seemed impossible, when contrary conclusions had been constructed concerning the same matter, either that both the conclusions which mutually inconsistent trains of reasoning had established should be true, or that there should be ambiguity concerning which train of reasoning should be credited, it was apparent that the true and whole nature of argument itself should be considered first. Once this was known, then they could also know whether the

results discovered by argument were truly held. Hence, skill in the discipline of logic began—that discipline which provides ways of distinguishing between modes of argument and the trains of reasoning themselves, so that it can be known which trains of reasoning are sometimes true, sometimes false, which moreover are always false, and which never false."75 And so logic came last in time, but is first in order. It is logic which ought to be read first by those beginning the study of philosophy, for it teaches the nature of words and concepts, without both of which no treatise of philosophy can be explained rationally.

Logic is so called from the Greek word *logos*, which has a double sense. For *logos* means either word (*sermo*) or reason, and hence logic can be called either a linguistic (*sermocinalis*) or a rational science. Rational logic, which is called argumentative, contains dialectic and rhetoric. Linguistic logic stands as genus to grammar, dialectic, and rhetoric, thus containing argumentative logic as a subdivision. It is linguistic logic that we put fourth after the theoretical, practical, and mechanical. It must not be supposed, however, that this science is called logical, that is, linguistic, because before its discovery there were no words, or as if men before its time did not have conversations with one another.76 For both spoken and written words existed previously, but the theory of spoken and written language was not yet reduced to an art; no rules for speaking or arguing correctly had yet been given. All sciences, indeed, were matters of use before they became matters of art. But when men subsequently considered that use can be transformed into art, and what was previously vague and subject to caprice can be brought into order by definite rules and precepts, they began, we are told, to reduce to art the habits which had arisen partly by chance, partly by nature—correcting what was bad in use, supplying what was missing, eliminating what was superfluous, and furthermore prescribing definite rules and precepts for each usage.77

Such was the origin of all the arts; scanning them all, we find this true. Before there was grammar, men both wrote and spoke; before there was dialectic, they distinguished the true from the false by reasoning; before there was rhetoric, they discoursed upon civil laws; before there was arithmetic,

there was knowledge of counting; before there was an art of music, they sang; before there was geometry, they measured fields; before there was astronomy, they marked off periods of time from the courses of the stars. But then came the arts, which, though they took their rise in usage, nonetheless excel it.[78]

This would be the place to set forth who were the inventors of the separate arts, when these persons flourished and where, and how the various disciplines made a start in their hands: first, however, I wish to distinguish the individual arts from one another by dividing philosophy into its parts, so to say. I should therefore briefly recapitulate the things I have said thus far, so that the transition to what follows may more easily be made.

We have said that there are four branches of knowledge only, and that they contain all the rest: they are the theoretical, which strives for the contemplation of truth; the practical, which considers the regulation of morals; the mechanical, which supervises the occupations of this life; and the logical, which provides the knowledge necessary for correct speaking and clear argumentation. And so, here, we may not incongruously understand that number "four" belonging to the soul—that "four" which, for reverence of it, the ancients called to witness in their oaths, whence we read:

"By him who gave the quaternary number to our soul!"[79]

How these sciences are comprised under philosophy, and again what they themselves comprise we shall now show, briefly repeating first the definition of philosophy.

BOOK TWO

Chapter One: Concerning the Distinguishing of the Arts

"Philosophy is the love of that Wisdom which, wanting in nothing, is a living Mind and the sole primordial Idea or Pattern of things."[1] This definition pays special attention to the etymology of the word. For *philos* in Greek means love, and *sophia* means wisdom, so that from them "philosophy," that is, "love of wisdom," was coined. The words "which, wanting in nothing, is a living Mind and the sole primordial Idea or Pattern of things" signify the divine Wisdom, which is said to be wanting in nothing because it contains nothing inadequately, but in a single and simultaneous vision beholds all things past, present, and future. It is called "living Mind" because what has once existed in the divine Mind never is forgotten; and it is called "the primordial Idea or Pattern of things" because to its likeness all things have been formed. There are those who say that what the arts are concerned with remains forever the same.[2] This, then, is what the arts are concerned with, this is what they intend, namely, to restore within us the divine likeness, a likeness which to us is a form but to God is his nature. The more we are conformed to the divine nature, the more do we possess Wisdom, for then there begins to shine forth again in us what has forever existed in the divine Idea or Pattern, coming and going in us but standing changeless in God.[3]

"Again, philosophy is the art of arts and the discipline of disciplines"[4]—that, namely toward which all arts and disciplines are oriented. Knowledge can be called an art "when it comprises the rules and precepts of an art"[5] as it does in the study of how to write; knowledge can be called a discipline when it is said to be "full"[6] as it is in the "instructional" science, or mathematics.[7] Or, it is called art when it treats of matters that only resemble the true and are objects of opinion; and

discipline when, by means of true arguments, it deals with matters unable to be other than they are. This last distinction between art and discipline is the one which Plato and Aristotle wished to establish.[8] Or, that can be called art which takes shape in some material medium and is brought out in it through manipulation of that material, as is the case in architecture; while that is called a discipline which takes shape in thought and is brought forth in it through reasoning alone, as is the case in logic.

"Philosophy, furthermore, is a meditating upon death, a pursuit of especial fitness for Christians, who, spurning the solicitations of this world, live subject to discipline in a manner resembling the life of their future home."[9] Yet again, philosophy is the discipline which investigates demonstratively the causes of all things, human and divine.[10] Thus, the theory of all pursuits belongs to philosophy (their administration is not entirely philosophical), and therefore philosophy is said to include all things in some way.[11]

Philosophy is divided into theoretical, practical, mechanical, and logical. These four contain all knowledge.[12] The theoretical may also be called speculative; the practical may be called active, likewise ethical, that is, moral, from the fact that morals consist in good action; the mechanical may be called adulterate because it is concerned with the works of human labor[13]; the logical may be called linguistic[14] from its concern with words. The theoretical is divided into theology, mathematics, and physics—a division which Boethius makes in different terms, distinguishing the theoretical into the intellectible, the intelligible, and the natural, where the intellectible is equivalent to theology, the intelligible to mathematics, and the natural to physics. And the intellectible he defines as follows.

Chapter Two: Concerning Theology

"The intellectible is that which, ever enduring of itself, one and the same in its own divinity, is not ever apprehended by any of the senses, but by the mind and the intellect alone. Its study," he says, "the Greeks call theology, and it consists of searching into the contemplation of God and the incorporeality of the

soul and the consideration of true philosophy."[15] It was called theology as meaning discourse concerning the divine, for *theos* means God, and *logos* discourse or knowledge. It is theology, therefore, "when we discuss with deepest penetration some aspect either of the inexpressible nature of God or of spiritual creatures."[16]

Chapter Three: Concerning Mathematics

The "instructional" science is called mathematics:[17] *mathesis*, when the "t" is pronounced without the "h," means vanity, and it refers to the superstition of those who place the fates of men in the stars and who are therefore called "mathematicians"; but when the "t" is pronounced with the "h," the word refers to the "instructional" science.[18]

This, moreover, is the branch of theoretical knowledge "which considers abstract quantity. Now quantity is called abstract when, intellectually separating it from matter or from other accidents, we treat of it as equal, unequal, and the like, in our reasoning alone"[19]—a separation which it receives only in the domain of mathematics and not in nature. Boethius calls this branch of knowledge the *intelligible* and finds that "it itself includes the first or *intellectible* part in virtue of its own thought and understanding, directed as these are to the celestial works of supernal divinity and to whatever sublunary beings enjoy more blessed mind and purer substance, and, finally, to human souls. All of these things, though they once consisted of that primary intellectible substance, have since, by contact with bodies, degenerated from the level of intellectibles to that of intelligibles; as a result, they are less objects of understanding than active agents of it, and they find greater happiness by the purity of their understanding whenever they apply themselves to the study of things intellectible."[20]

For the nature of spirits and souls, because it is incorporeal and simple, participates in intellectible substance; but because through the sense organs spirit or soul descends in different ways to the apprehension of physical objects and draws into itself a likeness of them through its imagination, it deserts its simplicity somehow by admitting[21] a type of composition.[22]

For nothing that resembles a composite can, strictly speaking, be called simple.

In different respects, therefore, the same thing is at the same time intellectible and intelligible—intellectible in being by nature incorporeal and imperceptible to any of the senses; intelligible in being a likeness of sensible things, but not itself a sensible thing. For the intellectible is neither a sensible thing nor a likeness of sensible things. The intelligible, however, is itself perceived by intellect alone, yet does not itself perceive only by means of intellect. It has imagination and the senses, and by these lays hold upon all things subject to sense. Through contact with physical objects it degenerates,[23] because, while through sense impressions it rushes out toward the visible forms of bodies[24] and, having made contact with them, draws them into itself through imagination, it is cut away from its simplicity each time it is penetrated by any qualities entering through hostile sense experience. But when, mounting from such distraction toward pure understanding, it gathers itself into one, it becomes more blessed through participating in intellectible substance.

Chapter Four: Concerning the Number "Four" of the Soul[25]

Number itself teaches us the nature of the going out and the return of the soul. Consider: Three times *one* makes three; three times three, nine; three times nine, twenty-seven; and three times twenty-seven, eighty-*one*. See how in the fourth multiplication the original "one," or unity, recurs; and you would see the same thing happen even if you were to carry the multiplication out towards infinity: always, at every fourth stage of the process, the number "one" recurs.[26] Now the soul's simple essence is most appropriately expressed by "one," which itself is also incorporeal.[27] And the number "three" likewise, because of the "one" which is its indivisible constituent link, is fittingly referred to the soul, just as the number "four," because it has two constituent links and is therefore divisible, belongs, properly speaking, to the body.[28]

The first progression of the soul, therefore, is that by which

from its simple essence, symbolized by the monad, it extends itself into a virtual threeness, in which it desires one thing through concupiscence, detests another through wrath, and judges between these two through reason.[29] And we rightly say it flows *from* the monad *into* threeness, because every essence is by nature prior to its powers. Again, the fact that the same "one" is found in the number "three," being multiplied in it three times, signifies that the soul is not distributed into parts but consists wholly in each of its powers: for we may not say that reason alone, or wrath alone, or concupiscence alone are each a third part of the soul, since reason is neither other than nor less than the soul in substance, and wrath is neither other than nor less than the soul, and concupiscence is neither other than nor less than the soul; but on the contrary, the soul, as one and the same substance, receives different names according to its different powers.

Next, the soul, from its being virtually threefold, steps down by a second progression to controling the music of the human body,[30] which music is constituted in the number "nine", since nine are the openings in the human body by which, according to natural adjustment, everything by which the body is nourished and kept in balance flows in or out. And this is the order (which obtains between these first two progressions) because the soul by nature possesses its powers before it is compounded with the body.

Subsequently, however, in a third progression, the soul, having poured itself out through the senses upon all visible things—which demand its supervision and which are symbolized by "twenty-seven," a cube number, extended tridimensionally after the manner of body—is dissipated in countless actions.[31]

But finally, in a fourth progression, the soul, freed from the body, returns to the pureness of its simplicity, and therefore in the fourth multiplication, in which three times twenty-seven makes eighty-one, the number "one" reappears in the arithmetical product in order that it may be glowingly evident that the soul, after this life's end, designated by "eighty," returns to the unity of its simple state, from which it had previously departed when it descended to rule a human body.[32] That the

measure of human life naturally consists in "eighty" is declared by the Prophet, saying:

If by reason of strength men live fourscore years, even greater is their labor and sorrow.[33]

Some men think that this fourfold progression is to be understood as being that number "four" of the soul of which we made mention above;[34] and they call it the number "four" of the soul to distinguish it from the number "four" of the body.

Chapter Five: Concerning the Number "Four" of the Body

For to the body too do they assign its number "four." As the figure "one" fits the soul, so the figure "two" fits the body.[35] Consider: Two times two makes four; two times four, eight; two times eight, sixteen; and two times sixteen, thirty-two. Here likewise, in the fourth multiplication the same number whence the operation began, namely "two," reappears, and the same thing would undoubtedly happen if one were to carry the process out to infinity: at each fourth stage of the process, the number "two" would recur. And this is the number "four" of the body, in which it is given to be understood that everything which is composed of divisibles, or solubles, is itself also divisible, or dissoluble.[36]

And now you see clearly enough, I should think, how souls degenerate from being intellectible things to being intelligible things when, from the purity of simple understanding clouded by no images of bodily things, they descend to the imagination of visible objects; and how they once more become more blessed when, recollecting themselves from this distracted state back toward the simple source of their nature, they, marked as it were with the likeness of the most excellent numeral, come to rest. Thus, that I may speak more openly, the intellectible in us is what understanding is, whereas the intelligible is what imagination is. But understanding is pure and certain knowledge of the sole principles of things—namely, of God, of ideas, and of prime matter, and of incorporeal substances. Imagination, however, is sensuous memory made up of the traces of corporeal objects inhering in the mind; it possesses in itself nothing

certain as a source of knowledge. Sensation is what the soul undergoes in the body as a result of qualities which come to it from without.[37]

Chapter Six: Concerning the Quadrivium[38]

Since, as we have said, the proper concern of mathematics is abstract quantity, it is necessary to seek the species of mathematics in the parts into which such quantity falls. Now abstract quantity is nothing other than form, visible in its linear dimension, impressed upon the mind, and rooted in the mind's imaginative part. It is of two kinds: the first is continuous quantity, like that of a tree or a stone, and is called *magnitude;* the second is discrete quantity, like that of a flock or of a people, and is called *multitude.* Further, in the latter some quantities stand wholly in themselves, for example, "three," "four," or any other whole number; others stand in relation to another quantity, as "double," "half," "once and a half," "once and a third," and the like. One type of magnitude, moreover, is *mobile,* like the heavenly spheres; another, *immobile,* like the earth. Now, multitude which stands in itself is the concern of arithmetic, while that which stands in relation to another multitude is the concern of music. Geometry holds forth knowledge of immobile magnitude, while astronomy claims knowledge of the mobile. Mathematics, therefore, is divided into arithmetic, music, geometry, and astronomy.[39]

Chapter Seven: Concerning the Term "Arithmetic"

The Greek word *ares* means *virtus,* or power, in Latin; and *rithmus* means *numerus,* or number, so that "arithmetic" means "the power of number."[40] And the power of number is this—that all things have been formed in its likeness.[41]

Chapter Eight: Concerning the Term "Music"

"Music" takes its name from the word "water," or *aqua* because no euphony, that is, pleasant sound, is possible without moisture.[42]

Chapter Nine: Concerning the Term "Geometry"[43]

"Geometry" means "earth-measure," for this discipline was first discovered by the Egyptians, who, since the Nile in its inundation covered their territories with mud and obscured all boundaries, took to measuring the land with rods and lines. Subsequently, learned men reapplied and extended it also to the measurement of surfaces of the sea, the heaven, the atmosphere, and all bodies whatever.

Chapter Ten: Concerning the Term "Astronomy"

"Astronomy" and "astrology" differ in the former's taking its name from the phrase "law of the stars," while the latter takes its from the phrase "discourse concerning the stars"—for *nomia* means law, and *logos*, discourse. It is astronomy, then, which treats the law of the stars and the revolution of the heaven, and which investigates the regions, orbits, courses, risings, and settings of stars, and why each bears the name assigned it; it is astrology, however, which considers the stars in their bearing upon birth, death, and all other events, and is only partly natural, and for the rest, superstitious; natural as it concerns the temper or "complexion" of physical things, like health, illness, storm, calm, productivity, and unproductivity, which vary with the mutual alignments of the astral bodies; but superstitious as it concerns chance happenings or things subject to free choice.[44] And it is the "mathematicians" who traffic in the superstitious part.[45]

Chapter Eleven: Concerning Arithmetic

Arithmetic has for its subject equal, or even, number and unequal, or odd, number. Equal number is of three kinds: equally equal, equally unequal, and unequally equal. Unequal number, too, has three varieties: the first consists of numbers which are prime and incomposite; the second consists of numbers which are secondary and composite; the third consists of numbers which, when considered in themselves, are secondary and composite, but which, when one compares them with other numbers [to find a common factor or denominator], are prime and incomposite.[46]

Chapter Twelve: Concerning Music[47]

The varieties of music are three: that belonging to the universe, that belonging to man, and that which is instrumental.

Of the music of the universe, some is characteristic of the elements, some of the planets, some of the seasons: of the elements in their mass, number, and volume; of the planets in their situation, motion, and nature; of the seasons in days (in the alternation of day and night), in months (in the waxing and waning of the moons), and in years (in the succession of spring, summer, autumn, and winter).

Of the music of man, some is characteristic of the body, some of the soul, and some of the bond between the two. It is characteristic of the body partly in the vegetative power by which it grows—a power belonging to all beings born to bodily life; partly in those fluids or humors through the mixture or complexion of which the human body subsists—a type of mixture belonging to all sensate beings; and partly in those activities (the foremost among them are the mechanical) which belong above all to rational beings and which are good if they do not become inordinate, so that avarice or appetite are not fostered by the very things intended to relieve our weakness. As Lucan says in Cato's praise:

> He feasted in conquering hunger;
> Any roof from storms served his hall;
> His dearest garb, the toga coarse,
> Civilian dress of the Roman.[48]

Music is characteristic of the soul partly in its virtues, like justice, piety, and temperance; and partly in its powers, like reason, wrath, and concupiscence.[49] The music between the body and the soul is that natural friendship by which the soul is leagued to the body, not in physical bonds, but in certain sympathetic relationships for the purpose of imparting motion and sensation to the body. Because of this friendship, it is written, "No man hates his own flesh."[50] This music consists in loving one's flesh, but one's spirit more; in cherishing one's body, but not in destroying one's virtue.

Instrumental music consists partly of striking, as upon tympans and strings; partly in blowing, as upon pipes or organs;

and partly in giving voice, as in recitals and songs. "There are also three kinds of musicians: one that composes songs, another that plays instruments, and a third that judges instrumental performance and song."[51]

Chapter Thirteen: Concerning Geometry[52]

Geometry has three parts: planimetry, altimetry, and cosmimetry. Planimetry measures the plane, that is, the long and the broad, and, by widening its object, it measures what is before and behind and to left and right. Altimetry measures the high, and, by widening its object, it measures what reaches above and stretches below: for height is predicated both of the sea in the sense of depth, and of a tree in the sense of tallness. *Cosmos* is the word for the universe, and from it comes the term "cosmimetry," or "universe-measurement." Cosmimetry measures things spherical, that is, globose and rotund, like a ball or an egg,[53] and it is therefore called "cosmimetry" from the sphere of the universe, on account of the preeminence of this sphere—not that cosmimetry is concerned with the measurement of the universe alone, but that the universe-sphere excels all other spherical things.

Chapter Fourteen: Concerning Astronomy

What we have just said does not contradict our previous statement that geometry is occupied with immobile magnitude, astronomy with mobile: for what we have just said takes into account the original discovery of geometry, which led to its being called "earth measurement."[54] We can also say that what geometry considers in the sphere of the universe—namely, the measure of the celestial regions and spheres—is immobile in that aspect which belongs to geometrical studies. For geometry is not concerned with movement but with space. What astronomy considers, however, is the *mobile*—the courses of the stars and the intervals of time and seasons. Thus, we shall say that without exception immobile magnitude is the subject of geometry, mobile of astronomy, because, although both busy themselves with the same thing, the one contemplates the static aspect of that thing, the other its moving aspect.

Chapter Fifteen: Definition of the Quadrivium

Arithmetic is therefore the science of numbers. Music is the distinguishing of sounds and the variance of voices. Or again, music or harmony is the concord of a number of dissimilar things blended into one. Geometry is the discipline treating immobile magnitude, and it is the contemplative delineation of forms, by which the limits of every object are shown. Putting it differently, geometry is "a fount of perceptions and a source of utterances."[55] Astronomy is the discipline which examines the spaces, movements, and circuits of the heavenly bodies at determined intervals.

Chapter Sixteen: Concerning Physics

Physics searches out and considers the causes of things as found in their effects, and the effects as derived from certain causes:

> Whence the tremblings of earth do rise, or
> from what cause the deep seas swell;
> Whence grasses grow or beasts are moved with
> wayward wrath and will;
> Whence every sort of verdant shrub, or rock,
> or creeping thing.[56]

The word *physis* means nature, and therefore Boethius places natural physics in the higher division of theoretical knowledge.[57] This science is also called physiology, that is, discourse on the natures of things, a term which refers to the same matter as physics. Physics is sometimes taken broadly to mean the same as theoretical science, and, taking the word in this sense, some persons divide philosophy into three parts—into physics, ethics, and logic. In this division the mechanical sciences find no place, philosophy being restricted to physics, ethics, and logic alone.[58]

Chapter Seventeen: What the Proper Business of Each Art Is

But although all the arts tend toward the single end of philosophy, they do not all take the same road, but have each of them their own proper businesses by which they are distinguished from one another.

The business of logic is with things, and it attends to our concepts of things, either through the understanding, so that our concepts may not be either things or even likenesses of them, or through the reason, so that our concepts may still not be things but may, however, be likenesses of them.[59] Logic, therefore, is concerned with the species and genera of things.

Mathematics, on the other hand, has as its business the consideration of things which, though actually fused, are rationally separated by it. For example, in actuality no line is found without surface and solidity. For no physical entity possesses pure length in such a way that it lacks breadth or height, but in every physical thing these three are found together. And yet the reason, abstracting from surface and from thickness, considers pure line, in itself, taking line as a mathematical object not because it exists or could exist as such in reality, but because the reason often considers actual aspects of things not as they are but as they can exist—exist, that is, not in themselves, but with respect to reason itself, or, as reason might allow them to be. From this consideration derives the axiom that continuous quantity is divisible into an infinite number of parts, and discrete quantity multipliable into a product of infinite size. For such is the vigor of the reason that it divides every length into lengths and every breadth into breadths, and the like—and that, to this same reason, a continuity lacking interruption continues forever.

The business of physics, however, is to analyze the compounded actualities of things into their elements. For the actualities of the world's physical objects are not pure but are compounded of pure actualities which, although they nowhere exist as such, physics nonetheless considers as pure and as such. Thus, physics considers the pure actuality of fire, or earth, or air, or water, and, from a consideration of the nature of each in itself, determines the constitution and operation of something compounded of them.[60]

Nor ought we to overlook the fact that physics alone is concerned properly with things, while all the other disciplines are concerned with concepts of things. Logic treats of concepts themselves in their predicamental framework, while mathematics treats of them in their numerical composition. Logic, therefore,

employs pure understanding on occasion; whereas mathematics never operates without the imagination, and therefore never possesses its object in a simple or non-composite manner. Because logic and mathematics are prior to physics in the order of learning and serve physics, so to say, as tools—so that every person ought to be acquainted with them before he turns his attention to physics—it was necessary that these two sciences base their considerations not upon the physical actualities of things, of which we have deceptive experience, but upon reason alone, in which unshakeable truth stands fast, and that then, with reason itself to lead them, they descend into the physical order.[61]

Having therefore already shown how Boethius's division of theoretical science fits in with what I gave just before, I shall now briefly repeat both divisions so that we may place their terminologies side by side and compare them.

Chapter Eighteen: Comparison of the Foregoing

The theoretical is divided into theology, mathematics, and physics; or, put differently, into intellectible, intelligible, and natural knowledge; or still differently, into divine, "instructional," and philological.[62] Thus, theology is the same as the intellectible and the divine; mathematics as the intelligible and the "instructional"; and physics as the philological and the natural.

There are those who suppose that these three parts of the theoretical are mystically represented in one of the names of Pallas, fictional goddess of wisdom. For she is called "Tritona" for *tritoona*, that is, threefold apprehension of God, called intellectible; of souls, called intelligible; and of bodies, called natural.[63] And the name of wisdom by right belongs to these three alone: for although we can without impropriety refer to the remaining branches (ethics, mechanics, and logic) as wisdom, still these are more precisely spoken of as prudence or knowledge—logic because of its concern for eloquence of word, and mechanics and ethics because of their concern for works and morals. But the theoretical alone, because it studies the truth of things, do we call wisdom.[64]

Chapter Nineteen: Continuation of the Previous Chapter

The practical is divided into solitary, private, and public; or, put differently, into ethical, economic, and political; or, still differently, into moral, managerial, and civil. Solitary, ethical, and moral are one; as also are private, economic, and managerial; and public, political, and civil. *Oeconomus* means manager, whence economic science is called managerial. *Polis* is the Greek word for the Latin *civitas*, or state, whence politics, the civil science, derives its name.[65] And when we speak of ethics as a subdivision of the practical, we must reserve the word for the moral conduct of the individual, so that ethical science and solitary science are the same.

Solitary science, therefore, "is that which, exercising care for itself, raises, adorns, and broadens itself with all virtues, allowing nothing in life which will not bring joy and doing nothing which will cause regret. The private science is that which assigns the householder's tasks, setting them in order according to this middle type of management. The public science is that which, taking over the care of public affairs, serves the welfare of all through its concern for provisions, its balancing of justice, its maintenance of strength, and its observance of moderation."[66] Thus, solitary science concerns individuals; private science, heads of families; and political science, governors of states. Practical science "is called 'actual' from the fact that it deals with its object by way of actions to be performed. The moral science is called moral because it seeks a decent custom (*mos*) of life and establishes rules conducing to virtue. The managerial science is so-called because it manages a wise order in domestic matters. The civil science is so-called because it ministers to the common welfare of civil society."[67]

Chapter Twenty: The Division of Mechanical Sciences into Seven

Mechanical science contains seven sciences: fabric making, armament, commerce, agriculture, hunting, medicine, and theatrics. Of these, three pertain to external cover for nature, by which she protects herself from harms, and four to internal, by which she feeds and nourishes herself. In this division we find

a likeness to the trivium and quadrivium, for the trivium is concerned with words, which are external things, and the quadrivium with concepts, which are internally conceived.[68] The mechanical sciences are the seven handmaids which Mercury received in dowry from Philology, for every human activity is servant to eloquence wed to wisdom.[69] Thus Tully, in his book on rhetoricians, says concerning the study of eloquence:

> By it is life made safe, by it fit, by it noble, and by it pleasurable: for from it the commonwealth receives abundant benefits, provided that wisdom, which regulates all things, keeps it company. From eloquence, to those who have acquired it, flow praise, honor, dignity; from eloquence, to the friends of those skilled in it, comes most dependable and sure protection.[70]

These sciences are called mechanical, that is, adulterate, because their concern is with the artificer's product, which borrows its form from nature. Similarly, the other seven are called liberal either because they require minds which are liberal, that is, liberated and practiced (for these sciences pursue subtle inquiries into the causes of things), or because in antiquity only free and noble men were accustomed to study them, while the populace and the sons of men not free sought operative skill in things mechanical. In all this appears the great diligence of the ancients, who would leave nothing untried, but brought all things under definite rules and precepts. And mechanics is that science to which they declare the manufacture of all articles to belong.

Chapter Twenty-one: First—Fabric Making

Fabric making includes all the kinds of weaving, sewing, and twisting which are accomplished by hand, needle, spindle, awl, skein winder, comb, loom, crisper, iron, or any other instruments whatever; out of any material made of flax or fleece, or any sort of hide, whether scraped or hairy, out of cane as well, or cork, or rushes, or hair, or tufts, or any material of this sort which can be used for the making of clothes, coverings, drapery, blankets, saddles, carpets, curtains, napkins, felts, strings, nets, ropes; out of straw too, from which men usually make their hats and baskets. All these pursuits belong to fabric making.

Chapter Twenty-two: Second—Armament

Armament comes second. Sometimes any tools whatever are called "arms," as when we speak of the arms of war, or the arms of a ship, meaning the implements used in war or on a ship. For the rest, the term "arms" belongs properly to those things under which we take cover—like the shield, the breastplate, and the helmet—or those by which we strike—like the sword, the two-faced axe, and the lance. "Missiles," however, are things we can fling, like the spear or arrow. Arms are so called from the arm, because they strengthen the arm which we customarily hold up against blows. Missiles (*tela*), however, are named from the Greek word *telon*, meaning "long," because the things so named are long; therefore, we use the word *protelare*, or "make long," to mean "protect." Armament, therefore, is called, in a sense, an instrumental science, not so much because it uses instruments in its activity as because, from some material lying shapeless at hand, it makes something into an instrument, if I may so name its product. To this science belong all such materials as stones, woods, metals, sands, and clays.

Armament is of two types, the constructional and the craftly. The constructional is divided into the building of walls, which is the business of the wood-worker and carpenter, and of other craftsmen of both these sorts, who work with mattocks and hatchets, the file and beam, the saw and auger, planes, vises, the trowel and the level, smoothing, hewing, cutting, filing, carving, joining, daubing in every sort of material—clay, stone, wood, bone, gravel, lime, gypsum, and other materials that may exist of this kind. Craftly armament is divided into the malleable branch, which forges material into shape by beating upon it, and the foundry branch, which reduces material into shape by casting it—so that "'founders' is the name for those who know how to cast a shapeless mass into the form of an implement."[71]

Chapter Twenty-three: Third—Commerce

Commerce contains every sort of dealing in the purchase, sale, and exchange of domestic or foreign goods. This art is beyond all doubt a peculiar sort of rhetoric—strictly of its own kind—for eloquence is in the highest degree necessary to it.

Thus the man who excels others in fluency of speech is called a *Mercurius*, or Mercury, as being a *mercatorum kirrius* (=*kyrios*)—a very lord among merchants.[72] Commerce penetrates the secret places of the world, approaches shores unseen, explores fearful wildernesses, and in tongues unknown and with barbaric peoples carries on the trade of mankind. The pursuit of commerce reconciles nations, calms wars, strengthens peace,[73] and commutes the private good of individuals into the common benefit of all.

Chapter Twenty-four: Fourth—Agriculture

Agriculture deals with four kinds of land: arable, set aside for sowing; plantational, reserved for trees, like the vineyard, the orchard, and the grove; pastoral, like the meadow, the hillside pasture, and the heath; and floral, like the garden and rose-hedges.

Chapter Twenty-five: Fifth—Hunting

Hunting is divided into gaming, fowling, and fishing. Gaming is done in many ways—with nets, foot-traps, snares, pits, the bow, javelins, the spear, encircling the game, or smoking it out, or pursuing it with dogs or hawks. Fowling is done by snares, traps, nets, the bow, birdlime, the hook. Fishing is done by drag-nets, lines, hooks, and spears. To this discipline belongs the preparation of all foods, seasonings, and drinks. Its name, however, is taken from only one part of it because in antiquity men used to eat merely by hunting, as they still do in certain regions where the use of bread is extremely rare, where flesh is the only food and water or mead the drink.

Food is of two kinds—bread and side dishes.[74] Bread (*panis*) takes its name either from the Latin word for one's laying a thing out (*ponis*), or from the Greek word for all (*pan*), because all meals need bread in order to be well provided. There are many kinds of bread—unleavened, leavened, that baked under ashes, brown bread, sponge-cake, cake, pan-baked, sweet, wheaten, bun-shaped, rye, and many other kinds. Side dishes consist of all that one eats with bread, and we can call them victuals. They are of many sorts—meats, stews, porridges,

vegetables, fruits. Of meats, some are roasted, others fried, others boiled, some fresh, some salted. Some are called loins, flitches also or sides, haunches or hams, grease, lard, fat. The varieties of meat dishes are likewise numerous—Italian sausage, minced meat, patties, Galatian tarts, and all other such things that a very prince of cooks has been able to concoct. Porridges contain milk, colostrum, butter, cheese, whey. And who can enumerate the names of vegetables and fruits? Of seasonings some are hot, some cold, some bitter, some sweet, some dry, some moist. Of drink, some is merely that: it moistens without nourishing, like water; other is both drink and food, for it both moistens and nourishes, like wine. Of the nutritious drinks, furthermore, some are naturally so, like wine or any other liquor; others accidentally so, like beer and various kinds of mead.

Hunting, therefore, includes all the duties of bakers, butchers, cooks, and tavern keepers.

Chapter Twenty-six: Sixth—Medicine

"Medicine is divided into two parts"[75]—"occasions" and operations. "The 'occasions' are six: air, motion and quiet, emptiness and satiety, food and drink, sleep and wakefulness, and the reactions of the soul. These are called 'occasions' because, when tempered, they occasion and preserve health,"[76] or, when untempered, ill-health. The reactions of the soul are called occasions of health or ill-health because now and again they either "raise one's temperature, whether violently as does wrath or gently as do pleasures; or they withdraw and lower the temperature, again whether violently as do terror and fear, or gently as does worry. And among them are some which, like grief, produce their natural effects both internally and externally."[77]

Every medicinal operation is either interior or exterior. "The interior are those which are introduced through the mouth, nostrils, ears, or anus, such as potions, emetics, and powders, which are taken by drinking, chewing, or sucking in. The exterior are, for example, lotions, plasters, poultices, and surgery, which is twofold: that performed on the flesh, like cutting, sewing, burning, and that performed on the bone, like setting and joining."[78]

Let no one be disturbed that among the means employed by medicine I count food and drink, which earlier I attributed to hunting. For these belong to both under different aspects. For instance, wine in the grape is the business of agriculture; in the barrel, of the cellarer, and in its consumption, of the doctor. Similarly, the preparing of food belongs to the mill, the slaughterhouse, and the kitchen, but the strength given by its consumption, to medicine.

Chapter Twenty-seven: Seventh—Theatrics[79]

The science of entertainments is called "theatrics" from the theatre, to which the people once used to gather for the performance: not that a theatre was the only place in which entertainment took place, but it was a more popular place for entertainment than any other. Some entertainment took place in theatres, some in the entrance porches of buildings, some in gymnasia, some in amphitheatres, some in arenas, some at feasts, some at shrines. In the theatre, epics were presented either by recitals or by acting out dramatic roles or using masks or puppets; they held choral processions and dances in the porches. In the gymnasia they wrestled; in the amphitheatres they raced on foot or on horses or in chariots; in the arenas boxers performed; at banquets they made music with songs and instruments and chants, and they played at dice; in the temples at solemn seasons they sang the praises of the gods. Moreover, they numbered these entertainments among legitimate activities because by temperate motion natural heat is stimulated in the body and by enjoyment the mind is refreshed; or, as is more likely, seeing that people necessarily gathered together for occasional amusement, they desired that places for such amusement might be established to forestall the people's coming together at public houses, where they might commit lewd or criminal acts.

Chapter Twenty-eight: Concerning Logic, Which Is the Fourth Part of Philosophy

Logic is separated into grammar and the theory of argument. The Greek word *gramma* means letter, and from it grammar takes

its name as the science of letters.[80] Properly speaking, the letter
is a written figure, while the term "element" is reserved for a
pronounced sound; here, however, "letter" is to be taken in a
larger sense as meaning both the spoken and the written symbol,
for they both belong to grammar.

There are those who say that grammar is not a part of
philosophy, but, so to say, an appendage and an instrument in
the service of philosophy. But concerning the theory of
argument, Boethius declares that it can be at once a part and an
instrument in the service of philosophy, just as the foot, hand,
tongue, eyes, etc., are at once the body's parts and its
instruments.[81]

Grammar, simply taken, treats of words, with their origin
formation, combination, inflection, pronunciation, and all things
else pertaining directly to utterance alone. The theory of
argument is concerned with the conceptual content of words.

Chapter Twenty-nine: Concerning Grammar

Grammar is divided into the letter, the syllable, the phrase,
and the clause. Or, according to another division, between
letters or written signs, and vocables or spoken signs. Yet again,
by another division, among the noun, the verb, the participle,
the pronoun, the adverb, the preposition, the conjunction, the
interjection, the articulate word, the letter, the syllable, metric
feet, accents, pointing, punctuating, spelling, analogy, etymo-
logy, glosses, differences, the barbarism, the solecism, errors,
metaplasm, schemata, tropes, prose composition, verse com-
position, fables, histories. But of all these I shall omit further
explanation, both because I should otherwise be more lengthy
than the brevity of my plan would warrant, and because in this
little work I have designed to inquire only into the divisions and
the names of things, so that the reader might thereby be
established in some beginning of knowledge merely. Let him
who desires to inform himself concerning these things read
Donatus,[82] Servius,[83] Priscian *Concerning Accents*, Priscian
Concerning the Twelve Verses of Vergil,[84] *The Barbarism*,[85] and
Isidore's *Etymologies*.[86]

Chapter Thirty: Concerning the Theory of Argument

Invention and judgment are integral parts running through the whole theory of argument, whereas demonstration, probable argument, and sophistic are its divisive parts, that is, mark distinct and separate subdivisions of it.[87] Demonstration consists of necessary arguments and belongs to philosophers; probable argument belongs to dialecticians and rhetoricians; sophistic to sophists and quibblers. Probable argument is divided into dialectic and rhetoric, both of which contain invention and judgment as integral parts: for since invention and judgment integrally constitute the whole genus, that is, of argumentative logic, they are necessarily found in all of its species at once. Invention teaches the discovery of arguments and the drawing up of lines of argumentation. The science of judgment teaches the judging of such arguments and lines of argumentation.

Now it may be asked whether invention and judgment are contained in philosophy.[88] They do not seem to be contained under the theoretical sciences, or under the practical, or under the mechanical, or even under the logical, where one would most expect them to be. They are not contained under the logical because they are not branches either of grammar or of argumentative logic. They are not branches of argumentative logic because they comprise it integrally, and nothing can at the same time constitute an integral and a divisive part of the same genus. Philosophy, therefore, seems not to contain all knowledge.

But what we should realize is that the word "knowledge" is customarily used in two senses, namely, for one of the disciplines, as when I say that dialectic *is* knowledge, meaning an art or discipline; and for any act of cognition, as when I say that a person who knows something *has* knowledge. Thus, for example, if I know dialectic I have knowledge; if I know how to swim I have knowledge; if I know that Socrates was the son of Sophroniscus I have knowledge—and so in every instance, anyone who knows anything may be said to have knowledge. But it is one thing when I say that dialectic is knowledge, that is an art or discipline, and another when I say that to know that Socrates was the son of Sophroniscus is knowledge, that is, an

act of cognition. It is always true to say that any knowledge which is an art or discipline is a distinct branch of philosophy; but it cannot always be said that all knowledge which is an act of cognition is a distinct branch of philosophy: and yet it is certainly true that all knowledge, whether it be a discipline or any act of cognition whatever, is somehow contained in philosophy—either as an integral part, or as a divisive part or branch.

A discipline, moreover, is a branch of knowledge which has a defined scope within the range of which the objective of some art is perfectly unfolded; but this is not true of the knowledge of invention or of judgment, because neither of these stands independently in itself, and therefore they cannot be called disciplines but are integral parts of a discipline—namely, of argumentative logic.

Furthermore, the question is raised whether invention and judgment are the same thing in dialectic that they are in rhetoric. It seems they are not, since then two opposed genera would be constituted of identical parts. It can be said, consequently, that these two words, "invention" and "judgment," are equivocally used for the parts of dialectic and rhetoric; or better, perhaps, let us say that invention and judgment are properly parts of argumentative logic, and as such are univocally signified by these words, but that in the subdivisions of this particular genus they are differentiated from one another by certain properties—the differentiations are not revealed through the terms "invention" and "judgment" because these names, far from designating invention and judgment as separate species, designate them only as generic parts.

Grammar is the knowledge of how to speak without error; dialectic is clear-sighted argument which separates the true from the false; rhetoric is the discipline of persuading to every suitable thing.

BOOK THREE

Chapter One: Concerning the Order and Method of Study and Discipline

Philosophy is divided into the theoretical, the practical, the mechanical, and the logical. The *theoretical* is divided into theology, physics, and mathematics; mathematics is divided into arithmetic, music, geometry, and astronomy. The *practical* is divided into solitary, private, and public. The *mechanical* is divided into fabric making, armament, commerce, agriculture, hunting, medicine, and theatrics. Logic is divided into grammar and argument: argument is divided into demonstration, probable argument, and sophistic: probable argument is divided into dialectic and rhetoric.

In this division only the divisive parts of philosophy are contained; there are still other subdivisions of such parts, but those given may suffice for now. If you regard but the number of distinct sciences, you will find twenty-one; if you should wish to count each name mentioned in the scheme, you will find twenty-eight.

We read that different persons were authors of these sciences. They originated the arts—some by beginning them, others by developing them, and others by perfecting them: and thus for the same art a number of authors are frequently cited.Of these I shall now list the names of a few.

Chapter Two: Concerning the Authors of the Arts

Linus was a theologian among the Greeks;[1] among the Romans, Varro;[2] and in our own time, John the Scot, *Concerning the Ten Categories in Relation to God*.[3] "Thales of Miletus, one of the seven sages, initiated natural physics among the Greeks,"[4] while among the Romans, Pliny treated it.[5] "Pythagoras of Samos was the inventor of arithmetic,"[6] and Nichomachus

wrote on it. "Among the Latins, first Apuleius and then Boethius translated this work."[7] The same Pythagoras also wrote the *Matentetradem*, that is, a book concerning the teaching of the quadrivium,[8] and he found in the figure "y" a likeness to human life.[9] Moses declares that the inventor of music was Tubal, who was of the seed of Cain;[10] the Greeks say it was Pythagoras, others that it was Mercury, who first introduced the tetrachord; others that it was Linus, or Zetus, or Amphio.[11] Geometry, they say, was first discovered in Egypt: its author among the Greeks was the great Euclid. Boethius passed this man's art on to us.[12] Eratosthenes too was most learned in geometry, and it was he who first found out about the revolution of the world. Certain ones say that Cham, son of Noah, first discovered astronomy. The Chaldeans first taught astrology as connected with the observance of birth, but Josephus asserts that Abraham first instructed the Egyptians in astrology.[13] "Ptolemy, king of Egypt, revived astronomy; he also drew up the *Canones* by which the courses of the stars are found. Some say that Nemroth the Giant was the greatest astrologer, and to his name astronomy too is ascribed. The Greeks say that this art was first thought out by Atlas, and because of this it is also said that he held up the very heaven."[14]

The originator of ethics was Socrates, who wrote twenty-four books on it from the point of view of positive justice. Then Plato, his disciple, wrote the many books of the *Republic* from the point of view of both kinds of justice, natural and positive.[15] Then Tully set forth in the Latin tongue the books of his own *Republic*. Further, the philosopher Fronto wrote the book *Strategematon*, or *Concerning Military Strategy*.

Mechanical science has had many authors. Hesiod Ascraeus was the first among the Greeks who applied himself to describing farming, and "after him Democritus. A great Carthaginian likewise wrote a study of agriculture in twenty-eight volumes. Among the Romans, Cato is first with his *Concerning agriculture*, which Marcus Terentius subsequently elaborated. Vergil too wrote his *Georgics;* then Cornelius and Julius Atticus and Aemilian or Columella, the famous orator who put together an entire corpus on this branch of knowledge."[16] Then there are Vitruvius, *On Architecture*, and Palladius, *On Agriculture*.

"They tell that the practice of fabric making was first shown the Greeks by Minerva, and they believe too that she designed the first loom, dyed fleece, and was the inventress of olive-growing and of handicraft."[17] By her Daedalus was taught, and he is believed to have practiced handicrafts after her.[18] "In Egypt, however, Isis, daughter of Inachus, introduced the custom of weaving linen and showed how vesture might be made of it."[19] And she also introduced there the use of wool. In Lybia the use of linen first began to spread from the temple of Ammon.

"Ninus, king of the Assyrians, first set wars in motion."[20] Vulcan, they tell, was the first smith, but divine history has it Tubal.[21] "Prometheus first invented the use of rings when he pressed a stone into an iron band."[22] The Pelasgians first discovered the use of the boat. At Eleusis in Greece Ceres first discovered the use of grain, "as did Isis in Egypt."[23] "To Italy Pilumnus brought the use of corn and spelt and the manner of grinding and pounding them,"[24] while Tagus brought the practice of sowing to Spain.[25] "Osiris introduced the culture of the vine among the Egyptians, Liber among the men of India."[26] "Daedalus first wrought a table and stool. One Apicius first assembled the apparatus of cookery, and in this art died at length a willing death from the consumption of delicacies."[27]

"Of medicine the author among the Greeks was Apollo, whose son Aesculapius ennobled it with praise and achievement and afterwards perished from lightning. Then the care of medicine lapsed and lay unknown for a long time, nearly five-hundred years, until the days of King Artaxerxes. Then Hippocrates brought it forth again to light; he was the son of Asclepius and was born on the Isle of Cos."[28]

"Games are thought to have taken start with the men of Lydia, who, coming out of Asia, settled in Etruria with Tyrrenus as prince, and there, amidst all the rites entailed by their many superstitions, held spectacles—a custom copied by the Romans, who fetched craftsmen thence to teach them how, and for this reason games bear in Latin the name *ludi* from the *Lydi*, or Lydians."[29]

"The letters of the Hebrews are believed to have taken start with Moses through the written Law; and those of the Chaldeans

and Syrians through Abraham. Isis founded the letters of the Egyptians; the Phoenicians those of the Greeks, when Cadmus brought the alphabet from Phoenicia into Greece."[30] "Carmentis, mother of Evander, who by her proper name is called Nicostrata, invented Latin letters."[31] "Moses first wrote divine history, while among the gentiles Dares the Phrygian first published the history of Troy—written on leaves of palms, they say. After Dares, Herdodotus was considered the first historian in Greece, and after him Pherecydes flourished in those times when Esdras wrote the Law."[32] Alcmon of Crotona is held the first inventor of fables.[33]

Egypt is the mother of the arts, and thence they came to Greece, and thence to Italy.[34] In Egypt grammar was first founded in the time of Osiris, husband of Isis. "There too dialectic was first founded by Parmenides, who, fleeing cities and the gatherings of men, dwelt for no short space of time on a rock where he thought out the science: hence, it has since been called the Rock of Parmenides."[35] "Plato too, upon the death of Socrates his master, led by love of learning, emigrated into Egypt, whence, having acquired liberal studies, he returned to Athens and, taking to himself disciples at the Academy, his villa, turned his efforts to studies in philosophy."[36] He, first, taught conceptual logic to the Greeks, which afterwards his disciple Aristotle expanded, perfected, and reduced to an art. Marcus Terentius Varro first translated dialectic from Greek into Latin.[37] At a later date Cicero wrote his *Topics*. Demosthenes, an artisan's son, is believed to have devised rhetoric among the Greeks, Tisias among the Latins, Corax among the Syracusans.[38] Rhetoric was written in Greek by Aristotle and Gorgias and Hermagoras, and brought into Latin by Tully, Quintilian, and Titian.[39]

Chapter Three: Which Arts Are Principally to Be Read

Out of all the sciences[40] above named, however, the ancients, in their studies, especially selected seven to be mastered by those who were to be educated. These seven they considered so to excel all the rest in usefulness that anyone who had been thoroughly schooled in them might afterward come to a know-

ledge of the others by his own inquiry and effort rather than by listening to a teacher. For these, one might say, constitute the best instruments, the best rudiments, by which the way is prepared for the mind's complete knowledge of philosophic truth. Therefore they are called by the name tri*vium* and quadri*vium*, because by them, as by certain *ways* (*viae*), a quick mind enters into the secret places of wisdom.

In those days, no one was thought worthy the name of master who was unable to claim knowledge of these seven. Pythagoras, too, is said to have maintained the following practice as a teacher: for seven years, according to the number of the seven liberal arts, no one of his pupils dared ask the reason behind statements made by him; instead, he was to give credence to the words of the master until he had heard him out, and then, having done this, he would be able to come at the reason of those things himself.[41] We read that some men studied these seven with such zeal that they had them completely in memory, so that whatever writings they subsequently took in hand or whatever questions they proposed for solution or proof, they did not thumb the pages of books to hunt for rules and reasons which the liberal arts might afford for the resolution of a doubtful matter, but at once had the particulars ready by heart. Hence, it is a fact that in that time there were so many learned men that they alone wrote more than we are able to read. But the students[42] of our day, whether from ignorance or from unwillingness, fail to hold to a fit method of study, and therefore we find many who study but few who are wise. Yet it seems to me that the student should take no less care not to expend his effort in useless studies than he should to avoid a lukewarm pursuit of good and useful ones. It is bad to pursue something good negligently; it is worse to expend many labors on an empty thing. But because not everyone is mature enough to know what is of advantage to him, I shall briefly indicate to the student which writings seem to me more useful than others, and then I shall add a few words on the method of study.

Chapter Four: Concerning the Two Kinds of Writings

There are two kinds of writings. The first kind comprises what are properly called the arts; the second, those writings

which are appendages of the arts. The arts are included in philosophy: they have, that is, some definite and established part of philosophy for their subject matter—as do grammar, dialectic, and others of this sort. The appendages of the arts, however, are only tangential to philosophy. What they treat is some extra-philosophical matter. Occasionally, it is true, they touch in a scattered and confused fashion upon some topics lifted out of the arts, or, if their narrative presentation is simple, they prepare the way for philosophy. Of this sort are all the songs of the poets—tragedies, comedies, satires, heroic verse and lyric, iambics, certain didactic poems, fables and histories, and also the writings of those fellows whom today we commonly call "philosophers"[43] and who are always taking some small matter and dragging it out through long verbal detours, obscuring a simple meaning in confused discourses—who, lumping even dissimilar things together, make, as it were, a single "picture" from a multitude of "colors" and forms. Keep in mind the two things I have distinguished for you—the arts and the appendages of the arts.[44]

Between these two, however, there is in my view such distance as the poet describes when he says:

> As much as the wiry willow cedes to the pale olive,
> Or the wild nard to roses of Punic red.[45]

It is a distance such that the man wishing to attain knowledge, yet who willingly deserts truth in order to entangle himself in these mere by-products of the arts, will find, I shall not say infinite, but exceedingly great pains and meagre fruit. Finally, the arts themselves, without these things that border on them, are able to make the student perfect, while the latter things, without the arts, are capable of conferring no perfection: and this the more especially since the latter have nothing desirable with which to tempt the student except what they have taken over and adapted from the arts; and no one should seek in them anything but what is of the arts. For this reason it appears to me that our effort should first be given to the arts, in which are the foundation stones of all things and in which pure and simple truth is revealed—and especially to the seven already mentioned, which comprise the tools of all philosophy; afterwards, if time

affords, let these other things be read, for sometimes we are better pleased when entertaining reading is mixed with serious, and rarity makes what is good seem precious. Thus, we sometimes more eagerly take up a thought we come upon in the midst of a story.

It is in the seven liberal arts, however, that the foundation of all learning is to be found. Before all others these ought to be had at hand, because without them the philosophical discipline does not and cannot explain and define anything. These, indeed, so hang together and so depend upon one another in their ideas that if only one of the arts be lacking, all the rest cannot make a man into a philosopher. Therefore, those persons seem to me to be in error who, not appreciating the coherence among the arts, select certain of them for study, and, leaving the rest untouched, think they can become perfect in these alone.[46]

Chapter Five: That to Each Art Should be Given What Belongs to It

There is still another error, hardly less serious than that just mentioned, and it must be avoided with the greatest care: certain persons, while they omit nothing which ought to be read, nonetheless do not know how to give each art what belongs to it, but, while treating one, lecture on them all. In grammar they discourse about the theory of syllogisms; in dialectic they inquire into inflectional cases; and what is still more ridiculous, in discussing the title of a book they practically cover the whole work, and, by their third lecture, they have hardly finished with the incipit. It is not the teaching of others that they accomplish in this way, but the showing off of their own knowledge. Would that they seemed to everyone as they seem to me! Only consider how perverse this practice is. Surely the more you collect superfluous details the less you are able to grasp or to retain useful matters.

Two separate concerns, then, are to be recognized and distinguished in every art: first, how one ought to treat of the art itself, and second, how one ought to apply the principles of that art in all other matters whatever. Two distinct things are involved here: treating *of* the art and treating *by means of* the art.

Treating of an art is treating, for instance, of grammar; but treating by means of that art is treating some matter grammatically. Note the difference between these two—treating of grammar, and treating some matter grammatically. We treat of grammar when we set forth the rules given for words and the various precepts proper to this art; we treat grammatically when we speak or write according to rule. To treat of grammar, then, belongs only to certain books, like Priscian, Donatus, or Servius; but to treat grammatically belongs to all books.

When, therefore, we treat of any art—and especially in teaching it, when everything must be reduced to outline and presented for easy understanding—we should be content to set forth the matter in hand as briefly and as clearly as possible, lest by excessively piling up extraneous considerations we distract the student more than we instruct him. We must not say everything we can, lest we say with less effect such things as need saying. Seek, therefore, in every art what stands established as belonging specifically to it. Later, when you have studied the arts and come to know by disputation and comparison what the proper concern of each of them is,[47] then, at this stage, it will be fitting for you to bring the principles of each to bear upon all the others, and, by a comparative and back-and-forth examination of the arts, to investigate the things in them which you did not well understand before. Do not strike into a lot of by-ways until you know the main roads: you will go along securely when you are not under the fear of going astray.[48]

Chapter Six: What Is Necessary for Study

Three things are necessary for those who study: natural endowment, practice, and discipline.[49] By natural endowment is meant that they must be able to grasp easily what they hear and to retain firmly what they grasp; by practice is meant that they must cultivate by assiduous effort the natural endowment they have; and by discipline is meant that, by leading a praiseworthy life, they must combine moral behavior with their knowledge. Of these three in turn we shall now set forth a few remarks by way of introduction.

Chapter Seven: Concerning Aptitude as Related to Natural Endowment

Those who work at learning must be equipped at the same time with aptitude and with memory, for these two are so closely tied together in every study and discipline that if one of them is lacking, the other alone cannot lead anyone to perfection —just as earnings are useless if there is no saving of them, and storage equipment is useless if there is nothing to preserve. Aptitude gathers wisdom, memory preserves it.

Aptitude is a certain faculty naturally rooted in the mind and empowered from within.[50] It arises from nature, is improved by use, is blunted by excessive work, and is sharpened by temperate practice.[51] As someone has very nicely said:

> Please! Spare yourself for my sake—there's only drudgery in those papers! Go run in the open air!

Aptitude gets practice from two things—reading and meditation. Reading consists of forming our minds upon rules and precepts taken from books, and it is of three types: the teacher's, the learner's, and the independent reader's. For we say, "I am reading the book *to* him," "I am reading the book *under* him," and "I am reading the book."[52] Order and method are what especially deserve attention in the matter of reading.

Chapter Eight: Concerning Order in Expounding a Text

One kind of order is observed in the disciplines, when I say, for instance, that grammar is more ancient than dialectic, or arithmetic comes before music; another kind in codices or anthologies, when I declare, for instance, that the Catilinarian orations are ahead of the *Jugurtha;* another kind in narration, which moves in continuous series; and another kind in the exposition of a text.

Order in the disciplines is arranged to follow nature. In books it is arranged according to the person of the author or the nature of the subject matter.[53] In narration it follows an arrangement which is of two kinds—either natural, as when deeds are recounted in the order of their occurrence, or artificial, as when a subsequent event is related first and a prior event is

told after it. In the exposition of a text, the order followed is adapted to inquiry.

Exposition includes three things: the letter, the sense, and the inner meaning. The letter is the fit arrangement of words, which we also call construction; the sense is a certain ready and obvious meaning which the letter presents on the surface; the inner meaning is the deeper understanding which can be found only through interpretation and commentary. Among these, the order of inquiry is first the letter, then the sense, and finally the inner meaning. And when this is done, the exposition is complete.[54]

Chapter Nine: Concerning the Method of Expounding a Text[55]

The method of expounding a text consists in analysis. Every analysis begins from things which are finite, or defined, and proceeds in the direction of things which are infinite, or un-defined. Now every finite or defined matter is better known and able to be grasped by our knowledge; teaching, moreover, begins with those things which are better known and, by acquainting us with these, works its way to matters which lie hidden. Furthermore, we investigate with our reason (the proper function of which is to analyze) when, by analysis and in-vestigation of the natures of individual things, we descend from universals to particulars. For every universal is more fully defined than its particulars: when we learn, therefore, we ought to begin with universals, which are better known and determined and inclusive; and then, by descending little by little from them and by distinguishing individuals through analysis, we ought to investigate the nature of the things those universals contain.

Chapter Ten: Concerning Meditation[56]

Meditation is sustained thought along planned lines: it prudently investigates the cause and the source, the manner and the utility of each thing. Meditation takes its start from reading but is bound by none of reading's rules or precepts. For it delights to range along open ground, where it fixes its free gaze upon the contemplation of truth, drawing together now these, now those causes of things, or now penetrating into profundities,

leaving nothing doubtful, nothing obscure. The start of learning, thus, lies in reading, but its consummation lies in meditation; which, if any man will learn to love it very intimately and will desire to be engaged very frequently upon it, renders his life pleasant indeed, and provides the greatest consolation to him in his trials. This especially it is which takes the soul away from the noise of earthly business and makes it have even in this life a kind of foretaste of the sweetness of the eternal quiet. And when, through the things which God has made, a man has learned to seek out and to understand him who has made them all, then does he equally instruct his mind with knowledge and fill it with joy. From this it follows that in meditation is to be found the greatest delight.

There are three kinds of meditation: one consists in a consideration of morals, the second in a scrutiny of the commandments, and the third in an investigation of the divine works. Morals are found in virtues and vices. The divine command either orders, or promises, or threatens.[57] The work of God comprises what his power creates, what his wisdom disposes, and what his grace co-effects. And the more a man knows how great is the admiration which all these things deserve, the more intently does he give himself to continual meditation upon the wonders of God.

Chapter Eleven: Concerning Memory

Concerning memory I do not think one should fail to say here that just as aptitude investigates and discovers through analysis, so memory retains through gathering. The things which we have analyzed in the course of learning and which we must commit to memory we ought, therefore, to gather. Now "gathering" is reducing to a brief and compendious outline things which have been written or discussed at some length.[58] The ancients called such an outline an "epilogue," that is, a short restatement, by headings, of things already said. Now every exposition has some principle upon which the entire truth of the matter and the force of its thought rest, and to this principle everything else is traced back. To look for and consider this principle is to "gather."

The fountainhead is one, but its derivative streams are many: why follow the windings of the latter? Lay hold upon the source and you have the whole thing. I say this because the memory of man is dull and likes brevity, and, if it is dissipated upon many things, it has less to bestow upon each of them. We ought, therefore, in all that we learn, to gather brief and dependable abstracts to be stored in the little chest of the memory, so that later on, when need arises, we can derive everything else from them. These one must often turn over in the mind and regurgitate from the stomach of one's memory to taste them, lest by long inattention to them, they disappear.[59]

I charge you, then, my student, not to rejoice a great deal because you may have read many things, but because you have been able to retain them. Otherwise there is no profit in having read or understood much. And for this reason I call to mind again what I said earlier: those who devote themselves to study require both aptitude and memory.[60]

Chapter Twelve : Concerning Discipline

A certain wise man, when asked concerning the method and form of study, declared:

> A humble mind, eagerness to inquire, a quiet life,
> Silent scrutiny, poverty, a foreign soil.
> These, for many, unlock the hidden places of learning.[61]

He had heard, I should judge, the saying, "Morals equip learning."[62] Therefore he joined rules for living to rules for study, in order that the student might know both the standard of his life and the nature of his study. Unpraiseworthy is learning stained by a shameless life. Therefore, let him who would seek learning take care above all that he not neglect discipline.

Chapter Thirteen : Concerning Humility

Now the beginning of discipline is humility. Although the lessons of humility are many, the three which follow are of especial importance for the student: first, that he hold no knowledge and no writing in contempt; second, that he blush

to learn from no man; and third, that when he has attained
learning himself, he not look down upon everyone else.

Many are deceived by the desire to appear wise before their
time. They therefore break out in a certain swollen importance
and begin to simulate what they are not and to be ashamed of
what they are; and they slip all the farther from wisdom in
proportion as they think, not of being wise, but of being thought
so. I have known many of this sort who, although they still
lacked the very rudiments of learning, yet deigned to concern
themselves only with the highest problems, and they supposed
that they themselves were well on the road to greatness simply
because they had read the writings or heard the words of great
and wise men. "We," they say, "have seen them. We have
studied under them. They often used to talk to us. Those great
ones, those famous men, they know us." Ah, would that no
one knew me and that I but knew all things! You glory in
having seen, not in having understood, Plato. As a matter of
fact, I should think it not good enough for you to listen to me.
I am not Plato. I have not deserved to see him. Good for
you! You have drunk at the very fount of philosophy—but
would that you thirsted still! "The king, having drunk from a
goblet of gold, drinks next from a cup of clay!"[63] Why are
you blushing? You have heard Plato!—may you hear
Chrysippus too! The proverb says, "What you do not know,
maybe Ofellus knows."[64] There is no one to whom it is given to
know all things, no one who has not received his special gift
from nature. The wise student, therefore, gladly hears all, reads
all, and looks down upon no writing, no person, no teaching.
From all indifferently he seeks what he sees he lacks, and he
considers not how much he knows, but of how much he is
ignorant. For this reason men repeat Plato's saying: "I would
rather learn with modesty what another man says than shameless-
ly push forward my own ideas."[65] Why do you blush to be
taught, and yet not blush at your ignorance? The latter is a
greater shame than the former. Or why should you affect the
heights when you are still lying in the depths? Consider,
rather, what your powers will at present permit: the man who
proceeds stage by stage moves along best. Certain fellows,
wishing to make a great leap of progress, sprawl headlong. Do

not hurry too much, therefore; in this way you will come more quickly to wisdom. Gladly learn from all what you do not know, for humility can make you a sharer in the special gift which natural endowment has given to every man. You will be wiser than all if you are willing to learn from all.

Finally, hold no learning in contempt, for all learning is good. Do not scorn at least to read a book, if you have the time. If you gain nothing from it, neither do you lose anything; especially since there is, in my judgment, no book which does not set forth something worth looking for, if that book is taken up at the right place and time; or which does not possess something even special to itself which the diligent scrutinizer of its contents, having found it nowhere else, seizes upon gladly in proportion as it is the more rare.

Nothing, however, is good if it eliminates a better thing. If you are not able to read everything, read those things which are more useful. Even if you should be able to read them all, however, you should not expend the same labor upon all. Some things are to be read that we may know them, but others that we may at least have heard of them, for sometimes we think that things of which we have not heard are of greater worth than they are, and we estimate more readily a thing whose fruit is known to us.

You can now see how necessary to you is that humility which will prompt you to hold no knowledge in contempt and to learn gladly from all. Similarly, it is fitting for you that when you have begun to know something, you not look down upon everyone else. For the vice of an inflated ego attacks some men because they pay too much fond attention to their own knowledge, and when they seem to themselves to have become something, they think that others whom they do not even know can neither be nor become as great. So it is that in our days certain peddlers of trifles come fuming forth; glorying in I know not what,[66] they accuse our forefathers of simplicity and suppose that wisdom, having been born with themselves, with themselves will die.[67] They say that the divine utterances have such a simple way of speaking that no one has to study them under masters, but can sufficiently penetrate to the hidden treasures of Truth by his own mental acumen. They wrinkle their noses and

purse their lips at lecturers in divinity and do not understand that they themselves give offense to God, whose words they preach—words simple to be sure in their verbal beauty, but lacking savor when given a distorted sense. It is not my advice that you imitate men of this kind.[68]

The good student, then, ought to be humble and docile, free alike from vain cares and from sensual indulgences, diligent and zealous to learn willingly from all, to presume never upon his own knowledge, to shun the authors of perverse doctrine as if they were poison, to consider a matter thoroughly and at length before judging of it, to seek to *be* learned rather than merely to seem so, to love such words of the wise as he has grasped, and ever to hold those words before his gaze as the very mirror of his countenance. And if some things, by chance rather obscure, have not allowed him to understand them, let him not at once break out in angry condemnation and think that nothing is good but what he himself can understand. This is the humility proper to a student's discipline.

Chapter Fourteen: Concerning Eagerness to Inquire

Eagerness to inquire relates to practice and in it the student needs encouragement rather than instruction. Whoever wishes to inspect earnestly what the ancients in their love of wisdom have handed down to us, and how deserving of posterity's remembrance are the monuments which they left of their virtue, will see how inferior his own earnestness is to theirs. Some of them scorned honors, others cast aside riches, others rejoiced in injuries received, others despised hardships, and still others, deserting the meeting places of men for the farthest withdrawn spots and secret haunts of solitude, gave themselves over to philosophy alone, that they might have greater freedom for undisturbed contemplation insofar as they subjected their minds to none of the desires which usually obstruct the path of virtue. We read that the philosopher Parmenides dwelt on a rock in Egypt for fifteen years.[69] And Prometheus, for his unrestrained love of thinking, is recorded to have been exposed to the attacks of a vulture on Mount Caucasus. For they knew that the true good lies not in the esteem of men but is hidden in a pure

conscience and that those are not truly men who, clinging to
things destined to perish, do not recognize their own good.
Therefore, seeing that they differed in mind and understanding
from all the rest of men, they displayed this fact in the very far-
removal of their dwelling places, so that one community might
not hold men not associated by the same objectives. A certain
man retorted to a philosopher, saying, "Do you not see that men
are laughing at you?" To which the philosopher replied, "They
laugh at me, and the asses bray at them." Think if you can how
much he valued the praise of those men whose vituperation,
even, he did not fear. Of another man we read that after
studying all the disciplines and attaining the very peaks of all
the arts he turned to the potter's trade. Again, the disciples of a
certain other man, when they exalted their master with praises,
gloried in the fact that among all his other accomplishments he
even possessed that of being a shoemaker.

I could wish that our students possessed such earnestness that
wisdom would never grow old in them. None but Abisag the
Sunamitess warmed the aged David, because the love of wisdom,
though the body decay, will not desert her lover.[70] "Almost all
the powers of the body are changed in aged men; while wisdom
alone increases, all the rest fade away."[71] "The old age of those
who have formed their youth upon creditable pursuits becomes
wiser with the years, acquires greater polish[72] through ex-
perience, greater wisdom with the passage of time, and reaps
the sweetest fruits of former studies. That wise and well-known
man of Greece, Themistocles,[73] when he had lived a full one-
hundred seven years and saw that he was about to die, is said to
have declared that he was sad to depart this life when he had
just begun to be wise. Plato died writing in his eighty-first
year.[74] Socrates[75] filled ninety-nine years with the pain and
labor of teaching and writing. I pass over in silence all the
other philosophers—Pythagoras, Democritus, Xenocrates, Zeno,
and the Elean (Parmenides)—who flourished throughout a long
life spent in the pursuit of wisdom. I come now to the poets—
Homer, Hesiod, Simonides, and Tersichorus,[76] who, when
advanced in years, sang, with the approach of death—how shall
I say it?—a swan-song sweeter than even their former wont.
When Sophocles, after an exceedingly old age and a long neglect

of his family affairs, was accused by his sons of madness, he declaimed to the judge the story of Oedipus which he had only recently composed, and gave such a specimen of his wisdom in these already broken years that he moved the austere dignity of the courtroom to the applause of the theatre. Nor is this a matter for wonder, when even Cato the censor, most erudite of the Romans, neither blushed nor despaired to learn Greek when he was already an old man. And, indeed, Homer reports that from the tongue of Nestor, who was already stooped with age and nearly decrepit, flowed speech sweeter than honey."[77] Consider, then, how much these men loved wisdom when not even decrepit age could call them away from its quest.

The greatness of that love of wisdom, therefore, and the abundance of judgment in elderly men is aptly inferred from the interpretation of that very name "Abisag" which I mentioned above. "For 'Abisag' means 'father mine, superabounding' or again 'my father's deep-voiced cry,' whence it is most abundantly shown that, with the aged, the thunder of divine discourse tarries beyond human speech. For the word 'superabounding' here signifies fulness, not redundance. And indeed, 'Sunamitess' in our language means 'scarlet woman,'"[78] an expression which can aptly enough signify zeal for wisdom.

Chapter Fifteen: Concerning the Four Remaining Precepts

The four following precepts are so arranged that they alternately refer first to discipline and next to practice.

Chapter Sixteen: On Quiet

Quiet of life—whether interior, so that the mind is not distracted with illicit desires, or exterior, so that leisure and opportunity are provided for creditable and useful studies—is in both senses important to discipline.

Chapter Seventeen: On Scrutiny

Now, scrutiny, that is, meditation, has to do with practice. Yet it seems that scrutiny belongs under eagerness to inquire, and if this is true, we are here repeating ourselves needlessly,

since we mentioned the latter above. It should, however, be recognized that there is a difference between these two. Eagerness to inquire means insistent application to one's work; scrutiny means earnestness in considering things. Hard work and love make you carry out a task; concern and alertness make you well-advised. Through hard work you keep matters going; through love you bring them to perfection. Through concern you look ahead; through alertness you pay close attention. These are the four footmen who carry the chair of Philology, for they give practice to the mind over which Wisdom sits ruler. The chair of Philology is the throne of Wisdom, and it is said to be carried by these bearers because it is carried forward when one practices these things. Therefore, the two front bearers, because of their power, are neatly designated as the youths Philos and Kophos, that is Love and Hard Work, because they bring a task to external perfection; the two rear bearers are with equal neatness designated as the maidens Philemia and Agrimnia (Epimeleia and Agrypnia), that is Concern and Alertness, because they inspire interior and secret reflection.[79] There are some who suppose that by the Chair of Philology is meant the human body, over which the rational soul presides, and which four footmen carry—that is, the four elements of which the two upper ones, namely fire and air, are masculine in function and in gender, and the two lower, earth and water, feminine.[80]

Chapter Eighteen: On Parsimony

Men have wished to persuade students to be content with slender means, that is, not to hanker after superfluities. This is a matter of especial importance for their discipline. "A fat belly," as the saying goes, "does not produce a fine perception."[81] But what will the students of our time be able to say for themselves on this point? Not only do they despise frugality in the course of their studies, but they even labor to appear rich beyond what they are. Each one boasts not of what he has learned but of what he has spent. But perhaps the explanation of this lies in their wish to imitate their masters,[82] concerning whom I can find nothing worthy enough to say!

Chapter Nineteen: On a Foreign Soil[83]

Finally, a foreign soil is proposed, since it too gives a man practice. All the world is a foreign soil to those who philosophize.[84] However, as a certain poet says:

> I know not by what sweetness native soil attracts a man
> And suffers not that he should e'er forget.[85]

It is, therefore, a great source of virtue for the practiced mind to learn, bit by bit, first to change about in visible and transitory things, so that afterwards it may be able to leave them behind altogether. The man who finds his homeland sweet is still a tender beginner; he to whom every soil is as his native one is already strong; but he is perfect to whom the entire world is as a foreign land. The tender soul has fixed his love on one spot in the world; the strong man has extended his love to all places; the perfect man has extinguished his. From boyhood I have dwelt on foreign soil, and I know with what grief sometimes the mind takes leave of the narrow hearth of a peasant's hut,[86] and I know, too, how frankly it afterwards disdains marble firesides[87] and panelled halls.[88]

BOOK FOUR

Chapter One: Concerning the Study of the Sacred Scriptures

Neither all nor only those writings which treat of God or of invisible goods are to be called sacred. In the books of pagans we find many things quite plausibly argued about the eternity of God and the immortality of souls, about eternal rewards owing to the virtues, and about eternal punishments owing to evils, and yet no one supposes that these books merit the term "sacred." Again, as we run through the series of books in the Old Testament and the New, we see that the collection is devoted almost entirely to the state of this present life and to deeds done in time, while rarely is anything clearly to be drawn[1] from them concerning the sweetness of eternal goods or the joys of the heavenly life. And yet these writings the catholic faith traditionally calls Sacred Scriptures.

The writings of philosophers, like a whitewashed wall of clay, boast an attractive surface all shining with eloquence; but if sometimes they hold forth to us a semblance of truth, nevertheless, by mixing falsehoods with it, they conceal the clay of error, as it were, under an over-spread coat of color. The Sacred Scriptures, on the other hand, are most fittingly likened to a honeycomb, for while in the simplicity of their language they seem dry, within they are filled with sweetness. And thus it is that they have deservedly come by the name sacred, for they alone are found so free from the infection of falsehood that they are proved to contain nothing contrary to truth.

Sacred Scriptures are those which were produced by men who cultivated the catholic faith and which the authority of the universal church has taken over to be included among the Sacred Books and preserved to be read for the strengthening of that same faith. Besides these, there exists an exceedingly large number of short works which holy and wise men have written at

various times and which, although they are not approved by the authority of the universal church, nevertheless pass for Sacred Scriptures, both because they do not depart from the catholic faith and because they teach many useful matters. But very likely more can be shown by enumerating these writings than by defining them.

Chapter Two: Concerning the Order and Number of the Books

The whole of Sacred Scripture is contained in two Testaments, namely, in the Old and in the New. The books in each Testament are divided into three groups. The Old Testament contains the Law, the Prophets, and the Hagiographers; the New contains the Gospel, the Apostles, and the Fathers.[2]

The first group in the Old Testament—that is, the Law, which the Hebrews call the *Torah*[3]—contains the Pentateuch, or the five books of Moses. First in this group is *Bresith*, or Genesis; second *Hellesmoth*, or Exodus; third, *Vaiecra*, or Leviticus, fourth *Vaiedaber*, or Numbers; fifth, *Adabarim*, or Deuteronomy.

The second group is that of the Prophets. It contains eight books. The first is called *Josue ben Nun*, which means "Son of Nun"—also called simply Josue or Jesus or Jesu Nave. The second is called *Sophtim*, and it is the book of Judges; the third, Samuel, and it is the first and second books of Kings; the fourth, *Malachim*, and it is the third and fourth books of Kings; the fifth, Isaias; the sixth, Jeremias; the seventh, Ezechiel; the eighth, *Thareasra*, and it consists of the Twelve [Minor] Prophets.

Next, the third group has nine books. The first is Job; the second, David; the third, *Masloth*, which in Greek is called Parables and in Latin, Proverbs—and these are Solomon's; the fourth, *Coeleth*, which is Ecclesiastes; the fifth, *Sira Syrin*, that is, the Canticle of Canticles; the sixth, Daniel; the seventh, *Dabrehiamin*, which is Paralipomenon; the eighth, Esdras; the ninth, Esther. All these total twenty-two.

Besides all these there are five other books—The Wisdom of Solomon, the Book of Jesus Son of Sirach, the Book of Judith, the Book of Tobias, and the Books of the Machabees—which are read, to be sure, but which are not included in the canon.[4]

The first group of the New Testament contains four books: Matthew, Mark, Luke, and John. The second likewise contains four: the fourteen letters of Paul collected in one book; then the Canonical Epistles; the Apocalypse; and the Acts of the Apostles. In the third group, first place is held by the Decretals, which we call canons, or rules; the second, by the writings of the holy Fathers and Doctors of the Church—Jerome, Augustine, Gregory, Ambrose, Isidore, Origen, Bede, and many other orthodox authors. Their works are so limitless that they cannot be numbered—which makes strikingly clear how much fervor they had in that Christian faith for the assertion of which they left so many and such great remembrances to posterity. Indeed, we stand convicted of indolence by our inability to read all that they could manage to dictate.

In these groups most strikingly appears the likeness between the two Testaments. For just as after the Law come the Prophets, and after the Prophets, the Hagiographers, so after the Gospel come the Apostles, and after the Apostles the long line of Doctors. And by a wonderful ordering of the divine dispensation, it has been brought about that although the truth stands full and perfect in each of the books, yet none of them is superfluous. These few things we have condensed concerning the order and number of the Sacred Books, that the student may know what his required reading is.

Chapter Three: Concerning the Authors of the Sacred Books

"Moses wrote the five books of the Law. Of the Book of Josue, that same Josue whose name it bears is believed to have been the author. The Book of Judges, they say, was produced by Samuel. The first part of the Book of Samuel he himself wrote, but the rest to the very end, David. *Malachim*, Jeremias first brought together into a single book, for previously this material had been scattered in histories of the individual kings."[5]

Isaias, Jeremias, and Ezechiel each wrote the books inscribed with their names. "The Book of the Twelve Prophets is inscribed with the names of its authors, whose names are: Osee, Joel, Amos, Abdias, Jonas, Michaeas, Nahum, Habacuc,

Sophonias, Aggeus, Zacharias, and Malachias. These are called the Minor Prophets because their discourses are short and are therefore included in a single book."6 As for Isaias and Jeremias and Ezechiel and Daniel, these four are the Major Prophets, each set apart in a separate book.

"The Book of Job some believe was written by Moses; others hold it to have been written by one of the Prophets, while a number suppose it the work of Job himself."7 The Book of Psalms David produced, though afterwards Esdras gave the psalms their present order and added the titles. Parables, Ecclesiastes, and the Canticle of Canticles Solomon composed. Daniel was the author of his own book. "The Book of Esdras bears its author's name in its title, though in it the discourses of Esdras and of Nehemias are equally contained. The Book of Esther is believed to have been written by Esdras. The Book of Wisdom is nowhere found among the Hebrews, and indeed its very title bespeaks a Greek origin for it. Certain Jews affirm that the book was produced by Philo. The Book of Ecclesiasticus was most certainly the work of Jesus son of Sirach of Jerusalem, nephew of Jesus the high priest, whom Zacharias mentions. This book is found among the Hebrews, but is placed among the Apocrypha. As for Judith and Tobias and the Books of the Machabees, of which, as Jerome says, the second proves rather to be Greek, it is by no means certain who wrote them."8

Chapter Four: What a "Bibliotheca" Is

"A *bibliotheca* (library) takes its name from the Greek, because in it books are preserved. For *biblio-* is to be understood as meaning 'of books' and *-theca* as 'repository.' After the Law had been burned by the Chaldeans and when the Jews had returned to Jerusalem, Esdras the scribe, inspired by the Divine Spirit, restored the books of the Old Testament, corrected all the volumes of the Law and the Prophets which had been corrupted by the gentiles, and arranged the whole of the Old Testament into twenty-two books, so that there might be just as many books of Law as there were letters in the alphabet."9 "Five letters of the Hebrew alphabet, however, are doubles—

caph, mem, nun, phe, and *sade:* these five are written in one form at the beginning or middle of a word, and in another at the end. For this reason, many think, five of the books are double: Samuel, *Malachim, Debrehiamin,* Esdras, and Jeremias with its *Cynoth,* or Lamentations."[10]

Chapter Five: Concerning Translators

"The translators of the Old Testament: first, those seventy translators whom Ptolemy Philadelphus, king of Egypt, had translate the Old Testament out of Hebrew into the Greek tongue. Well versed in all letters, he rivaled Pisistratus, tyrant of the Athenians (who, first, founded a library among the Greeks), and Seleucus Nicanor, and Alexander, and all the other ancients who cultivated wisdom, in his zeal for libraries. Into his library he gathered together not only the writings of all peoples but also the Sacred Scriptures, with the result that in his time seventy thousand books were to be found at Alexandria. To get the writings of the Old Testament he approached Eleazar the High Priest. Although the seventy translators had been isolated, each in his own cell, nevertheless, through the operation of the Holy Spirit it fell out that nothing in the translation of any one of them was found to differ, either in word order or in any other matter, from that of the rest."[11] They produced, therefore, but one translation. But Jerome says that this is a tale undeserving of belief.[12]

"The second, third, and fourth translations were made respectively by Aquila, Symmachus, and Theodotion, of whom Aquila was a Jew while Symmachus and Theodotion were Ebionite heretics. The practice of the Greek churches, however, has been to adopt and read texts which follow the seventy translators. The fifth translation is the popular one, whose author is unknown, so that it has to be called simply 'the Fifth.' The sixth and seventh derive from Origen, whose works were popularized by Eusebius and Pamphilus. The eighth is Jerome's, which is deservedly preferred to the others because it adheres more closely to the original words and is clearer in its insight into meanings."[13]

Chapter Six: Concerning the Authors of the New Testament

Several persons have written Gospels, but some among these, lacking the Holy Spirit, were bent more upon arranging a good story than upon weaving together the truth of history. For this reason, our holy Fathers, instructed by the Holy Spirit, accepted only four as authoritative, rejecting the rest. These four are those of Matthew, Mark, Luke, and John, after the likeness of the four rivers of Paradise, the four carrying-poles of the Ark,[14] and the four animals in Ezechiel. "The first, Matthew, wrote his Gospel in Hebrew. The second, Mark, wrote in Greek. The third, Luke, better instructed in the Greek tongue than the other Evangelists—he was, in fact, a doctor in Greece—wrote his Gospel for Bishop Theophilus, for whom he likewise composed the Acts of the Apostles. Fourth and last, John wrote his Gospel."[15]

"Paul wrote fourteen Epistles—ten to the churches, four to individuals. Most, however, say that the last one, the Epistle to the Hebrews, is not Paul's; some hold that Barnabas wrote it, others surmise it was Clement. The Canonical Epistles are seven: one by James, two by Peter, three by John, one by Jude. John the Apostle wrote the Apocalypse when in exile on the island of Patmos."[16]

Chapter Seven: That All the Other Scriptures Are Apocryphal, and What an Apocryphal Scripture Is

"These, then, are the writers of the Sacred Books, who, speaking through the Holy Spirit for our instruction, have set forth the precepts and rules of life. Apart from these, all the other works are called apocryphal. They are called apocryphal, that is, 'hidden,' because they have come into doubt. For their origin is obscure, unknown even to the Fathers, from whose day unto our own the authority of the true Scriptures has come down by a most certain and well-known tradition. Though some truth is to be found in these apocryphal writings, still, because of their numerous errors, no canonical authority is allowed them; and they are rightly judged not to be by those authors to whom they are ascribed. For heretics have published many things under the names of the Prophets—and later things

under the names of the Apostles. All of these accounts, after
diligent examination, have been deprived of canonical authority
and given the name of Apocrypha."[17]

Chapter Eight: The Sense of the Names of the Sacred Books

"The Pentateuch is so called from its five books: for *penta* in
Greek means 'five,' and *teucus*, 'book.' Genesis is so called from
its treating the generation of the universe; Exodus, from its
treating the exit of the sons of Israel from Egypt; Leviticus,
from its treating the duties of the levites and the various kinds of
sacrificial victims; the Book of Numbers from the fact that in it
the tribes, once out of Egypt, are numbered, and also from the
forty-two halting-places in the desert."[18] "The Greek word
deutrus is disyllabic and means 'second,' while *nomia* means 'law.'
Deuteronomy may therefore be construed as 'second law,' for in
this book are recapitulated those things said at greater length in
the preceding three.

"In the Book of Josue, which the Hebrews call *Josue ben Nun*,
the land of the promise is divided among the people. The Book
of Judges is so called from the leaders who judged the people
of Israel before there were kings among them."[19] To this book
some persons join the history of Ruth so as to form a single
work. "The Book of Samuel is so called because it describes the
birth, priesthood, and deeds of that leader; although it also
contains the histories of Saul and of David, both these men are
connected with Samuel, since he annointed them both. The
Hebrew word *malach* means 'of kings.' Hence the book called
Malachim from the fact that it arranges in order the kings of
Juda and of the Israelite nation, together with their deeds."[20]

"Isaias, more Evangelist than Prophet, produced his own
book, whose every utterance is replete with eloquent prose.
His canticles, however, move along in hexameter and penta-
meter measure. Jeremias, too, produced his book, together
with its Threnodies, which we call Lamentations, because they
are used on very sad occasions and at rites for the dead. He has
constructed them along the Hebrew alphabet four times repeat-
ed, using different meters. The first two alphabets are written
in something resembling Sapphic verse, because three short

lines of verse, closely conjoined and beginning each with the same letter, are concluded with a heroic line. The third alphabet is written in trimeter, and in it sets of three stanzas begin with the same Hebrew letter. The fourth alphabet is like the first and second."21 "Ezechiel has a very obscure beginning and end. The Twelve [Minor] Prophets occupy a single book."22

"The beginning and final portions of the Hebrew Book of Job are prose narrative interspersed with direct discourse, but the middle portions (from the words 'Let the day perish wherein I was born' [3:3] to 'Therefore I reprehend myself and do penance' [42:6]) are in heroic verse. The Book of Psalms is called the *Psalter* in Greek, the *Nabla* in Hebrew, and the *Organum*, or musical instrument, in Latin. It is called the *Psalter* in Greek because while one, as prophet, sang at the psaltery or harp, a chorus answered in unison."23 "They commonly group the psalms into five divisions but assemble them in one book."24 David wrote the psalms, but Esdras afterwards arranged them. "That all the psalms and the Lamentations of Jeremias and fully all the canticles of the Hebrews are metrical compositions is attested by Jerome, Origen, Josephus, and Eusebius of Caesarea. They resemble the work of the Roman Flaccus or the Greek Pindar, now running to iambics, now brilliantly Sapphic, and falling into trimeter or tetrameter."25

"Scripture most clearly teaches that Solomon was called by three names: *Idida*, or Beloved of the Lord, for the Lord loved him; *Coeleth*, or Ecclesiastes (the Greek word *ecclesiastes* names a man who convokes an *ecclesia*, or assembly, a man whom we should call a preacher, and who speaks not to a particular individual, but to an entire assemblage of people); finally, he is called 'the Pacific,' because in his reign peace obtained. He produced books equal in number to his names; the first inscribed *Masloth* in Hebrew, *Parabolae* in Greek, *Proverbia* in Latin, because by means of comparison and similitude it sets forth senses of words and symbols of truth. From the place where the text reads, 'Who shall find a valiant woman?' (31:10), each verse begins with a succeeding letter of the Hebrew alphabet, like the Lamentations of Jeremias and certain of the other scriptural canticles. The second is that which is called *Coeleth* in Hebrew, *Ecclesiastes* in Greek, and *Contionator* (The Preacher) in Latin,

from the fact that its discourse is addressed not specially to an individual, as in the case of Proverbs, but generally, to all men, as if to a whole assembly and the whole church. The third is the *Sira Syrin*, or Canticle of Canticles, which is, as it were, the epithalamium or marriage song of Christ and the church. In Proverbs he teaches a youth, and, by means of aphorisms, he instructs him in his duties; for this reason, the instruction is often repeated to him as to a son. In Ecclesiastes, however, he instructs a man of mature age that he must think nothing in the world to be lasting, but that all we see is frail and short-lived. Finally, in the Canticle of Canticles, he joins to the embraces of the Spouse a man already perfected, a man fully prepared because he has turned his back upon the world. Not far different from this order of teaching is the instruction which philosophers give their disciples. First they instruct them in ethics, next they explain physics to them, and, when they see that a student has become well advanced in these, they lead him to theology itself."[26]

"Daniel, among the Hebrews, is placed not among the Prophets but among the Hagiographers. The catholic church does not read his book in the version of the seventy translators, because this version is much at variance with the truth. Daniel, in largest part, and also the Prophet Esdras and a portion of Jeremias are written in the Chaldaic tongue, though in Hebrew letters. The Book of Job, moreover, shows a very great affinity with the Arabic. In the Hebrew text, Daniel lacks the story of Susanna, the Hymn of the Three Young Men, and the tales about Bel and the Dragon."[27]

"*Paralipomenon* is the Greek word for what we might call 'of things omitted' or 'of things left over.' In it are summarily and briefly explained those things which were either omitted or not fully set forth either in the Law or in the Books of Kings."[28] "In Hebrew it bears the name *Dabrehiamin*, which means 'words of days,' or, as we might more meaningfully say, 'chronicle of the entire divine history.'"[29]

"There is but one Book of Esdras, and in it the discourses of that same Esdras and of Nehemias are contained. The second, third, and fourth Books of Esdras are apocryphal."[30]

"The book entitled The Wisdom of Solomon is called Wisdom

because in it the coming of Christ, the Wisdom of the Father, is clearly set forth, together with his passion."[31] The Book of Jesus Son of Sirach is called Ecclesiasticus "because, dealing with the discipline of the entire church, it was put out with great care and attention to the religious way of life."[32] Of these last two books Jerome speaks as follows:

"There are also in circulation *Panaretus*, or the Book of Jesus Son of Sirach, and another inauthentic book entitled The Wisdom of Solomon. Of the first of these I have found the Hebrew text, called Parables, not Ecclesiasticus as among the Latins. To it had been joined Ecclesiastes and the Canticle of Canticles, to establish its kinship with Solomon not only through the number of books but also through the nature of the materials. The second of these is nowhere found among the Hebrews, because even its very style has the ring of Greek eloquence. Some of the ancient writers affirm that it is a work of Philo the Jew. Therefore, just as the church reads, to be sure, the Books of Judith and Tobias and of the Machabees, but does not adopt them into the canonical Scriptures, so let her read these two books to edify the people, but not to confirm the truth of ecclesiastical dogmas."[33]

"In sum, as there are twenty-two letters through which, in Hebrew, we write whatever we have to say, and the range of the human voice is defined by their initial sounds, so too there are counted up twenty-two books by whose words and principles the still weak and nursling infancy of the just man is nurtured in the teachings of God."[34]

"Certain persons, counting the history of Ruth and the Lamentations of Jeremias as separate and distinct books among the hagiographical writings, and adding these two to the twenty-two already mentioned, total twenty-four books of the Old Law—a number which symbolizes the twenty-four elders who, in the Apocalypse, adore the Lamb."[35]

Chapter Nine: Concerning the New Testament

Just as the entire body of the Old Testament writings can, broadly speaking, be called the Law, while the five books of Moses are called the Law in a special sense, so too, generally

speaking, the entire New Testament can be called the Gospel, even though those four books—namely, Matthew, Mark, Luke, and John—in which the deeds and words of the Savior are fully set forth, deserve to be called the Gospel in a special sense. "Gospel" means "good news," because the Gospel promises eternal goods, not earthly happiness as the Old Testament does if one takes its literal meaning.

Chapter Ten: Concerning the Tables, or Canons, of the Gospels

"Ammonius of Alexandria was the first to set up the Gospel tables; afterwards, Eusebius of Caesarea, following him, worked them out more fully. They were set up in order that by their means we might discover and know which of the Evangelists said things similar to those found in the others, and unique things as well. These tables are ten in number: the first contains numbers indicating places in which Matthew, Mark, Luke, and John have said the same things; the second, numbers of places in which three Evangelists—Matthew, Mark, and Luke—have done so; the third, in which three—Matthew, Luke, and John; the fourth, in which three—Matthew, Mark, and John; the fifth, in which two—Mark and Luke; the sixth, in which two— Matthew and Mark; the seventh, in which two—Matthew and John; the eighth, in which two—Luke and Mark; the ninth, in which two—Luke and John; and the tenth, in which individual Evangelists have said things peculiar to themselves alone.

"This is how these tables are used: throughout each Evangelist, a certain number is fixed in the margin beside small sections of text, and under such numbers is placed a certain space marked in red and indicating in which of the ten tables one will find the section number to which that space is subjoined. For example, if the space indicated is the first, this number will be found in the first table; if the second, in the second; if the third, in the third; and so through the series till one comes to the tenth. If, therefore, with any one of the Gospels open before one, one should wish to know which of the other Evangelists has spoken similarly, one would take the number placed beside the section of text and look for that same number in the table indicated for it, and there one would find who has said what.

Finally, looking up in the body of the text the places indicated by the numbers listed in the tables, one would find passages on the same subject in the individual Gospels."36

Chapter Eleven: Concerning the Canons of the Councils

"The Greek word *canon* is translated by the Latin *regula* (rule). A rule is so called because it leads one straight, and does not now and then draw one astray. Others say that a rule is so called either because it rules, or because it offers a norm for right living, or because it sets straight what is distorted and corrupted.

"The canons of the general councils, however, took their start in the time of Constantine. In the years before this time, when persecution was aflame, license to teach the people was certainly not granted. Therefore, Christianity was torn asunder by heresy for the very reason that permission was not given the bishops to meet together in a body until the time of the emperor just named. For he it was who gave Christians the right to congregate freely. Under him, also, the holy Fathers, gathering together from all the lands of the earth, gave us, in the Nicene council, a creed which accords with the evangelical and apostolic faith, the second such creed since the Apostles."37

Chapter Twelve: That the Principal Synods Are Four

"But among all the other councils, there are four holy synods which comprise the bases of our entire faith, being four in number like the Gospels or the rivers of Paradise.38 Of these, the first is the Nicene synod of 318 bishops, held in the reign of Constantine Augustus. In it was condemned the blasphemy of the Arian heresy, asserted by Arius himself concerning inequality in the blessed Trinity. That same holy synod, through the creed, defined the consubstantiality of God the Son with God the Father. The second synod of 150 Fathers was convoked at Constantinople under Theodosius the elder, and, condemning Macedonius, who denied that the Holy Spirit was God, it demonstrated that the Holy Spirit was consubstantial with the Father and the Son and gave us the form of the creed which the entire confession of the Greeks and the Latins declares in the churches. The third synod, the first of Ephesus, was of 200

bishops and took place under the younger Theodosius Augustus; it condemned, with just anathema, Nestorius, who was asserting that there were two persons in Christ, and it showed that the one person of our Lord Jesus Christ possesses two natures. The fourth synod, that of Chalcedon, was held with 630 priests under the Emperor Marcian, and in it the unanimous judgment of the Fathers condemned Abbot Eutyches of Constantinople who was announcing that the Divine Word and the flesh formed one nature—and also his defender, a certain Dioscorus, bishop of Alexandria, and Nestorius once more, with all the rest of the heretics. The same synod declared that Christ as God was born of the Virgin in such a way that in him we confess a substance of both divine and human nature.

"These are the four principal synods, most fully declaring the doctrine of the faith. But if there are, besides, any councils which the holy Fathers, filled with the Spirit of God, sanctioned, it is from the authority of these four, whose acts are set down in this work, that they derive their permanence and all their force.

"The word 'synod,' which is from the Greek, means a fellowship or assembly. The name 'council,' however, is taken from Roman practice. For in the season when suits were being tried, all used to come together and deal with one another by common consent. From the idea of common consent, we speak of council' (*concilium*) as if for 'counsel' (*consilium*)—because a *cilium* (lash or lid) is something belonging to the eyes. Hence too, *considium* (session) is also a *consilium* (counsel) by the change of the 'd' to an 'l.' An assembly (*coetus*), however, is a convention or congregation, from the verb 'to assemble' (*coire*), that is, to convene (*convenire*) in one body, and hence it is also called 'convention' (*conventus*): 'convention,' 'assembly,' or 'council,' then, from the association of many persons for one purpose."39

"The Greek word 'epistle' means *missa* (message) in Latin. We have the Canonical, that is, the regular, Epistles, which are also called 'catholic,' that is, universal, because they have been written not to one people or city only, but to all nations generally."40 "The Acts of the Apostles discuss the beginnings of the Christian faith among the nations and the history of the nascent church, and they narrate the deeds of the Apostles, which is the reason why they are called The Acts of the Apostles.

The Greek word *apocalypsis* is translated by the Latin word *revelatio*, or revelation. Thus, John says: 'The Apocalypse of Jesus Christ, which God has given him to make known to his servant John.'"⁴¹

Chapter Thirteen: Who Have Made Libraries

"Among us, the martyr Pamphilus, whose life Eusebius of Caesarea wrote, sought to equal Pisistratus in zeal for a sacred library. Pamphilus had in his library nearly thirty thousand volumes. Jerome, too, and Gennadius, hunted for ecclesiastical writers throughout the whole world, set them forth in order, and listed their works in a one-volume catalogue."⁴²

Chapter Fourteen: Which Writings Are Authentic⁴³

"Of our fellow Christians among the Greeks, Origen, laboring upon his writings, surpassed both Greeks and Latins in the number of his works. Jerome says that he has read six thousand of his books. But Augustine, in mental ability or in self-knowledge, surpasses the studious efforts of all these men. He wrote so many things that no one finds enough days and nights in which to write or indeed even to read his books."⁴⁴ "Other catholic men, too, have written many and outstanding books: Athanasius, bishop of Alexandria; Hilary, bishop of Poitiers; Basil, bishop of Cappadocia; Gregory the theologian (Gregory of Nyssa) and Gregory, bishop of Nazianzen; Ambrose, bishop of Milan; Theophilus, bishop of Alexandria; John, bishop of Constantinople; Cyril of Alexandria; Pope Leo; Proculus; Isidore of Spain; Bede; Cyprian, martyr and bishop of Carthage; Jerome the priest; Prosper; Origen, whose writings the Church neither altogether repudiates nor accepts as a whole; Orosius; Sedulius; Prudentius; Juvencus; Arator."⁴⁵ Rufinus, too, composed many books and he translated certain writings, "but because the blessed Jerome condemned him in some matters concerning freedom of the will, we should follow what Jerome teaches on those things."⁴⁶ "Gelasius also composed five books against Nestorius and Eutyches, and tracts after the manner of Ambrose; likewise he wrote two books against Arius, and

composed liturgical prefaces and orations and epistles on the faith."[47] Dionysius the Areopagite, ordained bishop of the Corinthians, has left many volumes as testimony of his mental ability. "Also, as to the *Chronicles* of Eusebius of Caesarea and the books of his *Ecclesiastical History*, although he was lukewarm in the first book of his narrative and afterwards wrote a book praising and apologizing for Origen the schismatic, nevertheless, on account of the unusual learning shown in the contents— learning which serves our instruction—the catholic church does not altogether repress it."[48] There is Cassiodorus, too, who wrote quite a useful work in explanation of the Psalms. There are still others whose names I shall not mention here.

Chapter Fifteen: *Which Are the Apocryphal Writings*[49]

"The Itinerary called that of Peter the Apostle and said to be by Saint Clement; eight books: apocryphal.

"The Acts called those of Andrew the Apostle: apocryphal.

"The Acts called those of Thomas: apocryphal.

"The Gospels which go under the name of Thaddeus: apocryphal.

"The Gospels which go under the name of the Apostle Barnabas: apocryphal.

"The Gospels which go under the name of the Apostle Thomas: apocryphal.

"The Gospels which go under the name of the Apostle Andrew: apocryphal.

"The Gospels which Lucian falsified: apocryphal.

"The Gospels which Ytius falsified: apocryphal.

"The Book concerning the Infancy of the Savior: apocryphal.

"The Book concerning the Birth of the Savior and concerning Holy Mary, or, concerning the Savior's Midwife: apocryphal.

"The book which is called, 'Of the Shepherd': apocryphal.

"All the books made by Leucius the Devil's disciple: apocryphal.

"The books which are called 'The Foundation': apocryphal.

"The book which is called 'The Treasure': apocryphal.

"The book which is called 'On the Daughters of Adam, or Genesis': apocryphal.

"The Hundred-verse Poem concerning Christ, Composed of Verses out of Vergil: apocryphal.

"The book which is called 'The Acts of Thecla and Paul': apocryphal.

"The so-called 'Book of the Nephew': apocryphal.

"The 'Book of Proverbs' written by heretics and signed with the name of Saint Sixtus: apocryphal.

"The Revelation which is called that of Paul: apocryphal.

"The Revelation which is called that of Thomas the Apostle: apocryphal.

"The Revelation which is called that of Stephen: apocryphal.

"The Book which is called 'The Passing of Holy Mary': apocryphal.

"The Book which is called 'The Repentance of Adam': apocryphal.

"The Book of Diogias, surnamed the Giant, who heretics say fought with the dragon after the flood: apocryphal.

"The book which is called 'The Testament of Job': apocryphal.

"The book which is called 'The Repentance of Origen': apocryphal.

"The book which is called 'The Repentance of Cyprian': apocryphal.

"The book which is called that of Iamne and Mambre: apocryphal.

"The book which is called 'The Fate of the Apostles': apocryphal.

"The book of Lusan: apocryphal.

"The Book of the Canons of the Apostles: apocryphal.

"The book 'Physiologus,' written by heretics and signed with the name of the blessed Ambrose: apocryphal.

"The History of Eusebius Pamphilus: apocryphal.

"The Opuscula of Tertullian or Africanus: apocryphal.

"The Opuscula of Posthumianus and Gallus: apocryphal.

"The Opuscula of Montanus and Priscilla and Maximilla: apocryphal.

"All the Opuscula of Faustus the Manichean: apocryphal.

"The Opuscula of Clement II of Alexandria: apocryphal.

"The Opuscula of Cassian, Priest of the Gauls: apocryphal.

"The Opuscula of Victorinus of Poitiers: apocryphal.

"The Opuscula of Faustus of Riez in the Gauls: apocryphal.

"The Opuscula of Frumentus: apocryphal.

"The Epistle of Jesus to Abgar: apocryphal.

"The Passion of Cyricus and Julitta: apocryphal.

"The Passion of George: apocryphal.

"The writings which are called 'The Contradiction of Solomon': apocryphal.

"All the phylacteries, which were written not, as they pretend, by an angel but more likely by a demon: apocryphal.

"These and things like them, which Simon Magus, Nicholas, Cerinthus, Marcion, Basilides, Ebion, also Paul of Samosata, Photius and Bonosus (who fell away through a like error), Montanus likewise with his most immoral followers, Apollinaris, Valentine or Manichaeus, Faustus, Sabellius, Arius, Macedonius, Eunomius, Novatus, Sabatius, Calixtus, Donatus and Eustachius, Nibianus, Pelagius, Julian and Laciensis, Celestine, Maximian, Priscillian of Spain, Lampedius, Dioscorus, Euticius, Peter and a second Peter (of whom one was a blot upon Alexandria, the other upon Antioch), Achatius of Constantinople and his fellows—and indeed all heresies which these very men, or their disciples, or schismatics, have taught or written—men whose names we have by no means recorded—we declare to be not only rejected but also destroyed by the whole catholic and Roman Church, and, together with their authors and the followers of their authors, damned under anathemas by an indissoluble bond unto eternity."

Chapter Sixteen: Some Etymologies of Things Pertaining to Reading

"A codex is composed of many books, a book is composed of one volume. And a codex is so called, by transference, from the trunks (*codicibus*) of trees or vines, as if it were a trunk because it contains a multitude of books coming out of itself like so many branches; a volume (*volumen*) is so called from 'to roll up' (*volvere*). *Liber* is the inner rind of a tree, upon which the ancients used to write before the use of paper or parchment. For this reason they used to call writers *librarii*, and a volume a *liber*."[50]

"*Scheda* (a leaf of paper), whose dimimutive form is *schedula*, is a

Greek word. What is still being corrected and has not yet been bound in books is properly called a *scheda*."[51] "The use of paper was discovered first at Memphis, a city of Egypt. Paper (*charta*) is so called because the stripped (*decerptum*) plant membrane of the papyrus is glued together at various points (*carptim*), and thus the *charta* is made. It is of several kinds. Parchment (*pergamenum*) is so called from Pergamum, where it was invented. The word 'skins' (*membrana*) is also used because these are drawn off from the members (*membra*) of cattle. Skins were first made yellow in color; later, at Rome, they learned how to make white skins."[52]

"The word 'homily' is used to mean a popular sermon, as when one makes an address before the people. A 'tractate' is the exposition of a single matter in its many aspects. A 'dialogue' is a conversation (*collatio*) between two or among several persons; the Latins call it *sermo*. *Sermo*, or talk, moreover, is so called because it is interwoven (*seritur*) among each of the speakers. Commentaries (*com-mentaria*) are so named as from *cum mente* (with the mind) or from *comminiscor* (call to mind); for they are interpretations, as, for example, commentaries on the Law or on the Gospel."[53] Certain persons say that the word "comments" should be restricted to books of the pagans, while "expositions"[54] should be kept for the Sacred Books. "The word 'gloss' is Greek, and it means tongue (*lingua*), because, in a way, it bespeaks (*loquitur*) the meaning of the word under it.[55] Philosophers call this an *ad-verbum* (upon the word) because, with one single word, it explains that word concerning the meaning of which there is question, as, for example, when *conticescere* (to become silent) is explained by the word *tacere* (to be still)."[56]

BOOK FIVE

Chapter One: Concerning Properties of Sacred Scripture and the Manner of Reading It

It should not be burdensome to the eager student that we set forth the number and order and names of the Sacred Books in such a variety and number of ways, for it often happens that these least matters, when unknown, obscure one's knowledge of great and useful things. Therefore, let the student prepare himself once and for all by fixing these matters in the forefront of his mind, in certain little formulae, so to say, so that thereafter he will be able to run the course before him with free step and will not have to search out new elementary facts as he comes to individual books. With these matters set in order, we shall treat successively all the other things which will seem of value for the task before us.

Chapter Two: Concerning the Threefold Understanding[1]

First of all, it ought to be known that Sacred Scripture has three ways of conveying meaning—namely, history, allegory, and tropology. To be sure, all things in the divine utterance must not be wrenched to an interpretation such that each of them is held to contain history, allegory, and tropology all at once. Even if a triple meaning can appropriately be assigned in many passages, nevertheless it is either difficult or impossible to see it everywhere. "On the zither and musical instruments of this type not all the parts which are handled ring out with musical sounds; only the strings do this. All the other things on the whole body of the zither are made as a frame to which may be attached, and across which may be stretched, those parts which the artist plays to produce sweetness of song."[2] Similarly, in the divine utterances are placed certain things which are

intended to be understood spiritually only, certain things that emphasize the importance of moral conduct, and certain things said according to the simple sense of history. And yet, there are some things which can suitably be expounded not only historically but allegorically and tropologically as well. Thus is it that, in a wonderful manner, all of Sacred Scripture is so suitably adjusted and arranged in all its parts through the Wisdom of God that whatever is contained in it either resounds with the sweetness of spiritual understanding in the manner of strings; or, containing utterances of mysteries set here and there in the course of a historical narrative or in the substance of a literal context, and, as it were, connecting these up into one object, it binds them together all at once as the wood does which curves under the taut strings; and, receiving their sound into itself, it reflects it more sweetly to our ears—a sound which the string alone has not yielded, but which the wood too has formed by the shape of its body. Thus also is honey more pleasing because enclosed in the comb, and whatever is sought with greater effort is also found with greater desire.[3] It is necessary, therefore, so to handle the Sacred Scripture that we do not try to find history everywhere, nor allegory everywhere, nor tropology everywhere but rather that we assign individual things fittingly in their own places, as reason demands. Often, however, in one and the same literal context, all may be found together, as when a truth of history both hints at some mystical meaning by way of allegory, and equally shows by way of tropology how we ought to behave.

Chapter Three: That Things, Too, Have a Meaning in Sacred Scripture

It ought also to be known that in the divine utterance not only words but even things have a meaning[4]—a way of communicating not usually found to such an extent in other writings. The philosopher knows only the significance of words, but the significance of things is far more excellent than that of words, because the latter was established by usage, but Nature dictated the former.[5] The latter is the voice of men, the former the voice of God speaking to men. The latter, once uttered, perishes; the former, once created, subsists. The unsubstantial word is the

sign of man's perceptions; the thing is a resemblance of the divine Idea. What, therefore, the sound of the mouth, which all in the same moment begins to subsist and fades away, is to the idea in the mind, that the whole extent of time is to eternity. The idea in the mind is the internal word, which is shown forth by the sound of the voice, that is, by the external word. And the divine Wisdom, which the Father has uttered out of his heart, invisible in Itself, is recognized through creatures and in them.[6] From this is most surely gathered how profound is the understanding to be sought in the Sacred Writings, in which we come through the word to a concept, through the concept to a thing, through the thing to its idea, and through its idea arrive at Truth.[7] Because certain less well instructed persons do not take account of this, they suppose that there is nothing subtle in these matters on which to exercise their mental abilities, and they turn their attention to the writings of philosophers precisely because, not knowing the power of Truth, they do not understand that in Scripture there is anything beyond the bare surface of the letter.

That the sacred utterances employ the meaning of things, moreover, we shall demonstrate by a particular short and clear example. The Scripture says: "Watch, because your adversary the Devil goeth about as a roaring lion."[8] Here, if we should say that the lion stands for the Devil, we should mean by "lion" not the word but the thing. For if the two words "devil" and "lion" mean one and the same thing, the likeness of that same thing to itself is not adequate. It remains, therefore, that the word "lion" signifies the animal, but that the animal in turn designates the Devil. And all other things are to be taken after this fashion, as when we say that worm, calf, stone, serpent, and other things of this sort signify Christ.

Chapter Four: Concerning the Seven Rules

This, too, ought to be taken diligent note of, namely, "certain learned men have said that among all other rules, seven pertain to the utterance of the Sacred Scriptures.

"The first rule is about the Lord and his Body and expressions which move from the one to the other and, in one person, show

now the Head, now the Body—as when Isaias says, 'The Lord hath clothed me with the garment of salvation, as a bridegroom decked with a crown and as a bride adorned with her jewels.'[9] For in one person named with two words, he has shown both the Head, that is, the bridegroom, and the church, that is, the bride. Therefore, in the Scriptures it must be observed when the Head specifically is being written of, when both Head and Body, when a double exchange takes place between the two terms, or when there is a single switch from one to the other. In this way may the intelligent reader know what pertains to the Head and what to the Body.

"The second rule concerns the true and the mixed Body of the Lord. For certain things seem to apply to a single person though in reality they do not all apply to that one person, as in the following case: 'Thou art my servant, O Israel, behold I have blotted out thy iniquities as a cloud and thy sins as a mist. Be converted to me and I shall redeem thee.'[10] This passage does not apply to a single entity, for the first part applies to him whose sins God has blotted out and to whom he says, 'Thou art mine,' and the second part applies to him to whom he says, 'Be converted to me and I shall redeem thee.' These, if they are converted, have their sins blotted out. According to this rule, Scripture speaks to all in such a way that the good are censured with the evil and the evil are praised for the good: but he who reads intelligently will learn what pertains to whom.

"The third rule concerns the letter and the spirit, that is, the Law and grace: the Law, through which we are admonished about precepts to be observed; grace, through which we are aided to act. The Law ought to be understood not only in a historical but also in a spiritual sense: for it is necessary both to remain faithful to the historical sense and to understand the Law in a spiritual way.

"The fourth rule concerns 'species' and 'genus' in cases when the part is taken for the whole and the whole for the part, as, for example, if God should speak to one people or city and yet his utterance is understood to be addressed to the whole world. For although the Lord threatened the one city of Babylon through the prophet Isaias, nevertheless, while speaking against that city he passed from this 'species,' or specific group of

mankind, to the 'genus,' or mankind in general, and turned his speech against the whole world. Surely, if he were not speaking against the entire world he would not have added later the following general remark: 'And I will destroy all the earth and will visit the evils of the world,'[11] and all the other remarks which follow, pertaining to the destruction of the world. For this reason he also added: 'This is the counsel that I have purposed upon all the earth, and this is the hand that is stretched out upon all nations.'[12] In the same way, after he has charged the whole world in the person of Babylon, he once more turns back to that city as from the 'genus' to the 'species,' telling the things that have happened specifically to it: "Behold I will stir up the Medes against them.'[13] For while Balthasar was reigning, Babylon was taken by the Medes. Thus, too, in the person of Egypt alone he wishes us to understand the whole world when he says: 'And I will set the Egyptians to fight against the Egyptians, kingdom against kingdom';[14] because Egypt is described as having had not many kingdoms but one kingdom.

"The fifth rule is about times, and by its means either the largest period of time is represented through the smallest, or the smallest period of time is understood through the largest. Thus is it with the three days of the Lord's burial, since he did not lie in the tomb three full days and nights, but nevertheless the total of three days is understood from a part of them. Or again, there is the fact that God predicted the sons of Israel would be servants in Egypt for four hundred years and then depart from the country, whereas, while Joseph ruled, they were lords of Egypt, nor did they depart from it at once after four hundred years as had been promised, but they left Egypt after four hundred thirty years had been accomplished.

"There is still another figure relating to times, through which certain things belonging to future time are recounted as if already done, as in the passage: 'They have pierced my hands and my feet, they have numbered all my bones, they have parted my garments amongst them,'[15] and words similar to these, in which future events are spoken of as if they had already occurred. But why are things which must yet be done spoken of as already having occurred? Because those things which, from our point of view lie in the future, have, from the standpoint of God's

eternity, already been done. For this reason, when anything is announced as having yet to be done, this is said from our point of view. But when things in the future are spoken of as already done, these must be taken from the standpoint of the eternity of God, with whom all things belonging to the future have already been accomplished.

"The sixth rule is about recapitulation. Recapitulation exists when Scripture turns back to a subject the telling of which has already gone by, as when Scripture, in speaking of the sons of Noah's sons, said that they dwelt 'according to their kindreds and their tongues';[16] yet afterwards, as if this is found in the same sequence of time, it says: 'All the earth was of one tongue and of the same speech.'[17] But how did the sons of Noah exist according to their kindreds and according to their tongues if there was one tongue for all, unless here, the narration, by recapitulating, has turned back to that which had already happened.

"The seventh rule is about the Devil and his body, and, according to it, things are often said of the very head of this body which belong more to the body. But often the things said seem to belong to its members and yet are not suitable except to the head. Indeed, under the name of the body, the head is to be understood, as in that passage from the Gospel concerning the cockle mixed with the grain, where the Lord says: 'A man who is an enemy hath done this,'[18] calling the Devil himself by the name 'man,' and designating the head by the name of the body. Likewise the body is signified under the name of the head, as when it is said in the Gospel: 'Have I not chosen you twelve? And one of you is a devil,'[19] referring to Judas, to be sure, because he was a body of the Devil. For the apostate angel is the head of all who are evil, and all who are evil are the body of this head. So much is he one with his members that often what is said of his body is rather extended to him, and again, what is said of him is referred back to his members. So in Isaias, where, after the prophetic discourse has said many things against Babylon, that is, against the Devil's body, it once more deflects the thought of the oracle to the head and says: 'How art thou fallen from heaven, O Lucifer, who didst rise in the morning,'[20] and so on."[21]

Chapter Five: What Interferes with Study

Now that we have prescribed definite material for the student and, by giving the names, have determined what writings especially belong to sacred reading, the next step seems to be that we say something about the manner and order of reading, so that from things already said one may know upon what material he ought to spend his effort, while from those which must still be said he may gather the method and plan of that same study of his. But because we more easily understand what ought to be done if, earlier, we have grasped what ought not to be done, the student should first of all be taught what he should avoid, and then informed how he may accomplish the things he should get done.

We must say why it is that from such a throng of students, of whom many are both strong in natural talent and energetic in applying themselves, so few, easily counted, are found who manage to reach knowledge. And, leaving out of our consideration those who are naturally dull and slow in understanding things, it seems especially important and worthwhile to ask why it is that two persons who have equal talent and exert equal effort and who are intent upon the same study, nevertheless do not attain a similar result in their understanding of it. The one penetrates it quickly, quickly seizes upon what he is looking for. The other labors long and makes little progress. But what one should know is that in every business, no matter what it is, two things are necessary, namely work and a method for that work, and these two are so connected that one without the other is either useless or less effective. And yet, as it is said, "Wisdom is better than strength,"[22] for sometimes even weights which we cannot budge by force, we raise through cleverness. Thus it is, to be sure, in all our study. He who works along without discretion works, it is true, but he does not make progress, and just as if he were beating the air, he pours out his strength upon wind. Consider two men both traveling through a wood, one of them struggling around in bypaths but the other picking the short cuts of a direct route: they move along their ways with the same amount of motion, but they do not reach the goal at the same time. But what shall I call Scripture if not a

wood? Its thoughts, like so many sweetest fruits, we pick as we read and chew as we consider them. Therefore, whoever does not keep to an order and a method in the reading of so great a collection of books wanders as it were into the very thick of the forest and loses the path of the direct route; he is, as it is said, "always learning yet never reaching knowledge." For discretion is of such importance that without it every rest from work is disgraceful and work itself is useless. May we all draw our own conclusion!

There are three things above all which ordinarily provide obstacles for the studies of students: carelessness, imprudence, and bad luck (*fortuna*). Carelessness arises when we simply omit, or when we learn less carefully, those things which are there to be learned. Imprudence arises when we do not keep to a suitable order and method in the things we are learning. Bad luck shows up in a development, a chance happening, or a natural occurrence, when we are kept back from our objective either by poverty, or by illness, or by some non-natural slowness, or even by a scarcity of professors, because either none can be found to teach us, or none can be found to teach us well. But as to these three matters, in the first of them—carelessness, that is—the student needs to be admonished; in the second—imprudence, that is—he needs to be instructed; while in the third—bad luck, that is—he needs to be assisted.

Chapter Six: What the Fruit of Sacred Reading Is

Let whoever comes to sacred reading for instruction first know what kind of fruit it yields. For nothing ought to be sought without a cause, nor does a thing which promises no usefulness attract our desires.

Twofold is the fruit of sacred reading, because it either instructs the mind with knowledge or it equips it with morals. It teaches what it delights us to know and what it behooves us to imitate. Of these, the first, namely knowledge, has more to do with history and allegory, the other, namely instruction in morals, has more to do with tropology. The whole of sacred Scripture is directed to this end.

Although it is clearly more important for us to be just than

to be wise, I nevertheless know that many seek knowledge rather than virtue in the study of the Sacred Word. However, since I judge that neither of these should be disapproved of but that both are necessary and praiseworthy, I will briefly expound what belongs to the aim of each. And first of all I shall speak about the man who embraces the beauty of morality.[23]

Chapter Seven: How Scripture Is to Be Studied for the Correction of Morals

The man who seeks knowledge of the virtues and a way of life from the Sacred Word ought to study especially those books which urge contempt for this world and inflame the mind with love for its creator; which teach the straight road of life and show how virtues may be acquired and vices turned aside. For, "First of all," so Scripture says, "seek the kingdom of God and his justice."[24] It is as if it plainly said: "Both desire the joys of the heavenly kingdom, and skillfully seek out those merits of justice by which one may come to these joys. Love and look for every good thing, every necessary thing. If there is love, a man cannot take his ease. Do you desire to reach your goal? Then learn how a man reaches the goal you are after."

This knowledge, however, is got in two ways, namely, by example and by instruction: by example, when we read the deeds of the saints, by instruction when we learn what they have said that pertains to our disciplining. Among the deeds and sayings of the saints, those marvelously written down by the most blessed Gregory should, I think, be taken to heart. Because those have seemed to me sweet beyond all others and full of the love of eternal life, I did not want to pass them over in silence.[25]

It is necessary, however, that one who has started out on this road should learn, in the books that he reads, to be stirred not only by the art of their literary composition[26] but by a desire to imitate the virtues set forth, so that it is not so much the stateliness or arrangement of words as the beauty of truth which delights him. Let him know too, that it is not conducive to his aim that, carried away by an empty desire for knowledge, he should delve into writings which are obscure or of deep meaning, in which the mind is busied rather than edified, lest mere study

take such a hold upon him that he is forced to give up good works. For the Christian philosopher,[27] reading ought to be a source of encouragement, not a preoccupation,[28] and to feed good desires, not to kill them. I remember that I was once told of a man of praiseworthy life who so burned with love of Holy Scripture that he studied it ceaselessly. And when, with the growth of his knowledge day by day, his desire for knowledge also grew, finally, consumed with imprudent zeal for it and scorning the simpler Scriptures, he began to pry into every single profound and obscure thing and vehemently to insist upon untangling the enigmas of the Prophets and the mystical meanings of sacred symbols (*sacramentorum*). But the human mind, unable to sustain such a burden, soon began to tire from the greatness of the task and the constancy of the tension, and to be confused by such a great concern for this troubling occupation that the man stopped performing not only useful but even necessary acts. When once the matter had taken this contrary turn, the person who had begun to study the Scriptures for the edification of his life now found them an occasion of error to him because he did not know how to bring into play the moderating influence of discretion. But at length, through the divine compassion, he was admonished by a revelation that he should not devote himself to the study of these writings any more but should make a habit of going instead to the lives of the holy fathers and the triumphs of the martyrs and other such writings dictated in a simple style; and so, restored in a short while to his original condition, he merited to receive so great a grace of internal peace that you might truly say in him was fulfilled that word of our Lord's—that word by which, after himself considering our labor and our sorrow, he wished devotedly to console us, saying: "Come to me, all of you who labor and are heavily burdened, and I will refresh you," and afterwards he says, "You will find rest for your souls."[29]

I brought forth this example to show those who are bent upon the discipline, not of literature, but of the virtues, that their study should not be an affliction but a delight. For even the Prophet says: "I have not known literature," or business; "I will enter into the power of the Lord; Lord, I will be mindful of thy justice alone. Thou hast taught me, O God, from my

youth."[30] For whoever studies the Scriptures as a pre-
occupation and, if I may say so, as an affliction to his spirit, is
not philosophizing but is making a business out of them, and so
impetuous and unwise a purpose can hardly avoid the vice of
pride. But what shall I say of the study of the simple Paul, who
wished to fulfill the Law before he learned it?[31] Surely this can
be a good enough example for us, so that we may be not hearers
nor students of the Law, but rather doers of it[32] before God.

It must be considered, moreover, that study customarily fills
the mind with loathing and afflicts the spirit in two ways,
namely, through its quality, if the material has been too obscure,
and through its quantity, if there has been too much of it. In
both these matters it is necessary to use great discretion lest
what has been sought for our recovery may be found to stifle us.
There are those who wish to read everything. Don't vie with
them. Leave well enough alone. It is nothing to you whether
you read all the books there are or not. The number of books is
infinite; don't pursue infinity! Where no end is in sight, there
can be no rest. Where there is no rest, there is no peace. Where
there is no peace, God cannot dwell. "His place," says the
Prophet, "is in peace, and his abode in Sion."[33] "In Sion," but
"in peace"; it behooves us to be Sion, but not to lose our peace.
Consider, but refuse to be preoccupied. Do not be a hoarder
lest perhaps you always be in want. Give ear to Solomon, give
ear to the Wise Man and learn prudence. "My son," he says,
"more than these require not. Of making many books there is
no end: and much study is an affliction of the flesh." Where,
then, does all this lead to? "Let us all hear together the con-
clusion of the discourse. Fear God, and keep His command-
ments: for this is all man."[34]

Chapter Eight: *That Study Is for Beginners, Action for the Perfect*

Let no one suppose, in view of what I said above, that I do
not favor diligence in students, because, on the contrary, I
intend to encourage diligent students toward their objective and
to show that those who learn willingly are worthy of praise.
But above I was speaking for the educated, now however for

those who have yet to be educated and are beginning the instruction which is the source of discipline. For the educated it is the pursuit of virtues, but for beginners, at the moment, it is the practice of study which is their objective—both pursuits to be conducted in such a way, however, that beginners may not pass up virtue, nor educated persons omit study, either. For frequently a task which has not been preceded by study is less prepared for, and instruction which is not followed up by good application of it is less useful. But it is of highest importance both that those already educated should watch out lest perhaps they cast their eyes back upon things behind them, and that beginners should console themselves if sometimes they long to reach the place where the others are. It is fitting, therefore, that both of these should keep at work and that both of them should move ahead. Let no one turn backward. You may climb ahead, not go back down. If, however, you are not yet able to climb ahead, keep to your own place.

The man who takes over someone else's job is not without fault. If you are a monk, what are you doing in a crowd? If you love silence, why does it delight you to be constantly in attendance upon declaimers? You ought always to be taken up with fastings and with prayers, yet you seek to play the philosopher, do you? The simplicity of the monk is his philosophy. "But I aspire to teach others," you say. Yours is not to teach but to weep.[35] If, however, you desire to be the learned teacher, hear what you shall do. The inexpensiveness of your dress and the simplicity expressed in your countenance, the innocence of your life and the holiness of your behavior ought to teach men. You teach better by fleeing the world than by following after it. But perhaps you persist, saying, "Well, what then? If I want to, may I not learn, at least?" I have told you above: "Study, but do not be preoccupied with it." Study can be a practice for you; it is not your objective. Instruction is good, but it is for beginners. You, however, have dedicated yourself to perfection, and therefore it is not enough for you if you put yourself on a level with beginners. It is fitting for you to manage more than this. Think, then, where you are, and you will easily recognize what you ought to do.

Chapter Nine: Concerning the Four Steps

There are four things in which the life of just men is now practiced and raised, as it were by certain steps, to its future perfection—namely, study or instruction, meditation, prayer, and performance. Then follows a fifth, contemplation, in which, as by a sort of fruit of the preceding steps, one has a foretaste, even in this life, of what the future reward of good work is. It is because of this foretaste that the Psalmist, when speaking of the judgments of God and commending them, immediately adds: "In keeping these there is a great reward."[36]

Of these five steps, the first, that is, study, belongs to beginners; the highest, that is, contemplation, to those who are perfect. As to the middle steps, the more of these one ascends, the more perfect he will be. For example: the first, study, gives understanding; the second, meditation, provides counsel; the third, prayer, makes petition; the fourth, performance, goes seeking; the fifth, contemplation, finds. If, therefore, you are studying and you have understanding and you already know what must be done, this is the beginning of the good for you, but it is not yet enough; you are not yet perfect. And so, mount into the ark of counsel[37] and meditate on how you may be able to fulfill what you have learned must be done. For there are many who have knowledge, but few who know in the way it behooves them to know. Further, since the counsel of man is weak and ineffective without divine aid, arouse yourself to prayer and ask the help of him without whom you can accomplish no good thing, so that by his grace, which, going before you has enlightened you, he may guide your feet, as you follow, onto the road of peace; and so that he may bring that which as yet is in your will alone, to concrete effect in good performance. It then remains for you to gird yourself for good work, so that what you have sought in prayer you may merit to receive in your practice. God wishes to work with you; you are not forced, but you are helped. If you are alone, you accomplish nothing; if God alone works, you have no merit. Therefore, may God work in order that you may be able to work; and do you also work in order that you may have some merit. Good performance is the road by which one travels

toward life. He who travels this road is in quest of life. "Take thou courage and do manfully."[38] This road has its reward. As often as we become fatigued by the journey's labor, we are enlightened by the grace of a solicitude from on high, and we "taste and see that the Lord is sweet."[39] And thus comes to pass what was said above—what prayer asks, contemplation finds.

You see, then, how perfection comes to those ascending by means of these steps, so that he who has remained below cannot be perfect. Our objective, therefore, ought to be always to keep ascending; but, because the instability of our life is such that we are not able to hold fast in one place, we are forced often to review the things we have done, and, in order not to lose the condition in which we now stand, we now and again repeat what we have been over before. For example: the man who is vigorous in his practice prays lest he grow weak; the man who is constant in his prayers meditates on what should be prayed for, lest he offend in prayer; and the man who sometimes feels less confidence in his own counsel, seeks advice in his reading. And thus it turns out that though we always have the will to ascend, nevertheless we are sometimes forced by necessity to descend—in such a way, however, that our goal lies in that will and not in this necessity. That we ascend is our goal; that we descend is for the sake of this goal. Not the latter, therefore, but the former ought to be the principal thing.

Chapter Ten: Concerning the Three Types of Students

It has, I think, been clearly enough shown that the same task does not lie before advanced persons and those who propose something more for themselves, as lies before beginners. But just as something has properly been allowed to the former (those who are advanced) which these beginners may by no means indulge in without committing a fault, so also from the beginners something is required to which the advanced are no longer obliged. Now, therefore, I come back to the promise still to be fulfilled, namely, that I show how the Sacred Scripture ought to be read by those who are still seeking in it for knowledge alone.

There are some who seek knowledge of the Sacred Scripture either in order that they may gather riches or in order that they may obtain honors or acquire fame. Their purpose ought to be commiserated in equal proportion to its perversity. There are still others who delight to hear the words of God and to learn of His works not because these bring them salvation but because they are marvels. They wish to search into hidden matters and to know about unheard-of things—to know much and to do nothing. In vain do they gape at God's power when they do not love his mercy. What else can I call their conduct than a turning of the divine announcements into tales? It is for this that we are accustomed to turn to theatrical performances, for this to dramatic recitations—namely, that we may feed our ears, not our mind. But persons of this sort I think should not so much be brought to confusion as helped. Their will is not evil, only senseless.

There are others, however, who study the Sacred Scriptures precisely so that they may be ready, in accordance with the Apostle's teaching, to "give the reason of that faith"[40] in which they have been placed to everyone who asks it of them, so that, for example, they may forthrightly demolish enemies of the truth, teach those less well informed, recognize the path of truth more perfectly themselves, and, understanding the hidden things of God more deeply, love them more intently. Surely the devotion of these persons deserves praise and is worthy of imitation.

Three, therefore, are the classes of men who study the Sacred Scripture, and of them the first are to be pitied, the second to be helped, the third to be praised.[41] But we, because we intend to give advice to all, desire that what is good should be increased in all, and what is perverted, changed. We wish that all should understand what we say and that all should do what we urge.

BOOK SIX

Chapter One: How the Sacred Scripture Should Be Read by Those Who Seek Knowledge in It

Two things I propose to you, my student—namely, order and method—and if you pay careful attention to them, the pathway of study will easily open up before you. In my consideration of these, however, I shall neither leave all things to your own natural ability nor promise that from my own diligence you will get everything you need. Instead, by way of foretaste for you, I shall briefly run over certain matters in such a way that you may find some things set forth to provide instruction and some things skipped over to allow scope for your own effort.

I have mentioned that order in study is a fourfold matter: one thing in the disciplines, another in books, another in narrative, and another in exposition.[1] How these are to be applied in the Divine Scripture I have not yet shown.

Chapter Two: Concerning the Order Which Exists in the Disciplines

First of all, the student of Sacred Scripture ought to look among history, allegory, and tropology for that order sought in the disciplines—that is, he should ask which of these three precedes the others in the order of study.[2]

In this question it is not without value to call to mind what we see happen in the construction of buildings, where first the foundation is laid, then the structure is raised upon it, and finally, when the work is all finished, the house is decorated by the laying on of color.[3]

Chapter Three: Concerning History

So too, in fact, must it be in your instruction. First you learn history and diligently commit to memory the truth of the deeds

that have been performed, reviewing from beginning to end what has been done, when it has been done, where it has been done, and by whom it has been done. For these are the four things which are especially to be sought for in history—the person, the business done, the time, and the place.[4] Nor do I think that you will be able to become perfectly sensitive to allegory unless you have first been grounded in history. Do not look down upon these least things. The man who looks down on such smallest things slips little by little. If, in the beginning, you had looked down on learning the alphabet, now you would not even find your names listed with those of the grammar students. I know that there are certain fellows who want to play the philosopher right away. They say that stories should be left to pseudo apostles. The knowledge of these fellows is like that of an ass. Don't imitate persons of this kind.

"Once grounded in things small, you may safely strive for all."[5] I dare to affirm before you that I myself never looked down on anything which had to do with education, but that I often learned many things which seemed to others to be a sort of joke or just nonsense. I recall that when I was still a school-boy I worked hard to know the names of all things that my eyes fell upon or that came into my use, frankly concluding that a man cannot come to know the natures of things if he is still ignorant of their names. How many times each day would I make myself pay out the debt of my little bits of wisdom, which, thanks to their shortness, I had noted down in one or two words on a page, so that I might keep a mindful hold on the solutions, and even the number, of practically all the thoughts, questions, and objections which I had learned. Often I proposed cases and, when the opposing contentions were lined up against one another, I diligently distinguished what would be the business of the rhetorician, what of the orator, what of the sophist. I laid out pebbles for numbers, and I marked the pavement with black coals and, by a model placed right before my eyes, I plainly showed what difference there is between an obtuse-angled, a right-angled, and an acute-angled triangle. Whether or not an equilateral parallelogram would yield the same area as a square when two of its sides were multiplied together, I learned by walking both figures and measuring them with my feet. Often I

kept watch outdoors through the winter nights like one of the fixed stars by which we measure time.⁶ Often I used to bring out my strings, stretched to their number on the wooden frame, both that I might note with my ear the difference among the tones and that I might at the same time delight my soul with the sweetness of the sound. These were boyish pursuits, to be sure, yet not without their utility for me, nor does my present knowledge of them lie heavy upon my stomach. But I do not reveal these things to you in order to parade my knowledge, which is either nothing at all or very little, but in order to show you that the man who moves along step by step is the one who moves along best, not like some who fall head over heels when they wish to make a great leap ahead.

As in the virtues, so in the sciences, there are certain steps. But, you say, "I find many things in the histories which seem to be of no utility: why should I be kept busy with this sort of thing?" Well said. There are indeed many things in the Scriptures which, considered in themselves, seem to have nothing worth looking for, but if you look at them in the light of the other things to which they are joined, and if you begin to weigh them in their whole context, you will see that they are as necessary as they are fitting. Some things are to be known for their own sakes, but others, although for their own sakes they do not seem worthy of our labor, nevertheless, because without them the former class of things cannot be known with complete clarity, must by no means be carelessly skipped. Learn everything; you will see afterwards that nothing is superfluous. A skimpy knowledge is not a pleasing thing.

But you ask if I have any opinion about the books which are useful for this study. I think the ones to be studied most are: Genesis, Exodus, Josue, the Book of Judges, and that of Kings, and Paralipomenon; of the New Testament, first the four Gospels, then the Acts of the Apostles. These eleven seem to me to have more to do with history than do the others—with the exception of those which we properly call historiographical.

But if we take the meaning of the word more broadly, it is not unfitting that we call by the name "history" not only the recounting of actual deeds but also the first meaning of any narrative which uses words according to their proper nature.⁷

And in this sense of the word, I think that all the books of either Testament, in the order in which they were listed earlier, belong to this study in their literal meaning.

Possibly, if it did not seem childish, I should interject in this place a few instructions on the manner of construing sentences, because I know that the Divine Scripture, more than all other books, is compressed in its text: but these matters I wish to refrain from, lest I protract the task before me by excessive digression. There are certain places in the divine page which cannot be read literally and which it is necessary that we construe with great judgment, so that we may not either overlook some things through negligence or, through misplaced diligence, violently twist them into something they were not written to say.

This, then, my student, is what we propose to you. This field of your labor, well cultivated by your plough, will bear you a manifold harvest. All things were brought forth in order: move along in order yourself. Following the shadow, one comes to the body: learn the figure, and you will come to the truth. I am not now saying that you should first struggle to unfold the figures of the Old Testament and penetrate its mystical sayings before you come to the Gospel streams you must drink from. But just as you see that every building lacking a foundation cannot stand firm, so also is it in learning. The foundation and principle of sacred learning, however, is history, from which, like honey from the honeycomb, the truth of allegory is extracted.[8] As you are about to build, therefore, "lay first the foundation of history; next, by pursuing the 'typical' meaning, build up a structure in your mind to be a fortress of faith. Last of all, however, through the loveliness of morality, paint the structure over as with the most beautiful of colors."[9]

You have in history the means through which to admire God's deeds, in allegory the means through which to believe his mysteries, in morality the means through which to imitate his perfection. Read, therefore, and learn that "in the beginning God created heaven and earth."[10] Read that in the beginning he planted "a paradise of pleasure wherein he placed man whom he had formed."[11] Him sinning God expelled and thrust out into the trials of this life. Read how the entire offspring of the

human race descended from one man; how, subsequently, flood destroyed sinners; how, in the midst of the waters, the divine mercy preserved the just man Noah with his sons; next, how Abraham received the mark of the faith, but afterwards Israel went down into Egypt; how God thereafter led the sons of Israel out of Egypt by the hand of Moses and Aaron, brought them through the Red Sea and through the desert, gave them the Law, and settled them in the land of promise; how often he delivered them as sinners into the hands of their enemies and afterwards freed them again when they were penitent; how first through judges, then through kings, he rules his people: "He took his servant David from following the ewes great with young."¹² Solomon he enlightened with wisdom. For the weeping Ezechiel he added on fifteen years. Thereafter he sent the straying people captive into Babylon by the hand of Nabuchodonosor. After seventy years he brought them back, through Cyrus. At last, however, when that time was already declining, he sent his Son into our flesh, and he, having sent his apostles into all the world, promised eternal life to those who were repentant. He foretold that he would come at the end of the ages to judge us, to make a return to each man according to his deeds—namely, eternal fire for sinners, but for the just, eternal life and the kingdom of which there shall be no end. See how, from the time when the world began until the end of the ages, the mercies of God do not slacken.

Chapter Four: Concerning Allegory

After the reading of history, it remains for you to investigate the mysteries of allegories, in which I do not think there is any need of exhortation from me, since this matter itself appears worthy enough in its own right. Yet I wish you to know, good student, that this pursuit demands not slow and dull perceptions but matured mental abilities which, in the course of their searching, may so restrain their subtlety as not to lose good judgment in what they discern. Such food is solid stuff, and, unless it be well chewed, it cannot be swallowed. You must therefore employ such restraint that, while you are subtle in your seeking, you may not be found rash in what you presume;

remembering that the Psalmist says: "He hath bent his bow and made it ready. And in it he hath prepared the instruments of death."[13]

You remember, I suppose, that I said above that Divine Scripture is like a building, in which, after the foundation has first been laid, the structure itself is raised up; it is altogether like a building, for it too has its structure. For this reason, let it not irk us if we follow out this similitude a little more carefully.

Take a look at what the mason does.[14] When the foundation has been laid, he stretches out his string in a straight line, he drops his perpendicular, and then, one by one, he lays the diligently polished stones in a row. Then he asks for other stones, and still others, and if by chance he finds some that do not fit with the fixed course he has laid, he takes his file, smooths off the protruding parts, files down the rough spots, and the places that do not fit, reduces to form, and so at last joins them to the rest of the stones set into the row. But if he finds some to be such that they cannot either be made smaller or be fitly shaped, he does not use these lest perhaps while he labors to grind down the stone he should break his file.

Pay attention now! I have proposed to you something contemptible to gapers but worthy of imitation to those who understand. The foundation is in the earth, and it does not always have smoothly fitted stones. The superstructure rises above the earth, and it demands a smoothly proportioned construction. Even so the Divine Page, in its literal sense, contains many things which seem both to be opposed to each other and, sometimes, to impart something which smacks of the absurd or the impossible. But the spiritual meaning admits no opposition; in it, many things can be different from one another, but none can be opposed. The fact, also, that the first course of stones to be laid upon the foundation is placed flush with a taut cord—and these are the stones upon which the entire weight of the others rests and to which they are fitted—is not without its meaning. For this is like a sort of second foundation and is the basis of the entire superstructure. This foundation both carries what is placed upon it and is itself carried by the first foundation. All things rest upon the first foundation but are not fitted to it in every way. As to the latter foundation,

everything else both rests upon it and is fitted to it. The first one carries the superstructure and underlies the superstructure. The second one carries the superstructure and is not only under the superstructure but part of it. The foundation which is under the earth we have said stands for history, and the superstructure which is built upon it we have said suggests allegory. Therefore, that basis of this superstructure ought also to relate to allegory. The superstructure rises in many courses of stones, and each course has its basis. Even so, many mysteries are contained in the Divine Page and they each have their bases from which they spring. Do you wish to know what these courses are? The first course is the mystery of the Trinity, because this, too, Scripture contains, since God, Three and One, existed before every creature. He, from nothing, made every creature—visible, namely, and invisible. Behold in these the second course. To the rational creature he gave free judgment, and he prepared grace for it that it might be able to merit eternal beatitude. Then, when men fell of their own will he punished them, and when they continued to fall he strengthened them that they might not fall further. What the origin of sin, what sin, and what the punishment for sin may be: these constitute the third course. What mysteries he first instituted for man's restoration under the natural law: these are the fourth course. What things were written under the Law: these, the fifth course. The mystery of the incarnation of the Lord: this, the sixth course. The mysteries of the New Testament: these, the seventh course. Finally, the mysteries of man's own resurrection: these, the eighth course.[15]

Here is the whole of divinity, this is that spiritual structure which is raised on high, built, as it were, with as many courses of stones as it contains mysteries. You wish also to know the very bases themselves. The bases of the courses are the principles of the mysteries. See now, you have come to your study, you are about to construct the spiritual building. Already the foundations of history have been laid in you: it remains now that you found the bases of the superstructure. You stretch out your cord, you line it up precisely, you place the square stones into the course, and, moving around the course, you lay the track, so to say, of the future walls. The taut cord shows the

path of the true faith. The very bases of your spiritual structure are certain principles of the faith—principles which form your starting point. Truly, the judicious student ought to be sure that, before he makes his way through extensive volumes, he is so instructed in the particulars which bear upon his task and upon his profession of the true faith, that he may safely be able to build onto his structure whatever he afterwards finds. For in such a great sea of books and in the manifold intricacies of opinions which often confound the mind of the student both by their number and their obscurity, the man who does not know briefly in advance, in every category so to say, some definite principle which is supported by firm faith and to which all may be referred, will scarcely be able to conclude any single thing.

Do you wish that I should teach you how such bases ought to be laid? Look back at those things which I listed for you a moment ago. There is the mystery of the Trinity. Many books have already been composed on this mystery, many opinions given which are difficult to understand and complicated to resolve. It would be too long and too burdensome for you to work through absolutely all of them and possibly you would find many by which you were more muddled than edified. Do not insist on doing this: you will never have done. First learn briefly and clearly what is to be believed about the Trinity, what you ought unquestionably to profess and truthfully to believe. Afterwards, however, when you have begun to read books and have found many things obscurely, many things clearly, and many things doubtfully written, take those things which you find clear and, if it should be that they conform, add them to their proper base. The doubtful things interpret in such a way that they may not be out of harmony. But those things that are obscure, elucidate if you can. But if you cannot penetrate to an understanding of them, pass over them so that you may not run into the danger of error by presuming to attempt what you are not equal to doing. Do not be contemptuous of such things, but rather be reverent toward them, for you have heard that it is written: "He made darkness his hiding-place."[16] But even if you find that something contrary to what you have already learned, should be held with the firmest faith, still it is not well for you to change your opinion daily, unless first you have

sought the advice of men more learned than yourself and, especially, unless you have learned what the universal faith, which can never be false, orders to be believed about it. Thus should you do concerning the mystery of the altar, thus concerning the mystery of baptism, that of confirmation, that of marriage, and all which were enumerated for you above. You see that many who read the Scriptures, because they do not have a foundation of truth, fall into various errors and change their views almost as often as they sit down to read. But you see others who, in accordance with that knowledge of the truth upon which, interiorly, they are solidly based, know how to bend all Scriptural passages whatever into fitting interpretations and to judge both what is out of keeping with sound faith and what is consonant with it. In Ezechiel you read that the wheels follow the living creatures, not the living creatures the wheels; it says: "When the living creatures went, the wheels also went together by them: and when the living creatures were lifted up from the earth, the wheels also were lifted up with them."[17] So it is with the minds of holy men: the more they advance in virtues or in knowledge, the more they see that the hidden places of the Scriptures are profound, so that those places which to simple minds and minds still tied to earth seem worthless, to minds which have been raised aloft seem sublime. For the text continues: "Whithersoever the spirit went, thither as the spirit went the wheels also were lifted up withal, and followed it: for the spirit of life was in the wheels."[18] You see that these wheels follow the living creatures and follow the spirit.

Still elsewhere it is said: "The letter killeth, but the spirit quickeneth,"[19] because it is certainly necessary that the student of the Scripture adhere staunchly to the truth of the spiritual meaning and that the high points of the literal meaning, which itself can sometimes be wrongly understood too, should not lead him away from the central concern in any way whatever. Why was that former people who received the Law of life reproved, except that they followed the death-dealing letter in such a way that they did not have the life-giving Spirit? But I do not say these things in order to offer anyone the chance to interpret the Scriptures according to his own will, but in order to show the man who follows the letter alone that he cannot

long continue without error. For this reason it is necessary both that we follow the letter in such a way as not to prefer our own sense to the divine authors, and that we do not follow it in such a way as to deny that the entire pronouncement of truth is rendered in it. Not the man devoted to the letter "but the spiritual man judgeth all things."[20]

In order, therefore, that you may be able to interpret the letter safely, it is necessary that you not presume upon your own opinion, but that first you be educated and informed, and that you lay, so to speak, a certain foundation of unshaken truth upon which the entire superstructure may rest; and you should not presume to teach yourself, lest perhaps when you think you are introducing you are rather seducing yourself. This introduction must be sought from learned teachers and men who have wisdom, who are able to produce and unfold the matter to you both through the authorities of the holy fathers and the evidences of the Scriptures, as is needful; and, once you have already had this introduction, to confirm the particulars they have taught you by reading from the evidences of the Scriptures.

So the matter appears to me. Whoever is pleased to follow me in this, I accept with pleasure. Whoever thinks things ought not to be done in this way, let him do what he pleases: I shall not argue with him. For I know that a number of people do not follow this pattern in learning. But how certain of these advance, this too I am not unaware of.

If you ask what books are best for this study, I think the beginning of Genesis on the works of the six days; the three last books of Moses on the mysteries of the Law; Isaias; the beginning and end of Ezechiel; Job; the Psalter; the Canticle of Canticles; two Gospels in particular, namely those of Matthew and John; the Epistles of Paul; the Canonical Epistles; and the Apocalypse; but especially the Epistles of Paul, which even by their very number show that they contain the perfection of the two Testaments.[21]

Chapter Five: Concerning Tropology, That Is, Morality

Concerning tropology I shall not at present say anything more than what was said above, except that it is more the meaning of

things than the meaning of words which seems to pertain to it. For in the meaning of things lies natural justice, out of which the discipline of our own morals, that is, positive justice, arises.22 By contemplating what God has made we realize what we ourselves ought to do. Every nature tells of God; every nature teaches man; every nature reproduces its essential form, and nothing in the universe is infecund.23

Chapter Six: Concerning the Order of Books

The same order of books is not to be kept in historical and allegorical study. History follows the order of time; to allegory belongs more the order of knowledge, because, as was said above, learning ought to take its beginning not from obscure but from clear things, and from things which are better known. The consequence of this is that the New Testament, in which the evident truth is preached, is, in this study, placed before the Old, in which the same truth is announced in a hidden manner, shrouded in figures. It is the same truth in both places, but hidden there, open here, promised there, shown here. You have heard, in the reading from the Apocalypse (5:5), that the book was sealed and no one could be found who should loose its seals save only the Lion of the tribe of Judah. The Law was sealed, sealed were the prophecies, because the times of the redemption to come were announced in a hidden manner. Does it not seem to you that that book had been sealed which said: "Behold a virgin shall conceive and bear a son: and his name shall be called Emmanuel"?24 And another book which says: "Thou, Bethlehem Ephrata, art a little one among the thousands of Juda: out of thee shall he come forth unto me that is to be the ruler in Israel: and his going forth is from the beginning, from the days of eternity."25 And the Psalmist: "Shall not Sion say: This man and that man is born in her? and the Highest himself hath founded her."26 And again: "And of the Lord, of the Lord are the issues from death."27 And yet again he says: "The Lord said to my Lord: Sit thou at my right hand."28 And a little later in the same place: "With thee is the principality in the day of thy strength, in the brightness of the saints; from the womb before the day-star I begot thee."29 And Daniel says:

"I beheld therefore in the vision of the night, and lo, one like
the son of man came with the clouds of heaven, and he came
even to the Ancient of days... And he gave him power, and
glory, and a kingdom: and all peoples, tribes, and tongues shall
serve him: his power is an everlasting power that shall not be
taken away."[30]

Who do you think could understand these things before they
were fulfilled? They were sealed, and none could loose their
seals but the Lion of the tribe of Judah. There came, therefore,
the Son of God, and he put on our nature, was born of the
Virgin, was crucified, buried; he rose again, ascended to the
skies, and by fulfilling the things which had been promised, he
opened up what lay hidden. I read in the Gospel that the angel
Gabriel is sent to the Virgin Mary and announces the coming
birth:[31] I remember the prophecy which says, "Behold, a virgin
shall conceive."[32] I read that when Joseph was in Bethlehem
with Mary, his pregnant wife, the time for her to give birth
arrived "and she brought forth her firstborn son,"[33] who the
angel had foretold would reign on the throne of David his
father: I remember the prophecy, "Thou, Bethlehem Ephrata,
art a little one among the thousands of Judah: out of thee shall
he come forth to me that is to be the ruler of Israel."[34] Again I
read: "In the beginning was the Word; and the Word was with
God: and the Word was God":[35] I remember the prophecy
which says, "His going forth is from the beginning, from the
days of eternity."[36] I read: "The Word was made flesh and
dwelt among us":[37] I remember the prophecy which says, "You
shall call his name Emmanuel, that is, God with us."[38] And in
order not to risk making this tedious to you by following
through each item: unless you know beforehand the nativity of
Christ, his teaching, his suffering, his resurrection and ascension,
and all the other things which he did in the flesh and through
the flesh, you will not be able to penetrate the mysteries of the
old figures.

Chapter Seven: Concerning Order of Narration

Concerning order of narration it ought especially to be re-
marked in this place that the text of the Divine Page keeps

neither to a natural nor to a continuous order of speech, both because it often places later things before early ones—for instance, after it has listed a number of items, suddenly the line of discourse turns back to previous ones, as if narrating subsequent ones; and because it often connects even things which are separated from each other by an interval of time, as if one followed right on the heels of the other, so that it seems as if no lapse of time stood between those events which are set apart by no pause in the discourse.

Chapter Eight: Concerning the Order of Exposition

Exposition includes three things: the letter, the sense, and the deeper meaning (*sententia*). The letter is found in every discourse, for the very sounds are letters; but sense and a deeper meaning are not found together in every discourse. Some discourses contain only the letter and sense, some only the letter and a deeper meaning, some all these three together. But every discourse ought to contain at least two. That discourse in which something is so clearly signified by the mere telling that nothing else is left to be supplied for its understanding contains only letter and sense. But that discourse in which the hearer can conceive nothing from the mere telling unless an exposition is added thereto contains only the letter and a deeper meaning in which, on the one hand, something is plainly signified and, on the other, something else is left which must be supplied for its understanding and which is made clear by exposition.

Chapter Nine: Concerning the Letter

Sometimes the letter is perfect, when, in order to signify what is said, nothing more than what has been set down needs to be added or taken away—as, "All wisdom is from the Lord God";[39] sometimes it is compressed, when something is left which must be supplied—as, "The Ancient to the lady Elect";[40] sometimes it is in excess, when, either in order to inculcate an idea or because of a long parenthetical remark, the same thought is repeated or another and unnecessary one is added, as Paul, at the end of his Epistle to the Romans, says: "Now to him..."

and then, after many parenthetical remarks, concludes, "to whom is honor and glory."[41] The other part of this passage seems to be in excess. I say "in excess," that is, not necessary for making the particular statement. Sometimes the literal text is such that unless it is stated in another form it seems to mean nothing or not to fit, as in the following: "The Lord, in heaven the throne of him,"[42] that is, "the throne of the Lord in heaven"; "the sons of men, the teeth of those are weapons and arrows,"[43] that is, "the teeth of the sons of men"; and "man, like grass the days of him,"[44] that is, "man's days": in these examples the nominative case of the noun and the genitive case of the pronoun are put for a single genitive of the noun; and there are many other things which are similar. To the letter belong construction and continuity.

Chapter Ten: Concerning the Sense

Some sense is fitting, other unfitting. Of unfitting sense, some is incredible, some impossible, some absurd, some false. You find many things of this kind in the Scriptures, like the following: "They have devoured Jacob."[45] And the following: "Under whom they stoop that bear up the world."[46] And the following: "My soul hath chosen hanging."[47] And there are many others.

There are certain places in Divine Scripture in which, although there is a clear meaning to the words, there nevertheless seems to be no sense, either because of an unaccustomed manner of expression or because of some circumstance which impedes the understanding of the reader, as is the case, for example, in that passage in which Isaias says: "In that day seven women shall take hold of one man, saying: We will eat our own bread, and wear our own apparel: only let us be called by thy name. Take away our reproach."[48] The words are plain and open. You understand well enough, "Seven women shall take hold of one man." You understand, "We will eat our own bread." You understand, "We will wear our own apparel." You understand, "Only let us be called by thy name." You understand, "Take away our reproach." But possibly you cannot understand what the sense of the whole thing together is. You

do not know what the Prophet wanted to say, whether he promised good or threatened evil. For this reason it comes about that you think the passage, whose literal sense you do not see, has to be understood spiritually only. Therefore, you say that the seven women are the seven gifts of the Holy Spirit, and that these take hold of one man, that is, Christ, in whom it pleased all fulness of grace to dwell because he alone received these gifts without measure; and that he alone takes away their reproach so that they may find someone with whom to rest, because no one else alive asked for the gifts of the Holy Spirit.

See now, you have given a spiritual interpretation, and what the passage may mean to say literally you do not understand. But the Prophet could also mean something literal by these words.[49] For, since he had spoken above about the slaughter of the transgressing people, he now adds that so great would be the destruction of that same people and to such an extent were their men to be wiped out that seven women will hardly find one husband, for only one woman usually has one man; and, while now women are usually sought after by men, then, in contrary fashion, women will seek after men; and, so that one man may not hesitate to marry seven women at the same time, since he might not have the wherewithal to feed and clothe them, they say to him: "We will eat our own bread, and wear our own apparel." It will not be necessary for you to be concerned about our well-being, "only let us be called by thy name," so that you may be called our husband and *be* our husband so that we may not be heralded as rejected women, and die sterile, without children—which at that time was a great disgrace. And that is why they say, "Take away our reproach."

You find many things of this sort in the Scriptures, and especially in the Old Testament—things said according to the idiom of that language and which, although they are clear in that tongue, seem to mean nothing in our own.

Chapter Eleven: Concerning the Deeper Meaning

The divine deeper meaning can never be absurd, never false. Although in the sense, as has been said, many things are found to disagree, the deeper meaning admits no contradiction, is

always harmonious, always true. Sometimes there is a single deeper meaning for a single expression; sometimes there are several deeper meanings for a single expression; sometimes there is a single deeper meaning for several expressions; sometimes there are several deeper meanings for several expressions. "When, therefore, we read the Divine Books, in such a great multitude of true concepts elicited from a few words and fortified by the sound rule of the catholic faith, let us prefer above all what it seems certain that the man we are reading thought. But if this is not evident, let us certainly prefer what the circumstances of the writing do not disallow and what is consonant with sound faith. But if even the circumstances of the writing cannot be explored and examined, let us at least prefer only what sound faith prescribes. For it is one thing not to see what the writer himself thought, another to stray from the rule of piety. If both these things are avoided, the harvest of the reader is a perfect one. But if both cannot be avoided, then, even though the will of the writer may be doubtful, it is not useless to have elicited a deeper meaning consonant with sound faith."[50] "So too, if, regarding matters which are obscure and farthest removed from our comprehension, we read some of the Divine Writings and find them susceptible, in sound faith, to many different meanings, let us not plunge ourselves into headlong assertion of any one of these meanings, so that if the truth is perhaps more carefully opened up and destroys that meaning, we are overthrown; for so we should be battling not for the thought of the Divine Scriptures but for our own thought, and this in such a way that we wished the thought of the Scriptures to be identical with our own, whereas we ought rather to wish our thought identical with that of the Scriptures."[51]

Chapter Twelve: Concerning the Method of Expounding a Text[52]

The method of expounding a text consists of analysis. Analysis takes place through separating into parts or through examination. We analyze through separation into parts when we distinguish from one another things which are mingled together. We analyze by examination when we open up things which are hidden.

Chapter Thirteen: That We Are Not Here Going to Speak of Meditation[53]

And now those things which pertain to reading have been explained as lucidly and briefly as we know how. But as for the remaining part of learning, namely meditation, I omit saying anything about it in the present work because so great a matter requires a special treatise, and it is more worthy to be altogether silent about a matter of this sort than to say anything about it imperfectly. For it is a thing truly subtle and at the same time delightful, one which both educates beginners and exercises the perfect, one which has not yet been treated in writing and which therefore deserves all the more to be followed up.

Now therefore, let us ask Wisdom that it may deign to shine in our hearts and to cast light upon its paths for us, that it may bring us "to its pure and fleshless feast."[54]

APPENDICES

Appendices A and B represent authentic additions made by Hugh to the text of the *Didascalicon* (see Buttimer, pp. xv–xvi). They appear in a small but superior class of manuscripts and were perhaps intended for more perfect integration into the text in a subsequent edition. Because chapter xiii of Book vi was clearly meant to stand as the conclusion of the *Didascalicon*, these two chapters are placed in an appendix, even though Buttimer treats them as chapters xiv and xv of Book vi.

Appendix C, equally authentic, occupies an even more obviously inappropriate place in most manuscripts of the delta family, which, as if it were an introduction to the entire work, prefix it to the *Didascalicon's* true preface, (see Buttimer, pp. xvi and xxxi). It may have been intended for insertion after chapter vi of Book i, since it clarifies certain obscurities in that chapter (see, e.g., i, vi. n. 42 on *ousiai*; appendix C makes clear where, if not in the divine Mind as John the Scot had held, the *ousiai* exist—namely, in the angelic intellect). Because Hugh's intention regarding it is not certain, however, it is here placed in an appendix, following Buttimer.

Appendix A: Division of the Contents of Philosophy (Buttimer, vi. xiv)

Consider these three: wisdom, virtue, and need. Wisdom is the understanding of things as they are.[1] "Virtue is a habit of the mind—a habit adapted to the reason like a nature."[2] A need is something without which we cannot live, but [with which, i.e., when supplied] we would live more happily. The following three are remedies against three evils to which human life is subject: wisdom against ignorance, virtue against vice, and needs against life's weakness. In order to do away with the three evils, we seek after the three remedies, and in order to find the three remedies, every art and every discipline was discovered.[3]

For the sake of wisdom the theoretical arts were discovered; for the sake of virtue the practical arts were discovered; for the sake of our needs the mechanical arts were discovered. These three were first in practice, but afterwards, for the sake of

eloquence, logic was discovered. Logic, though last to be discovered, ought to be the first learned. Four, then, are the principal sciences, from which all the others descend; these are the theoretical, the practical, the mechanical, and the logical.

The theoretical is divided into theology, physics, and mathematics. Theology treats of invisible substances, physics of the invisible causes of visible things, mathematics of the visible forms of visible things. And this mathematics is divided into four sciences. The first is arithmetic, which treats of number, that is, of discrete quantity in itself. The second is music, which treats of proportion, that is, of discrete quantity in relation to something else. The third is geometry, which treats of space, that is, of immobile continuous quantity. The fourth is astronomy, which treats of motion, that is, of mobile continuous quantity. The element of arithmetic is the number "one." The element of music is the single tone. The element of geometry is the point. The element of astronomy is the moment of time.

The practical is divided into solitary, private, and public. The solitary teaches how each man can found his own life upon upright habits and furnish it out with virtues. The private teaches how to regulate one's domestics and those bound to one by ties of flesh. The public teaches how a whole people and nation ought to be governed by their rulers. The solitary pertains to individuals, the private to the heads of families, and the public to the governors of states.

The mechanical treats of the manual occupations of men and is divided into seven arts. The first is fabric making, the second armament, the third commerce, the fourth agriculture, the fifth hunting, the sixth medicine, and the seventh theatrics.

The logical is divided into grammar and the theory of argument. The theory of argument is divided into probable argument, necessary argument, and sophistical argument. Probable argument is divided into dialectic and rhetoric. Necessary argument belongs to philosophers, sophistical to sophists.

In these four parts of philosophy such order ought to be preserved in learning as will place logic first, ethics second, the theoretical arts third, and the mechanical arts fourth. For eloquence ought to be attained first; then, as Socrates says in the

Ethics, the eye of the heart must be cleansed by the study of virtue, so that it may thereafter see clearly for the investigation of truth in the theoretical arts. Last of all, the mechanical arts follow, which, by themselves, are altogether ineffective unless supported by knowledge of the foregoing.

Appendix B: Concerning Magic and Its Parts (Buttimer, VI. xv)[1]

The first discoverer of magic is believed to have been Zoroaster, king of the Bactrians, whom some say is none other than Cham the son of Noah with his name changed. He was afterwards killed by Ninus, king of the Assyrians, who had conquered him in war and who also caused his books, filled with the arts of evil-doing, to be destroyed by fire. Aristotle writes of this man that his books had preserved for the remembrance of posterity as many as two million two hundred thousand verses on the art of magic, dictated by himself. Subsequently, Democritus elaborated this art at the time when Hippocrates was enjoying fame in his practice of medicine.

Magic is not accepted as a part of philosophy, but stands with a false claim outside it: the mistress of every form of iniquity and malice, lying about the truth and truly infecting men's minds, it seduces them from divine religion, prompts them to the cult of demons, fosters corruption of morals, and impels the minds of its devotees to every wicked and criminal indulgence. As generally received, it embraces five kinds of sorcery: *mantiké*—which means divination, vain mathematics, fortunetelling, enchantments, and illusions. *Mantiké*, moreover, contains five sub-species, of which the first is necromancy, which means divination by means of the dead; for "*necros*" in Greek means "dead," and "necromancy" is derived from it. Divination in this case is achieved through the sacrifice of human blood, for which the demons thirst and in which they delight when it is spilled. The second is geomancy, or divination by means of earth; the third, hydromancy, or divination by means of water; the fourth, aeromancy, is divination by means of air; and the fifth is divination by fire, which is called pyromancy. For Varro declared that four were the elements in which divination consisted—earth, water, fire, and air. The

first, therefore, namely necromancy, would seem to belong to hell—the second to earth, the third to water, the fourth to air, and the fifth to fire.

[False] mathematics is divided into three types: soothsaying, augury, and horoscopy. *Aruspices* (soothsayers) are so called as being *horuspices*, that is, inspectors of times (*horarum inspectores*), who observe the times in which things should be done; or they are called *aruspices* as being examiners of altars (*aras inspicientes*), who observe the future from the entrails and viscera of sacrificial animals. Augury, or *auspicium*, sometimes pertains to the eye, and is called *auspicium* as being *avispicium* (the watching of birds) because it concerns itself with the movement and flight of birds; sometimes it pertains to the ears, and then it is called *augurium* for *garritus avium* (the chattering of birds), which is heard by ear. Horoscopy, which is also called constellation, consists in seeking the fates of men in the stars, as do the *genethliaci*, who observe births and were once especially called *magi*, of whom we read in the Gospel.

Fortunetellers are those who seek divinations by lots. Sorcerers are those who, with demonic incantations or amulets or any other execrable types of remedies, by the cooperation of devils and by evil instinct, perform wicked things. Performers of illusions are those who with their demonic art make sport of human senses through imaginative illusions about one thing's being turned into another.

All in all, therefore, there are eleven parts of magic: under *mantiké*, five—necromancy, geomancy, hydromancy, aeromancy, and pyromancy; under [false] mathematics, three—soothsaying, augury, and horoscopy; then there are three others—fortune-telling, sorcery, and performing illusions.

Mercury is reported the first discoverer of illusions; the Phrygians discovered auguries; Tages first gave soothsaying to the Etruscans; hydromancy first came from the Persians.

Appendix C: Concerning the Three Subsistences of Things (Buttimer, pp. 134–5)

Things are able to subsist in three ways: in actuality, in the intellect, in the divine Mind—that is, in the divine Idea, in man's

idea, and in themselves. In themselves they pass away without subsistence; in the intellect of man they subsist, to be sure, but are not immutable; in the divine Mind they subsist without change. Likewise, what exists in actuality is an image of what exists in the mind of man, and what exists in the mind of man is an image of what exists in the divine Mind. The rational creature was made according to the divine Mind; the visible creature was made according to the rational creature. Therefore, the whole movement and orientation of the rational creature ought to be toward the divine Mind, just as the whole movement and orientation of the visible creature is toward the rational creature.[1]

Just as a man, when he has conceived something in his mind, draws an example of it externally, so that what was known only to him may be seen plainly by others, and afterwards, to make it still more evident, explains in words how the thing drawn as an example matches his idea of it; so, too, God, wishing to show his invisible Wisdom, drew its example in the mind of the rational creature, and next, by making the corporeal creature, showed the rational creature an external example of what it itself contained within.[2] Thus, the rational creature was made in first place and in the likeness of the divine Idea, with nothing mediating between them. The corporeal creature, however, was made in the likeness of the divine Idea through the mediation of the rational creature.[3]

For this reason, the book of Genesis, speaking of the angels under the appellation "light," says: "God said: Let there be light. And the light came to be."[4] Concerning all the other works of God, however, it says: "God said: Let it be. And it was so"—and then it adds, "And God made it."[5] For the angelic nature first existed in the divine Idea as a plan, and then afterwards it began to subsist in itself through creation. The other creatures, however, first existed in the Idea of God; next, they were made in the knowledge of the angels; and finally they began to subsist in themselves. When, therefore, Genesis says, "God said: Let it be," this refers to the divine Mind. When it says, "And it was so," this refers to the angelic intellect. And when it says, "And God made," it refers to the actuality of things.[6]

ABBREVIATIONS

AHDL *Archives d'histoire doctrinale et littéraire du moyen âge*
BGPM *Beiträge zur Geschichte der Philosophie des Mittelalters*
CM *Classica et mediaevalia*
CP *Classical Philology*
CSEL *Corpus scriptorum ecclesiasticorum latinorum*
DTC *Dictionnaire de théologie catholique*
ETL *Ephemerides theologicae lovanienses*
GCFI *Giornale critico della filosofia italiana*
JTS *Journal of Theological Studies*
MGH *Monumenta Germaniae historica*
MH *Mediaevalia et humanistica*
MP *Modern Philology*
MRS *Mediaeval and Renaissance Studies*
MS *Mediaeval Studies*
MSR *Mélanges de science religieuse*
NS *The New Scholasticism*
PL *Patrologiae cursus completus; series latina* (ed. J. P. Migne)
RB *Revue bénédictine*
RHE *Revue d'histoire ecclésiastique*
RMAL *Revue du moyen âge latin*
RSPT *Revue des sciences philosophiques et théologiques*
RSR *Recherches de science religieuse*
RTAM *Recherches de théologie ancienne et médiévale*
Schol. *Scholastik*
Scrip. *Scriptorium*
SE *Sacris erudiri*
Spec. *Speculum*
ST *Studi e testi*
Trad. *Traditio*

NOTES

INTRODUCTION

1. The *Didascalicon* can be dated only with reference to Hugh's *De sacramentis christianae fidei*, of the structure of which it contains a preliminary sketch (see *Didascalicon* VI. iv). The *De sacramentis*, begun after February, 1130 (see Roger Baron, *Science et sagesse chez Hugues de Saint-Victor* [Paris: P. Lethielleux, 1957], p. XLV) was brought to practical completion sometime in 1133 (cf. Jos. de Ghellinck, *Mouvement théologique du XIIe siècle* [Bruges: Editions "de Tempel" 1948], pp. 189–90, esp. p. 189, n. 6; p. 193, n. 5). A date in the late 1120's is thus possible for the *Didascalicon*. A much earlier date seems unlikely. Hugh did not arrive at Saint Victor until 1115–18. He would not have begun teaching at once. By the time he composed the *Didascalicon*, however, it is probable that he had been teaching some time and had written his *De grammatica*, *Practica geometriae*, possibly a lost *De astronomia*, the *De ponderibus*, the *Epitome Dindimi in philosophiam*, the *De scripturis et scriptoribus sacris*, and the *De sacramentis legis naturalis et scriptae dialogus*, which last Baron (*Science et sagesse*, p. XLVI) ranks among Hugh's earliest productions. By 1127 Hugh was clearly a person of importance in the Abbey, for his name appears after those of Abbot Gilduin and Prior Thomas in a charter of this date (Jean de Toulouse, *Annales*, Bibliothèque Nationale, MS Latin 14368, anno 1127; cf. Fourier Bonnard, *Histoire de l'abbaye royale et de l'ordre des chanoines réguliers de St-Victor de Paris* [2 vols.; Paris: Arthur Savaète, n.d.], I, 89, n. 1). This is a fair date to suggest for the *Didascalicon*.

2. The school, at least during Hugh's lifetime, remained public. See Bernhard Bischoff, "Aus der Schule Hugos von St. Viktor," *Aus der Geisteswelt des Mittelalters*, ed., Albert Lang, Joseph Lechner, and Michael Schmaus, *BGPM*, Supplementband III, Halfband I (Münster, 1935), pp. 246–50. Abaelard is witness to its public character under William of Champeaux, who founded the community in 1108; see *Historia calamitatum mearum*, J. T. Muckle, ed. *MS*, XII (1950), 177–78.

3. Treatments of various aspects of the early didascalic tradition will be found in Werner Jaeger, *Paideia: the Ideals of Greek Culture*, tr. Gilbert Highet (Oxford: Basil Blackwell, 1939); Henri-Irénée Marrou, *Histoire de l'éducation dans l'antiquité* (Paris: Editions du Seuil, 1948); Aubrey Gwynn, *Roman Education from Cicero to Quintilian* (Oxford: Clarendon Press, 1926); H.-I. Marrou, *Saint Augustin et la fin de la culture antique* (Paris: E. de Boccard, 1949); and Pierre Courcelle, *Les Lettres grecques en occident de Macrobe à Cassiodore* (Paris: E. de Boccard, 1948). For the later didascalic tradition, see refs. listed in n. 6–10.

4. See Charles Henry Buttimer, ed., *Hugonis de Sancto Victore Didascalicon*

de studio legendi: a Critical Text ("Studies in Medieval and Renaissance Latin," X; Washington, D. C.: Catholic University of America Press, 1939), pp. xv-xliii. A few additional manuscripts are noted by Buttimer's reviewers; see *Bibliothèque de l'Ecole des chartes* CIII (1942), 236; and *Etudes classiques*, VIII (1939), 432-33.

5. See G. Paré, A. Brunet, P. Tremblay, *La Renaissance du XIIe siècle: les écoles et l'enseignement* (Paris: Librairie philosophique J. Vrin, 1933), ch. i, pp. 17-55. On secularist adaptations of learning, see further M.-D. Chenu, "L'Homme et la nature: perspectives sur la renaissance du XIIe siècle," *AHDL*, XIX (1952), 39-66; reprinted with alterations in M.-D. Chenu, *La Théologie au XIIe siècle* (Paris: Librairie philosophique J. Vrin, 1957), pp. 19-51.

6. Ludwig Baur has done this for the work of Gundissalinus. See his *Dominicus Gundissalinus: De divisione philosophiae*, *BGPM*, IV (Münster, 1906), 164-316; broad sketch of the transmission of didascalic materials from hellenistic through late scholastic writers (pp. 316-97); Hugh of St. Victor discussed (pp. 358-63).

7. See, for example, Jos. Mariétan, *Le Problème de la classification des sciences d'Aristote à Saint-Thomas* (Paris: Félix Alcan, 1901) and Martin Grabmann, *Die Geschichte der scholastischen Methode*, II (Freiburg im Breisgau: Herder'sche Verlagshandlung, 1911; reprinted, Graz: Akademische Druck- und Verlagsanstalt, 1957), 28-54, 235-49.

8. See de Ghellinck, *Mouvement théologique* and Beryl Smalley, *The Study of the Bible in the Middle Ages* (New York: Philosophical Library, 1952), pp. 1-111.

9. See Paré, Brunet, Tremblay, *Renaissance du XIIe siècle*, pp. 94-137, 213-39, and O. Schmidt, *Hugo von St. Victor als Pädagog* (Meissen, 1893).

10. Richard P. McKeon has written this kind of history for rhetoric, "Rhetoric in the Middle Ages," *Spec.*, XVII (1942), 1-32; for dialectic, "Dialectic and Political Thought and Action," *Ethics*, LXV (1954-55), esp. pp. 3-16; and for poetic, "Poetry and Philosophy in the Twelfth Century: the Renaissance of Rhetoric," *MP*, XLIII (1945-46), 217-34. The first and last of these are reprinted with some alterations in R. S. Crane, ed., *Critics and Criticism, Ancient and Modern* (Chicago: University of Chicago Press, 1952), pp. 260-96 and 297-318.

11. Thus Ludwig Baur, noting the rise to prominence of the Aristotelian schematization of knowledge in the twelfth century, names only Hugh, Richard of St. Victor, Gundissalinus, and Michael Scot as its proponents, and, regarding the latter two as directly inspired by Arabic sources, treats principally Hugh, and very briefly Richard, as springing from the Latin encyclopedic tradition; see Baur, *Gundissalinus*, pp. 358 ff.

12. Notably by Grabmann, who, dating Radulfus Ardens a century too early and hence regarding his four-part division of the arts in the *Speculum universale* as antecedent to Hugh, denies, but on false grounds, Baur's implication that Hugh was the first proponent of this division (Grabmann, *Geschichte der scholastischen Methode*, I, 252); at the same time he adduces the schematization of knowledge found in Bamberg MS Q.VI.30 as further

evidence that the fourfold division of the arts "findet sich nicht allein bei Hugo von St. Viktor" (Vol. II, p. 238), not recognizing that the Bamberg classification represents a conflation, not without its crudities, of the divergent schemas of William of Conches and Hugh. Max Manitius apparently follows Grabmann in speaking of Hugh's fourfold division "wie bei Radulfus Ardens" (*Geschichte der lateinischen Literatur des Mittelalters*, II [München, 1931], 114).

13. Thus Mariétan praises Hugh's classification because, since Aristotle, "aucun auteur n'était entré dans autant et de si minutieux détails. Il offre même sur ce point plus de renseignements que le Philosophe de Stagire" (*Problème de la classification*, p. 131); at the same time, he reserves to Thomas "une solution qui éclaircit tous les doutes constatés, soit chez Aristote soit chez les écrivains des âges suivants" (p. 176) and observes that Thomas "donne à ce problème la solution la plus logique et la plus parfaite qu'il ait reçue" (p. 194). So, too, A. Mignon, *Les Origines de la scolastique et Hugues de Saint-Victor*, I (Paris, 1896), 65–66, places Hugh in the "true" stream of scholastic philosophy on the ground that he distinguishes clearly between philosophy and theology as to object and method—so clearly that "la distinction des deux ordres de science est établie dans ses traités aussi nettement qu'elle le sera plus tard dans les ouvrages du docteur angélique."

14. See Paré, Brunet, Tremblay, *Renaissance du XIIe siècle*, pp. 100–1. The three causes are apparently taken over from Baur, *Gundissalinus*, pp. 357–58, who, however, advances them not to explain Hugh but the Aristotelianism of the twelfth century at large.

15. Paré, Brunet, Tremblay, *Renaissance du XIIe siècle*, pp. 97 ff. for general bracketing of Thierry and Hugh; pp. 169–73 for comparison of Hugh and John of Salisbury; pp. 173–210 for discussion of twelfth-century "humanists," utilitarians, scientists, etc.

16. Thus, Tullio Gregory, in the latest work to appear on William of Conches (*Anima mundi: la filosofia di Guglielmo di Conches e la scuola di Chartres* [Publicazioni dell'Università di Roma, III; Florence: Sansoni, 1955])—though he discusses in detail (pp. 29–40) the relative contributions of William and Hugh to the *brano* published by Ottaviano (Carmelo Ottaviano, ed., *Un brano inedito della "Philosophia" di Guglielmo di Conches* [Naples: Alberto Morano, 1935]; though he notes the different approaches of William and Hugh to *natura* (p. 181, n. 3) and their different views on the problem of initial chaos (pp. 197–98 and p. 198, n. 1); and though he notes the "angoli di vistà diversissimi" with which they approach *sermo* (p. 269) and the differences between their schematizations of knowledge (pp. 270–78)—nowhere does he bring these differences into relation with the form taken by the *Didascalicon*. The same failure is to be found in Heinrich Flatten, *Die Philosophie des Wilhelm von Conches* (Coblenz: Görres-Druckerei, 1929), pp. 20–32. Baron, *Science et sagesse*, makes only two references to William, and these most general (pp. 55 and 80). Admitting that "Hugues a parfaitement pris conscience de la nouveauté qu'il apportait par son tableau de la philosophie et que cette innovation devait se justifier" (p. 79), Baron

fails to make clear wherein precisely that novelty lay, or as against whom it required particular justification.

17. Smalley, *Study of the Bible*, p. 86.

18. Paré, Brunet, Tremblay, *Renaissance du XIIe siècle*, pp. 94–95.

19. Baron provides no help here. He observes that the "célèbre tableau [de la division de la philosophie] qu'en propose Hugues est au point d'aboutissement d'une longue évolution et ne prend toute sa signification que par l'exposé de la longue série d'essais qui l'ont précédé" (*Science et sagesse*, p. 38), but, while providing a sketch of this evolution (pp. 38–47), he does not make such contrasts between the *Didascalicon* and selected earlier works as might have thrown the distinctive quality of the *Disdascalicon* into sharp relief.

20. It is ascribed to the entire first book in the *Indiculum* of Hugh's works found in Merton MS 49 and drawn up for the Victorine edition of 1152. See Buttimer, p. xvii, and de Ghellinck, "La Table des matières de la première édition des oeuvres de Hugues de Saint-Victor," *RSR*, I (1910), 270–79. Titles ascribed to the first chapters of the remaining five books in the Buttimer edition also apply unmistakably to the whole books rather than to the chapters, although, to avoid confusing discrepancies with Buttimer, the present translation does not change the location of the titles. Hugh's demonstrative intention is expressed in the opening words of *Didascalicon* I.xi: "Having therefore demonstrated the origin of the theoretical, the practical, and the mechanical arts, we must investigate as well the derivation of the logical..." The reasoned derivation of the arts in *Didascalicon* I contrasts with their historical and human derivation treated briefly in *Didascalicon* III.ii, "Concerning the Authors of the Arts."

21. Ultimately underlying Hugh's scheme is Aristotle's division of the sciences into theoretical and practical, as in *Topics* VII.i and *Metaphysics* II.i, with a further productive subdivision specified in *Topics* VI.iii and VIII.ii, and *Metaphysics* VI.i, VI.ii, and XI.vii. Augustine mentions a twofold division of philosophy into action and contemplation (*De civitate Dei* VIII.iv), but only to assert its consistency with his preferred Platonic division (cf. *ibid.*, XI.xxv) and without associating it with Aristotle. Cassiodorus, more explicit, reports even the Greek names for the theoretical and practical sciences and the three subdivisions of each, but, making independent use of the Greek source common to him and Boethius (Ammonius of Alexandria's commentary on Porphyry's *Isagoge*), invents a Latin terminology which, unlike that of Boethius, does not come into general use (see Courcelle, *Lettres grecques*, pp. 323–25). It is Boethius who transmits the distinction to the medieval West, not only through the π and θ described as woven into the garment of Philosophia in the *De consolatione philosophiae* I. pr. i, and consistently associated with *practica* and *theoretica* by commentators, but more explicitly in the schema of the theoretical and practical sciences introduced into his first commentary on the *Isagoge* (entitled *In Porphyrium dialogi duo* in *PL*, XLIV, 11A f.; cf. *CSEL*, XLVIII, 8–9) and of the theoretical sciences in his *De trinitate* ii. Authority for the addition of the logical arts is found in his second commentary which, resolving the noncommital reserve of the first,

recognizes logic as both instrument and part of philosophy (second commentary, entitled *Commentaria in Porphyrium a se translatum*, in *PL*, XLIV, 71–158; see *ibid.*, 73B–75A; cf. *CSEL*, XLVIII, 138–143). A certain basis, though not the direct inspiration, for the addition of the mechanical arts exists in Boethius's translation of Aristotle's *Topics*, esp. vi.iii, and viii, ii (*PL*, XLIV, 978B and 996B), where, however, Aristotle's productive category is called *effectiva*. Hugh's term *mechanica* derives from late Carolingian masters, whose peculiar etymology for it he adopts (see *Didascalicon* i.ix). The mechanical arts are mentioned, but under different names and without being considered parts of philosophy, by the Latin *Asclepius* i.iii (A. D. Nock, ed. *Corpus Hermeticum*, II [Paris, 1945], 306); Augustine *De doctrina christiana* ii.xxx. 47 and ii.xxxix. 58 (*PL*, XXXIV, 57 and 62); Chalcidius, commentary on the *Timaeus* (Johannes Wrobel, ed. *Platonis Timaeus interprete Chalcidio cum eiusdem commentario* [Leipzig: B. G. Teubner, 1876]; or F. Mullach, ed., *Fragmenta philosophorum graecorum*, II [Paris: Firmin-Didot, n.d.], 237); Cassiodorus *Inst.* i.xxviii. 5–7 (R. A. B. Mynors, ed., *Cassiodori Senatoris institutiones* [Oxford: Clarendon Press, 1937], pp. 71–72; or Leslie Webber Jones, tr. *An Introduction to Divine and Human Readings by Cassiodorus Senator* [New York: Columbia University Press, 1946], pp. 129–31); and Isidore of Seville *Etymologiae* ii.xxiv. 3–16. Rhabanus groups *mechanica* with the quadrivium and medicine as comprising the Platonic *physica*, and he limits *mechanica* to "peritia fabricae artis et in metallis et in lignis et lapidibus" (*De universo* xv.i; (*PL*, CXI, 413C). Gerbert defends the twofold Aristotelian division as "the division of Vitruvius and Boethius" against proponents of the Platonic scheme in a debate before the emperor (see Richer *Historiarum libri* iii.lvii–lxv; *PL*, CXXXVIII, 106–9). The Platonic division is followed by Bede, Alcuin, Rhabanus, and John the Scot.

22. "Alter Augustinus," "secundus Augustinus," "lingua Augustini," "anima Augustini": reported as epithets given Hugh by his contemporaries. See *PL*, CLXXV, cxxxviiiA and clxviiiA-B. Cf. de Ghellinck, *Mouvement théologique*, p. 185, n. 2.

23. On 1127 as the probable date of the *Didascalicon*'s composition, see n. 1. It is true that no division of philosophy appears in the commentary on the *Timaeus* found by Schmid at Uppsala and alleged by him to be a copy of William's earlier version of this work (see Toni Schmid, "Ein Timaioskommentar in Sigtuna," *CM*, X [1949], 220–26), but Schmid's attribution of the work to William has been questioned by Edouard Jeauneau, "L'Usage de la notion d'*integumentum* à travers les gloses de Guillaume de Conches," *AHDL*, XXIV (1957), 35–100. The schema does appear in the version of William's commentary on the *Timaeus* printed in *PL*, CLXXII, 246 ff. On evidence for two versions of William's commentary on the *Timaeus*, see Gregory, *Anima mundi*, pp. 12 ff., and J. M. Parent, *La Doctrine de la création dans l'école de Chartres* (Paris: Librairie philosophique J. Vrin, 1938), p. 120. William's glosses on the *De consolatione philosophiae* are excerpted in Charles Jourdain, "Des commentaires inédits de Guillaume de Conches et de Nicolas Triveth sur 'La Consolation de la philosophie' de Boèce," *Notices et extraits des manuscrits de la Bibliothèque Impériale*, XX (1862), 40–82, and in the

same author's *Excursions historiques et philosophiques à travers le moyen-âge* (Paris, 1888), pp. 31–68.

24. Baur, *Gundissalinus*, pp. 358–59. Of Gundissalinus, by contrast, Baur notes that his material is "durch lose und sehr äusserliche Übergänze hergestellt" (*ibid.*, p. 164).

25. See *Didascalicon* I.vii, *ad fin.*

26. *Ibid.*, I.ii, n. 21.

27. *Ibid.*, n. 22.

28. *Ibid.*, I.iii, n. 24.

29. *Ibid.*, I.xi, n. 75.

30. *Ibid.*, I.ii. Augustinian view underlying the Boethian passage quoted by Hugh is cited, *ibid.*, n. 21.

31. *Ibid.*, I.i, *ad fin.* With Hugh's adaptation of the Platonic doctrine of reminiscence here and in the passage from the *Epitome* (see n. 33), cf. William of Conches' claim that both Plato and Boethius, far from teaching the pre-existence of souls, which would be heresy, speak *per integumenta* on this subject: "Certain persons wish to condemn Plato and his follower, Boethius, and foist upon Plato the doctrine that souls, before coming into bodies, knew all things, but, upon being joined to flesh, forgot all things and recovered them afterwards through study.... Such persons do not know Plato's mode of speaking, for in philosophy he speaks in parables (*per integumenta*)." William's dispute with an unidentified contemporary on the Platonic doctrine of reminiscence suggests a possible motive for Hugh's adaptive allusions to it. Texts and discussion of the dispute in Pierre Courcelle, "Etude critique sur les commentaires de la *Consolation* de Boèce (IX–XVe siècles)," *AHDL*, XII (1939), 87–9. Cf. Hugh's view, borrowed verbatim from Boethius, of the degeneration of intellectible substance upon its descent to the physical world, *Didascalicon* II.iii.

32. See *Didascalicon* II.i.

33. Roger Baron, ed., "Hugonis de Sancto Victore *Epitome Dindimi in philosophiam*: introduction, texte critique, et notes," *Trad.*, XI (1955), 109–10. That Hugh may have intended to incorporate in the *Didascalicon* a schematized account of the origin of the four parts of philosophy, resembling that in the *Epitome*, is suggested by my Appendix A. Richard of St. Victor incorporates such a schematic account in his condensation of the *Didascalicon* in the *Excerptiones priores*; so, too, does the revision of William of Conches' *Philosophia mundi* (refs. cited, Appendix A, n. 3). Cf. *De arca Noe morali*, Prologus (*PL*, CLXXVI, 619), where, in a more familiar doctrinal formulation of the Fall, Hugh teaches that the radical good lost by the first man was a cognitive one. Man had *known* his Creator. From that knowledge had come love, from love adherence, from adherence physical immortality. When the knowledge was lost, the goods dependent on it deteriorated. Love, adherence, immortality, and physical well-being were lost as well. Comparable analysis of the Fall in *In Ecclesiasten homiliae* (*PL*, CLXXIV, 227D–228B).

34. Augustine wrote four separate commentaries on it: Books XI–XIII of the *Confessiones*, the *De Genesi liber imperfectus*, the lengthy *De Genesi secundum litteram*, and the *De Genesi contra Manichaeos*.

35. Chenu argues that the great twelfth-century problem was not merely, as has been said, the relation between faith and reason, but more broadly, the relation between nature and the divine, nature and grace. For detailed discussion and documentation of this thesis, see Chenu, "L'Homme et la nature," *AHDL*, XIX (1952), 39–66; *Théologie au XIIe siècle*, pp. 19–51; and "Moines, clercs et laïcs au carrefour de la vie évangélique (XIIe siècle)," *RHE*, XLIX (1954), 59 ff.

36. For William's and Hugh's exchange of views on this point, see Appendix C, n. 3. Similar difference between William and Hugh on the creation of Eve; cf. *De philosophia mundi* 1.xxiii (*PL*, CLXXII, 56A–B) and *De sacramentis* i.vi. 35–37 (*PL*, CLXXVI, 284C–88A; Roy J. Deferrari, tr. *Hugh of Saint Victor On the Sacraments of the Christian Faith* [Publication No. 58 of The Mediaeval Academy of America; Cambridge, Mass.: The Mediaeval Academy of America, 1951], pp. 117–20). On the unformed condition of the rational creature and the source of its acquired form, see *Didascalicon* I.ii, n. 21.

37. See Dionysius Lasić, *Hugonis de S. Victore theologia perfectiva: eius fundamentum philosophicum ac theologicum* (Romae: Pontificium Athenaeum Antonianum, 1956), pp. 8 ff.

38. See *Didascalicon* I.x. n. 69, where texts in the complicated history and varied twelfth-century use of this conception are cited in connection with Hugh's first definition of *natura*.

39. The *De sapientia animae Christi* (*PL*, CLXXVI, 845–56), though written in response to a question put by Walter of Mortagne, suggests by the very length and detail of the answer, the importance Hugh attached to the point. For Augustine's treatment, see esp. *De libero arbitrio* II.ix ("Quid sapientia sine qua nemo beatus; an una sit in omnibus sapientibus"), x ("Una est sapientiae lux omnibus sapientibus communis"), xii ("Una et incommutabilis in omnibus intelligentibus veritas, eaque nostra mente superior"), and xiii ("Exhortatio ad amplexum veritatis quae una beatos fecit"); *PL*, XXXII, 1253–1263. See, further, *Didascalicon*, I.i. n. 1, 2.

40. See *Didascalicon* I.vi. n. 42, with explanation and texts cited.

41. For ref., see *Didascalicon* I.i. n. 5, *ad fin*. Cf. texts cited in connection with Hugh's first definition of "natura" (I.x. n. 69); note particularly the passage from *De sacramentis* I.v. 3 quoted *in extenso* (I.vi. n. 42).

42. See *Didascalicon* I.i. n. 5. Discussion of the figure and of the general influence of pseudo-Dionysius on Hugh in Heinrich Weisweiler, "Sakrament als Symbol und Teilhabe: Der Einfluss des Pseudo-Dionysius auf die allgemeine Sakramentlehre Hugos von Sankt-Viktor, "*Schol.*, XXVII (1952), 321–43. The late date of Hugh's commentary on the *Celestial Hierarchy* makes it uncertain what influence the latter might have exercised on the *Didascalicon* by, for example, the celebrated definition of "hierarchy" ("a divine order, both knowledge and action, conforming as far as possible to the Form of God and rising toward likeness to God in direct proportion to the illuminations divinely conferred upon it" [*PL*, CLXXV, 989–90]), of which Hugh observes (*ibid.*, 992B) that it applies only to angels and men. The concept of a hierarchy of participation in the divine ideas, however, is

suggested in Augustine *De diversis quaestionibus* i.xlvi, "De ideis" (*PL*, XL, 31), where the rational soul's participation in the divine ideas is said to surpass the participation of all the rest of created reality; cf. *Enarratio in Ps. CIII*, sermo iv.ii (*PL*, XXXVII, 1379): "Thus says the Lord: I do not exact participation in the divine Wisdom from creatures not made in my image; but of those so made, I do exact it"; *Confessiones* vii.ix: "by participation in that divine Wisdom which ever remains One in itself are souls renewed and made wise"; *De consensu evangelistarum* i.xxiii. 35 (*PL*, XXXIV, 1058): "we do not merely admit, we especially preach that highest Wisdom of God which, through participation in Itself, makes wise whatever soul becomes truly wise." In the last three texts, participation in the divine Wisdom as a whole is restricted to the rational soul; the rest of created reality participates in some pattern or idea within the divine Wisdom.

43. See Appendix A.

44. See *Didascalicon* ii.xviii.

45. See *Didascalicon* Preface, third paragraph.

46. See *Didascalicon* v.ix.

47. For John the Scot's view that religion and philosophy are convertible, see *De praedestinatione* i (*PL*, CXXII, 356–8) and *De divisione naturae* i.lxix (*PL*, CXXII, 513). Augustine's view in *De vera religione* v.viii (*PL*, XXXIV, 126) and *De ordine* ii.ix. 26 (*PL*, XXXII, 1007). With Augustine's statement (*ibid.*, ii.v. 14) that philosophy has "no other function than to teach what is the First Principle of all things, ...how great an Intellect dwells therein, and what has proceeded from it for our welfare," cf. Hugh's *Epitome* (Baron, ed., p. 107): "The end of all philosophy is apprehension of the highest Good, which lies in the Maker of things alone," and the opening sentence of *Didascalicon* i.i. On essential differences between Hugh and John the Scot, see *Didascalicon* i.i. n. 16; i.vi. n. 42; i.ii. n. 21.

48. Ref. to *Epitome* cited, *Didascalicon* i.ii. n. 19.

49. Baron, ed., pp. 114–15.

50. Reading *abiudicaverunt*, as in two of Baron's MSS, in place of his *adiudicaverunt*, which does not make sense; *ibid.*, p. 115.

51. *Ibid.*

52. Literally, "where they should admit," reading *ammiserint* in place of Baron's *amiserint*, which makes no sense.

53. *Ibid.*, p. 116.

54. *De philosophia mundi* i, Praefatio (*PL*, CLXXII, 41D ff.). The work appeared 1125–30, or about the same time as the *Didascalicon*.

55. *Metalogicon* i.vi; C. C. J. Webb ed., (Oxford: Clarendon Press, 1924), p. 21; Daniel D. McGarry (Berkeley: University of California Press, 1955), p. 25.

56. *Ibid.*, i.v (Webb, p. 19; McGarry, p. 23).

57. *Ibid.*, i.i (Webb, p. 7; McGarry, p. 11).

58. Jourdain, ed., "Commentaires inédits," p. 72.

59. Ottaviano, ed., *Un brano*, pp. 27, 28, 34. For summary of Hugh's position on the mechanical arts and a close paraphrase of *Didascalicon* i.viii, see Ottaviano, *Un brano*, p. 25.

60. *Epitome*, Baron, ed., p. 116.

61. See William's commentary on the *De consolatione philosophiae*, Jourdain, ed., "Commentaires inédits," pp. 72–3.

62. *De scripturis et scriptoribus sacris* i (*PL*, CLXXV, 9D).

63. *De arca Noe morali*, Prologus (*PL*, CLXXVI, 619).

64. Barthélemy Hauréau, *Histoire de la philosophie scolastique*, I (Paris, 1872), 424, and Ueberweg-Heinze, *Grundriss der Geschichte der Philosophie*, II (9th ed., 1905), 223. Cited in Baron, *Science et sagesse*, p. 7, n. 30; p. 11, n. 46.

65. See *Didascalicon* VI.iii.

66. See *Didascalicon* V.viii and vii; note his discussion of *occupatio* in the passage from *In Ecclesiasten homiliae* cited, *Didascalicon* V.vii. n. 28.

67. *Historia calamitatum*, Muckle, ed., pp. 191–2.

68. *In Ecclesiasten homiliae* (*PL*, CLXXVI, 152D).

69. *De philosophia mundi* I.xxiii (*PL*, CLXXII, 56B f.). The irritableness of William's words in this entire passage suggests caricature rather than a fair picture of his opponents' position, and it is not impossible to see Hugh of St. Victor as among those intended.

70. *De animae exsilio et patria* (*PL*, CLXXII, 1241–6).

71. Hans Willner, ed., *Des Adelard von Bath Traktat De eodem et diverso*, *BGPM*, IV (Münster, 1904), p. 16.

72. See *Didascalicon* I.i. n. 10, for documentation of the disputes. Despite the differences between Abaelard and the Chartrians in their approach to these materials, the former interpreting them *per involucrum*, the latter with a literalness related to their scientific purpose, Chenu notes of Abaelard that "sans qu'il soit, loin de là, le seul à user de ce parallélisme (cf. Guillaume de Conches et les Chartrains), il en est bien le patron au XIIe siècle" ("Involucrum: le mythe selon les théologiens médiévaux," *AHDL*. XXII [1955] 77); same view in Parent, *Doctrine de la création*, pp. 70 ff., esp. pp. 74–5

73. Frequently the subject of commentaries apart from the rest of the text (see Courcelle, "Etude critique," *AHDL*, XII [1939], pp. 119 ff.), the metre was recognized as a summary of the *Timaeus*, or even as a "summa totius philosophiae," according to one enthusiastic gloss reported by Courcelle (*ibid.*, p. 10, n. 4).

74. *Ibid.*, pp. 77–94.

75. See, e.g., *Didascalicon* I.vi. n. 34, 35, 38, 45; I.vii. n. 56; I.ix. n. 59; I.x. n. 69; II.i. n. 7; II.iii. n. 18; II.iv. n. 26, 27, 28; II.vi. n. 39; II.vii. n. 40, 41; II.xviii. n. 63.

76. Quoted in the final sentence of the *Didascalicon* VI.xiii.

77. For discussion and edition of the work, see Theodore Silverstein, ed., "Liber Hermetis Triplicis de VI rerum principiis," *AHDL*, XXII (1955), 217–302.

78. See *Didascalicon* I.vii. n. 53, 55; III.ii. n. 8.

79. For examples, see *Didascalicon* I.i. n. 1, 4, 8, 9, 10, 13, 17; I.iv. n. 25.

80. So Courcelle, "Etude critique," *AHDL*, XII (1939), p. 65.

81. So Parent, *Doctrine de la création*, p. 19.

82. His commentaries are on the Pentateuch, the Books of Kings, Ecclesiastes, the Lamentations of Jeremiah, the Magnificat, the Lord's

Prayer, the Ark of Noah, the *Celestial Hierarchy* of pseudo-Dionysius, and the rule of St. Augustine and occupy some 650 columns in the *PL*.

83. See *Didascalicon* III.iv. On the contrast between Hugh and the Chartrians on the use of poetry and literary prose in teaching the arts, see *ibid.*, n. 44; III.v. n. 48; II.xxix. n. 84.

84. See *Didascalicon* IV.i. Cf. Abaelard, for whom the author of the Latin *Asclepius* is "that most ancient of philosophers, great of name, Mercury, whom, on account of his excellence, men called a god" (*Theologia christiana* i.v [*PL*, CLXXVIII, 1141A]); Plato, "that greatest of philosophers" (*ibid.*, 1144A); and Macrobius, "himself no mean philosopher, and the expositor of the great philosopher Cicero" (*ibid.*, 1153C).

85. "...how many men of letters we now see who wish to be called Christians, who enter the church with the rest of the faithful, who there partake of the sacraments of Christ, yet in whose hearts the memory of Saturn and Jove, of Hercules and Mars, of Achilles and Hector, of Pollux and Castor, of Socrates and Plato and Aristotle is more often found than that of Christ and his saints! They love the frivolities of the poets, and they neglect or (what is worse) deride and contemn the truth of the Divine Scriptures. Let them now reflect what good it does them to enter the church exteriorly, while interiorly, in their hearts, they commit fornication far from the true faith. ...What good does it do to know the truth if one loves falsehood?" *De arca Noe morali* (*PL*, CLXXVI, 674B–C). On the mythological as well as cosmological lore found in the glosses of William of Conches, as in those of Remigius of Auxerre before him, see Jeauneau, "La Notion d'integumentum," *AHDL*, XXIV (1957), 35–100.

86. *In Ecclesiasten homiliae* (*PL*, CLXXV, 238A–B). The first opinion, that nature is self-caused and cyclically self-renewing, is reported in Augustine *De civ. Dei* XII.xiii; cf. the account of the pre-Socratics, *ibid.*, VIII.ii. Cf. Hugh's gloss on Ecclesiastes 1:10 ("Nothing under the sun is new... it hath already gone before in the ages that were before us"), which forms an extended treatment of those "philosophers of the gentiles" who "with amazing madness tried to assert the eternity of time," who held that the universe of changeable things has neither beginning nor end but repeats itself every 15,000 years, and who taught that all nature, all men, all events, all fates and fortunes, all fathers and sons were identically repeated in each such cycle. Cf. Macrobius *In somnium Scipionis* II.xi (Franciscus Eyssenhardt ed., [Leipzig: B. G. Teubner, 1893], pp. 620–3; tr. William Harris Stahl, *Macrobius' Commentary on the Dream of Scipio* [New York: Columbia University Press, 1952], pp. 219–22), where the Great Year is given as 15,000 years, and *Timaeus* 39D, with Chalcidius's commentary (Wrobel, pp. 183–4; Mullach, p. 208) with its reference to an "annorum innumerabilem seriem." Cf. Cicero *De finibus* II.xxxi. 102 and *De natura deorum* II. 51; see P. R. Coleman-Norton, "Cicero's Doctrine of the Great Year," *Laval théologique et philosophique*, III (1947), 293–302.

87. *In Ecclesiasten homiliae* (*PL*, CLXXV, 283C).

88. In addition to the references cited above, n. 86–7, see *In Pentateuchon* iv (*PL*, CLXXV, 33B): "Our authors differ from the philosophers in that

the latter treat God as nothing but an artisan. They hold that there are three creative principles—God, matter, and the archetypal ideas—whereas our authors hold that there is a single creative principle and that this is God alone." Cf. *De sacramentis* I.i. 1 (*PL*, CLXXVI, 187B): "The philosophers of the gentiles hold to three uncaused principles: an artisan, matter, and form. They say that creation was brought from matter into its present form by the artisan, and they believe God to be a mere shaper, not a creator. But the true faith confesses only one uncaused and eternal first principle, and confesses that by him alone was non-existent creation created."

89. *In Ecclesiasten homiliae* (*PL*, CLXXV, 239D).

90. *Ibid.*, 177A–B.

91. *In Hierarchiam Coelestem* I.i (*PL*, CLXXV, 925–D): "...and this truth had to be served by them [the ancients]: it was not the truth which leads to Life, and they were not the sons of Life. Their task, therefore, was given them for our sakes. To us the consummation of truth was reserved, for us its beginning prepared. They found that truth which it behooved the sons of Life to use in the service of the highest truth. The labor of it was given to them, the fruit to us."

92. Above, p. 10.

93. For specific texts, see *Didascalicon* I.i, n. 1. On heresies risked by John the Scot and Remigius, see further Courcelle, "Etude critique," pp. 59–65; new details on the dependence of Remigius on John the Scot available from the Scotian commentary, unknown to Courcelle, on *De cons. phil.* III. m.ix, in H. Silvestre, "Le Commentaire inédit de Jean Scot Erigène au mètre IX du livre III du 'De consolatione philosophiae' de Boèce," *RHE*, XLVII (1952), 44–122. Remigius's approach was merely extended by Adalbold of Utrecht, but the latter's lengthy discussion of how the *Summum Bonum* can be *forma* without being *formatum* has independent importance for the history of this term; see R. C. B. Huygens, "Mittelalterliche Kommentare zum O qui perpetua," *SE*, VI (1954), 410–413. On Hugh's knowledge of the writings of Remigius, see *Didascalicon* I.x. n. 74; II.iv. n. 29; II.xviii. n. 63; II.xxiv. n. 72; III.ii. n. 6, 8, 9, 14, 19, 24, 26, 31, 36.

94. See *Didascalicon* I.ix. n. 69.

95. On Hugh's adaptation of the *homo erectus* theme, see *Didascalicon* I.i. n. 3.

96. Hugh so interprets it in the *De contemplatione*; see *Didascalicon* I.i. n. 4.

97. See *Didascalicon* I.vi. n. 42.

98. See Parent, *Doctrine de la création*, pp. 48 ff.

99. See refs. to his *De sex dierum operibus, Didascalicon* II.i. n. 7; II.iv. n. 28; and esp. II.vii. n. 41.

100. See section II of the Introduction. On the mind as patterned, like the angelic intellect, after the entire "contents" of the divine Mind, see *Didascalicon* I.vi. n. 42.

101. See p. 46.

102. *Ibid.*

103. *Ibid.*, cf. n. 9.

104. *Ibid.*, cf. n. 11.

105. *Ibid.*, cf. n. 10.

106. *Ibid.*

107. In his glosses on the *De cons. phil.* and the earlier glosses on the *Timaeus*, both probably in existence before the *Didascalicon*; not, however, in the *De philosophia mundi* or the later glosses on the *Timaeus*, where he reports the identification, but no longer as his own view. See also *Didascalicon* i.i. n. 10.

108. Glosses on the *Timaeus*; see Parent, *Doctrine de la création*, p. 170. Variant interpretation of *idem, diversum, dividuum, individuum*, in his glosses on the *De cons. phil.*, Jourdain, ed., "Commentaires inédits," pp. 75-6.

109. See Parent, *Doctrine de la création*, p. 169.

110. Glosses on the *De cons. phil.*, Jourdain, ed., "Commentaires inédits," pp. 76-7.

111. See *Didascalicon* i.i. n. 7.

112. *Ibid.*

113. *Ibid.*

114. See *Didascalicon* i.i. n. 10, *ad fin.*

115. Cf. William of Conches, commentary on *De cons. phil.*, ed. Jourdain, "Commentaires inédits," p. 76: "I call the [world-]soul threefold in nature, that is, in power and property, because it is vegetable in grasses and trees, sensible in brute animals, rational in men."

116. *De tribus diebus* xviii (*PL*, CLXXVI, 828B-C): "One must not in any way suppose that, as the intelligence of man is personally joined with the body which it activates, so too the Creator Spirit is personally joined with the body of this sense-perceptible world; for God fills the world in a manner quite different from that in which the soul fills the body."

117. For details, see below, *Didascalicon* i.i. n. 8.

118. The *De septem septenis* vii (*PL*, CXCIX, 961D-962A) speaks of "that created spirit" or "natural movement" "which is called 'nature' by Hermes Mercury, 'world-soul' by Plato, 'fate' by certain other men, and 'the divine dispensation' by theologians"; Herman of Carinthia *De essentiis* (Manuel Alonso, ed. [Comilles: Universidad Pontificia, 1946], p. 63) declares: "[Naturam] eodem nomine vocare possumus quo Plato significans mundi animam vocat." Adelard of Bath parallels *natura* and *anima* in *De eodem et diverso* (Willner, ed., p. 15; see Willner's interpretation of the passage, *ibid.*, p. 77). Sources of the identification of *natura* and world-soul are Chalcidius, for whom the "works of nature" are the works of the world-soul (see *Didascalicon* i.ix. n. 59), and the Latin *Asclepius* (Nock, ed., II, 299).

119. See *Didascalicon* i.vi, and esp. n. 38. Though to name God in *Didascalicon* i.vi, Hugh uses the Timaean *Genitor et Artifex naturae*, he carefully defines God in the orthodox terminology of Boethius' *De hebdomadibus*.

120. See *Didascalicon* i.vii. n. 53; cf. i.x. n. 69. Note particularly the striking contrast provided by the different uses to which Hugh and the "Liber Hermetis" author put the phrase "unicuique rei non solum esse sed etiam tale esse constituit."

121. See *Didascalicon* i.x. n. 71. To the refs. there cited as precedents for Hugh's rejection of the world-soul in favor of solar fire, add Jerome *In*

Ecclesiasten i (*PL*, XXIII, 1017A), clearly Hugh's authority. Cf. Isidore *De natura rerum* xxvii.ii (*PL*, LXXXIII, 1001A), and Rupert of Deutz *In Ecclesiasten* v (*PL* CLXVIII, 1201). Though in the *Didascalicon* Hugh reserves to the archetypal Exemplar the distribution of each thing's *esse* and *esse talis*, in the homilies on Ecclesiastes he considers that the fiery *spiritus* or *occulta naturae vis* of the sun "unicuique secundum suae naturae capacitatem propriam qualitatem distribuit" (homilia ii [*PL*, CLXXV, 137A]). The two positions suggest the *Nous qualificans* and *natura qualificata* of the" Liber Hermetis." Note further homilia xi (*PL*, CLXXV, 185A–186C), where the divine Wisdom, stretching from end to end of the universe, "comitatur ac fovet cuncta quae operata est, ut non subsistat sine ipsa quae facta et creata sunt ab ipsa"—an attending and nourishing function reserved to the world-soul in writers of different stamp. The divine Wisdom "pursues" genera in their "degeneration" or "flight" down the hierarchical ladder of being, and, deserting none, gives to each a beauty suited to its genus—"unicuique quod suum est tribuit" (*ibid.*).

122. See *Didascalicon* i.ix. n. 59.

123. See *Didascalicon* i.vi. n. 34, 35.

124. See concluding paragraph of *Didascalicon* i.v; cf. concluding paragraph of i.vii and the considerations which form the bulk of i.ix.

125. See Appendix C.

126. See remarks introductory to Appendices A, B, and C.

127. William of Conches attempts to reconcile the Platonic (*Timaean*) and scriptural (Pauline and pseudo-Dionysian) hierarchies of daimons and angels, *De philosophia mundi* i.xvi-xx (*PL*, CLXXII, 47A–48D). Honorius Augustodunensis cites scriptural warrant for declaring that angels possess bodies of fire and locates them above the *aqueum coelum* next over the firmament, *Libellus octo quaestionum* iii (*PL*, CLXXII, 1189A-B); cf. *De imagine mundi* i.lxvii (*PL*, CLXXII, 138A) and i.cxxxix (*ibid.*, 146C). See further the anonymous twelfth-century commentary on Genesis mistakenly printed among the works of Remigius of Auxerre (*PL*, CXXXI, 54D–55A); Clarenbaldus of Arras *Liber de eodem secundus* (Nicholas Häring, ed., *AHDL*, XXII [1955], 212); and esp. *Summa sententiarum* tractatus ii.i (*PL*, CLXXVI, 81), a distinctly un-Hugonian passage despite the mistaken claim of Baron (*Science et sagesse*, p. 56, n. 116) that its tenor is identical with Hugh's *In Pentateuchon* viii (*PL*, CLXXV, 34–35). Once and tentatively (*ibid.*, vii [*PL*, CLXXV, 37B]), Hugh concedes that man's body may have been made through the ministry of angels ("'Faciamus hominem ad imaginem et similitudinem nostram'... ipse [Deus] ad angelos ita loquatur, quorum ministerio forsitan formatum est corpus hominis"). Such a function is not mentioned in the tract on the angels in *De sacramentis* i.v.

128. To the refs. given in Appendix C, n. 1, add Hugh's *Expositio in Hierarchiam coelestem* i.iii (*PL*, CLXXV, 929–930).

129. *Théologie au XIIe siècle*, p. 20.

130. Section 1 of Introduction, concluding two paragraphs.

131. It is necessary to distinguish between works which are "encyclopedic" in virtue of speculating on the nature of the ἐγκύκλιος παιδεία, the

cycle of arts by which education can best be accomplished, and those that are "encyclopedic" in the modern sense, that is, as repositories of information on a wide variety of subjects. Isidore's *Etymologiae* is encyclopedic in the latter sense, the *Didascalicon* in the former. Cf. Baur, *Gundissalinus*, pp. 317–318, for further discussion of the distinction as applied to works in the didascalic tradition.

132. *De arca Noe morali* iv.i (*PL*, CLXXVI, 663B): "Let no man excuse himself. Let no man say, 'I am not able to build a house for the Lord; my poverty does suffice for such an expensive project; I have no place in which to build it.'... You shall build a house for the Lord out of your own self. He himself will be the builder; your heart will be the place; your thoughts will supply the material."

133. See *Didascalicon* ii.i.

134. *De Trinitate* xiv.xvii (*PL*, XLII, 1054–5).

135. *De ordine* i.viii (*PL*, XXXII, 988). Cf. Augustine's criticism of the *De ordine* in the *Retractationes* i.iii. 2 (*PL*, XXXII, 588): "In these books I am displeased... because I attributed a great deal to the liberal arts, of which many saintly men are much in ignorance, and with which many who are not saintly are thoroughly conversant."

136. Cf. Henri-Irénée Marrou, *Saint Augustin et la fin de la culture antique* (Paris: E. de Boccard, 1949), pp. 356–85.

137. *De doctrina christiana* ii.xlii. 63 (*PL*, XXXIV, 65).

138. *Ibid.*, i.xxxv. 39 (*PL*, XXXIV, 34); cf. ii.vii. 10 (*PL*, XXXIV, 39): "Everyone who studies the divine Scriptures will find nothing in them but the insistence that God be loved for God's sake and that one's neighbor be loved for God's sake."

139. *Ibid.*, ii.vii. 9–11 (*PL*, XXXIV, 39–40).

140. See *Didascalicon* iii.i.

141. See *Didascalicon* iii.iii.

142. *De doctrina christiana* ii.xix. 29 (*PL*, XXXIV, 50). The survey extends to ii.xxxix. 58 (*ibid.*, 62).

143. The looseness of the classification is suggested, for example, by the double appearance of astronomy in it: in II.A.3 by name, in II.B.3 as number applied to motion. Augustine's more conventional formulation of the arts, as in *De ordine* ii.xii ff. (*PL*, XXXII, 1011 ff.) should not be forgotten. The point at issue here, however, is the difference between the formulations of the *De doctrina christiana* and the *Didascalicon*. Baron (*Science et sagesse*, p. 46, n. 57) follows de Bruyne in attributing the above scheme to Rhabanus Maurus as a sign of his independence and originality.

144. See *Didascalicon* ii.xxvii.

145. *Ibid.*, iii.iv.

146. See Appendix B.

147. *De doctrina christiana* ii.xxix. 46 (*PL*, XXXIV, 57).

148. *Ibid.*, iv.iii. 4–5 (*PL*, XXXIV, 90–1).

149. *Ibid.*, ii.xxxix. 58 (*PL*, XXXIV, 62).

150. *Ibid.*, 59 (*PL*, XXXIV, 62).

151. *De sacramentis* i. Prologus. 6 (*PL*, CLXXVI, 185; Deferrari, p. 5).

152. Henry Osborn Taylor, *The Mediaeval Mind*, II (London: Macmillan and Co., 1938), 387, n. 2; cf. L. W. Jones, "The Influence of Cassiodorus on Medieval Culture," *Spec.*, XX (1945), 438.

153. *Institutiones* i.xxi (Mynors, p. 60; Jones, p. 120).

154. *Ibid.*, i. xxi, xxvii, xxviii (Mynors, pp. 60, 68, 69–71; Jones, pp. 120, 127, 128–9).

155. *Ibid.*, ii.iii (Mynors, p. 110; Jones, p. 159).

156. See Introduction, n. 21.

157. *Institutiones* i.xxviii, xxix, xxxi (Mynors, pp. 71–3, 78–9; Jones, pp. 130–1, 135–6).

158. See *Didascalicon* ii.ii. n. 16.

159. *Ibid.*, i.iv. n. 27.

160. So Hugonin in his introductory essay to Hugh's works (*PL* CLXXV, cols. L–LI). Mignon, *Origines de la scolastique*, I, 65–6, would have Hugh's distinction between philosophy and theology "as perfect" as that of St. Thomas. Mariétan, *Problème de la classification*, pp. 134–5, believes that the "theology" of Hugh's first three books is Aristotle's "first philosophy," or metaphysics, while the last three books treat revealed theology. The same interpretation is found in Manitius, *Geschichte der lateinischen Literatur*, III, 113; in John P. Kleinz, *The Theory of Knowledge of Hugh of Saint Victor* (Washington, D. C.: Catholic University of America Press, 1944), pp. 8–12; and in F. Vernet, "Hugues de Saint-Victor," *DTC*, VII, part 1 (Paris, 1927), 258–60, who also summarizes the views of several others on the point. Against these, the anachronism of approaching twelfth-century authors, particularly William of Conches and Hugh of St. Victor, with the modern distinction between philosophy and theology in mind has been pointed out by Parent, *Doctrine de la création*, pp. 20–1, and the unity of natural and supernatural knowledge in Hugh's thought has been demonstrated by Jakob Kilgenstein, *Die Gotteslehre des Hugo von St. Viktor* (Würzburg, 1898), esp. pp. 51–7.

161. See *Didascalicon* i.ii.

162. *In Ecclesiasten homiliae* (*PL*, CLXXV, 197B): "This is man's wisdom in this life, namely, to seek and search out the divine Wisdom."

163. See *Didascalicon* i.v.

164. *Ibid.*, ii.xxx, third paragraph (*ad fin.*); cf. ii.i, third paragraph.

165. In the sense that the intellectual creature remains unformed unless it turns toward the divine Wisdom which forms and informs it. See *Didascalicon* i.ii. n. 21.

166. Cf. Hugh's statement in *Didascalicon*, Preface: "The book instructs the reader as well of secular writings as of the Divine Writings." Vernet (see n. 160) cites this statement but takes *scripturae* as if it were *scientiae*; Hugonin (see n. 160) does the same. The distinction between the works of creation (*opera conditionis*) and the works of man's restoration or salvation (*opera restaurationis*) is basic to Hugh's thought and recurs constantly in his works: cf. *De arca Noe morali* iv.iii (*PL*, CLXXVI, 667); *De vanitate mundi* ii (*ibid.*, 716–17); *Expositio in Hierarchiam coelestem* i.i (*PL*, CLXXV, 926–7); and *De sacramentis* i. Prologus. ii (*PL*, CLXXVI, 183; Deferrari, pp. 3–4),

which also adds the qualification, "The worldly or secular writings have the works of creation as their material; the Divine Writings, the works of restoration."

167. *Expositio in Hierarchiam coelestem* i.i (*PL*, CLXXV, 923–8).

168. *Ibid.* (esp. cols. 926D–928B). Cf. *De arca Noe morali* iv.vi (*PL*, CLXXVI, 672B): "Because, with superstitious curiosity, the philosophers of the gentiles investigated the natures of things, that is, the works of creation, they came to nothingness and vanity in their thoughts. Because the philosophers of the Christians ceaselessly ponder the works of salvation, they drive away all vanity from their thoughts."

169. "naturalibus quoque pro modo subjunctis, ut in illis eruditionem conformaret." *Expositio in Hierarchiam coelestem* i.i (*PL*, CLXXV, 927A).

170. The *De tribus diebus* (*PL*, CLXXVI, 811–38) is entirely devoted to such demonstrations, combining them, significantly, with scriptural evidences. Cf. *De sacramentis* i.iii.1 ff. (*PL*, CLXXVI, 217 ff.; Deferrari, pp. 41 ff.), which presents an abbreviated version of the *De tribus diebus* on man's knowledge of the Trinity.

171. *De sacramentis* i. Prologus. 5 (*PL*, CLXXVI, 185C; Deferrari, p. 5).

172. *Ibid.* Significantly, the restoration of man in truth and virtue is attributed alike to the allegorical (doctrinal) and tropological (moral) interpretation of Scripture in the *De sacramentis* and to the theoretical and practical arts in the *Didascalicon* (see esp. i.v and i.viii). Scripture is the primary source for such arts.

173. *Expositio in Hierarchiam coelestem* i.i (*PL*, CLXXV, 927A).

174. Philippe Delhaye, "La Place de l'éthique parmi les disciplines scientifiques au XIIe siècle," in *Miscellanea moralia in honorem eximii domini Arthur Janssen* (Gembloux: Editions J. Duculot, 1948), pp. 29–44, argues that two ethics, one theological and one philosophical or natural, were recognized in the Middle Ages, even among the Victorines and by Hugh in particular (*ibid.*, pp. 31–4). Delhaye's thesis requires modification in the case of Hugh, who recognized one ethical science subserved in part by pagan writings, but finally and perfectly by Scripture. Cf. Delhaye's "L'Enseignement de la philosophie morale au XIIe siècle," *MS*, XI (1949), 77–99, which, repeating the argument that "les classifications scientifiques du XIIe siècle font place à l'*ethica* comme une science morale distincte de la théologie," finds that this natural ethics was attached to the study of the trivium, especially to commentaries made by the teacher of grammar upon literary texts in the manner prescribed by Quintilian, to moralizations of the ancient poets like those of Bernardus Silvestris on the *Aeneid* or Arnulph of Orléans on Ovid, and to the study of Cicero's *De inventione*, with its appended treatment of the virtues necessary to deliberative and demonstrative oratory. Practiced, to be sure, by men of Chartrian connection, such an approach to grammar was foreign to Hugh's thinking. See *Didascalicon* ii.xxix. n. 84; iii.iv. n. 44; iii.v. n. 48. Cf. *In Ecclesiasten homiliae* (*PL*, CLXXV, 177D–78B), where Hugh, admitting the existence of a natural ethics among pagan philosophers, blames its inadequacies as in part responsible for the failure of these philosophers to attain to the true Wisdom. Note that Godfrey of St.

Victor *Fons philosophiae* (ed. Pierre Michaud-Quentin, *Analecta Mediaevalia Namurcensia*, VIII [Namur: Editions Godenne, 1956]), lines 483 and 485–96, divides the tropological interpretation of Scripture into ethics, economics, and politics—arts enumerated in the first half of the *Didascalicon*.

175. *Mouvement théologique*, p. 186.

176. See *Didascalicon* III.xix. n. 86–8.

177. *Ibid.*, VI.iii.

178. *PL*, CLXXVI, 951, or Karl Müller, ed., *Hugo von St. Victor: Soliloquium de arrha animae und De vanitate mundi* ("Kleine Texte für Vorlesungen und Übungen," Hans Lietzmann, ed., Heft CXXIII; Bonn, 1913), p. 3.

179. *PL*, CLXXV, cols. clxi–clxiii.

180. First denied by Mabillon (*Vetera analecta* [Paris, 1675], I, 326) on the basis of two notes in twelfth-century MSS from the monasteries of Anchin and Marchienne which say that Hugh was from the territory of Ypres, the story has been further attacked in recent years by F. E. Croydon, "Notes on the Life of Hugh of St. Victor," *JTS*, XL (1939), 232–53, and most recently by Roger Baron, "Notes biographiques sur Hugues de Saint-Victor," *RHE*, LI (1956), 920–34. For defense of the story, see Jerome Taylor, *The Origin and Early Life of Hugh of St. Victor: An Evaluation of the Tradition* ("Texts and Studies in the History of Mediaeval Education," V, A. L. Gabriel and J. N. Garvin ed., Notre Dame, Indiana: The Mediaeval Institute, 1957). Critical review of the arguments of Baron and of Taylor in Robert Javelet, "Les Origines de Hugues de Saint-Victor," *Revue des sciences religieuses* (*Strasbourg*), XXXIV (1960), 74–83.

181. On this movement in general, and particularly on its development in the twelfth century, see Chenu, "Moins, clercs, et laïcs," *RHE*, XLIX (1954), 59–94. Cf. J. C. Dickinson, *Origins of the Austin Canons and Their Introduction into England* (London: Macmillan & Co., Ltd., 1950).

DIDASCALICON: PREFACE

1. Ps. 35:4.

2. Cf. Matt. 25:18.

3. Cf. Isidore of Seville *Sententiarum libri* III.ix. 5–8 (*PL*, LXXXIII, 681B–82A) for comparable discussion of quick and slow students. The preceding two paragraphs of the preface are found in only one class of MSS (see Buttimer, pp. xv–xvii). It is not improbable that Hugh added them against the temporarily influential Cornificians, who preached that study was futile for those lacking natural ability, superfluous for those possessing it. On the career of this academic sect, see John of Salisbury *Metalogicon* I.i–x (Webb, pp. 5–28; McGarry, pp. 9–33). On the scant reverence of the Cornificians for Hugh, *ibid.*, I.v (Webb, p. 19, McGarry, p. 23).

4. With *Didascalicon* I–III, cf. Hugh's *Epitome* (Baron, ed.), a briefer and earlier treatment of the same materials in dialogue form; with *Didascalicon* IV–VI, cf. Hugh's earlier and briefer *De scripturis et scriptoribus sacris praenotatiunculae* (*PL*, CLXXV, 9–28). On Hugh's method of producing opuscula

on limited questions, then absorbing these into more comprehensive treatments, see *De sacramentis* Praefatio (*PL*, CLXXVI, 173–4; Defarrari, p. 1), and Heinrich Weisweiler, "Die Arbeitsmethode Hugos von St. Viktor, ein Beitrag zum Entstehen seines Hauptwerkes *De sacramentis*," *Schol.*, XX–XXIV (1949), 59–87, 232–67. That Hugh was still contemplating additions to the text of the *Didascalicon* is evident from Appendices A, B, and C.

NOTES TO BOOK ONE

1. This keynote sentence of the *Didascalicon* is adapted from Boethius *De consolatione philosophiae* III. pr. x: "...you have seen what the form of the perfect and imperfect good is. ...Of all things to be sought, the highest and cause why the others are sought is the Good. ...in that Good lies the substance of God." The commentary tradition on the *De consolatione* identifies the Boethian "Form of the Good" with the Second Person of the Trinity, to whom is assigned the role of formal cause or exemplar of creation. So, e.g., in the ninth century by Remigius of Auxerre, on whose work Hugh relies elsewhere in the *Didascalicon*. See Remigius's commentary on *De consolatione* III.m.9: "By 'form' he [Boethius] means the Son of God, who is the Wisdom of God and through whom all things have been made. ...Or, again, he calls 'form' that Exemplar and Idea which was in the mind of God and according to whose likeness the world was afterwards made. ...Saint John gives this very Idea and Pattern of God the name 'Life'; Plato calls it 'the ideas'" (Latin text in H. F. Stewart, "A Commentary of Remigius Autissiodorensis on the *De consolatione philosophiae* of Boethius," *JTS*, XVII [1916], 31; improved text of Remigius in parallel columns with John the Scot's earlier handling of the same ideas in Silvestre, "Le Commentaire inédit de Jean Scot," *RHE*, LXVII [1952], 44–122, esp. 53–4). Comparable interpretation of *forma* in the twelfth century by William of Conches (cf. Parent, *Doctrine de la création*, p. 130). Use of the term "form" in connection with Christ has Pauline and patristic sanction, as in Phil. 2:6, Augustine *De civ. Dei* VII.ix and *Sermo cxvii: De verbis evangelii Johannis* 1:1–3 (*PL*, XXXVIII, 662–3). With the terms and effects associated with Wisdom in this opening chapter, cf. Hugh's paraphrase of the Father's words about the Son in *De tribus diebus* xxiv (improperly printed as *Didascalicon* VII; *PL*, CLXXVI, 834): "He is the Wisdom through whom I have made all things. ...As God together with me, he created you; as man together with you, he came down alone to you. ...He is the Form, he the Medicine, he the Exemplar, he your Remedy." The need of fallen man for reunion with the divine Wisdom lies at the basis of Hugh's thinking on education. Treatments of Hugh's concept of Wisdom in Baron, *Science et sagesse*, pp. 147–66, and Jørgen Pedersen, "La Recherche de la sagesse d'après Hugues de Saint-Victor," *CM*, XVI (1955), 91–133. Allusion to the opening sentence of the *Didascalicon* is found as early as 1159 in John of Salisbury *Metalogicon* II.i (Webb, p. 61; McGarry, p. 74), and earlier in the opening words of William of Conches' revised *Philosophia mundi* (Ottaviano, ed., *Un brano*, p. 19; on the authorship of the *brano*, see Tullio Gregory, "Sull'attribuzione a Guglielmo di Conches di un

rimaneggiamento della *Philosophia mundi,*" *GCFI,* XXX [1951], 119–25).
The form of the many borrowings from the *Didascalicon* found in the revised
form of the *Philosophia mundi* suggests that the *Didascalicon* circulated
originally in student *reportationes* and that these, rather than the *Didascalicon*
as we have it now, were used in the revision.

2. Cf. John 1:9 and Hugh's commentary on this verse in *De sapientia
animae Christi* (*PL,* CLXXVI, 848C–848D): "'He [the Word] was the true
Light which illuminates every man who comes into this world.' What is the
Word if not the divine Wisdom? For what John calls the Word, Paul calls
'the Wisdom of God' (I Cor. 1:24). ...Wisdom is the Word because 'I,
Wisdom, came forth from the mouth of God, the Firstborn before every
creature' (Eccli. 24:5). ...And so Wisdom itself is Light, and God is Light,
for God is Wisdom. And when God illuminates, he illuminates with Wis-
dom and Light. Nor does he illuminate with any other light but that Light
which he himself is. ..." The power of the divine Word or Wisdom to cure,
before illuminating, man's eyes for the perception of itself is contrasted to
the powerlessness of natural or worldly knowledge to do the same, in
Hugh's *Expositio in hierarchiam coelestem* i.i (*PL,* CLXXV, 923B–6D). That
Hugh is not an extreme illuminationist, however, is clear from his empiricist
analysis of knowledge (*scientia*) as the product of *sensus, imaginatio,* and *ratio,*
in *De unione corporis et spiritus* (*PL,* CLXXVII, 287B–9A). To knowledge
he contrasts wisdom or understanding (*intelligentia*), an informing of the
pure reason from within by the divine presence operating concurrently with
reason as a man's soul moves upward toward God (*ibid.,* 289A). Cf. *De sacra-
mentis* i.iii. 3, 30 (*PL,* CLXXVI, 217C, 234C; Deferrari, pp. 42, 60–1),
where even man's knowledge of God is said to be partly natural (through
self-knowledge and knowledge of the physical universe) and only partly the
effect of grace (through internal inspiration and external teaching confirmed
by miracles).

3. Cf. Boethius *De consolatione philosophiae* ii.pr.v: "In all other animals
it is natural that they should not know themselves; in man it is a defect;"
and Hugh *In Ecclesiasten homiliae* (*PL,* CLXXV, 174C): "What more foolish
than always to look to the lowest things and to hold one's face toward
earth? This is the lot of the beasts, who are granted to seek nothing higher.
But Wisdom dwells in things of heaven, and those unwilling to rise erect
and be lifted toward it are like the beasts and gaze at earth." Further dis-
cussion (*ibid.,* 248D–51C), where Hugh glosses the text, "I said in my heart
concerning the sons of men, that God would prove them, and show them to
be like beasts" (Eccl. 3:18). Involved is the medieval commonplace,
derived ultimately from Ovid *Metamorphoses* 1.83–6, which took the prone
posture of beasts and the erect posture of man, his head toward the stars, as a
symbol of the former's bondage to earth and the latter's relationship to the
divine. For texts and studies in the transmission of this theme, see Theodore
Silverstein, "The Fabulous Cosmogony of Bernardus Silvestris,' '*MP,*
XLVI (1948–9), 97, n. 28. To the references listed by Silverstein, add the
striking use of the theme by Augustine *De Trinitate* xii.i (*PL,* XLII, 998).
Full collection of ancient and earlier Christian references in S. O. Dickerman,

De argumentis quibusdam apud Xenophontem, Platonem, Aristotelem obviis e structura hominis et animalium petitis (Halle, 1909), pp. 92–101.

4. Ultimate source, Xenophon *Memorabilia* IV.ii.24–25. Of frequent Latin allusions to this famous epigram, that most commonly cited in the twelfth century was Macrobius *Commentarium in somnium Scipionis* I.ix.1–2 (Eyssenhardt, p. 521; Stahl, p. 124). However, cf. Macrobius *Saturnalia* I.vi.6; Ausonius *Ludus de VII sapientibus* cxxxvii-ix; Ambrose *Sermo* II *in Ps. cxviii* xiii-iv (*PL*, XV, 1214–5) and *Sermo* x.x–xvi (*ibid.*, 1332–3). Location of the inscription precisely on the tripod seems to be reminiscence of Priscian *Institutiones grammaticae* I.iv (Heinrich Keil, ed. *Grammatici latini*, II [Leipzig: B. G. Teubner, 1858], 17). For general discussion of the significance of the Delphic inscription in medieval thought, see Etienne Gilson, *The Spirit of Mediaeval Philosophy* (New York: Charles Scribner's Sons, 1936), ch. xi, pp. 209–28. In *De contemplatione et eius speciebus* ii (Barthélemy Hauréau, ed., *Hugues de Saint-Victor: nouvel examen de l'édition de ses oeuvres* [Paris, 1859], pp. 177–8), Hugh identifies Wisdom's "tripod" as the threefold sense of Sacred Scripture, source of man's self-knowledge; the identification helps emphasize the fact that, for Hugh, "philosophy" makes use of Scripture. On self-awareness as the indispensible condition of man's movement toward the divine Wisdom, see *De tribus diebus* xvii (*PL*, CLXXVI, 825A): "No man is truly wise who does not see that he himself exists." The basis of this condition is man's nature as a mysterious projection of the divine Wisdom: "The first and principal mystery [*sacramentum*] of the divine Wisdom, therefore, is the created wisdom, that is, the rational creature, which, partly visible, partly invisible, has been made its own gateway and road to contemplation" (*ibid.*, 824D).

5. With the opening paragraph of the *Didascalicon*, cf. Hugh's *Epitome* (Baron, ed., p. 107): "Philosophy rightly spends every effort on three things. The first is the investigation of man; this is necessary that man may know himself and recognize that he has been created. Next, when he has begun to know himself, let him investigate what that is by which he was made. Last, let him, as his practice, begin to meditate on the marvelous works of his Maker, so that he may equally understand what it is that was made with him and for his sake. By this triple way the search for Wisdom runs toward its end. The end of all philosophy is apprehension of the highest Good, which lies in the Maker of all things alone." The threefold task of philosophy Hugh derives from the "three eyes" man possessed before the fall (see *De sacramentis* I.x.2 and I.vi.12–15 [*PL*, CLXXVI, 329C–30A, 270C–2C; Deferrari, pp. 167, 102–4]; cf. *Expositio in Hierarchiam coelestem* III [*PL*, CLXXV, 976A ff.]). These are the eye of flesh, through which man saw the physical world; the eye of reason, through which he saw himself and what he contained; the eye of contemplation, through which he saw within himself God and "the things which are within God." These last are the exemplary causes in the divine Wisdom, shared originally by the intellectual creature, but lost to him through his fall. The first stage of philosophy, *lectio* (study, reading), with which alone the *Didascalicon* is concerned, begins to restore man's lost participation in the divine Wisdom through opening

his mind to that "apprehension of Truth and perfect knowledge" originally received by man "not by study or any teaching over periods of time, but simultaneously and immediately from the very beginning of his creation by a single and simple illumination of divine imparting"; see *De sacramentis* 1.vi.12 (*PL*, CLXXVI, 270D; Deferrari, p. 102). For the succeeding stages by which philosophy completes man's restoration—meditation, prayer, performance, and contemplation—see *Didascalicon* v.ix.

6. The Middle Ages had direct knowledge of Plato primarily through the incomplete translation of the *Timaeus* by Chalcidius. The passage to which Hugh alludes concerns the world-soul (see Wrobel, pp. 32, 92–3; Mullach, pp. 162–3, 186–7). On Hugh's transference of these materials to the human soul, see n. 8, 10.

7. "Entelechy" is said to be Plato's term for the world-soul in Remigius of Auxerre, commentary on Martianus Capella (Bibliothèque Nationale, MS latin 14754, fol. 3ʳ) ("Plato tamen endelichiam animam mundi dicit"), and John the Scot on the same text (Cora E. Lutz, ed., *Iohannis Scotti annotationes in Marcianum* [Cambridge, Mass.: Mediaeval Academy of America, 1939], p. 10); for a twelfth-century use of "entelechy" to designate the world soul, see Bernardus Silvestris *De mundi universitate* (Carl Sigmund Barach and Johann Wrobel, ed. [Innsbruck, 1876]), *passim*, and Silverstein, "Fabulous Cosmogony," *MP*, XLVI (1948–9), 94, 114–6. That "entelechy" was not Plato's but Aristotle's term and was used by him to name "the first perfection of a natural organic body" is made clear, however, by Chalcidius (Wrobel, pp. 262 ff.; Mullach, pp. 227–9), who employs the term with particular reference to man. Hugh, while seemingly associating the term with Plato, employs it here with reference to man's soul, not the world-soul.

8. Several interpretations of "dividual and individual substance" and "same and diverse nature" current in the twelfth century are summarized in the *brano* revision of William of Conches' *Philosophia mundi* (Ottaviano, ed., *Un brano*, pp. 48–51). One interpretation, applying these terms to the human soul and agreeing in several particulars with the *Didascalicon*, may safely be inferred to be Hugh's (*ibid.*, pp. 49–50): "The soul is said to consist of 'dividual' and 'individual' substance because, to speak first of the human soul, it is an individual thing, lacking parts [cf. *Didascalicon* 1.i, where the soul is called "simple essence (not) in any way distended in quantitative parts"]; but it is said to be 'dividual' because of its diverse effects, namely, vegetative life, sense-endowed life, and rational life [cf. *Didascalicon* 1.iii, where the threefold vivifying effects of the soul are treated], or because it is irascible, concupiscent, and rational [cf. *Didascalicon* 11.iv, for the soul's extension to virtual threeness in irascible, concupiscent, and rational powers]. ...Its being composed of the 'same' and 'diverse' is similarly evident in the human soul, for, according to Plato, it consists of the rational and irrational, that is, of reason and sensuality; reason always moves the soul toward self-sameness or unity through the virtues, sensuality toward external earthly things through the vices [cf. *Didascalicon* 11.iv, for the soul's distraction when it moves toward the world of sense, its recovery of unity when it returns to the source of its nature]." The wide variety of interpretations of this

Timaean passage in the twelfth century is suggested, in addition to those noted by the *brano* author, by Adelard of Bath's association of the "same" with *philosophia*, the "diverse" with *philocosmia* (pursuit of the world) (see *De eodem et diverso*, Willner, ed., pp. 3–4) and by Abaelard's association of both terms with the Holy Spirit, "same" in substance and nature in relation to Father and Son, but "diverse" from them in person and gifts (see n. 10).

9. Adapted from Chalcidius (Wrobel, p. 120; Mullach, p. 193): "And Plato himself... composes the soul of all the elements so that it may have knowledge both of the elements and of the things which are made from them...." The "soul" involved in Chalcidius is the world soul; the "elements" are fire, air, water, and earth, invisible in their pure state.

10. Adapted from Boethius *De consolatione philosophiae* iii.m.ix: "When, divided, it has gathered movement into two spheres, it passes along on its way back to itself and circles the deep design and turns the heaven in like image." Boethius, echoing the doctrine of the *Timaeus*, speaks of the world-soul. Hugh's adaptation of world-soul materials to the soul of man had pointed contemporary significance. The passages from the *Timaeus* and *De consolatione* to which Hugh alludes figured, along with others, in Abaelard's contention that the Platonic *nous* and world-soul designated allegorically (*per involucrum*) the Son and Holy Spirit. The passages received a certain notoriety both on Abaelard's condemnation at Soissons, in 1121, for this and other "novelties" (see Remigius Stölzle, ed., *Abaelard's 1121 zu Soissons verurtheilter Tractatus de unitate et trinitate divina* [Freiburg im Breisgau, 1891] pp. xxii–xxvi and pp. 9 ff.; cf. H. Ostlender, ed., *Theologia Summi Boni, BGPM*, XXV, 2–3 [1939], pp. xxii–xxiii) and again on his reaffirmation of his views in 1124 (*Theologia christiana* i.v [*PL*, CLXXVIII, 1139C–66C], and in 1125 (*Introductio in theologiam* i.xv–xxv [*PL*, CLXXVIII, 1104D–34D]; on the dating of these works see J. G. Sikes, *Peter Abailard* [Cambridge: Cambridge University Press, 1932], Appendix I, pp. 258–71). He abandoned his identification of the Holy Spirit and the world soul in *De dialectica* (Victor Cousin, ed., *Ouvrages inédits d'Abélard* [Paris, 1836], pp. 475–6; newly ed. by L. M. De Rijk, *Petrus Abaelardus: Dialectica* [Assen, 1956], pp. 558–9), at least part of which was written after the appearance of the *Didascalicon*, i.e., after 1127 (Sikes, p. 271; De Rijk, pp. xxii–iii), but concern for his use of the world-soul materials persisted as late as 1139, when William of St. Thierry's *Disputatio adversus Abaelardum* (see esp. ch. v [*PL*, CLXXX, 265A–6D]; cf. *Disputatio altera adversus Abaelardum* [*ibid.*, 321C–D]) led to Abaelard's second condemnation, at Sens. Identification of the Platonic world soul with the Holy Spirit appeared also in William of Conches' early gloss on the *Timaeus* passage (Schmid, "Ein Timaeoskommentar," *CM*, X [1949], 239) and on *De consolatione* iii.m.ix (Jourdain, "Commentaires inédits," p. 75), as also in Thierry of Chartres *De sex dierum operibus* (B. Hauréau ed., *Notices et extraits de quelques manuscrits latins de la Bibliothèque Nationale*, I [Paris, 1890], 61; newly ed. by N. Häring, *AHDL*, XXII [1955], 193). Like Abaelard, William of Conches abandoned the identification (see his later glosses on the *Timaeus*, in Parent, *Doctrine de la création*, p. 166). For convenient summary of the controversy, in which the *Didascalicon* may have played an incidental

part hitherto unremarked, see, in addition to Parent, *Doctrine de la création*, pp. 69–81, Tullio Gregory, "L''anima mundi' nella filosofia del XII secolo," *GCFI*, XXX (1951), 494–508, and, by the same author, *Anima mundi*, pp. 123–74. Hugh's adaptation of the materials to the human soul seems to point to their more proper use; it goes back to an older commentary tradition found, e.g., in Remigius of Auxerre, commentary on *De consolatione* iii.m.ix (Stewart, ed., p. 33; Silvestre, ed., p. 60): "To men of better judgment, however, it seems that in this place we should understand rather the rational soul, which has great likeness to the world, so that in Greek man is called a 'microcosm,' that is, a lesser world" (comparable observation by John the Scot [Silvestre, p. 61]). Remigius takes the "twin spheres" of the Boethian text as literally the two eyes, but John the Scot writes: "The soul is not called 'divided' because divided in its very nature, but because its access to the contemplation of external things is divided into two eyes, here simply called 'two spheres'. ...For as spiritual things are beheld by the mind, so corporeal things are seen by eyes of flesh" (Silvestre, p. 63). Cf. Hugh's *De sacramentis* i.vi. 5 (*PL*, CLXXVI, 266B; Deferrari, p. 97): "The rational soul was equipped with a double sense in order that it might grasp visible things without through the flesh and invisible things within through the reason... so that it might enter within to contemplate and go outside itself to contemplate—within, contemplating Wisdom; without, the works of Wisdom." Hugh's use of these materials is reflected in Alanus de Insulis *De planctu naturae* (*PL*, CCX, 443C), where the "circling" of man's reason from heavenly things to earthly and back to heavenly is mentioned.

11. Quoted from Chalcidius, who ascribes the verses to Empedocles (Wrobel, p. 120; cf. p. 254; Mullach, p. 193; cf. p. 226). William of Conches also cites the verses (Parent, *Doctrine de la création*, p. 169). The principle of knowledge of like by like underlies Hugh's conception of man's progressive assimilation to the divine Wisdom. On the history of the principle, see A. Schneider, "Der Gedanke der Erkenntnis des Gleichen durch Gleiches in antiker und patristischer Zeit," *Abhandlungen zur Geschichte der Philosophie des Mittelalters*, *BGPM*, Supplementband II (Münster, 1923), 49–77.

12. Cf. Macrobius *In somnium Scipionis* i.xiv. 19–20 (Eyssenhardt, pp. 542–3; Stahl, pp. 146–7) for a listing of the opinions of twenty-one Greek philosophers who agree on the soul's incorporeality.

13. "non secundum compositionem sed secundum compositionis rationem." Adapted from Chalcidius (Wrobel, pp. 265–6; Mullach, p. 229).

14. No such work by Varro is now known. Manitius (III, *Geschichte der lateinischen Litteratur*, 115, n. 1) claims Hugh is here citing John the Scot, but Manitius does not give the source. P. G. Meyer ("Hugo von Sankt Viktors Lehrbuch," *Ausgewählte Schriften* [Freiburg im Breisgau, 1890], p. 159, n. 1) suggests Hugh means John the Scot's *De divisione naturae*, or ΠΕΡΙ ΦΥΣΩΝ, but the quotation, if it is such, is not to be found in this work. On Varro's belief in the soul's incorporeality, see Claudianus Mamertus *De statu animae* ii.viii (*CSEL*, XI, 130). The *Premnon physicon* of Nemesius, translated by Alfanus in 1085 (Carolus Burkhard, ed. [Leipzig: B. G. Teubner, 1917]), contains no passage similar to that cited here by Hugh.

15. Detailed exposition of the psychology of knowledge in Hugh's *De unione corporis et spiritus* (*PL*, CLXXVII, 285–94). Contrast between types of change undergone by body as opposed to soul in *De sacramentis* I.iii. 15–16 (*PL*, CLXXVI, 221C–3A; Deferrari, pp. 46–7).

16. Cf. John the Scot *De divisione naturae* II.iv (*PL*, CXXII, 531): "Man, as we have said and shall most often say again, has been created of such a dignity of nature that there is no created thing, visible or invisible, that cannot be found in him." John here expounds Maximus the Confessor on man as the "laboratory" (*officina*) of all created things, through whom creation will achieve reunion (*adunatio*) with the Creator (*ibid.*, III.xxxvi; *PL*, CXXII, 733). Hugh, by contrast, teaches that the soul's being composed of all things is the psychological basis of man's own return to the divine Wisdom, Exemplar of all. The passage is good for illustrating the radical difference that underlies superficial points of contact between the Hugonian and Scotian systems.

17. "summum in vita solamen". The phrase occurs in the opening words of Boethius *De syllogismo hypothetico* (*PL*, LXIV, 831B). Cf. the address to Philosophy in *De consolatione philosophiae* III.pr.i: "O summum lassorum solamen animorum."

18. Cf. Augustine *De libero arbitrio* II.ix.26 (*PL*, XXXII, 1254): "No one is blessed except in that highest Good which is seen and possessed in the Truth we call Wisdom."

19. Quoted from Boethius *De musica* II.ii (*PL*, LXIII, 1195D). Cf. Augustine *De civitate Dei* VIII.ii; Isidore *Etymologiae* VIII.vi.1–3. Hugh, in the *Epitome* (Baron, ed., p. 106), remarks that the etymology of "philosophy" is "a question not to be passed over simply because the interpretation is common knowledge, for not all men understand the force of the terms in the same way." The *Epitome's* explanation of the terms, while differing in detail from that of the present chapter, involves the same noetic mysticism. The "love" implied by philosophy is "not that love by which the perfectly known is loved, but that by which Truth, tasted, is more fully desired." Wisdom is "the unwavering comprehension of the true." The "true," while defined as a transcendental relationship ("that what is, is, is true; and that what is not, is not, similarly"), is said to exist "in That which is," i.e., in "the divine Wisdom itself, in which is every 'true' that is true." With Baron's imperceptive remark (*Epitome*, p. 121), "Il [Hugues] nous présente seulement la sagesse comme le lieu de toutes les vérités et de toute vérité. Rien n'indique qu'il puisse s'agir de la Sagesse divine," cf. Pedersen, "Recherche de la sagesse," *CM*, XVI (1955), 110: "...pour Hugues... la vérité est une réalité ontologique à la valeur religieuse, en vertu de l'appropriation de la sagesse à la seconde personne de la Trinité..." Cf. *De tribus diebus* xxvi (*PL*, CLXXVI, 837A).

20. Quoted from Boethius *De arithmetica* I.i (*PL*, LXIII, 1079D).

21. Quoted from Boethius *In Porphyrium dialogi* I.iii. (*PL*, LXIV, 10D–11A; *CSEL*, XLVIII, 7). With the Boethian source, cf. Augustine *De Genesi ad litteram* I.v (*PL*, XXXIV, 249–50): "But the spiritual, intellectual, or rational creature, which is seen to be closer to the divine Word, can have

a formless life. ...For turned from the unchangeable Wisdom, it lives in folly and perfidy, and such a life is its formlessness. But when it has turned toward the unchangable Light of Wisdom, the Word of God, it is formed... so that it may live wisely and blessedly. The source of the intellectual creature is the eternal Wisdom, which, remaining unchangeable in itself, never ceases by hidden inspiration to call to that creature whose source it is, inviting him to turn to his source, because otherwise he cannot be formed and perfected." See also John the Scot *De divisione naturae* ii.xvi (*PL*, CXXII, 548B): "But the invisible, that is, intellectual and rational creature is said to be without form before it turns to its form, namely to its Creator. For it is not sufficient for it to subsist composed of an essence and an essential differentia... unless it is perfected by having turned to the sole-begotten Word, I mean the Son of God, who is the form of all intellectual life. Without him, it remains imperfect and unformed." Cf. Wisdom 7:21, where the divine Wisdom is said to make those who pursue it sharers in the friendship of God. Boethius, in the passage here quoted by Hugh, proceeds immediately to divide philosophy into the theoretical and the practical, noting the triple subdivisions of each and declining to say whether logic is a part of philosophy. Suppressing this part of his source, Hugh instead prepares for the inclusion in philosophy of the mechanical arts (ch. viii) and of logic (ch. xi) by a five-chapter development of points relating to human psychology, cosmology, and the effects of the fall.

22. Quoted from Boethius *Commentaria in Porphyrium a se translatum* i.i (*PL*, LXIV, 71A ff.; *CSEL*, XLVIII, 135 ff.).

23. On the meaning of this Boethian term and its modification by twelfth- and thirteenth-century authors, including Hugh of St. Victor, see M.-D. Chenu, "Imaginatio: note de lexicographie philosophique médiévale," *ST*, CXXII (1946), 593–602. On the relations among *sensus, imaginatio, affectio imaginaria, ratio in imaginationem agens*, and *ratio pura supra imaginationem*, see Hugh's *De unione corporis et spiritus* (*PL*, CLXXVII, esp. 288D–9A).

24. Entire chapter quoted from Boethius *Commentaria in Porphyrium a se translatum* i.i (*PL*, LXIV, 71A ff.; *CSEL*, XLVIII, 135 ff.). Another translation, differing slightly in detail, by Richard P. McKeon, *Selections from Medieval Philosophers*, I (Chicago: Charles Scribner's Sons, 1929), 70–3. The chapter advances Hugh's argument for a fourfold division of philosophy by proposing that the rational soul: (1) includes vegetative and sensual functions (province of the mechanical arts); (2) is concerned with words and their arrangements and with reasoning (province of the logical arts); and (3) spends every effort to acquire the natures of things (theoretical arts) and moral instruction (practical arts).

25. "inextricabilem labyrinthum" A Boethian phrase; cf. *De consolatione philosophiae* iii.pr.xii: "me inextricabilem labyrinthum rationibus texens."

26. Hugh's expression "involved words" (*perplexus sermo*) may refer to the deliberate concealment of an inner meaning beneath an ambiguous or allegorical verbal surface (*involucrum, integumentum, cortex*), a concealment which Abaelard, William of Conches, Thierry of Chartres, Clarenbald of Arras, Bernardus Silvestris, and Arnulph of Orléans claimed to find in Plato, Vergil,

Ovid, Priscian, Martianus Capella, Macrobius, and Boethius, and which was practiced by Bernardus Silvestris and by Alanus de Insulis in their own poetry. See Jeauneau, "La Notion d'*integumentum*," *AHDL*, XXIV (1957), 35–100; M.-D. Chenu, "*Involucrum:* le mythe selon les théologiens médiévaux," *AHDL*, XXII (1955), 75–9; and Pierre Courcelle, "Les Pères devant les enfers virgiliens," *AHDL*, XXII (1955), 5–74. Reserving allegory to Scripture, Hugh demands scientific clarity in the arts. Cf. *Didascalicon* III.iv, where he rejects fables, histories, didactic poems, and ornamental prose as tangential to philosophy. His position prepares the way for the insistence, later in the century, of Alanus de Insulis that the language of theology be "intellectu perceptibilis," i.e., avoid "involucra verborum"; see Alanus de Insulis *Theologiae regulae* xxxiv (*PL*, CCX, 637).

27. "Philosophia est disciplina omnium rerum humanarum atque divinarum rationes plene investigans." Hugh repeats this definition (II.i.n.10), substituting *probabiliter* for *plene.* The closest parallel is in Cassiodorus *Institutiones* II.iii.5 (Mynors, ed., p. 110): "Philosophia est divinarum humanarumque rerum in quantum homini possibile est, probabilis scientia," where the force of *probabilis* must be "demonstrable," not "probable" as rendered by Jones, *Divine and Human Readings*, p. 160. Further analogues of the definition occur in Cicero *De oratore* I.xlix.212; *De officiis* II.ii.5; in Augustine *Contra academicos* I.vi (*PL*, XXXII, 914); in Alcuin *De dialectica* i (*PL*, CI, 952); in Rhabanus Maurus *De universo* xv.i (*PL*, CXI, 416A, 413B); in Isidore of Seville *Etymologiae* II.xxiv.1,9. Note, however, that Hugh gives the terms of the definition a meaning original with him. His "human things" are specifically the matters served by the mechanical arts, his "divine things" are the truth and virtue served respectively by the theoretical and practical arts (cf. *Didascalicon* I.viii). For Cicero, on the other hand, "human things" comprise ethics and physics; for Augustine, the four cardinal virtues (see *Contra academicos* I.vii [*PL*, XXXII, 916]: "Knowledge of human things is that knowledge which comprises the light of prudence, the propriety of temperance, the strength of fortitude, and the holiness of justice"; cf., however, *De trinitate* XIV.i and XII.xiv [*PL*, XLII, 1037C, 1009D], where the term receives somewhat broader extension); for Alcuin and Rhabanus, ethics alone. Isidore merely repeats the definitions of Cicero and Cassiodorus. Even for the latter, whose words Hugh closely follows, "human things" correspond to the practical (*actuales*) arts, "divine" to the theoretical (*inspectivae*).

28. A Chalcidian idea. See n. 59.

29. "tot esse philosophiae partes quot sunt rerum diversitates ad quas ipsam pertinere constiterit" On the originality of this principle, see Baur, *Gundissalinus*, p. 359.

30. "Rise" refers to the historical origin of the arts in the needs suffered by man in the fall. More schematized treatment of the same topic in Hugh's *Epitome* (Baron, ed., pp. 109–10); to three evils (ignorance of the good, desire of evil, and mortal weakness) correspond three goods (knowledge of truth, love of virtue, and the pursuit of conveniences), promoted by three categories of arts (theoretical arts, practical arts, and mechanical arts). The

schematization of the *Epitome* is reproduced in Richard of Saint Victor *Excerptiones priores* 1.ii–v (*PL*, CLXXVI, 194A–6) and in the *brano* revision of William of Conches' *Philosophia mundi* (Ottaviano, *Un brano*, pp. 22–5).

31. That is, to angels and God.

32. The twofold nature of man is stressed in the Latin *Asclepius*, which infers from it man's twofold task of imitating the divine *ratio* and *diligentia* in his immortal part, and, in his mortal, of tending and managing the earth through "agriculture, care of herds, architecture, maintenance of harbors, navigation, social relationships, commerce"; the earthly part of the universe is said to be maintained "by the knowledge and use of those arts and disciplines without which God willed the world should not be perfect"; see *Asclepius* 1.viii (Nock, ed., p. 306). The importance given man's earthly tasks in the *Asclepius* suggests the importance to which Hugh elevates the mechanical arts, though with certain essential differences. Hugh relates these arts to the alleviation of fallen man, not to the perfecting of the world by God's original plan; he makes theoretical knowledge of them part of man's pursuit of the divine Wisdom, hence not completely dissociated from man's spiritual part as in the *Asclepius*; he notes that their execution, while not properly part of philosophy, has on occasion been praiseworthily undertaken by philosophers (*Didascalicon* III.xiv), whereas in *Asclepius* 1.ix (Nock, ed., p. 307) attendance on the lower world is assigned to "all who, through the conflict of their double nature, have sunk under the body's weight to a lower grade of intelligence"; he fills them out to the number seven in schematic parallel with the liberal arts and, to name them, employs terms found scattered in Isidore of Seville. Hugh quotes the *Asclepius* in the concluding words of the *Didascalicon* (VI.xiii) and may allude to it in his elaboration of "the number 'four' of the soul" (*Didascalicon* II.iv). On the soul as that which man truly is, see Macrobius *In somnium Scipionis* II.xii.9–10 (Eyssenhardt, ed., p. 625; Stahl, p. 224), and Nemesius *Premnon physicon* 1.vi–vii (Burkhard, ed., p. 6), where, however, there is no question of mechanical arts. Cf. *De sacramentis* 1.vi.2 (*PL*, CLXXVI, 264C–D; Deferrari, p. 95).

33. Cf. *Asclepius* 1.xii (Nock, ed., p. 311).

34. With the title of the present chapter ("De tribus rerum maneriis"), cf. the passage beginning, "Cum igitur tres sunt maneries operum," in the commentary on the *Timaeus* published by Schmid ("Ein Timaioskommentar," *CM*, X [1948], 220–66) and thought by him and by Gregory (*Anima mundi*, pp. 15–7) to reproduce the earliest form of William of Conches' glosses on the *Timaeus*, composed in the first years of William's teaching, or between 1120–5 (on dating, see Gregory, *Anima mundi*, pp. 3, 7), and referred to in his *Philosophia mundi* as "glossulae nostrae super Platonem" (*PL*, CLXXII, 47A). The phrase as it occurs in these "glossulae" refers properly to "the work of God, the work of nature, and the work of the artificer, who imitates nature" (cf. *Didascalicon* 1.ix) but forms part of a larger discussion of that being "which exists eternally, ungenerated," of that which "is generated and does not always exist," and of the relations between the world and time; cf. Chalcidius' translation of the *Timaeus* 27D–8C (Wrobel, pp. 23–4; Mullach, p. 157).

35. These distinctions among "eternal," "perpetual," and "temporal" occur in William of Conches' commentary on the *De consolatione philosophiae* III.m.ix (see Parent, *Doctrine de la création*, pp. 125–36). Absent from the commentaries of John the Scot, Remigius, Bovo of Corvey, and Adalbald of Utrecht, they appear to be original with William in this formulation, though perhaps suggested to him by the discussion of time and eternity in *De consolatione* v.pr.vi, or by cognate distinctions among time, "sempiternity," and eternity in Boethius *De Trinitate* iv, or the eternal, "sempiternal," and perpetual, as inspired by *Timaeus* 28C (Wrobel, p. 24; Mullach, p. 157) and defined by William in his later glosses on the text (Parent, *Doctrine de la création*, pp. 152–3).

36. Buttimer's text for this sentence and for the first sentence of the next paragraph should be repunctuated as follows: "In primo ordine id constituimus cui non est aliud 'esse' et 'id quod est,' id est, cuius causa et effectus diversa non sunt. …Illud vero cui aliud est 'esse' et 'id quod est,' id est, quod aliunde ad esse venit," etc. Cf. Boethius *De hebdomadibus* (*PL*, LXIV, 1311B), which, as Buttimer does not observe, is the source of the terminology.

37. See preceding note for correction of Buttimer's punctuation of this sentence to this point.

38. "Nature" and "world" in this passage are coextensive with the whole of creation, not merely with the physical universe. Nature's two parts are (1) the incorporeal, invisible, rational creation or created wisdom (angels and human souls), made in the likeness not of a single exemplar in the Mind of God, but of the entire Mind of God with all the exemplary causes it contains (see n. 42); and (2) the corporeal, visible creation, which, as initially created (primordial matter) was changeless because unformed, and out of which God made the immutable bodies of the superlunary world and the changing bodies of the sublunary world. Cf. *In Ecclesiasten homiliae* (*PL*, CLXXV, 128D), where Hugh says that the angelic nature and the primordially unformed matter of visible creation were made together with time in the beginning. Like Hugh, William of Conches teaches the equal perpetuity of spiritual and material creation; cf. his commentary on the *Timaeus* (Parent, *Doctrine de la création*, p. 148): "The work of the Creator is perpetual, lacking dissolution, for neither the physical world nor spirit is dissolved." Cf. Hugh's *De sacramentis* I.v.2–5 (*PL*, CLXXVI, 246–9; Deferrari, pp. 75–7), in which Hugh, basing his doctrine on Eccli., 1:4 ("wisdom hath been created before all things"), closely follows Augustine's teaching, as e.g., in *Confessiones* XII.ii.7–9, 11–3, 15, where the two parts of creation ("heaven and earth") of Gen. 1:1 are said to be (1) the "heaven of heavens," that spiritual, unchanging wisdom, mind, or nature made by God before time, yet not coeternal with himself nor identical with the divine Wisdom, and (2) the originally formless and hence unchanging matter (on the unchangeableness of primordial matter, see esp. *Confessiones* XII.xii) underlying the physical universe, itself now subdivided into the superior "heaven" and the inferior earth. Though Augustine, and Hugh following him, speak of the "created wisdom" in Neoplatonic terms, they have in mind primarily

the angels, secondarily rational souls (see n. 42). Note that though John the Scot divides "nature" into two parts (*De divisione naturae* III.i [*PL*, CXXII, 621A]: "The first and greatest division of all nature is into that Nature which creates the established universe and that nature which is created *in* the established universe") and teaches that the former part "encompasses all things" (*ibid.*, 620C), the resemblance to Hugh is only superficial. The parts of John's "nature" are Creator and creation; Hugh's "nature", in the present context, that is, is like Augustine's, entirely created.

39. The primordial causes are the uncreated exemplars of creation subsisting in the divine Wisdom, or Mind. See *De sacramentis* I.iv.26 (*PL*, CLXXVI, 246C; Deferrari, p. 74). Hugh's use of the term parallels that of John the Scot, who, however, regards the primordial causes, or *ousiai*, as created (see n. 42). For discussion of the manner in which created nature proceeds from the primordial causes, see *De sacramentis* I.ii.3 (*PL*, CLXXVI, 207; Deferrari, p. 30): "Now these effect without movement and produce without transference, since eternity did not lose anything of its own state by ordaining time, nor did it minister substance from its own store by creating corruptible things, but remaining what it was, it made what was not. ... For it did not degenerate by creating lower things; it did not by nature descend into those very things to which it had given beginning; rather, without using its own nature, it created that nature by which things that were not might take beginning, since the work and the Maker could not be the same by nature."

40. Only the rational creature came forth from the primordial causes *nullo mediante*; the corporeal creation was made *mediante rationali creatura*. See *De sacramentis* I.iv.26 (*PL*, CLXXVI, 246B–C; Deferrari, pp. 73–4) and Appendix C.

41. Taking *constitit*, the reading of MS N, rather than Buttimer's *consistit*, which provides an awkward shift in tense. For another instance in which MS N supplies a better reading, see *Didascalicon* IV.i.n.1.

42. In certain of Hugh's contemporaries, the term *ousiai* typically suggests the influence of John the Scot; see, e.g., Etienne Gilson, "La Cosmogonie de Bernardus Silvestris," *AHDL*, III (1928), 10, n. 4, and G. Raynaud de Lage, *Alain de Lille* (Montréal: Institut d'études médiévales, 1951), p. 60. Note, however, that John regularly translates the term as *essentia* (to the refs. cited by Gilson, *loc. cit.*, add the striking passage in *De divisione naturae* I.lxiii [*PL*, CXXII, 621A], where *ousiai* is used specifically for the primordial causes or archetypal essences); it is rather Augustine *De Trinitate* v.viii (*PL*, XLII, 917D), quoted, moreover, in *De sacramentis* II.i.4 (*PL*, CLXXVI, 376D; Deferrari, p. 211), who proposes "substance," Hugh's term here, as a translation for the Greek word. Hugh is clearly alluding to John the Scot, but the allusion takes the form of a correction rather than of a borrowing. In John the Scot, as in his twelfth-century follower Bernard of Chartres, the *ousiai*, though created and, hence, it would seem, distinct from God, are held to subsist in the Mind of God, to be one with the Mind of God, and even coeternal (though "not quite") with it (*De divisione naturae* II.xv–xxvii [*PL*, CXXII, 545C–66D]; summary of John's and Bernard's teaching in Parent,

Doctrine de la création, pp. 45–8). Hugh removes the ambiguity and paradox of the Scot's teaching by admitting the existence of uncreated exemplars in the Mind of God (see first definition of "nature," *Didascalicon* i.x), to be sure, but by exalting the "intellectual creature" to a place of prior importance in creation and ascribing the "ousiai" to this creature's mind. See *De sacramentis* i.iv.26 (*PL*, CLXXVI, 246B–C; Deferrari, pp. 73–4); *De tribus diebus* xxv (*PL*, CLXXVI, 835B); and Appendix C, which, loosely appended to a whole class of *Didascalicon* MSS, may have been intended for revisionary insertion after the present chapter, the meaning of which it clarifies. On prelapsarian man as included in the term "rational creature" and as sharing knowledge of the "substances" of things, see *De sacramentis* i.vi.1, 12 (*PL*, CLXXVI, 263B–4C, 270C–D; Deferrari, pp. 93–5, 102). Hugh's alteration of John the Scot emphasizes the two postulates on which Hugh's educational theory rests—the rational creature's exclusive assimilation to the divine Wisdom, and its natural capacity to contain the rest of creation (cf. *Didascalicon* i.i). In a highly significant passage in *De sacramentis* i.v.3 (*PL*, CLXXVI, 247–8C; Deferrari, pp. 75–6) Hugh explains as follows (Deferrari's translation altered): "We read that only the rational creature was made in the likeness of God; it is not said that any other creature beside this one was so made, even though every creature has in the divine Idea and eternal Providence the cause and likeness out of which and according to which it is perfected in subsistence. But there is a great difference, a gap, between having a likeness in God and having God himself as one's likeness. ...It could not suffice for the rational creature to have in the divine Idea some one thing, this or that, for the exemplar to whose likeness it would be formed. Rather, the rational creature claimed all of God, so to speak, in order to be made in his image, and it was sent forth striving for God's total perfection. ...Through its striving and imitation, through its being an image and likeness, this second being contained all things that were in the First—ideas and causes and likenesses and forms, the dispositions and foreseeings of all future things which were to be made. And when the corporeal things to be made were actually made, they were made to the likeness of those things made in this second being, just as the latter was made in the likeness of the unmade things in the First. Thus, the corporeal creature is in third place, after the second or rational creature, because made with reference to the rational creature, just as the rational creature was made with reference to the First and uncreated Nature." The source of Hugh's teaching is Augustine *De Genesi ad litteram* ii.viii (*PL*, XXXIV, 269–70); cf. *De civitate Dei* xii.xvi (*PL*, XLI, 363–5, where the chapter is numbered "15"; *CSEL*, XL, 591–5). Cf. Chalcidius on the divine intelligences of the fixed stars and the aetherial daimons, "whom the Hebrews call holy angels" and in whom the divine Mind promulgates "Fate," or divine law for the governance of all things (Wrobel, pp. 195 ff.; Mullach, pp. 290 ff.).

43. Buttimer's punctuation of this sentence has been revised as follows: "...natura est, quae mundum continet omnem, idque in gemina secatur: est quiddam quod a causis suis primordialibus, ut esse incipiat, nullo movente, ad actum prodit solo divinae voluntatis arbitrio, ibique immutabile omnis

finis atque vicissitudinis expers consistit (ejusmodi sunt rerum substantiae quas Graeci ousias dicunt); et cuncta superlunaris mundi corpora, quae etiam ideo quod non mutentur divina appellata sunt." For key distinctions which make this punctuation of the passage necessary, see n. 38, 40, 42. On the heavenly bodies as divine, see, e.g., Mabrobius *In somnium Scipionis* I.xi.6 (Eyssenhardt, p. 528; Stahl, p. 131), and Chalcidius's commentary on the *Timaeus* (Wrobel, p. 195; Mullach, p. 209). Cf. Augustine *De civitate Dei* IV.xi and VII.xv (*PL*, XLI, 121–3, 206–7).

44. See Hugh's third definition of "nature," *Didascalicon* I.x.n.71. Cf. *Didascalicon* II.x.

45. "Nihil in mundo moritur" The "world," for Hugh, means more than the physical universe; it means all of creation (see n. 38). The source of the quotation may be Adelard of Bath *Quaestiones naturales* (Martin Müller, ed., *BGPM*, XXI [Münster, 1934], 9): "in hoc sensibile mundo nil omnino moritur," where, however, *sensibilis* indicates Adelard's restriction of "world" to the physical cosmos. Similarly restricted are William of Conches *Dragmaticon philosophiae* (G. Gratarolus ed. [Strasbourg, 1567], p. 233): "Nihil in mundo perire physica sententia est"; Macrobius *In somnium Scipionis* II.xii.13 (Eyssenhardt, p. 626; Stahl, p. 224): "nihil intra vivum mundum perire, sed ... solam mutare speciem"; and Servius *Comm. in Verg. Georg.* IV.ccxxvi (Georg Thilo, ed. [Leipzig, 1887], p. 337): "nihil enim est quod perire funditus possit."

46. Buttimer mistakenly places this explanatory clause within the preceding quotation.

47. On the stability of essences (and of forms "in their genera"), see further Hugh's *In Ecclesiasten homiliae* (*PL*, CLXXV, 215). On the passing away of forms, cf. Bernardus Silvestris *De mundi universitate* II.viii (Barach and Wrobel, p. 52).

48. Sallust *Bellum Jugurthinum* II.iii.

49. Ultimate source, Persius *Saturae* III.84. Probably taken by Hugh from Remigius of Auxerre's commentary on the *De consolatione philosophiae* (ed. Stewart, p. 39), where the line is quoted and correctly attributed to Persius.

50. Maximianus *Elegiae* I.222.

51. The reference is specifically to the contrast between perpetual and temporal being, developed in the last paragraph of the preceding chapter.

52. Chalcidius reports agreement of *mathematici* on the lunar sphere as the lowest among the heavenly spheres and notes the dependence of the sublunary world upon moon, sun, and planets for the regulation of time, seasons, climates, birth and death, growth and decay, and "every variety of interchange and local motion" (Wrobel, pp. 143–4; Mullach, p. 198). The special power of the moon over terrestrial bodies is discussed by Firmicus Maternus *Matheseos libri VIII* IV.i.1–10 (W. Kroll and F. Skutsch, ed., [Leipzig: B. G. Teubner, 1897], pp. 16–7), a work quoted extensively in the "Liber Hermetis Mercurii Triplicis de VI rerum principiis," a twelfth-century compilation which seems to have more than one source in common with Hugh (see n. 53). Closest as a whole to Hugh is Macrobius's division of the universe into fiery *aether*, where all is eternal, incorrupt, and divine,

and the sublunary region of earth, water, and air, where all is changing, corruptible, and mortal (*In somnium Scipionis* i.xxi.33; cf. *Somnium* iv.3 [Eyssenhardt, pp. 657, 577; Stahl, pp. 180–1, 73]), a division which both suggests the terms Hugh applies to the two regions in the present chapter and appears to underlie, in part, the special role he later assigns to aetherial fire (third definition of "nature," *Didascalicon* i.x.n.71). Cf. Hugh's constant, though corrective, refs. to Macrobius in the discussion of cosmimetry in his *Practica geometriae* (Roger Baron, ed., "Hugonis de Sancto Victore Practica geometriae: introduction, texte," *Osiris*, XII [1956], 212–24), where, moreover, he alludes (*ibid.*, p. 224) to an intended treatment of astronomy, either never written or since lost.

53. Contrasting with Hugh's use of the term "nature" (n. 38), the present use, taken from "astronomers," shows unmistakable relationship to the "Liber Hermetis Mercurii Triplicis" (Silverstein, ed., *AHDL*, XXII [1955], 217–302), which, citing the *De electionibus* of Zahel ben Bischr as saying that planets and signs of the zodiac "in naturalibus operantur," says further that this quality of the heavenly bodies "a philosophis *natura* dicitur, que iuxta varias vires suas in universis et singulis sub lunari globo variatur" (*ibid.*, p. 282). It is from it that the quality of temporal things is also called their "nature" (*ibid.*); proceeding from the divine Cause or Good (*Tugaton*) and the *Nous* or *Ratio*, the celestial "Nature" distributes to the inferior world of generation the essences of which *Nous* is the source, and in this sense establishes each thing's being and nature ("unicuique rei non solum esse sed etiam tale esse constituit") (*ibid.*, pp. 248–9). Not only Zahel but a pseudo-Pythagorean *Matentetraden* or *Liber quadrivii* may have been common sources for Hugh and the author of the "Liber Hermetis" (see n. 55). Found also in the Latin *Asclepius* i.iii (Nock, ed. p. 299, lines 3–15), the conception of a generating celestial Nature was assimilated in various ways to the Timaean world-soul by twelfth-century writers of Chartrian connection or spirit, as, e.g., Adelard of Bath *De eodem et diverso* (Willner, ed., pp. 15, 77–8); William of Conches and Thierry of Chartres (refs. cited in n. 10); Bernardus Silvestris (see Silverstein, "Fabulous Cosmogony," *MP*, XLVI [1948–9], 104–7 and notes); Alanus de Insulis (see de Lage, *Alain de Lille*, pp. 59–80). For occurrence of the conception in vernacular poetry, see Gérard Paré, *Les Idées et les lettres au XIIe siècle: Le Roman de la rose* (Montréal: Institut d'études médiévales Albert-le-Grand, 1947), ch.V, "La Confession de Nature," pp. 202–78. The doctrine of the world-soul Hugh explicitly rejects, interpreting the superlunary "nature" as an aetherial fire emanating principally from the sun (see n. 71) and attributing the distribution as well as the source of each thing's being and nature exclusively to the divine Mind or Wisdom (see n. 69; contrast Hugh's use of the phrase "non solum esse sed etiam talis esse" with that of the "Liber Hermetis.")

54. The phrase is from Chalcidius, where it is associated with the generative function of the world-soul (see n. 59).

55. Cf. "Liber Hermetis" (Silverstein, ed., *AHDL*, XXII [1955]), 268): "In the *Matentetrade*, mathematicians call the superlunary world 'time' because of the course and motion of the heavenly bodies; but they call the sub-

lunary world 'temporal' because the mutability of things below is directed according to the perpetual order of the things above." Striking coincidence in phraseology suggests either that the author of the "Liber Hermetis," dated by Silverstein tentatively between 1135–47, borrowed from Hugh or that both used the same source. In *Didascalicon* III.ii, Hugh speaks of Pythagoras as the author of "the *Matentetradem,* a book concerning the teaching of the quadrivium"; cf. the gloss on Silverstein's MS D1 (Bodleian, Digby 67, fol. 72ʳ): "i.e. liber de doctrina quadruvii [sic]." While this piece of information may represent an inference from a passage in Remigius of Auxerre's commentary on Martianus Capella (see *Didascalicon* III.ii.n.8), one cannot exclude the possibility that a book with this title and attributed to Pythagoras existed in Hugh's time and supplied both him and the "Liber Hermetis" author with the passage in question. See Silverstein's discussion ("Liber Hermetis," *AHDL,* XXII [1955], 224–5).

56. On the sublunary world as "underworld" and the superlunary world as "elysium," see Macrobius *In somnium Scipionis* I.xi,4–8 (Eyssenhardt, pp.527–9; Stahl, pp. 131–2); Cf. Abaelard *Theologia* I.xvii (*PL,* CLXXVIII, 1018A–B) and Bernardus Silvestris *Commentum super VI libros Eneidos Virgilii* VI (Guilielmus Riedel ed., [Greifswald: Typis Julii Abel, 1924], p. 29), who in turn follows William of Conches' commentary on the *De consolatione philosophiae*: "Philosophers have called this sublunary region 'infernum' because the lower part of the world is full of misery and sorrow" (cited in Jeauneau, "La Notion d'*integumentum,*" *AHDL,* XXIV [1957], 42).

57. The distinction between *intelligentia* and *scientia* derives from Hugh's view of the knowledge process. Twofold in nature, man descends to the world of corporeal objects through his wholly corporeal senses and imagination; he ascends to spiritual objects through the internal operation of his purely spiritual reason. When the reason turns "below" to examine sense impressions (*imaginationes*) critically, it is "informed" though clouded over by them, and the result is knowledge; when it turns "upward" toward spiritual objects and God, it operates with the concurrent aid of divine inspiration and revelation and is "illuminated" with "understanding." Further detail on the faculties and their objects, see n. 2; cf. refs. cited in n. 15, 23. See Augustine *De Trinitate* XII and XIV.i (*PL,* XLII, 997 ff.), where consideration of the exterior and interior operations of man leads to distinction between *scientia* as "actio qua bene utimur temporalibus rebus" (1009D) or "temporalium rerum cognitio intellectualis" (1012B), and *sapientia* as "aeternarum rerum cognitio intellectualis" (1012B), and where the distinction between *scientia* and *sapientia* is further related to a definition of wisdom as "knowledge of human and divine things."

58. On mechanical as "adulterate," see n. 64.

59. Adapted from Chalcidius's commentary on the *Timaeus* (Wrobel, p. 88; Mullach, p. 185). Hugh makes radical changes in the meaning of his source. In Chalcidius, the *opera Dei* are ascribed to the *summus Deus,* who founds all things according to the exemplary causes existing in his eternal Providence (πρόνοια) or Mind (νοῦς), and promulgates the law or "fate" of natural things in created intelligences subsisting visibly in the fixed stars of

the outer *ignis* ('ἀπλανῆ) and invisibly in the *daemones* or blessed angels of the *aether*. The *opera naturae* are the province of the *anima mundi*, a *secunda mens* and the substantial projection of God's law of "fate"; ruling all things according to their proper natures, the *anima mundi* may be called their "law." The *opera artificis*—human arts, disciplines, and the things effected with their aid—are regular and fruitful because, imitating nature, they too are ruled by the law, idea, and order of the *anima mundi* (for summary of these ideas, see Wrobel, pp. 225-7; Mullach, p. 219; for details, see antecedent discussion in Wrobel, pp. 195-225; Mullach, pp. 209-18). Hugh accepts the Chalcidian idea of the exemplary causes (see first definition of "nature", *Didascalicon* i.x.n.69) and their communication to the angelic intellect (see discussion of *ousiai*, n. 42), rejecting, however, the identification of angels with the heavenly bodies (*ibid.*). Among the *opera Dei* he includes the ordering and disposition of the movements of all things, which, in Chalcidius, were *opera naturae*; the *anima mundi*, in which certain of his contemporaries saw reference to the Holy Spirit (see n. 10), he altogether rejects, limiting the *opera naturae* to the sun's superintendence of growth and decay in terrestrial life (see third definition of "nature," *Didascalicon* i.x.n.71, and *In Ecclesiasten homiliae* [*PL*, CLXXV, 215-71]). The *opera artificis imitantis naturam* are associated not, as in Chalcidius, with the *anima mundi*, but with man's efforts, through the mechanical arts, to supply both the internal and external needs of his body (see *Didascalicon* II.xx). Somewhat more elaborate division of the *opera artificis* in *In Ecclesiasten homiliae* (*PL*, CLXXV, 215-7). An interpretation of the "three works," differing in detail from both Chalcidius and Hugh, is found in William of Conches' commentaries on the *Timaeus* (Parent, *Doctrine de la création*, p. 147) and on the *De consolatione philosophiae* (*ibid.*, pp. 127-8).

60. Gen. 1:1.

61. Gen. 1:11.

62. Gen. 3:7.

63. Luke 12:25.

64. Hugh associates "mechanical" with the Greek μοῖχος, Latin *moechus*, adulterer, rather than with μηχαγη, machine. Cf. Martin of Laon *Scholica graecarum glossarum* (M. L. W. Laistner, ed., "Notes on Greek from the Lectures of a Ninth Century Monastery Teacher," *Bulletin of the John Rylands Library*, VII [1922-3], 439): "'Moechus' means adulterer, a man who secretly pollutes the marriage bed of another. From 'moechus' we call 'mechanical art' any object which is clever and most delicate and which, in its making or operation, is beyond detection, so that beholders find their power of vision stolen from them when they cannot penetrate the ingenuity of the thing." Martin of Laon was a pupil of John the Scot and a teacher of Remigius of Auxerre, with whose works Hugh shows familiarity elsewhere in the *Didascalicon*. Sallust *Bellum Jugurthinum* XII.iii, uses the term *claves adulterinae*; see n. 48, for direct quotation of this work.

65. Ps. 103:10.

66. Comparable discussion of man's unarmed state in Adelard of Bath *Quaestiones naturales* (Müller, ed., *BGPM*, XXXI [1934], 19-21).

67. Cicero *De inventione* i.xxiv.34.

68. The passage which follows is a good example of the generalizing and schematizing habit of Hugh's mind. With his reduction of numerous current definitions of "nature" to three basic senses, cf. the more diffuse survey in John of Salisbury *Metalogicon* i.viii (Webb, pp. 23–4; McGarry, pp. 28–9).

69. This conception of nature, associated by Augustine with the teaching of Socrates (*De civitate Dei* viii.iii; note esp. the reference to "the Nature which is unchangeable Light, where live the causes of all created natures"), is recognizable also in the eternal pattern of the world in Timaeus 28, and in subsequent Neoplatonic discussions of *Nous* (e.g. in Macrobius *In somnium Scipionis* i.ii.14–17, i.xiv.5–15 [Eyssenhardt, pp. 482–3, 539–42; Stahl, pp. 85–6, 143–5], and in Chalcidius [Wrobel, pp. 27, 90–1, 534; Mullach, pp. 159, 186, 251]); it found its biblical counterpart in the concept of *sapientia* set forth in Wisd. 7:22–8:1; Eccli. 1:1–10, 24:5–14; Prov. 8:22–30; and in scattered places in the Psalms (see O. S. Rankin, *Israel's Wisdom Literature* [Edinburgh: T. and T. Clark, 1954], ii, 222–64 and notes). Neoplatonic literature and the sapiential books of the Old Testament are the two principal sources from which the idea enters the writings of the Christian Fathers, who employ it in their interpretations of the biblical Hexaemeron and the Joannine prologue especially. Thus, in their exegesis of Gen. 1:1 ("In principio creavit Deus caelum et terram"), *principium* was frequently identified with the divine Son, Wisdom, or Mind, and *caelum et terram* with the archetypal exemplars of spiritual and corporeal nature produced from all eternity within the Son (so, e.g., Augustine *De diversis quaestionibus* i.i, "De ideis," [*PL*, XL, 30–1]; cf. the discussion of Gen. 1:1 in Chalcidius [Wrobel, pp. 306–10; Mullach, pp. 240–1]). This interpretation of Genesis was reinforced not only by the passages from the sapiential books cited above but by John 1:1–4, in which the reading preferred by Augustine and given currency in the West by his authority ("In principio erat Verbum.... *Quod factum est in ipso vita erat*"), led to the interpretation of *vita* as that formal principle, within the living Wisdom, according to which all things were created (see Augustine *In Joannis evangelium* tractatus i.xvi–xvii [*PL*, XXXV, 1387]; see also n. 1). Occurring also in the commentary tradition on Boethius *De consolatione philosophiae* iii.m.ix (in addition to the commentaries of Remigius of Auxerre and John the Scot cited in n. 1, see that of Adalbold of Utrecht in E. T. Silk, "Pseudo-Johannes Scottus, Adalbold of Utrecht, and the Early Commentaries on Boethius," *MRS*, III [1954], 17, or in R. B. C. Huygens, "Mittelalterliche Kommentare zum *O qui perpetua*," *SE*, VI [1954], 414: "Et quid est mens Dei nisi Filius Dei, per quem et a quo facta sunt omnia, et in quo omnia quae facta sunt, sunt et vivunt, sicut scriptum est, 'Quod factum est in ipso vita erat'?"; and of William of Conches, in Parent, *Doctrine de la création*, 128–30), the concept found lengthy theoretical elaboration in the ninth century in John the Scot's discussion of "universalis natura quae et creatur et creat et in primordialibus causis constituta est" (*De divisione naturae* ii.xv–xxii [*PL*, CXXII, 545C–66D]; see n. 42). On the concept as transmitted from John the Scot to Bernard and Thierry of Chartres and William of Conches, see Parent,

Doctrine de la création, pp. 44–58. Interspersed in Abaelard's controversial account of pre-Christian allusions to the Trinity in the Law, the Prophets, and the pagan philosophers are references to this concept which form a convenient catalogue of *loci* cited repeatedly throughout the twelfth century; see *Theologia christiana* i.iii–v and *Theologia* i.xiii–xxiv (*PL*, CLXXVIII, 1126D–66B, 998C–1034D). Hugh's "whence each thing takes not only its being but its 'being such or such a thing'" is found also in the "Liber Hermetis," where, however, the "nature" meant is a cosmic or astronomical agency mediating between the divine Mind and the world (see n. 53).

70. Adapted from Boethius *Contra Eutychen* i (*PL*, LXIV, 1342B).

71. "Natura est ignis artifex, ex quadam vi procedens in res sensibiles procreandas." Ultimate source, Cicero *De natura deorum* ii.xxii: "Zeno igitur naturam ita definit ut eam dicat ignem esse artificiosum, ad gignendum progredientem via. ...natura non artificiosa solum sed plane artifex ab eodem Zenone dicitur." For an instance of direct knowledge of the *De natura deorum* in the twelfth century, see Theodore Silverstein, "Adelard, Aristotle, and the *De natura deorum*," *CP*, XLVII (1952), 82–6. Hugh's phrasing, however, suggests that he drew from Victorinus *Expositio in librum De inventione* ad i.xxiv: "natura est ignis artifex quadam via vadens in res sensibiles procreandas" (in Carolus Halm, ed., *Rhetores latini minores* [Leipzig: B. G. Teubner, 1863], p. 215, or J. C. Orellius, ed., *M. Tullii Ciceronis opera*, V [Turici, 1833], p. 70). Cf. John of Salisbury *Metalogicon* i.viii (Webb, p. 24; McGarry, p. 29), where a further variation of the passage appears. Citing the definition in his exegesis of Eccl. 1:5–6 ("Oritur sol et occidit. ...Pergit spiritus et in circulos suos revertitur"; *In Ecclesiasten homiliae* [*PL*, CLXXV, 136C–7C]), Hugh locates the *ignis artifex* in the sun, ascribing to its emanations the fostering of vegetative and sense-endowed life; for discussion of the quasi-spiritual nature of aetherial fire and its special mediating function between senses and reason (via imagination) in man, see Hugh's *De unione corporis et spiritus* (*PL*, CLXXVII, 286A–C); cf. Kleinz, *Theory of Knowledge of Hugh of St. Victor*, pp. 37–9. Hugh rejects explicitly the "opinion of those erring persons" who regard the cosmos as animated by a world-soul (*In Ecclesiasten homiliae*, loc. cit.), alluding particularly, it seems, to his contemporaries Adelard of Bath (see *De eodem et diverso* [Willner, ed. p. 15]) and William of Conches (see commentary on the *Timaeus* [Parent, *Doctrine de la création*, p. 166] and on the *De consolatione philosophiae* [Jourdain, "Commentaires inédits," pp. 75–61]), where William argues that it is false to locate the animating principle of the cosmos in the sun. Note Remigius of Auxerre's commentary on *De consolatione* iii.m.ix (Stewart, p. 32; Silvestre, p. 58): "Philosophers say that the sun is the world-soul because, just as the soul gives heat to the body, so the sun's heat vivifies all things and, suffused through all creatures, brings them into being; in fact, physicists claim that by this heat, in conjunction with moisture, all things both beget and are begotten, God so disposing." Antecedents of Hugh's and Remigius's position in the Latin *Asclepius* i.ii (Nock, p. 298, lines 5–11), which presents fire as the generating agency by which the *caelum*

or *natura* vivifies the air, water, and earth below; Macrobius *In somnium Scipionis* I.xxi.35 (Eyssenhardt, p. 578; Stahl, p. 181), which declares that "earth, water, and air, lying beneath the moon, are unable to produce a body capable of sustaining life but need the help of aetherial fire, which supplies to earthly members their power to support life and soul"; similarly, Macrobius, *ibid.*, I.xx.7 (Eyssenhardt, p. 565; Stahl, p. 169) speaks of the sun as the source of aetherial fire, mind of the universe, and heart of heaven, a passage to which Chalcidius apparently refers when reporting that some persons regard the sun as the vital source of the world soul (Wrobel, p. 170; Mullach, p. 240). In rejecting the world soul in favor of solar fire, Hugh belongs, in one sense, to the conservative tradition represented by the ninth-century Bovo of Corvey, who was scandalized to find the world-soul in Boethius (see *In Boethii De consolatione* III.m.ix *commentarius* [*PL*, LXIV, 1239 ff.]); and the eleventh-century Manegold of Lautenbach, connected with the Victorines as teacher of William of Champeaux, and who regarded Chalcidius and Macrobius as fertile sources of heresy (*Opusculum contra Wolfelmum coloniensem* (*PL*, CLV, 149 ff.]). In another sense, Hugh went beyond their conservatism by using the very texts and authorities to which they object, but giving them a different meaning (see Introduction, sec. III). Hugh goes farther than Augustine, who suspended judgment on the world-soul for lack of knowledge (*Retractationes* I.xi.4; cf. *De ordine* II.xi; *De immortalitate animae* xv.xxiv; *De musica* VI.xiv.44), and Jerome, who is noncommital (*Commentariorum in Isaiam prophetam libri XVIII* xvi [*PL*, XXIV, 558A–B]); he also departs from the cosmology of Victorinus himself, though using his words, and resembles John the Scot (cf. E. and R. von Erhardt-Siebold, *Cosmology in the Annotationes in Marcianum: More Light on Erigena's Astronomy* [Baltimore, 1940], p. 41: "...the sun holds in Erigena's system of cosmogonic powers a position similar to that of the Lower Logos, the *Anima Mundi*, in the Christian-neoplatonic theology of Marius Victorinus Afer"). Hugh's position may have been influenced by pseudo-Dionysius, who describes fire as "having power over all things and ability to move to its proper action whatever comes to be in them" (see Hugh *Expositio in Hierarchiam coelestem* [*PL*, CLXXV, 1331A]).

72. Hugh discusses the generating properties of heat and moisture at some length in *In Ecclesiasten homiliae* (*PL*, CLXXV, 137C–8D). See also Macrobius *In somnium Scipionis* II.x.10–2 (Eyssenhardt, pp. 618–9; Stahl, p. 218), where aetherial fire is said to feed upon moisture.

73. Vergil *Georgica* IV.382. Cited also by Thierry of Chartres *De sex dierum operibus* (Häring, ed., p. 194).

74. Hugh's source appears to be Remigius of Auxerre's commentary on Martianus Capella, Bibliothèque Nationale, MS Latin 14754, fol. 10v–11r: "[Iupiter] unus idemque non solum diversis nominibus sed et vario sexu appellatur, iuxta illum versiculum Valerii Sorani: Iuppiter omnipotens rerum regumque creator, Progenitor genitrixque deum, deus unus et idem. ...Ipse est enim ignis aethereus qui nunquam de sede aetheris descendit." In Augustine *De civitate Dei* VI.ix, xi, xiii the same verses are quoted and Varro's interpretation of them given, but without relating Jupiter to

aetherial fire. In the Latin *Asclepius* III.xx–xxi (Nock, pp. 321–2), the "god and father of all things" is said to be "filled with the fertility of both sexes."

75. Quoted from Boethius *Commentaria in Porphyrium a se translatum* II (*PL*, LXIV, 73A–B; *CSEL*, XLVIII, 139). Another translation of the Boethius passage by Richard P. McKeon, *Selections from Medieval Philosophers*, I (New York: Charles Scribner's Sons, 1929), 73 f.

76. By contrast, Adelard of Bath *De eodem et diverso* (Willner, ed., p. 18) credits grammar with making speech possible for men, who "at first roamed the fields like beasts, without mutual intercourse and with their reason silent."

77. Another translation of the previous paragraph in Ernest A. Moody, *Truth and Consequence in Modern Logic* (Amsterdam, 1953), pp. 13–4.

78. Cf. Cicero *De oratore* I.xlii.187–8: "Almost all things now comprehended in the arts were once scattered and disordered. So in music,... in geometry,... in astronomy, ... in grammar, all these things seemed unknown and without order. A certain art was therefore imposed on them from without... to tie together the disconnected and fragmentary material and delimit it in some kind of rational order."

79. This verse, comprising line 47 of the Pythagorean *Aureum carmen*, is quoted in Porphyry's *Life of Pythagoras*, whence, according to Courcelle, *Lettres grecques*, p. 25, n. 4, it was taken by Macrobius *In somnium Scipionis* VI.xli (Eyssenhardt, p. 504; Stahl, p. 107), whose Latin and whose association of the number with the soul Hugh follows. Text of the *Aureum carmen* in F. Mullach, *Fragmenta philosophorum graecorum*, I, 416–84, together with the fifth-century commentary of Hierocles of Alexandria, which, however, sheds no light on Hugh's further elaboration of the *quaternarium animae* and *quaternarium corporis* in *Didascalicon* II.iv–v.

BOOK TWO

1. Quoted from Boethius *In Porphyrium dialogi* I.iii (*PL*, LXIV, 10D; *CSEL*, XLVIII, 7). See *Didascalicon* I.ii.n.21.

2. On permanence in the things studied by the arts, see Boethius *De arithmetica* I.i (*PL*, LXIII, 1079D): "Wisdom is the grasp of the truth of those things which truly exist and are of themselves endowed with unchangeable substance" (see *Didascalicon* I.ii.n.20); cf. Remigius of Auxerre, commentary on *De consolatione philosophiae* I.pr.i (Stewart, p. 26): "...the seven liberal arts... will never perish in any way, for even if knowledge should fail, the knowable will always exist." On permanence in the arts themselves, see Cassiodorus *Institutiones* II.iii.22 (Mynors, p. 131; Jones, p. 179): "They [the sciences] are neither increased by expansion nor diminished by contraction nor modified by any changes but abide in their own proper nature and observe their own rules with indisputable constancy"; and Adelard of Bath *De eodem et diverso* (Willner, ed., p. 4 and p. 39, n. 1), where Philosophia and her arts are identified with the Platonic *idem*, Philo-

cosmia (love of the world) with the *diversum*. For Hugh, the ultimate concern of the arts is with the changeless archetypal patterns in the divine Wisdom, to whose likeness the arts restore man.

3. The arts intend restoration of the radical cognitive good lost to man through the fall—knowledge of his Creator, of himself, of things created with and for himself, and of things he is to make with these last. See *De arca Noe morali* prologus (*PL*, CLXXVI, 619). Cf. *In Ecclesiasten homiliae* (*PL*, CLXXV, 197A–B), where man's lost contemplation of the divine Wisdom is said to make its pursuit in this life incumbent on all, and *De sacramentis* I.vi.12, "On man's knowledge before sin" (*PL*, CLXXVI, 270D; Deferrari, p. 102).

4. Quoted from Cassiodorus *Institutiones* II.iii.5 (Mynors, p. 110; Jones, p. 160) or Isidore *Etymologiae* II.xxiv.9.

5. Quoted from Isidore *Etymologiae* I.i.2.

6. "disciplina, quae dicitur plena" Hugh's text changes the sense of the source, Cassiodorus *Institutiones* II.ii.17 (Mynors, p. 109; Jones, p. 158): "Disciplina enim dicta est quae discitur plena"; cf. Isidore *Etymologiae* I.i.1: "Disciplina a discendo nomen accepit. ... Nam scire dictum a discere, quia nemo nostrum scit nisi qui discit. Aliter dicta disciplina quia discitur plena." Cf. Hugh's definition of philosophy, *Didascalicon* I.iv, as "disciplina...*plene* investigans."

7. "ut est in doctrina" Cf. *Didascalicon* II.iii: "Mathematica autem doctrinalis scientia dicitur." Following Boethius, *doctrina* became the traditional name for mathematics, its sense being variously explained. See, e.g., Hugh *Epitome* (Baron, ed., p. 112): "The first theoretical art is mathematics, which is called 'instructional' because, by the start it makes, it forms contemplation and constitutes the approach to instruction concerning hidden things, or, because it accompanies its arguments with visible figures set forth for instruction." Cf. William of Conches' commentary on the *Timaeus* (*PL*, CLXXII, 250), on the *De consolatione philosophiae* (Jourdain, "Commentaires inédits," p. 73), and the *brano* (Ottaviano, p. 26), the latter of which adds: "Mathematics is 'instructional'... because through instruction in numbers, proportions, and other matters taught in the quadrivium, knowledge of the Creator and his creatures is prepared for us, or because this science is the way to physics and theology, since it treats the exemplary numbers of things and the invisible forms of visible things, whereas physics treats the invisible causes of visible things, and theology invisible essences." For an arithmological treatment of the procession of the divine Wisdom from the Father and of creation, see Thierry of Chartres *De sex dierum operibus* (Häring, ed pp. 137–216). Underlying the view that mathematics and theology are closely related are such texts as Boethius *De arithmetica* II.ii (*PL*, LXIII, 1083D): "Whatever things were constructed by the primeval Nature of things were formed according to the pattern of numbers"; and Macrobius *In somnium Scipionis* I.v.3 (Stahl, p. 95; translation altered): "Not without reason did he attribute fulness to numbers, for fulness properly belongs only to things divine and heavenly. ... This, therefore, is the common fulness of all numbers, that to our thought as it passes from ourselves to heavenly

things, they represent the first degree of abstraction belonging to incorporeal being."

8. Adapted from Isidore *Etymologiae* i.i.3; cf. Cassiodorus *Institutiones* ii.ii.17 (Mynors, p. 108; Jones, p. 158).

9. Quoted from Isidore *Etymologiae* ii.xxiv.9 or Cassiodorus *Institutiones* ii.iii.5 (Mynors, p. 110; Jones, p. 160), and particularly apposite to Hugh's thought when taken in conjunction with Macrobius's explanation, *In somnium Scipionis* i.xiii.5–7 (Stahl, pp. 138–9): "...Plato...in his *Phaedo* (64A, 67D) lays down the rule that a man must not die of his own volition. And yet in the same dialogue he also says that philosophers ought to seek after death, and that philosophy is itself a meditation upon dying. These statements seem to be contradictory but are really not so, for Plato acknowledged two deaths in a man. ...Man dies when the soul leaves the body in accordance with the laws of nature; he is also said to die when the soul, still residing in his body, spurns all bodily allurements under the guidance of philosophy, and frees itself from the tempting devices of the lusts and all the other passions. This is the death which, as we pointed out above, proceeds from the second type of those virtues which befit only philosophers." The virtues alluded to are the "cleansing virtues...found in the man who is capable of attaining the divine. They release the minds only of those who have resolved to cleanse themselves from any contamination with the body, and by an escape from mortal things, as it were, to mingle solely with the divine" (*ibid.*, i.viii.8 [Stahl, p. 122]). Cf. Abaelard *Theologia christiana* ii (*PL*, CLXXVIII, 1185).

10. Cf. *Didascalicon* i.iv.n.27.

11. Buttimer's punctuation altered.

12. Cf. William of Conches' commentary on *De consolatione philosophiae* (Jourdain, "Commentaires inédits," pp. 72–3): "There are *two* species of knowledge: wisdom and eloquence. ...These two are called the species of knowledge because in them is all knowledge." When explained, this contrast between Hugh and William sets their respective mysticism and naturalism in strong relief. See Introduction, sec. ii.

13. See *Didascalicon* i.ix.n.64.

14. See *Didascalicon* i.xi.

15. Quoted from Boethius *In Porphyrium dialogi* i.iii (*PL*, LXIV, 11C; *CSEL*, XLVIII, 8).

16. Quoted from Isidore *Etymologiae* ii.xxiv.13 or from Isidore's source, Cassiodorus *Institutiones* ii.iii.6 (Mynors, p. 111; Jones, p. 160, where, however, the passage is incorrectly translated).

17. See n. 7.

18. At the basis of the distinction are the Greek μάθησις, knowledge, and ματαιότης, vanity. For refs. and discussion. see Lynn Thorndyke, *A History of Magic and Experimental Science*, II (New York: Macmillan, 1929), 11, n. 3; and Paré, Brunet, Tremblay, *Renaissance du XIIe siècle*, p. 177, n. 1. To the refs. cited in these sources, add Augustine *De doctrina christiana* ii.xxi, where superstitious *mathematici* are explicitly named. On the distinction in William of Conches, see Heinrich Flatten, *Die Philosophie des Wilhelm von Conches*

(Coblenz: Görres-Druckerei, 1929), p. 23; and in Clarenbaldus of Arras, see Wilhelm Jansen, *Der Kommentar des Clarenbaldus von Arras zu Boethius de Trinitate* ("Breslauer Studien zur historischen Theologie," III; Breslau: Kommissionsverlag Müller u. Seiffert, 1926), p. 38.

19. Quoted from Cassiodorus *Institutiones* II. Praefatio. 4; II.iii.6; or II.iii.21 (Mynors,pp. 92, 111, or 130; Jones, pp. 160 and 179, where, however, the passage is mistranslated). Cf. Isidore *Etymologiae* II.xxiv.14; and III. Praefatio.

20. Quoted from Boethius *In Porphyrium dialogi* i.iii (*PL*, LXIV, 11C; *CSEL*, XLVIII, 8).

21. "quo amittit" in both Buttimer's text and Migne's. The sense, however, requires *admittit (ammittit)*.

22. "compositionis rationem" See *Didascalicon* I.i.n.13.

23. Cf. Macrobius *In somnium Scipionis* i.xiv.7–9 (Eyssenhardt, p. 540; Stahl, pp. 143–4, where, however, *patrem* is mistakenly read for *partem*; translation here corrected): "The soul acquires that part to which it gives its attention, and, when its attention little by little retreats toward the bodily structure, the soul, itself incorporeal, degenerates. ...Degenerating toward lower and earthly things, it discovers that the weakness of perishable bodies cannot sustain the pure divinity of mind." Though Macrobius here treats the world soul's descent from contemplation of *Nous* to the animation of the physical universe, Hugh, as before with passages from the *Timaeus* and *De consolatione philosophiae* (see *Didascalicon* I.i.n.8, 10), adapts the material to the human soul in its dual relationship to the divine Mind and the body. Cf. *In Ecclesiasten homiliae* (*PL*, CLXXV, 156C–7A), and Boethius *De consolatione philosophiae* v.pr.ii: "Human souls are necessarily more free when they preserve themselves in contemplating the divine Mind, less so when they lapse toward the bodily, still less when they are bound down by earthly limbs."

24. Buttimer's *invisibiles corporum formas* corrected to *in visibiles corporum formas*, as required by sense.

25. With this chapter's arithmological conception of the *quaternarium animae*, clearly attributed by Hugh to others (see concluding sentence of this chapter: "some men think"), cf. his own interpretation of the *quaternarium* as the four major categories of the arts in *Didascalicon* I.xi, an interpretation also found in his earlier *Epitome* (Baron, ed., p. 108): "Ancient authority defined the first and principal parts of philosophy as four, and therefore ordained that the number 'four' be venerated in an oath; from this 'four' rises the shrine of Wisdom, built by philosophy in the recesses of the rational soul, and every building is obviously constructed with a four-sided plan." Despite the reminiscence of Vitruvius *De architectura* III.i in the last part of the statement and the resemblances to Macrobius and others indicated in the notes to this chapter, neither the *Epitome's* "ancient authority" for the fourfold division of philosophy nor the present chapter's "some men," proponents of the arithmological interpretation of the *quaternarium*, can be identified. They are not to be found in the published commentaries of Dunchad, John the Scot, Remigius of Auxerre, Bovo of Corvey, Adalbold

of Utrecht, or William of Conches on the *Timaeus* or *De consolatione philosophiae*, nor in Hugh's own copy of the Remigius commentary on Martianus Capella (Bibliothèque Nationale, MS Latin 14754). Most likely source would seem to be an as yet unknown Carolingian commentary on one of the above, or perhaps more likely, on Macrobius *In somnium Scipionis* i.v–vi, which treat the numbers of the Pythagorean decade and cite the oath to which Hugh refers, or i.ix–xiv, which treat the heavenly origin, descent into the body, and reascension of man's soul, sections repeatedly quoted during the Middle Ages. Ignoring the latter section, M.-D. Chenu, "Platon à Citeaux," *AHDL*, XXI (1954), 99–106, suggests only Macrobius i.v–vi as ultimate source of Hugh's arithmology and calls attention to the use, ca. 1151, of *Didascalicon* ii.iv by Nicholas of Clairvaux, whose interest in the material, like Hugh's, he characterizes as "à la faveur et pour le besoin de perceptions religieuses," in contrast to the Chartrian interest in arithmology, which he calls "une studiosité scolaire, avec le caractère objectif et technique que procure la lecture des textes" (*ibid.*, p. 104). Chartrian arithmology, while it affords certain striking parallels with the present chapter, as suggested in the notes immediately following, is concerned not with man but with the world-soul (as in William of Conches) or with the arithmetical rationalization of the relations of Father and the divine Wisdom, or Son (as in Thierry of Chartres). By the different contexts in which the ideas common to Hugh and the Chartrians appear, the distinctiveness of the Victorine and Chartrian schools is emphasized. On Hugh's interpolation of this chapter on the soul into the discussion of mathematics, cf. Macrobius *In somnium Scipionis* i.vi.5 (Eyssenhardt, p. 496; Stahl, p. 100): "wise men have not hesitated to proclaim... that the soul is a number moving itself."

26. The arithmetical series which, in this and the following chapter, represent the progressions of soul (1–3–9–27–81) and body (2–4–8–16–32) suggest extensions of the so-called lambda diagram commonly found in commentaries on the *Timaeus* 35A ff., a passage which, as interpreted by Macrobius i.vi.2 (Eyssenhardt, p. 495; Stahl, p. 99), teaches "that God, who made the world-soul, intertwined odd and even in its makeup: that is, used the numbers 'two' and 'three' as a basis, alternating the odd and even numbers from two to eight and from three to twenty-seven." The diagram is described further in Macrobius i.vi.45–6 (Eyssenhardt, p. 505; Stahl, pp. 108–9) and Chalcidius (Wrobel, pp. 98–9; Mullach, p. 188); it is reproduced by William of Conches in his commentary on the *Timaeus* (see Jeauneau, "La Notion d'*integumentum*," *AHDL*, XXIV [1957], 89), where the linear, square, and cube numbers in both series are regarded as symbolizing the world-soul's power to move body in all three dimensions.

27. Cf. William of Conches' commentary on the *Timaeus* 35B (see Jeauneau, "La Notion d'*integumentum*," *AHDL*, XXIV [1957], 89): "The number 'one' appears in the composition of the [world] soul in order, by its own indivisibleness, to symbolize the indivisibleness of the soul's essence." See also Macrobius *In somnium Scipionis* i.vi.7–9 (Eyssenhardt, pp. 496–7; Stahl, pp. 100–1), who, referring the number "one," or monad, primarily to

the supreme God and the divine Mind, attributes it as well to the [world] soul, "free from contamination with anything material ... and endowed with a simple nature," and man's soul (*ibid.*, I.xii.5 [Eyssenhardt, p. 531; Stahl, p. 134]); cf. *ibid.*, I.xii.6 (Eyssenhardt, p. 531; Stahl, p. 135): "Souls, whether of the world or of the individual, will be found to be now unacquainted with division if they are reflecting on the singleness of their divine state, and again susceptible to it when that singleness is being dispersed through the parts of the world or of man." Cf. Boethius *De unitate et uno* (*PL*, LXIII, 1075D f.): "'One' descends from the first One which created it. ... For the nearer each 'one' is to that first and true One, the more one and simple will be the matter it forms; conversely, the farther it is from that first One, the more multiplied and complex it will be... so that as a 'one' descends from higher to lower, degeneration takes place."

28. Cf. William of Conches' commentary on *Timaeus* (in Jeauneau, "La Notion d'*integumentum*," *AHDL*, XXIV [1957], 90): "Even number, which can be divided into two equal parts, refers to dissoluble things, while odd number, which cannot be divided into equal parts, refers to indissoluble things"; and Thierry of Chartres *De sex dierum operibus* xxx (Häring, ed., p. 194) and *Librum hunc* (Jansen, ed., p. 12), where the number "two" is said to be the principle of all otherness and mutability and to represent matter, according to Plato and Pythagoras.

29. The term "monad" is found in Macrobius, who, applying it both to the world-soul and to the human soul (see ref. in preceding note), declares further (*ibid.*, I.vi.42 [Eyssenhardt, p. 504; Stahl, p. 108]) that the number "three" marks the three divisions of soul into *cupiditas, animositas,* and *ratio.* Cf. Chalcidius (Wrobel, pp. 230–3; Mullach, pp. 220–1), whose *cupiditas, iracundia,* and *ratio* are closer to Hugh's *concupiscentia, ira,* and *ratio.* Identical with Hugh, however, in terminology and in transference of world-soul materials to man is Remigius of Auxerre, commentary on *De consolatione philosophiae* III.m.ix (Stewart, p. 33; Silvestre, p. 61): "This smaller world man], then, has a soul of threefold nature. It is wrathful, concupiscible, and rational—wrathful that it may be filled with wrath by the vices and pleasures of the body; concupiscible that it may love God and seek the virtues; rational that it may be able to distinguish between Creator and creature, good and evil."

30. See *Didascalicon* II.xii.

31. Cf. Hugh's exegesis of Eccl. 1:13 in *In Ecclesiasten homiliae* (*PL*, CLXXV, 155D, 156C–7A): "Because the sons of men were unwilling to stand fast in the Truth, they now become distended and divided into a multiplicity of parts and occupied with vanity. ... For since the mind of man would not remain in that one Good in whom it could rest happily and possess the fulness of the highest Truth without being pulled asunder and without dissipation, it was cast outside itself and scattered abroad upon the multiplicity of visible things."

32. Cf. Macrobius *In somnium Scipionis* I.xii.17 (Eyssenhardt, p. 538; Stahl, p. 137): "Be not disturbed that in reference to the soul, which we say is immortal, we so often use the term 'death'... for when it has rid itself

completely of all taint of evil and has deserved to be sublimated, it again leaves the body and, fully recovering its former state, returns to the splendor of everlasting life."

33. Ps. 89:10.

34. See *Didascalicon* I.xi.n.79.

35. See n. 28.

36. *Ibid.*

37. Cf. *De unione corporis et spiritus* (*PL*, CLXXVII, 287B ff.), where Hugh explains that the forms of sensible things, drawn into the eyes by the rays of vision and passing through the seven *tunicae* and three *humores* of the eyes, enter the cerebrum, or *cella phantastica*, of the brain, where they become *imaginationes*. The other senses, similarly "informed" by physical objects, introduce the forms of those objects "by hidden channels" into the *cella phantastica*. The *imaginationes* so formed are purely corporeal and are possessed by brute animals as well as man. In man, however, passing into the middle part of the brain, they are sufficiently purified and spiritualized by the reason to "touch the very substance of the rational soul." Reason, like a light, makes clear and well defined what an "imagination" presents to it; an "imagination," on the other hand, darkens and cloaks the reason—"insofar as it comes upon it, it clouds, and overshadows, and enwraps, and covers over the reason." If reason merely contemplates its "imaginations" in order to form knowledge (*scientia*) from them, it wears them like garments easily cast off. If, however, it clings to them with love, then they adhere to it like a skin which cannot be stripped off without pain, so that even souls separated from the body can be held in the grip of corporeal impressions (*passiones*) because not yet cleansed from affection for them. But the primary movement of the reason should be upward toward God, who, working along with the reason and informing it from above and within, produces *understanding* within it, in contrast with "imaginations," which, informing the reason from below and without, produce *knowledge*. To the physiology of sense perception, emanating from Constantine the African and found also, e.g., in William of Conches *Philosophia mundi* IV.xxiv–xxvi (*PL*, CLXXII, 95A–6C), Hugh characteristically adds the concluding emphasis on the upward orientation of the reason toward God. For identification of "knowledge" with the mechanical arts and "understanding" with the theoretical and practical arts, see *Didascalicon* I.viii. n. 57.

38. Compare this entire chapter with Boethius *De arithmetica* I.i (*PL*, LXIII, esp. 1081A–B), with which it has many verbal parallels.

39. Cf. William of Conches' commentary on *De consolatione philosophiae* I.pr.i (Jourdain, "Commentaires inédits," p. 73) for a closely comparable discussion of the four branches of mathematics. It is characteristic that William's discussion of mathematics should be interpolated into a literary commentary, while Hugh's appears in a textbook on the arts.

40. See Cora E. Lutz, ed., *Iohannis Scotti Annotationes in Marcianum* (Cambridge, Mass.: Mediaeval Academy of America, 1939), pp. 89, 152, for translation of ἄρης as *virtus* and ῥυθμός as *numerus*. Cf. William of Conches' commentary on *De consolatione philosophiae* I.pr.i (Jourdain, "Commentaires

inédits," p. 73): "arithmetic treats multitude in itself, that is, the power of numbers."

41. Cf. Boethius *De arithmetica* i.ii (*PL*, LXIII, 1083B): "Whatever things were constructed by the primeval Nature of things were formed according to the pattern of numbers. For this was the principal exemplar in the Mind of the Creator." Cf. Thierry of Chartres *De sex dierum operibus* xxxvi (Häring, ed., p. 196): "But the creation of numbers is the creation of things"; and xliii (*ibid.*, p. 198): "Just as all things derive their existence from the One, so from the One Equal to the One [the divine Mind or Wisdom] proceed the form, mode, and measure of each thing. ... Therefore, as the One Equal to the One contains within himself and generates from himself the ideas of all things, so does he contain within himself and bring forth from himself the very forms of all things... [together with] all proportions and inequalities. And all things resolve themselves into him." Cf. Häring's discussion of the passage and speculation on its relation to a possible medieval translation of Plato's *Parmenides* (*ibid.*, pp. 160–9).

42. Cf. Georgius Henricus Bode, ed., *Scriptores rerum mythicarum latini tres* (Cellis, 1834), p. 213: "Sane *moys* Graece *aqua* dicitur; inde Musa quasi *aquatica*. Aer enim per arterias canentis egrediens, humore aspergitur, nec umquam per gutturis fistulam nisi humoris adjutorio canitur. Secundum Varronem etiam ipsae sunt Musae quae et Nymphae; nec, ut ait Servius, immerito. Nam aquae, inquit, sonus musicen efficit, ut in hydraulis, id est aquaticis organis, videmus." Completely different derivation of "music" in Cassiodorus *Institutiones* ii.v.1 (Mynors, p. 142; Jones, pp. 189–90) and Isidore *Etymologiae* iii.xv.1.

43. Entire chapter related to Cassiodorus *Institutiones* ii.vi.1 (Mynors pp. 150–1; Jones, pp. 197–8), or Isidore *Etymologiae* iii.x.1–3.

44. Cf. Isidore *Etymologiae* iii.xxvii, which, however, is too brief to be the source of Hugh's chapter. Same distinction between the natural and superstitious aspects of astrology in Abaelard *Expositio in Hexaemeron* (Victor Cousin, ed., *Petri Abaelardi opera*, I [Paris, 1849], 649–51). Cf. Augustine *De diversis quaestionibus*, "Contra mathematicos" (*PL*, XL, 28D–9A).

45. Cf. the distinction between true and superstitious mathematics in *Didascalicon* ii.iii; see also i.viii, where Hugh attributes to "mathematicians" the distinction between superlunary and sublunary worlds.

46. The terminology of this chapter is explained and illustrated briefly in Isidore *Etymologiae* v.i–viii, and in detail in Boethius *De arithmetica* i.iii–xvii (*PL*, LXIII, 1083–96).

47. Entire chapter digested from Boethius *De musica* i.ii (*PL*, LXIII, 1171D f.) Adelard of Bath seems to have drawn on the same source in the *De eodem et diverso* (Willner, ed., p. 27).

48. Lucan *Pharsalia* ii.384–7. Cf. *In Ecclesiasten homiliae* (*PL*, CLXXV, 157B–C), where inordinate concern with supplying the needs of this life, identified with the "evil" of Matt. 6:34 ("Sufficient for the day is the evil thereof") and associated, therefore, with the vain solicitudes for food, drink, and clothing of the Sermon on the Mount, is said to be second only to inordinate zeal for knowledge as an *occupatio*, that is, "a distraction and binding

down of minds, diverting, dissipating, and trapping souls, so that they cannot think the things of salvation."

49. See n. 29.

50. Eph. 5:29.

51. Quoted, with slight changes, from Boethius *De musica* I.xxxiv (*PL*, LXIII, 1196B).

52. The chapter is digested from the *praenotanda* of Hugh's *Practica geometriae* (Baron, ed., pp. 187–8).

53. The allusion to the ball and egg in connection with cosmimetry, missing from the *Practica geometriae*, suggests the comparison of the universe to a ball and egg found, e.g., in Honorius Augustodunensis *De imagine mundi* I.i (*PL*, CLXXII, 121A), but also in Hildegarde of Bingen and William of Conches and deriving from Macrobius *Saturnalia* vii, though in William of Conches, from Arabic tradition as well. The details which link William to Arabic tradition are missing from Hugh.

54. The reference is to the reputed origin of geometry in Egypt, where periodic inundations of the Nile required continual remeasurement of fields.

55. "fons sensuum et origo dictionum" The phrase, though attested to in its present position by the authority of all MSS of the *Didascalicon*, is actually part of the traditional definition of *topica*. Cf. Cassiodorus *Institutiones* II.iii.14 (Mynors, p. 124; Jones, p. 172): "Nunc ad topica veniamus, quae sunt argumentorum sedes, fontes sensuum, [et] origines dictionum"; reproduced in Isidore *Etymologiae* II.xxix.16. Application of this phrase to geometry may be related to the view of mathematics, geometry in particular, as concerned with visible form, and to the view that form, in turn, is the source of a thing's species or genus and name. See n. 41. Cf. Richard of St. Victor *Excerptiones priores* I.viii (*PL*, CLXXVII, 197A): "Arithmetic treats the visible forms of visible objects. ...But every visible form is quantitatively determined," and Cassiodorus *Institutiones* II.v.11 (Mynors, p. 150; Jones, p. 197), where the Holy Trinity is said to employ geometry in granting various species and forms to creatures.

56. Vergil *Georgica* II.479 ff. Müller, ed., Adelard of Bath *Quaestiones naturales*, p. 89, apparently ignoring the Vergilian source of these lines and pointing out that they read like a table of contents for Adelard's work, concludes that Hugh has read and is here summarizing the *Quaestiones naturales*.

57. Boethius *In Porphyrium dialogi* II.iii (*PL*, LXIV, 11C; *CSEL*, XLVIII, 8). On *physis* as nature, cf. William of Conches' commentary on *De consolatione philosophiae* (Jourdain, ed. "Commentaires inédits," p. 73): "Physics treats the properties and qualities of bodies, whence it is called physics, that is, natural"; cf. his commentary on the *Timaeus* (*PL*, CLXXII, 247): "Physics treats the natures and complexions of bodies, for 'physis' means nature."

58. The division of philosophy into physics, ethics, and logic, attributed by Augustine to Plato, was commonly accepted before the twelfth century on the authority of Augustine. See Introduction, ii.

59. On the mind's formal, not physical, inclusion of reality, see *Didascali-*

con 1.i; on the reason's formation of knowledge from sense perception of things, and on "understanding" as formed, not from sense perception of things, but from above and within, see *ibid.* 11.v.n.37.

60. Cf. Adelard of Bath *Quaestiones naturales* i (Müller, ed., p. 6); also William of Conches *De philosophia mundi* 1.xxi (*PL*, CLXXII, 48D), where, against the ignorant who cite philosophers to maintain "that the elements are properties and qualities of things we see," William cites Constantinus Afer, a physicist, "according to whom none of those four we see, and which some persons think are elements, is an element—not earth, not water, not air, not fire."

61. Hugh's effort, throughout this chapter, is to establish the necessary interrelationship of logic, mathematics, and physics as dealing, all of them, with things (*res*), though on different levels—physics dealing with actualities as analyzable into elements, mathematics dealing with arithmetical concepts abstracted from actual entities, logic dealing with concepts on the totally abstract level of understanding or on the lower level of knowledge. On the distinction between *res* and *verba* as applied by the Chartrians, especially William of Conches, to exclude the logical arts from philosophy, see Paré, Brunet, Tremblay, *Renaissance du XIIe siècle*, p. 103, n. 1, and pp. 194-7.

62. Instead of "philological" one would expect "physiological" in the sense defined in 11.xvi. Richard of St. Victor, excerpting the present chapter, writes *physiologiam*, not *philologiam* (*Excerptiones priores* i.vii [*PL*, CLXXVII, 197A]). "Philological," however, has the support of all MSS, and that the term was used for physics appears from Dunchad's commentary on Martianus (Cora E. Lutz, ed., *Glossae in Martianum* [Lancaster, Pa.: Lancaster Press, Inc., 1944], p. 13): "Phylologia vero inferior intelligentia per quam intelligimus res visibiles et invisibiles significatur."

63. Cf. Remigius of Auxerre's commentary on Martianus Capella (Bibliothèque Nationale, MS Latin 14754, fol. 3ʳ): "Pallas, id est Tritonia. ...Tritonia dicta quasi trito nota noticia. Scire videlicet deum, animam, corpoream creaturam." John the Scot on Martianus (Lutz, ed., p. 11) has a comparable gloss but assigns the threefold knowledge to the three parts of rational nature, " αἴσθησις, λόγος, νοῦς, hoc est sensus, ratio, animus." Cf. William of Conches, who, drawing upon Fulgentius (see *Fabii Planciadis* [*Fulgentii*] *opera*, Rudolfus Helm, ed., [Leipzig: B. C. Teubner, 1898], pp. 36-9), associates the interpretation of Pallas as the theoretical arts with the myth of the judgment of Paris: "...in the fables one finds that three goddesses, Juno, Pallas, and Venus, sought to discover from the judgment of Paris which of them was the worthiest. ...The fable concerns nothing other than the three kinds of life: the theoretical or contemplative, the practical or active, and the philargic or sensual. Pallas stands for the contemplative, Juno for the active, Venus for the sensual. This can be proved by the gifts the goddesses promised Paris. Pallas promised him wisdom, because by contemplation does a man become wise." Cited in Jeauneau, "Notion d'*integumentum*," *AHDL*, XXIV (1957), 52.

64. With the restriction of wisdom to arts studying the truth of things

(*res*), see Appendix A, where Hugh, quoting Boethius *De arithmetica* i.i, defines wisdom as "the comprehension of *things* as they exist." The present exclusion of logic, ethics, and mechanics from wisdom is at variance with *Didascalicon* ii.xvii, where Hugh associates logic with mathematics and physics as concerned, though on different levels, with *things*, and with *Didascalicon* i.viii, where Hugh, arguing from premises carefully laid down in earlier chapters of Bk. i, demonstrates that both practical and mechanical arts must be taken as parts of wisdom. In the *Epitome* (Baron, ed., pp. 115–6), Hugh rejects the view which "by too severe a test" excludes logic and the mechanical arts from philosophy; he argues that logic and the mechanical arts are proper parts, though admittedly not the first parts, of philosophy. See Introduction, ii.

65. Cf. William of Conches' commentary on the *De consolatione philosophiae* (Jourdain, "Commentaires inédits," p. 73): "Economics teaches how each man should manage his own family, whence it is called 'economics' or managerial, for an *economicus* is a manager. Politics concerns the governance of a state, for *polis* is a *civitas*, or state."

66. Quoted, with slight changes, from Boethius *In Porphyrium dialogi* i.iii (*PL*, LXIV, 11D f.; *CSEL*, XLVIII, 8).

67. Quoted from Isidore *Etymologiae* ii.xxiv.16, or from Isidore's source, Cassiodorus *Institutiones* ii.iii.7 (Mynors, p. 112; Jones, p. 161).

68. Cf. the *brano* revision of William of Conches *De philosophia mundi* (Ottaviano, ed., p. 34): "It is to be noted that as in the liberal arts there is the trivium concerned with eloquence and the quadrivium concerned with wisdom, so in the mechanical arts, the first three are called a trivium because they pertain to extrinsic goods—to fabric making, armament, and commerce; while four are a quadrivium because related to internal remedies or foods. It is asked how dramatics pertains to interior things. Two things are vitally necessary to man... movement to keep the mind from languishing, joy to keep the body from exhaustion by too much work. So, plays and diversions were established...."

69. Cf. John the Scot on Martianus (Lutz, ed., p. 74): "After Mercury gives her the seven liberal arts, then the virgin gives him the seven mechanical arts." Cf. also *ibid.*, p. 59.

70. Quoted from Cicero *De inventione* i.iv.5.

71. Quoted from Augustine *Enarrationes in psalmos* Ps. 67:39 (*PL*, XXXVI, 836D).

72. So Remigius of Auxerre on Martianus Capella (Bibliothèque Nationale, MS 14754, fol. 1ʳ): "Mercurius dictus est quasi... mercatorum kyrios, id est dominus, quia sermo maxime inter mercatores viget. ...Mercurius in similitudine facundie et sermonis." Cf. Dunchad on Martianus (Lutz, ed., p. 5). The third Vatican mythographer, drawing on Fulgentius, supplies a variant etymology (Bode, *Scriptores rerum mythicarum*, pp. 214–5): "Fulgentius Mercurium negotiis praeesse dicit; ideo Mercurium dictum quasi merces curantem, quod negotiatores, quibus praeest, mercibus semper invigilent; sive ab Ἑρμῆς Graeco, quod disserere interpretatur, eo quod

negotiatori maxime linguarum dissertio sit necessaria." Cf. Helm, *Fabii Planciadis [Fulgentii] opera*, pp. 29–30.

73. Cf. the third Vatican mythographer (Bode, *Scriptores rerum mythicarum*, p. 215), where *medius currens*, alternate etymology for *Mercurius*, supplies pacific symbolism for Mercury's caduceus: "Ideo serpentibus innexam et caduceum dictum, quod rhetoris sermo inter venenosas adversariorum litigationes *medius currens*, omnem rixam cadere cogat, eosque sibi adinvicem reconciliet. Nam bellantes disertorum oratione sedantur."

74. The following paragraph adapted from Isidore *Etymologiae* xx.iii.

75. The phrase is the incipit of the *Isagoge Joannitii ad Tegni Galiegni* (see *Articella* [Venice: Baptista de Tortes, 1487], fol. 2ʳ⁻ᵃ), which supplies the often widely separated excerpts joined in this chapter. Thus, the "two parts" of the incipit refer in the original to *theorica et practica*, but Hugh, telescoping the intervening material, makes them refer to "occasions" and operations. On Johannitius and the *Tegni* of Galen in particular, see, e.g., Pierre Duhem, *Le Système du monde*, III (Paris, 1916), 88–9, and C. H. Haskins, *Studies in the History of Mediaeval Science* (Cambridge, Mass.: Harvard University Press, 1927), p. 374, n. 18, and refs. there cited.

76. *Isagoge Joannitii* (*Articella*, fol. 3ᵛ⁻ᵃ: "Occasiones... aut faciunt sanitatem aut conservant. ...sex modi sunt: quorum unus est aer qui humanum corpus circumdat, cibus et potus, motus et quies, somnus et vigiliae, inanitio et repletio, et accidentia animae."

77. *Ibid.*, fol. 3ʳ⁻ᵃ: "Sunt quaedam accidentia animae quae... commovent naturalem calorem... aut impetuose ut ira... aut leviter cum suavitate, ut deliciae et gaudium. Sunt alia quae... contrahunt et celant aut impetuose ut terror vel timor, aut leviter ut angustia, et sunt quae commovent naturalem virtutem intus et extra, ut est tristitia."

78. *Ibid.*, fo. 4ᵛ⁻ᵃ: "Operatio medicinae habet triplicem effectum: intus ut ea quae ore aut naribus, auribus, sive ano sive vulva intromittamus; fores ut epithima, cataplasma, emplaustra, et similia, quae foris operantur.... Cyrurgia duplex est: in carne et in osse: in carne ut incidere, suere, coquere; in osse ut solidare aut innectere aut reddere."

79. With Hugh's favorable attitude toward *theatrica*, perhaps not unconnected with the rise of liturgical drama in the twelfth century, cf. the shift in the late thirteenth-century view of Robert Kilwardby, who, otherwise importantly influenced by Hugh, condemns *theatrica* as unsuitable for believers; see Kilwardby's *De ortu et divisione philosophiae* xi, as outlined in Baur, *Gundissalinus*, p. 373.

80. Cf. Isidore *Etymologiae* i.v.1.

81. Cf. the *brano* revision of William of Conches *De philosophia mundi* (Ottaviano, ed., p. 28): "These three [grammar, the theory of argument, and rhetoric] are the appendages and instruments of philosophy, and therefore are not part of philosophy itself but are oriented toward it. Boethius, however, seems to say that logic is both instrument and part, so that nothing stands in the way of the opinion of certain persons that logic is contained in philosophy." Cf. Boethius *Commentaria in Porphyrium a se translatum* i.ii–iii (*PL*, LXIV, 73B–75A; *CSEL*, XLVIII, 138–43).

82. Probably the *Ars minor*, a brief dialogue on the eight parts of speech, generally memorized by medieval students. Text in Keil, IV *Grammatici latini*, 355–66.

83. Probably his commentary on Donatus is meant. See Keil, *ibid.*, pp. 405–48,

84. Keil prints these two opuscula, *ibid.*, III, 519–28 and 459–515. The first is not actually Priscian's (*ibid.*, pp. 400–10, for discussion of authorship), the second only partially his (*ibid.*, p. 398). Note that Hugh makes no mention of Priscian's lengthy and detailed *Institutionum grammaticarum libri XVIII* (*ibid.*, II and III), which was studied at Chartres and embodied verbatim in Thierry of Chartres' *Heptateuchon*. In *De philosophia mundi* iv.xli (*PL*, CLXXII, 100D f.) William of Conches announces his intention to comment on Priscian; commentary contained, according to Parent (*Doctrine de la création*, p. 117), in Bibliothèque Nationale, MS Latin 14065. On the use of Priscian (and Donatus) in the twelfth century, see C. H. Haskins, *The Renaissance of the Twelfth Century* (Cambridge, Mass.: Harvard University Press, 1927), pp. 129–31, and Paré, Brunet, Tremblay, *Renaissance du XIIe siècle*, pp. 151–2 and notes. Hugh, unwilling to allow students a protracted concern with one or a few arts, prepared a compendium of grammar; see Jean Leclercq, ed., "Le 'De grammatica' de Hugues de Saint-Victor," *AHDL*, XV (1943–5), 263–322.

85. The third part of Donatus *Ars major* (Keil, IV *Grammatici latini*, 392–402), deriving its title from the incipit of that part.

86. See *Etymologiae* i.

87. Cf. *Didascalicon* i.xi. par. 3. Hugh's division of "linguistic logic," the fourth part of philosophy, derives from the double sense of *logos* as word or reason and is as follows:

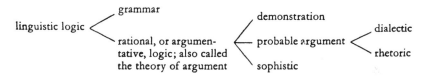

The terms "genus" and "species," which tend to be restricted in modern times to biological classifications, are quite properly used by Hugh to name class and sub-class in any order of being. Thus, linguistic logic stands as genus, or class, to grammar and rational logic, its species or sub-classes; rational logic stands as genus, or class, to demonstration, probable argument, and sophistic, its species or sub-classes. By "divisive part" Hugh means a separable part, like the limbs of a body; by "integral part" he means an inseparable constituent found throughout the whole, like soul and body, which comprise the whole of a living man and cannot be separated without loss of existence to the whole as such.

88. Hugh's problem in this and the next two paragraphs is to determine the precise sense in which invention and judgment, as treated, e.g., in Cicero *De inventione* and Aristotle *De interpretatione* (translated into Latin and twice

commented upon by Boethius), are included in philosophy. He concludes that these two studies are "integral parts," but not "divisive parts," of philosophy. See preceding footnote for meaning of these terms. On invention and judgment as parts of logic, see also Boethius *Commentaria in Porphyrium a se translatum* I.ii (*PL*, LXIV, 73B; *CSEL*, XLVIII, 139); *In Topica Ciceronis commentaria* I (*PL*, LXIV, 1044C); Cicero *Topica* II.vi; Abaelard *Logica ingredientibus* (B. Geyer, ed., "Peter Abaelards philosophische Schriften," *BGPM*, XXI [1919–33], 1–3). Division of logic into demonstration, probable argument, and sophistic, in John of Salisbury *Metalogicon* II.iii (Webb, pp. 64–5; McGarry, p. 79). On the term *ratio disserendi*, here translated "theory of argument," see Cicero *De fato* I.i.

BOOK THREE

1. Cf. Augustine *De civitate Dei* XVIII.xiv and xxxvii, where Linus is listed with Orpheus and Musaeus as a theologian-poet among the Greeks. He is mentioned with Homer and Vergil in Martianus Capella *De nuptiis philologiae et Mercurii* II.ccxii (Adolphus Dick, ed. [Leipzig: B. G. Teubner, 1925], p. 78), and is identified with Homer by Dunchad commenting on Martianus (Lutz, ed., p. 12). On the meaning of "theologus" and "theologia" in this context, see Paré, Brunet, Tremblay, *Renaissance du XII siècle*, pp. 308–9, n. 3; cf. Isidore *Etymologiae* VIII.vi.18, VIII.vii.9. On Hugh's euhemerism throughout the chapter, cf. Augustine *De consensu evangelistarum* I.xxiii.32 (*PL*, XXXIV, 1056–7), who explains the teaching of Euhemerus and reports Cicero's discussion of euhemerism in *De natura deorum* I.

2. Cf. Augustine *De civitate Dei* VI.ii.

3. See Maïeul Cappuyns, *Jean Scot Erigène, sa vie, son oeuvre, sa pensée* (Louvain: Abbaye de Mont Césare, 1933), p. 71, n. 2, for identification of this work as the first part of John the Scot's *De divisione naturae*, where the applicability to God of the Aristotelian categories is examined.

4. Adapted from Isidore *Etymologiae* II.xxiv.4.

5. Pliny's *Historia naturalis* is meant.

6. Quoted from Remigius on Martianus Capella (Bibliothèque Nationale, MS Latin 14754, fol. 18ʳ: "Hic enim arithmeticae repertor fuit." Cf. John the Scot on Martianus (Lutz, ed., pp. 57, 74) and Isidore *Etymologiae* III.ii.1.

7. Quoted from Isidore *Etymologiae* III.i.1; cf. Cassiodorus *Institutiones* ii.iv.7 (Mynors, p. 140; Jones, p. 187).

8. On the "Matentetradem," cf. Remigius on Martianus Capella, Bibliothèque Nationale, MS 14754, fol. 18ʳ: "Qui [Pythagoras] non tacuit mathen tetradem, id est doctrinam quaternariam. Omnis enim doctrinae perfectio in iiii artibus continetur, Arithmetica, Geometria, musica, astronomia. Hoc est illud quadruvium [sic] sine quo nulli proponitur philosophandum." Cf. Martianus Capella *De nuptiis* II.cvii (Dick, ed., p. 44) and John the Scot's gloss (Lutz, ed., p. 57). That an actual book with this title existed in Hugh's time is suggested not only by Hugh's statement but by the "Liber Hermetis Mercurii Triplicis de VI rerum principiis," Silverstein, ed., *AHDL*, **XXII**

(1955), 217–302; see esp. p. 268, and Silverstein's discussion, pp. 224–5. It is possible, however, that the anonymous author of the "Liber Hermetis" is merely drawing on Hugh's statements in the *Didascalicon*, and that Hugh is making a mistaken inference from Remigius. See *Didascalicon* i.vii. n. 52, 53, 55.

9. Cf. Remigius on Martianus Capella (Bibliothèque Nationale, MS Latin 14754, fol. 17ʳ⁻ᵛ): "Pytagoras [sic] namque .y. litteram ad similitudinem humanae vitae adinvenit. ...Nam .y. litteram ab una virgula incipit et in quoddam bivium finditur; sic et natura humana in puericia simplex est nec facile apparet an bonum an malum item apprehendat. In adolescentia vero iam aut virtutes eligit que per dextram virgulam breviorem et angustiorem significantur, aut ad vitia deflectit quae notantur per sinistram virgulam latiorem." Briefer ref. to this figure in Isidore *Etymologiae* i.iii.7.

10. See Paul E. Beichner, *The Medieval Representative of Music, Jubal or Tubalcain?* ("Texts and Studies in the History of Mediaeval Education," A. L. Gabriel and J. N. Garvin, ed., II; Notre Dame, Ind.: The Mediaeval Institute, 1954).

11. Cf. Isidore *Etymologiae* iii.xvi.1, xxii.6.

12. Cf. Cassiodorus *Institutiones* ii.vi.3 (Mynors, p. 152; Jones, p. 198); for Boethius's translation, see *PL*, LXIII, 1307 ff.

13. See n. 34.

14. Adapted from Isidore *Etymologiae* iii.xxv.1, iii.26; Cf. Cassiodorus *Institutiones* ii.vii.3 (Mynors, pp. 155–6; Jones, pp. 201–2). On the figure of Nimrod, see Haskins, *Studies in the History of Mediaeval Science,* ch. xvi, The early twelfth-century Victorine codex (Bibliothèque Nationale, MS Latin 14754), contains the "Astronomie de Nemrod" (fols. 202ᵛ–229ᵛ) and the "Canones Ptolomei" (fols. 233ʳ–255ᵛ). Despite dependence on Isidore or Cassiodorus in the present passage, Hugh could have known both astronomical works; so A. van de Vyver, "Les plus anciennes Traductions latines médiévales (Xe–XIe siècles) de traités d'astronomie et d'astrologie," *Osiris,* I (1937), 658–91, who without qualification speaks of the MS as "la copie du maître victorin" (*ibid.,* p. 688). Further discussion of the MS in relation to Hugh by van de Vyver in "Les premières Traductions latines (Xe–XIe siècles) de traités arabes sur l'astrolabe," *Premier Congrès internationale de géographie historique,* II *Mémoires* (Brussels, 1931), 278, n. 47.

15. On Socrates as the originator of ethics, cf. Isidore *Etymologiae* ii.xxiv.5 and Augustine *De civitate Dei* viii.iii. On the writings of Socrates and Plato on positive and natural justice, cf. William of Conches' commentary on the *Timaeus* (*PL,* CLXXII, 246): "Because Socrates delivered so perfect an opinion regarding justice [in the state], his disciples asked him to compose a treatise on it, and he, satisfying their wish, treated this part of justice, namely positive. For justice is partly positive, partly natural. The positive is invented by men, like the hanging of a thief; the natural, like love of parents, is not. ...Then Plato, his disciple, when he had composed ten books of the *Republic* and wished to perfect what his master Socrates had slighted, composed this work [the *Timaeus*] on natural justice." Cf. Chalcidius on *Timaeus* (Wrobel, p. 72; Mullach, p. 181).

16. Quoted from Isidore *Etymologiae* xviii.i.1.

17. Adapted, *ibid.*, xix.xx.1–2.

18. *Ibid.*, xix.viii.1.

19. Adapted from Martianus Capella *De nuptiis* ii.xlviii (Dick, ed., p. 67), and Remigius's commentary on Martianus (Bibliothèque Nationale, MS 14754, fol. 25ʳ): "apud egyptios... Isis... monstravit sementem lini, id est quomodo sereretur et usum quomodo inde vestes fierent."

20. Adapted from Isidore *Etymologiae* xviii.i.1.

21. *Ibid.*, xix.vi.2; Gen. 4:22.

22. Adapted from Isidore *Etymologiae* xix.xxxii.1.

23. Quoted from Martianus Capella *De nuptiis* ii.clviii (Dick, ed., p. 67).

24. Adapted from Martianus, *ibid.*, and Remigius's gloss (Bibliothèque Nationale, MS Latin 14754, fol. 25ʳ): "Italia signat, id est attribuit Pilumno fragmenta frugis et farris. Ipse enim invenit usum molendi et pinsendi frumenta."

25. Cf. Martianus Capella *De nuptiis* ii.xlvii (Dick, ed., p. 66).

26. Quoted from Remigius on Martianus Capella, as cited in Karl Schulte, ed., *Das Verhältnis von Notkers Nuptiae Philologiae et Mercurii zum Kommentar des Remigius Autissiodorensis* (Münster, 1911), p. 66: "Osyris... apud Aegyptios cultum vinearum repperit," to which the third Vatican mythographer (Bode, *Scriptores rerum mythicarum*, p. 244): "...sicut apud Aegyptios Osiris... sic apud Indos Liber... usum invenerit vinearum." Cf. John the Scot on Martianus (Lutz. ed. p. 63).

27. Quoted from Isidore *Etymologiae* xx.i.1.

28. Adapted, *ibid.*, iv.iii.1–2.

29. Adapted, *ibid.*, xviii.xvi.2.

30. Adapted, *ibid.*, i.iii.5–6.

31. Closely adapted from Remigius on Martianus Capella (Bibliothèque Nationale, MS Latin 14754, fol. 25ʳ): "Carmentis ipsa est Nicostrata... mater Evandri... haec primum latinas litteras repperit." Cf. Schulte, *Das Verhältnis*, p. 76; Isidore *Etymologiae* iii.iv.1; and John the Scot on Martianus (Lutz, ed., p. 69).

32. Adapted from Isidore *Etymologiae* i.xlii.1–2.

33. *Ibid.*, i.xxxix.1.

34. Cf. Hugh's statement (first paragraph of the present chapter): "Certain ones say that Cham, son of Noah, first discovered astronomy. The Chaldeans first taught astrology.... Josephus asserts that Abraham first instructed the Egyptians in astrology." Back of the contradiction between Hugh's previous and present remarks lie two conflicting traditions attributing the origin of the arts variously to the Egyptians or to the Chaldeans (Noah, his sons, Abraham). Martianus Capella reports that the arts, discovered in Egypt by Thoth, otherwise known as Mercury or Trismegistus, and hidden there for a time, were unknown in Europe till after the flood. Cicero *De natura deorum* iii.xxii, Lactantius, and Arnobius speak of Mercury as the discoverer of the arts, and Macrobius *In somnium Scipionis* i.xix.2, credits Egypt with the discovery "omnium philosophiae disciplinarum." Cassiodorus, Isidore, and Rhabanus Maurus, on the other hand, credit the Hebrews,

especially Abraham, with having taught the arts to the Egyptians, and take this view from Josephus *Antiquitates* i.viii.2. Josephus recounts that the arts survived the flood because the sons of Seth, warned by Adam's prediction of the world's destruction in fire and water, erected two pillars, one stone, one clay, on which they inscribed all that was known of the arts. In a unique gloss in one of the oldest MSS of the Remigius commentary on Martianus, a gloss not improbably by Remigius, the sons of Noah are credited with having set up the two columns preserving the arts. "By means of this, when Abraham was in exile in Egypt, he taught astronomy, and from this all the other arts were originally discovered in Egypt and taken from there to Greece." In the Remigius commentary on Donatus *Ars maior* only Cham is credited with having erected the two pillars. For full discussion, see Cora E. Lutz, "Remigius' Ideas on the Origin of the Seven Liberal Arts," *MH*, X (1956), 32–49.

35. Adapted from Martianus Capella *De nuptiis* iv.cccxxx (Dick, ed., p. 153) and a Remigius gloss on the text reported by Raymond Klibansky, "The Rock of Parmenides: Mediaeval Views on the Origin of Dialectic," *MRS*, I (1941–3), 182: "Hic [Parmenides] philosophus fuit et primus apud Aegyptios artem dialecticam repperit. Erat autem solitus deserere divitates et conventus publicos et in hac rupe solus residere, ut liberius posset dialecticam meditari. Unde et a Parmenide rupes Parmenidis vocata est. Claret autem et hanc et alias artes apud Aegyptum repertas et ab his ad Graecos deductas." Hugh refers again to Parmenides and his rock, *Didascalicon* iii.xiv.

36 Closely adapted from Remigius on Martianus (cited in Klibansky, *op. cit.* in previous note, p. 182): "Socrates Platonis magister fuit, post cuius mortem Plato amore sapientiae Aegyptum demigravit ibique perceptis liberalibus studiis Athenas rediit et apud Achedemiam villam coadunatis studiis operam dedit."

37. Cf. Dunchad on Martianus (Lutz, ed., p. 19): "Varro primum dialecticam Romanis tradidisset... protulit primo a Greca in Latinam linguam."

38. Cf. John the Scot on Martianus (Lutz, ed., p. 110): "Corax fuit inventor rhetoricae artis, Tisias usitator." Cf. Cicero *De oratore* i.xx.91.

39. Adapted from Isidore *Etymologiae* ii.ii.1.

40. That Hugh uses the terms "art" and "science" interchangeably is evident from a comparison of the title and opening sentence of this chapter.

41. Cf. Aulus Gellius *Noctes atticae* i.ix.1–7 for a comparable account of Pythagoras's teaching method.

42. "scholares" So Buttimer, p. 53, but "scholastici" in *PL*, CLXXVI, 768C. Clearly, students, not scholars in the sense of masters, are meant. On the history and meanings of *schola, scholaris*, see Paré, Brunet, Tremblay, *Renaissance du XIIe siècle*, p. 59, n. 3; on *scholasticus, ibid.*, pp. 70–1; on the meaning of *scholares* in Hugh in particular, *ibid.*, p. 71, n. 1.

43. Apparently an allusion to the terminology of medieval florilegia, which typically classified excerpts under *auctores*, or poets, and *philosophi*, or prose writers. See Paré, Brunet, Tremblay, *Renaissance du XIIe siècle*, p. 153, n. 21.

44. Hugh's views of literature in relation to grammar and the other arts

are flatly opposed to those of the school of Chartres—an opposition not without its paradoxical elements, however. Thus, Hugh, who, as against the Chartrians, insists on the rightful place in philosophy of the logical arts, including grammar (see *Didascalicon* ii.xvii.n.61; xix.n.64; xxviii.n.81; and Introduction, sec. ii), nonetheless excludes from philosophy the songs of poets, fables, and histories which he earlier reported as parts of grammar (*Didascalicon* ii.xxix). On the other hand, the Chartrians, much given to elaborate commentary on poets, fables, and histories, exclude from philosophy the entire trivium, including the literary commentary which they practice in connection with grammar and other arts. With Hugh's views in this chapter, cf. John of Salisbury *Metalogicon* i.xxiv (Webb, p. 53 ff.; McGarry, pp. 65 ff.), where Bernard of Chartres is described as "the most copious fount of literary study in Gaul in modern times," his teaching of grammar by means of commentary on poetry and prose is praised, and his admonition to students that histories and poems were to be read with utmost diligence is recorded. See also John of Salisbury's own view, formed by William of Conches, his teacher in grammar and described by John as "the richest teacher of letters after Bernard of Chartres" (*ibid.*, i.v [Webb, pp. 16–7; McGarry, p. 21]), that a grammarian, in commenting upon a poem, should explain whatever the *auctor* has borrowed from the arts and woven by *picturatio* into "a sort of image of all the arts" (*ibid.*, i.xxiv [Webb, p. 54; McGarry, pp. 66–7]). The phrase "appendages of the arts" occurs also in the *brano* revision of William of Conches' *De philosophia mundi* (Ottaviano, ed., p. 28), where, however, as one would expect in a work of Chartrian inspiration, it applies to grammar, dialectic, and rhetoric, which are there excluded from philosophy.

45. Vergil *Eclogae* v.16–7. Of Hugh's interpolation of poetry at this point, Paré, Brunet, Tremblay (*Renaissance du XIIe siècle*, p. 171) remark: "heureux démenti à son dédain pour la verbosité des poètes."

46. Cf. Vitruvius *De architectura* i.i.12: "...they easily believe it possible that all the disciplines are linked together in subject matter and have a common bond. The curriculum of the disciplines (*encyclios disciplina*), like a single body, is composed of the disciplines as so many members." Contrast Adelard of Bath *De eodem et diverso* (Willner, ed., p. 17), where Philosophia requires Adelard to choose among the liberal arts one which will be his special reward for assiduity, "for to embrace them all together would be beyond your capacity."

47. "quid uniuscuiusque sit proprium" Cf. Cicero *De oratore* ii.ix.38.

48. Hugh's recommendations throughout this chapter run counter to Bernard of Chartres' method of teaching grammar by reading not technical treatments "*of* the art" but poets and historians who treat "*by means of* the art," and by explaining to beginning students not only "what was simple and according to rule" but "grammatical figures, rhetorical embellishment, and sophistical quibbling, as well as the relation of given passages to other studies" (said in praise of Bernard by John of Salisbury *Metalogicon* i.xxiv [Webb, p. 55; McGarry, p. 67]; see n. 44). Cf. John's view that the works of the *auctores*, especially Vergil and Lucan, are "seasoned with every part of

philosophy"—grammar and poetics "flood the entire composition"; logic "interpolates its reasonings, agleam with gold"; rhetoric, "when persuasion is in order, supplies the silver luster of its resplendent eloquence": mathematics "is drawn in the footsteps of the other arts in the four-wheeled car of the quadrivium, interweaving its 'colors' and pleasing ornaments with manifold variety"; physics, "from its store," does the same; and ethics "exceeds all the other arts by the loveliness of the beauty it brings" (*ibid.*; McGarry's translation altered). With Bernard's literary approach to teaching the arts, especially grammar, cf. Hugh's *De grammatica* (Leclercq, ed., *AHDL*, XV [1943-4], 263-322), which follows his principle that in teaching an art, "when everything must be reduced to outline and presented for easy understanding, we should be content to set forth the matter in hand as briefly and clearly as possible, lest by excessively piling up extraneous considerations we distract the student more than we instruct him" (see third paragraph of present chapter). William of Conches' commentary on the *Timaeus*, an exercise which involves excursions into the "by-ways" of many arts (cf. *PL*, CLXXII, 247: "Something of all the arts is contained in this work. In the summary of positive justice, there is something from the practical arts. In the discussion of the formal and final cause of the universe and of the world soul, there is something from theology. In the discussion of numbers and proportions, there is something from mathematics. In the discussion of the four elements, the creation of animals, and primordial matter, there is something from physics") exemplifies the "comparative and back-and-forth examination of the arts" which Hugh allows to proficients but disapproves as a means of learning the arts.

49. Hugh draws here upon traditional discussion of the relative value, in the educational process, of *ingenium* (or *natura*) and *exercitium* on the one hand, and *ars* or *disciplina* on the other. See, e.g., Cicero *De oratore* i.iv.14 and *passim*; Quintilian *Institutiones oratoriae* iii.v.1; Augustine *De civitate Dei* xi.xxv; Boethius *In Topica Ciceronis commentaria* vi (*PL*, LXIV, 1168C). Note, however, that in the words which follow Hugh gives his own definition to each term, altering particularly the sense of *disciplina* from "art" to moral excellence.

50. Quoted by John of Salisbury *Metalogicon* i.xi (Webb, p. 28; McGarry, p. 34, where the translation is "an immanent power infused into one's soul by nature"), and wrongly attributed by him to Isidore. (see Webb's note, p. 28, l. 27).

51. Quoted by John of Salisbury *Metalogicon* i.xi (Webb, p. 29; McGarry, p. 36), who attributes it to "a certain wise man," evidently Hugh, as neither Webb nor McGarry recognizes.

52. Cf. John of Salisbury *Metalogicon* i.xxiv (Webb, p. 53; McGarry, p. 65): "The word 'reading' is equivocal. It may refer either to the activity of teaching and being taught, or to the occupation of studying written things by oneself."

53. That is, works may be selected for inclusion in a single codex either because they belong to a single author or connected group of authors, or because they treat a common subject.

54. The four types of order set forth in this chapter form the structure of *Didascalicon* VI, where they are applied to Sacred Scripture (see *Didascalicon* VI.i: "I have mentioned that order in study is a fourfold matter: one thing in the disciplines, another in books, another in narrative, and another in exposition. How these are to be applied to Sacred Scripture I have not yet shown"). An order like that among disciplines is sought among history, allegory, and tropology (chs. ii, iii, iv, v); then, the order of biblical books in relation to Scripture study (ch. vi), the order of narration observed in Scripture (ch. vii), and the order to be observed in expounding Scripture (chs. viii, ix, x, xi) are discussed. The problems of order, then, are one, though they bear upon two distinct classes of writing, secular and scriptural.

55. *Didascalicon* VI.xii bears the same title. Raising the same question with regard to Scripture, the later chapter is briefer than the present one and adds nothing to it.

56. Entire chapter, omitting the last three sentences of the first paragraph, reproduced in Hugh's *De contemplatione et eius speciebus* (Hauréau, ed., *Nouvel examen*, pp. 177–8; on the authenticity of the work, see D. Lasić, "Hugo de Sancto Victore auctor operis 'De contemplatione et ejus speciebus,'" *Antonianum*, XXVIII [1953], 377–88), where meditation is presented as a division of contemplation, itself defined as "the setting out of the mind along the manifold roads of salvation" and "an illumination of the mind which fixes it, to its salvation, upon the invisible things of God." These definitions, as well as the present chapter's reference to the divine commandments and works substantiate the view that the "arts" of *Didascalicon* I–III, hardly profane, are part of a "philosophy" which includes Sacred Scripture among its sources and intends nothing less than man's salvation.

57. "praecipiens... promittens... terrens" The *De contemplatione et eius speciebus* (Hauréau, ed., *Nouvel examen*, p. 178) reads "praecipiens... prohibens... permittens," which makes better sense. The reading "permittens" is supported by three MSS of Buttimer's gamma class (see Buttimer, p. 60).

58. Cf. William of Conches' commentary on the *Timaeus* (*PL*, CLXXII, 250): "As Priscian says when speaking of exercises for boys, to recollect is to gather into one a number of things held in the mind by study or teaching."

59. Image unhappily borrowed from Augustine *De Trinitate* XII.xxiv.23 (*PL*, XLII, 1011A).

60. Cf. the instruction on the art of memorizing, the tables, and the mnemonic devices included in Hugh's *Chronica* (William M. Green, ed., "Hugh of St. Victor, De tribus maximis circumstantiis gestorum," *Spec*, XVIII [1943]) and suggestive of the high value Hugh places on factual knowledge. Cf. *Didascalicon* VI.iii.

61. Verses quoted in John of Salisbury *Policraticus* VII.xiii (C. C. J. Webb, ed. [Oxford: Clarendon Press, 1909], II, 43), where they are attributed to Bernard of Chartres. Quoted again in the twelfth century by Peter Comestor *Sermo III* (*PL*, XCVIII, 1730D), and in the thirteenth century by Vincent of Beauvais *Speculum doctrinale* I.xxviii (Douai, 1624) and Guibert de Tournai *De modo addiscendi* IV.xxvi (Bonifacio, ed. [Turin, 1653], p. 243).

62. Cf. Quintilian *Institutiones oratoriae* i.xviii; xii.i; Seneca *Epistulae morales* esp. lxxxviii.

63. Ref. to King Agathocles, who drank from a goblet of clay after drinking from one of gold to remind himself of his humble origin. See Valerius Maximus *Facta et dicta memorabilia* vii.iv.1; the work was frequently epitomized during the Middle Ages. Cf. M. Junianus Justinus *Historiarum philippicarum libri XLIV* xxii.i and Cicero *Ver.* ii.iv.55.

64. Cf. Horace *Saturae* ii.ii.2 and Vergil *Eclogae* viii.63.

65. From Jerome *Epistulae* ep. liii.i.2 (*CSEL*, LIV, 443).

66. Buttimer's text has been repunctuated here as follows: "nugigeruli nunc quidam, nescio unde gloriantes." See Buttimer, p. 63.

67. Cf. Job 12:2.

68. Cf. Paré, Brunet, Tremblay (*Renaissance du XIIe siècle*, p. 67, n. 5), who see in these words an unmistakable allusion to Abaelard. Not merely these words, however, but the entire chapter alludes to Abaelard, who, in the *Historia calamitatum mearum* (J. T. Muckle, ed., *MS*, XII [1950], 163–214), describes his presumption in setting up as master while still a student (*ibid.*, p. 176); his attempt to out-dispute his master William of Champeaux, founder of Saint Victor and therefore "forefather" to Hugh (*ibid.*); his contempt for the venerated Anselm of Laon, whose lectures in divinity he abandoned, asserting that to literate men, the text of Scripture and its glosses were enough, without a master, to enable them to expound the Sacred Text (*ibid.*, p. 180); his notorious affair with Heloise (*ibid.*, pp. 182–91); and the condemnation and burning at Soissons of his *De unitate et trinitate divina* (*ibid.*, pp. 192–6). On Abaelard's personality, see Paré, Brunet, Tremblay, *Renaissance du XIIe siècle*, pp. 277–81.

69. See n. 35.

70. 3 Kgs. 1. Interpretation in last paragraph of present chapter.

71. Quoted from Jerome *Epistulae* ep. lii.iii.2 (*CSEL*, LIV, 416).

72. Buttimer's text (p. 65) reads *tristior* here, but I have used *tritior*, which, besides being the reading of Jerome, Hugh's source, is the reading of MS N of the *Didascalicon*, a MS which contains a good text (see Buttimer, p. xxxi) and one whose readings must be followed elsewhere.

73. The best MSS of Jerome omit any name here. That Jerome was thinking of Theophrastus, however, may plausibly be inferred from Cicero *Tusc. disp.* iii.xxviii.69. On Themistocles as an aged Greek of worthy accomplishment, see Cicero *De senectute* vii.xxi.

74. *Ibid.* v.xiii.

75. Isocrates is the correct reading in Jerome *Epistulae* ep. lii.iii.2 (*CSEL*, LIV, 416); cf. Cicero *De senectute* v.xiii.

76. Stesichorus is the correct reading in Jerome, ref. cited in n. 71.

77. Quoted from Jerome *Epistulae* ep. lii.iii.3 (*CSEL*, LIV, 417–8). On Homer and Nestor, see Cicero *De senectute* x.xxxi.

78. Quoted, with adaptation, from Jerome, ref. cited in, n. 77.

79. Cf. Martianus Capella *De nuptiis* (Dick, ed., p. 62), and gloss of Remigius of Auxerre (Bibliothèque Nationale, MS Latin 14754, fols. 23ᵛ–24ʳ): ʿMemorantur hii duo, labor et amor, subvehere lecticam a fronte, hoc est ab

anteriore parte. Nam posticam, id est extremam partem lectice sustulerunt pimelia et agrimnia dilecta mancipia. Pimelia graece: latine cura. Non illa quae sollicitudines saeculi parit, sed illa quae studium sapientiae. Agrimnia vigilia interpretatur, et his duabus rebus, cura et vigilia, acquiritur sapientia." Allusion to the same passage from Martianus found in John of Salisbury *Metalogicon* iv.xvii (Webb, p. 183; McGarry, p. 229).

80. Cf. Remigius's gloss on Martianus (Bibliothèque Nationale, MS Latin 14754, fol. 22ᵛ): "Haec autem lectica significat corpus omnium philosophorum. Lectica iiii portatoribus gestabatur et humanum corpus iiii elementis subsistit. Et pulchre duobus sexibus portabatur, duobus scilicet pueris et duabus puellis sicut in sequentibus legitur, quia iiii elementorum duo quodammodo sunt mares, ignis et aer, duae feminae, terra et aqua." Cf. Dunchad on Martianus (Lutz, ed., p. 3).

81. Quoted from Jerome *Epistulae* ep. LII.xi (*CSEL*, LIV, 435). Cited by Anselm of Havelberg *Epistula ad Abbatem Ecbertum* (*PL*, CLXXXVIII, 1120); Anselm, proponent of the canonical reform in which the Abbey of Saint Victor figured, applied the saying to Rupert of Deutz, Cistercian proponent of monasticism. The phrase, thus, is found in the polemics between monks and canons over the true nature of "vita aspostolica." See Chenu, "Moines, clercs, et laïcs," *RHE*, XLIX (1954), 72, where Anselm of Havelberg is quoted and discussed.

82. Buttimer reads "quia magistros suos imitari nolunt." The variant *volunt*, attested by three MSS, one of them "H" which Buttimer rates highly (see Buttimer, p. xx), makes better sense. Hugh is ironical here. On contemporary masters who grew rich in fees, see Paré, Brunet, Tremblay, *Renaissance du XIIe siècle*, pp. 76-7.

83. "exilium" On *exilium* for the wise man, cf. Seneca *Epistulae morales* LXVIII and CII; John of Salisbury *Epistula CXXXIV* (to Thomas Becket) (*PL*, CXCIX, 113).

84. Cf. *In Ecclesiasten homiliae* (*PL*, CLXXV, 221C): "All the world is a foreign soil to those whose native land should be heaven. ...Therefore comes a 'time for scattering stones' (Eccl. 3:5), so that man may see he has no stable dwelling here and may get used to withdrawing his mind and freeing it from the chains of earthly pleasures."

85. Ovid *Epistulae ex Ponto* i.iii.35-6.

86. Cf. Vergil *Eclogae* 1.68-70.

87. See Vernet, *DTC*, VII, 241, and ref. to Cicero there given.

88. Cf. Horace *Carmina* II.xvi.9-12. On various interpretations placed upon this autobiographical reference in their bearing upon Hugh's origin, see Taylor, *Origin and Early Life of Hugh of St. Victor*, pp. 51-4.

BOOK FOUR

1. Taking the variant *depromi*, substantiated by MS N, which Buttimer rates highly (see Buttimer, p. xxxi), in place of Buttimer's *deprimi*, which makes poor sense.

2. Substance of this chapter from Jerome *In libros Samuel et Malachim* (*PL*, XXVIII, 552 ff.) or Isidore *Etymologiae* VI.i, neither of whom, however, divides the New Testament into three groups parallel to the Old. On the originality of Hugh's grouping, see Ludwig Ott, "Hugo von St. Viktor und die Kirchenväter," *Divus Thomas* (Fr.), ser. 3, XXVII (1949), 184; cf. Baron, *Science et sagesse*, p. 104, who, without denying Hugh's originality, finds earlier traces of the division.

3. Though the meaning of the Hebrew titles in this chapter is to be found in Hugh's sources, Hugh himself undertook to learn Hebrew. On this point, see Smalley, *Study of the Bible*, p. 103. Cf. Abaelard's recommendation that Heloise and her nuns learn Greek and Hebrew (*PL*, CLXXVIII, 325 and 511–2).

4. Hugh excludes these books from the canon on the authority of Jerome; see n. 33 and context.

5. Adapted from Isidore *Etymologiae* VI.ii.1–12.

6. Adapted from *ibid.*, VI.ii.26–7.

7. Adapted from *ibid.*, VI.ii.13.

8. Adapted from *ibid.*, VI.ii.28–33.

9. Quoted from *ibid.*, VI.iii.1–2.

10. Quoted from Jerome *In libros Samuel et Malachim* (*PL*, XXVIII, 551A).

11. Adapted from Isidore *Etymologiae* VI.iii.3–5; VI.iv.1–2.

12. See Jerome *Praefatio in Pentateuchum* (*PL*, XXVIII, 150A–B).

13. Adapted from Isidore *Etymologiae* VI.iv.3–5.

14. Cf. Gregory *Regulae pastoralis liber* II.xi (*PL*, LXXVIII, 48D).

15. Adapted from Isidore *Etymologiae* VI.ii.35–9.

16. Adapted from *ibid.*, VI.ii.44–9.

17. Quoted from *ibid.*, VI.ii.50–3.

18. Quoted from *ibid.*, VI.ii.2–6.

19. Adapted from *ibid.*, VI.ii.7–9.

20. Adapted from *ibid.*, VI.ii.9–11.

21. Quoted from *ibid.*, VI.ii.22–4.

22. Adapted from *ibid.*, VI.ii.25–7.

23. Quoted from *ibid.*, VI.ii.14–5. Cf. Jerome *Praefatio in Job* (*PL*, XXVIII, 1081A–B).

24. Quoted from Jerome *In libros Samuel et Malachim* (*PL*, XXVIII, 553A).

25. Adapted from Isidore *Etymologiae* II.vi.17, 21.

26. Adapted from Jerome *Comm. in Ecclesiasten* (*PL*, XXIII, 1063A–4B) with interpolation from Isidore *Etymologiae* VI.ii.18–20 and Jerome *In libros Samuel et Malachim* (*PL*, XXVIII, 551A). Cf. Hugh's *In Ecclesiasten homiliae* (*PL*, CLXXV, 116 [misnumbered 161] B).

27. Adapted from Jerome *Praefatio in Danielem* (*PL*, XXVIII, 1291B–2B).

28. Quoted from Isidore *Etymologiae* VI.ii.12.

29. Quoted from Jerome *In libros Samuel et Malachim* (*PL*, XXVIII, 554A).

30. Adapted from Isidore *Etymologiae* VI.ii.28.

31. Quoted from *ibid.* vi.ii.30.

32. Quoted from *ibid.* vi.ii.32.

33. Quoted from Jerome *Praefatio in Salamonem* (*PL*, XXVIII, 1242A–3A).

34. Quoted from Jerome *In libros Samuel et Malachim* (*PL*, XXVIII, 551A–2A).

35. Adapted from *ibid.* (*PL*, XXVIII, 554A–B).

36. Both paragraphs quoted from Isidore *Etymologiae* vi.xv; found also in Rhabanus Maurus *De universo* v.vi. Cf. Jerome *Praefatio in Evangelia* (*PL*, XXIX, 528A–42A). Illustrations of canon tables in the Book of Kells in W. R. W. Koehler, ed., *Medieval Studies in Memory of A. Kingsley Porter*, II (Cambridge, Mass.: Harvard University Press, 1939), 644–61.

37. Both paragraphs quoted from Isidore *Etymologiae* vi.xvi.1–4. This and the following chapter comprise Rhabanus Maurus *De universo* v.vii.

38. Dates of the four synods, or General Councils, named by Hugh are as follows: Nicaea, 325; Constantinople, 381; Ephesus, 431; Chalcedon, 451.

39. Previous three paragraphs quoted from Isidore *Etymologiae* vi.xvi.5–12.

40. Adapted from *ibid.*, vi.viii.17 and vi.ii.46.

41. Adapted from *ibid.*, vi.ii.48–9.

42. Quoted from *ibid.*, vi.vi.1–2.

43. On the meaning of "authentic," see Paré, Brunet, Tremblay, *Renaissance du XIIe siècle*, pp. 147–8, and M.-D. Chenu, "'Authentica' et 'magistratia': deux lieux théologiques au XIIe–XIIIe siècles," *Divus Thomas* (Piacenza), XXVIII (1925), 257–85.

44. Quoted from Isidore *Etymologiae* vi.vii.2–3.

45. Adapted from the pseudo-Gelasian decretal iv.ii.180 ff. (E. von Dobschütz, ed., *Texte und Untersuchungen*, XXXVIII [Leipzig, 1912], 36–7). That Hugh's knowledge of the decretal came to him via Ivo of Chartres *Panormia* is the judgment of Ludwig Ott (ref. cited in n. 2), reaffirming the conclusion of Dobschütz.

46. Quoted from the pseudo-Gelasian decretal iv.v.232-6 (Dobschütz, ed., pp. 44–5).

47. Adapted from the *Libri pontificalis pars prior* li (Theodore Mommsen, ed., *MGH:Gesta pontificum romanorum*, I [Berlin, 1898], 117).

48. Quoted from the pseudo-Gelasian decretal iv.v.242–6 (Dobschütz, ed. p. 46).

49. Entire chapter quoted from the pseudo-Gelasian decretal v.ii–xi.263–353 (Dobschütz, ed., pp. 49–60).

50. Adapted from Isidore *Etymologiae* vi.xiii.

51. Adapted from *ibid.*, vi.xiv.8.

52. Adapted from *ibid.*, vi.x.1–2, vi.xi.1–2.

53. Adapted from *ibid.*, vi.viii.2–5.

54. Taking *expositiones*, the reading of MS "H", which Buttimer (p. xx) evaluates as one of the three best MSS of the *Didascalicon*, in place of Buttimer's *expositores*, which makes poor sense.

55. Cf. William of Conches' commentary on the *Timaeus* (*PL*, CLXXII,

250): "A comment, following the thought alone, pays no attention to the continuity or exposition of the letter. A gloss, however, does all these things; it is therefore called 'gloss' as meaning tongue. It must give as clear an exposition as if it were the tongue of a doctor speaking."

56. Adapted from Isidore *Etymologiae* i.xxx.1.

BOOK FIVE

1. Hugh's threefold understanding of Scripture derives from the *historia' significatio typica, moralitas* of Gregory the Great; see *Didascalicon* vi.iii. n. 9. A threefold understanding of Scripture is also taught by Jerome (*historia' tropologia, intelligentia spiritualis'*), who was influenced in turn by Origen and Philo Judaeus. A tradition of fourfold interpretation is found, e.g., in Augustine (*historia, allegoria, analogia, aetiologia*), Bede (*historia, allegoria, tropologia, anagoge*), and Bede's many imitators, including the comparably influential Rhabanus Maurus. Refs. for the authors named are: Gregory *Moralium libri* Epistula missoria iii (*PL*, LXXV, 513C); Jerome *Epistolae* ep. cxx.xii (*PL*, XXII, 1005); Augustine *De Genesi ad litteram imperfectus liber* ii (*PL*, XXXIV, 222); Bede *De tabernaculo et vasis eius* i.vi (*PL*,XCI, 410B–D); Rhabanus Maurus *Commentaria in Exodum* iii.xi (*PL*, CVIII, 147D–8B). Further authors and refs. in Paré, Brunet, Tremblay, *La Renaissance du XIIe siècle*, 221–2, and in Jean Daniélou, "Les divers Sens de l'Ecriture dans la tradition chrétienne primitive," *ETL*, XXIV (1948), 119–26. Cf. Hugh's *De scripturis et scriptoribus sacris* iii (*PL*, CLXXV, 12), where Hugh subdivides *allegoria* into *simplex allegoria* and *anagoge*.

2. Quoted verbatim from Isidore *Quaestiones in Vetus Testamentum* Praefatio iv (*PL*, LXXXII, 208), but independently applied by Hugh to Scripture. Earlier source in Augustine *Contra Faustum Manichaeum* xxii.xciv (*PL*, XLII, 463), which, however, is not verbally identical with Hugh.

3. So Augustine reasons on the utility of tropes and figures in Scripture, *De doctrina christiana* ii.vi. 8 (*PL*, XXXIV, 39).

4. Cf. *ibid.*, i.ii; ii.i; iii.v ff. (*PL*, XXXIV, 10, 35, 68 ff.).

5. Taking *natura* in the first of the three senses defined by Hugh in *Didascalicon* i.x, namely, as the divine Wisdom, Second Person of the Godhead, conceived as archetypal exemplar of creation. See *ibid.*, n. 69.

6. Cf. Augustine *In Joannis evangelium* xiv.iii.7 (*PL*, XXXV, 1506): "We speak flying words which pass away: as soon as your word has sounded in your mouth, it passes... into silence." *De Genesi ad litteram liber imperfectus* v. 19 (*PL*, XXXIV, 227): "...away with the impiety by which we should think that the Word of God, the only-begotten Son, is like a word uttered by us. The Word of God... neither begins to be nor ceases." *De civitate Dei* xvi.vi.1 (*PL*, XLI, 484): "God does not speak as do we to one another.... For the speaking of God, anterior and superior to all his works, is the immutable Idea of his work. It has no noisy and fading sound, but an energy which abides eternally and brings forth effects in time."

7. Cf. John the Scot *De divisione naturae* iii.xxxv (*PL*, CXXII, 723): "As

through sense perception one comes to a concept, so through the creature one comes back to God."

8. Peter. 5:8.
9. Isa. 61:10.
10. Isa. 44:21–22.
11. Isa. 13:11.
12. Isa. 14:26.
13. Isa. 13:17.
14. Isa. 19:2.
15. Ps. 21:17–19.
16. Gen. 10:20, 31.
17. Gen. 11:1.
18. Matt. 13:28.
19. John 6:71.
20. Isa. 14:12.
21. Entire chapter quoted, with some omissions and adaptations, from Isidore *Libri sententiarum* i.xix.1–19 (*PL*, LXXXIII, 581A–6A). Paré, Brunet, Tremblay, *Renaissance du XIIe siècle*, p. 229, mistakenly observe of these rules that Hugh "les emprunte mot pour mot, sans nommer leur auteur, non pas au *De doctrina christiana*, mais au *De Genesi ad litteram* de saint Augustin"; cf., however, *ibid.*, p. 222: "Hugues, afin de guider l'interprète, expose alors les sept règles de Tichonius, dont le *De doctrina christiana* donnait déjà la substance, mais dont il emprunte le texte à saint Isidore." On the rules, see F. C. Burkitt, *The Book of Rules of Tyconius* (Oxford, 1894).
22. Wisdom 6:1.
23. "moralitatis gratiam" The phrase is Gregory the Great's. Entire context of phrase quoted in *Didascalicon* vi.iii.n.9.
24. Matt. 6:33.
25. Gregory's *Moralium libri, sive expositio in librum Job* is an example of scriptural commentary with conspicuous moral orientation. Treating first the historical and allegorical senses of a passage, it culminates in exposition of the moral sense. See, e.g., Gregory's treatment of the first four verses of Job—the historical sense (*PL*, LXXV, 527D), allegorical sense (*ibid.*, 533D), and moral sense (*ibid.*, 542D–554C). Cf. also Gregory's general observations on the relation of Scripture to moral concern: "We ought to transform what we read into our very selves, so that when our mind is stirred by what it hears, our life may concur by practicing what has been heard" (*ibid.*, 542C); and "Sacred Scripture holds a kind of mirror to the eyes of our mind so that our interior face may be seen in it. There we recognize what is shameful in ourselves, what beautiful.... Scripture tells the deeds of the saints and excites the hearts of the weak to imitate them" (*ibid.*).
26. "colore dictaminis" Cf. Hugh's dedication to his elegantly phrased ascetical treatise, *De arrha animae:* "I do not wish to stir you here by the art of literary composition (*colore dictaminis*)...." (Karl Müller, ed., *Hugo von St. Victor:* Soliloquium de arrha animae *und* De vanitate mundi [Bonn, 1913], p. 3; *PL*, CLXXVI, 951).
27. For use of the term "philosophy" and its cognates in a strictly moral-

istic context, see, e.g., Hildebert of Lavardin's letter to William of Champeaux on the latter's monastic conversion (*PL*, CLXX., 141 f.): "...now at last you have decided to philosophize," etc. Such a use represents a traditional Christian extension of the Socratic emphasis on moral uprightness in the philosopher and derives from the identification of the "wisdom" sought with Christ, Wisdom of the Father.

28. "occupatio" Cf. Hugh's exegesis of Eccl. 1:12–3 ("proposui in animo meo quaerere et investigare sapienter de omnibus quae fiunt sub sole. Hanc occupationem pessimam dedit Deus filiis hominum ut occuparentur in ea") in *In Ecclesiasten homiliae* (*PL*, CLXXV, 149D–59B). The kind of reading condemned as *occupatio* is that classifiable with works performed "under time and for time" and which are "vain in act and fruit"; opposed is reading classifiable with works done "under time but for eternity" and which "in act are, in a measure, vain, but which in fruit are not so, since even if the work itself passes away, its reward does not" (*ibid.*, 151C). Intellectual *occupatio* is a greater evil than preoccupation with material goods; see *Didascalicon* II.xii.n.48, esp. the definition of *occupatio* there cited.

29. Matt. 11:28–29.

30. Ps. 70:15–17.

31. See Palladius *Paradisus seu historia lausiaca* xxviii, "Vita abbatis Pauli simplicis" (*PL*, LXXIII, 1126C–30A; tr. Ernest A. Wallis, *The Paradise of the Holy Fathers*, I [London: Chatto and Windus, 1907], 125–8). The Paul intended was a late fourth-century ascetic, one of the desert fathers.

32. Cf. James 1:22; Romans 2:13.

33. Ps. 75:3. Cf. Isidore *Etymologiae* xv.i.5, where *Sion* is interpreted as *speculatio*.

34. Eccl. 12:12–3.

35. Cf. Jerome *Contra Vigilantium* xv (*PL*, XXIII, 351B).

36. Ps. 18:12.

37. Buttimer's *arcem consilii* emended to *arcam consilii*. Cf. Hugh's *De arca Noe morali* ii (*PL*, CLXXVI, 635A f.), where the construction and inhabiting of the *arca sapientiae* in the soul are treated.

38. Jos. 1:18; cf. 1 Par. 22:13 and 1 Cor. 16:13.

39. Ps. 33:9.

40. "reddere rationem de ea... fide" Quoted from 1 Peter 3:15, in which, however, the correct reading is "reddere rationem de ea...spe." On variations of this this text and the relation of the common twelfth-century form of it, here cited by Hugh, to the twelfth-century preoccupation with the place of reason in faith, see de Ghellinck, *Mouvement théologique*, pp. 279–84; discussion of Hugh's use of the phrase, p. 282.

41. Vernet, *DTC*, VII, 292, regards Hugh's three types of readers as taken from Bernard *Sermones in Cantica* sermo xxxvi (*PL*, CLXXXIII, 968D). Bernard's classification, however, is fivefold and applies not to readers of Scripture but, more generally, to seekers after knowledge: "There are some who wish to know merely to know, and this is base curiosity; there are some who wish to know in order to become known themselves, and this is base vanity; ...there are some who wish to know in order to sell their

knowledge for money or for honors, and this is a base effort. But there are some who wish to know in order that they may edify others, and this is charity, and some who wish to know in order that they may be edified, and this is prudence."

BOOK SIX

1. See *Didascalicon* iii.viii.n.54.

2. By saying that "the order sought in the disciplines"—i.e., an order of study based upon natural priority, like the priority of arithmetic to music (see *Didascalicon* iii.viii)—is to be sought among history, allegory, and tropology, Hugh emphasizes that these three are not merely senses of Scripture but separate studies, to be pursued successively. Cf. Paré, Brunet, Tremblay, *Renaissance du XIIe siècle*, pp. 222 ff., and diagram, p. 219, who, however, may go too far in referring to these studies as "disciplines"; Hugh's term for them is *eruditiones* or *lectiones*. See *De sacramentis* i.Prologus (*PL*, CLXXVI, 183; Deferrari, p. 3): "Since I previously dictated a compendium on the first instruction in the Sacred Utterance, which consists in a historical reading, I have now prepared this second instruction, which consists in allegory, for those who are to be introduced to it." (Deferrari's translation altered).

3. Borrowed from Gregory the Great; see n. 9. Paré, Brunet, Tremblay, *Renaissance du XIIe siècle*, p. 259, mistakenly suggest, instead, Rhabanus Maurus; see *De universo* xiv.xxiii (*PL*, CXI, 400D ff.), where the image represents an approach to Scripture taken also from Gregory but possibly influenced by others as well. In the chapters immediately following, Hugh identifies the foundation with "history," or the literal level of Scripture; the building itself with "allegory," which includes both the mysteries of faith and the method of deriving them from the letter; and the color with "tropology," the moral interpretation of Scripture, aimed at personal sanctification.

4. With these four historical considerations, cf. the three discussed in Hugh's *De tribus maximis circumstantiis gestorum* (Green, ed., *Spec.*, XVIII [1943], 484–93) and the six "circumstances" pertinent to allegorical interpretation in *De scripturis et scriptoribus sacris praenotatiunculae* xiv ff. (*PL*, CLXXV, 20 ff.). On the place of history in Hugh's thought, see Paré, Brunet, Tremblay, *Renaissance du XIIe siècle*, pp. 218–27; W. A. Schneider, *Geschichte und Geschichtsphilosophie bei Hugo von St. Victor: Ein Beitrag zur Geistesgeschichte des 12. Jahrhunderts* ("Münster'sche Beiträge zur Geschichtsforschung," Folge III, Heft 1; Münster, 1933), who, however, is unacquainted with the whole of Hugh's *De tribus maximis circumstantiis gestorum*; and M.-D. Chenu, "Conscience de l'histoire et théologie au XIIe siècle," *AHDL*, XXI (1954), 107–33.

5. Quoted from Marbodus *De ornamentis verborum* Prologus (*PL*, CLXXI, 1687).

6. "Saepe nocturnus horoscopus ad hiberna pervigilia excubavi" On *horoscopus* as one of the thirty-six fixed stars, see the Latin *Asclepius* iii

(Scott, ed., I, 325). Martin of Laon *Scholica graecarum glossarum* (Laistner, ed., p. 437) glosses *horoscopus* as *horarum inspector*, but the hours involved may have been night hours and measured by the fixed stars.

7. "quae secundum proprietatem verborum exprimitur" The meaning seems to be, "any narrative which makes literal sense." The "proper nature" or "property" of words is apparently to signify literally or directly (cf. the brief discussion of literal vs. allegorical signification, above v.iii). Hugh discusses passages lacking literal sense below, vi.x; passages lacking literal sense would belong to allegory, not to history.

8. Cf. Jerome *Epistula cxxix (ad Dardanum)* vi (*PL*, XXII, 1105): "...the truth of history, which is the foundation of spiritual understanding"; Rhabanus Maurus *De universo* xxii.i (*PL*, CXI, 594C): "...Divine Scripture is a honeycomb filled with the honey of spiritual wisdom."

9. Quoted, with slight adaptations, from Gregory the Great *Moralium libri* Epistula missoria iii (*PL*, LXXV, 513C). Cf. Hugh's *De arca Noe morali* i.i (*PL*, CLXXVI, 621): "God dwells within the human heart in two ways, namely, through knowledge and through love. Yet, there is but one dwelling, for everyone who knows God loves him, and no one can love him who does not know him. Yet, knowledge and love of God differ in this way, namely, knowledge builds the house of faith while love, through virtue, paints the edifice as with color spread upon the whole." "History" and "allegory" provide knowledge, faith-knowledge, one might say; "tropology" provides love and virtue. Cf. *Didascalicon* i.v and viii, where knowledge and virtue are said to work the restoration of man's nature.

10. Gen. 1:1.

11. Gen. 2:8.

12. Ps. 77:70.

13. Ps. 7:13–14.

14. With the exposition that follows, cf. Philo of Alexandria, cited without ref. in Smalley, *Study of the Bible*, p. 5: "Allegory is 'a wise architect who directs the superstructure built upon a literal foundation.'" The resemblance is more than coincidental, but I cannot trace a line of transmission from Philo to Hugh, who seems to borrow the analogy directly from Gregory's *Moralium libri*; see n. 9 and context.

15. The eight "courses" dictate the structure of Hugh's *De sacramentis*, composed to provide students with the definitive knowledge of doctrine he requires as a prerequisite to allegorical interpretation. See *De sacramentis* i. Prologus (*PL*, CLXXVI, 183; Deferrari, p. 3). Table of correspondences between the "courses" and parts of the *De sacramentis* in Paré, Brunet, Tremblay, *Renaissance du XIIe siècle*, 263–4; cf. G. Robert, *Les Ecoles et l'enseignement de la théologie pendant la première moitié du XIIe siècle* (Paris, 1909), pp. 140–8, who first recognized in the present chapter a sketch later filled out in the *De sacramentis*.

16. Ps. 17:12.

17. Ezech. 1:19.

18. *Ibid.*, 1:20.

19. II Cor. 3:6.

20. I Cor. 2:15.

21. The Pauline Epistles are fourteen in number; the number fourteen is twice seven, the perfect number.

22. Cf. William of Conches' commentary on the *Timaeus* (*PL*, CLXXII, 246) for preliminary definitions of both kinds of justice, natural ("it was not invented by man... it is most evident in the creation of the universe") and positive ("it is invented by man... it is most evident in the decrees of the state"); the *Timaeus*, associated with natural justice, and the *Republic*, associated with positive justice, are observed to constitute "one and continuous tract upon justice" (*ibid.*, 250). On natural justice as productive of standards of positive justice, or morality, see, in the same commentary, William's *moralisatio* of the movements of the stable firmament and the erratic planets: "God gave man eyes so that when man saw that there are two motions in the heavens and two in himself, and that the Divine Wisdom makes the erratic planets follow the rational motion of the firmament, man would subject the erratic movements of his flesh to the rational motion of his spirit, a matter for practical philosophy" (quoted in Jeauneau, "La Notion d'*integumentum*," AHDL, XXIV [1957], 77). Equally striking is Hugh's *moralisatio* of the movement from chaos to order in the six days of creation (*De sacramentis* I.i.3 [*PL*, CLXXVI, 188C ff.; Deferrari, pp. 8–9]): "The omnipotent God... just as he made everything else for the rational creature, so in all [the works of the six days] must have followed a plan especially adapted to the benefit and interest of the rational creature. Now this plan was one in which not only a service but also an example should be prepared for the rational creature. ...The rational creature itself was first made unformed in a way proper to it, and was afterwards to be formed through conversion to its Creator. Therefore, exteriorly, it was first made to see matter unformed, then formed, so that it would perceive how great was the distance between mere being and beautiful being. And by this it was warned not to be content with having received mere being from the Creator through its own creation, but to seek beautiful and happy being, which it was destined to receive from the Creator through turning toward him with love." (Deferrari's translation altered.)

23. "omnis natura rationem parit, et nihil in universitate infecundum est," the passage has a Hermetic ring. Cf. Latin *Asclepius* I.iv (Nock, pp. 299–300), where the reproductive power of all species is discussed: *ibid*, III.xiv (Nock, pp. 313–4), where the power of procreation is attributed to both matter and spirit as a "quality of nature, which has in itself the power and material of both conception and birth"; and esp., *ibid.*, VI.xxi (Nock, pp. 321–3) on the fecundity of all created beings: "it is impossible that any one of the things that exist should be infecund."

24. Isa. 7:14.

25. Mich. 5:2.

26. Ps. 86:5.

27. Ps. 67:21.

28. Ps. 109:1.

29. Ps. 109:3.

30. Dan. 7:13–14.
31. Luke 1:26–31.
32. Isa. 7:14.
33. Luke 2:4–7.
34. Mich. 5:2.
35. John 1:1.
36. Mich. 5:2.
37. John 1:14.
38. Isa. 7:14; cf. Matt. 1:23.
39. Eccli. 1:1.
40. II John 1:1.
41. Rom. 16:25–7.
42. Ps. 10:15.
43. Ps. 56:5.
44. Ps. 102:15.
45. Ps. 78:7.
46. Job 9:13.
47. Job 7:15. This and the previous example are adduced by Gregory the Great *Moralium libri* Epistula missoria iii (*PL*, LXXV, 513D) to show the impossibility of understanding all things in Scripture literally.
48. Isa. 4:1.
49. The exclusively allegorical interpretation is Origen's; see Jerome *Translatio homiliarum Origenis in visiones Isaiae* Homilia iii: "De septem mulieribus" (*PL*, XXIV, 910 ff.). Jerome himself, in his commentary on Isaias, gives both a literal and an allegorical interpretation; *Commentaria in Isaiam prophetam* ii.iv (*PL*, XXIV, 72–3).
50. Quoted from Augustine *De Genesi ad litteram* i.xxi (*PL*, XXXIV, 262).
51. Quoted from *ibid.*, i.xviii (*PL*, XXXIV, 260).
52. Cf. *Didascalicon* iii.ix.
53. Cf. Hugh's *De contemplatione et ejus speciebus* (Hauréau, ed., *Nouvel Examen*, pp. 177–210), which, however, gives brief treatment to meditation as but one species of contemplation and which, moreover, gives the impression of being an outline rather than a finished treatise; cf. Baron, *Science et sagesse*, p. xxxi, who regards the work as a *reportatio*.
54. "ad puram et sine animalibus coenam" These are the concluding words of the Latin *Asclepius* (Nock, 355), here interpolated into a Christian context. Failure to recognize the source led Grabmann to transcribe the passage as "ad puram et finalem coenam" (*Geschichte der scholastischen Methode*, II, 235, n. 3).

APPENDIX A

1. Cf. Boethius *De arithmetica* i.i (*PL*, LXIII, 1079D).
2. "Virtus est habitus animi in modum naturae rationi consentaneus" Variant form in *De sacramentis* i.vi.17 (*PL*, CLXXVI, 273B; Deferrari, p. 105): "Virtus... est... affectus mentis secundum rationem ordinatus."

Ultimate source, Cicero *De inventione* ii.liii: "Virtus est animi habitus modo atque rationi consentaneus." Cited with slight variations, not without their significance, by Augustine *De diversis quaestionibus* i.xxxi (*PL*, XL, 20); William of Conches, commentary on the *Timaeus* (*PL*, CLXXII, 247); and the *brano* revision of William of Conches *De philosophia mundi* (Ottaviano, ed., p. 29). Thierry of Chartres, in his commmmentary on the *De inventione*, glosses Cicero's definition as follows: "The definition of virtue is to be understood thus: virtue is a habit of the mind by which the mind is made to return to the norm of nature through following reason. Vice exceeds the norm of nature; virtue, through following reason, produces a return to this norm" (quoted in Delhaye, "Enseignement de la philosophie morale," *MS*, XI [1949], 98).

3. Schematization of the three evils, three remedies, and three arts in Richard of Saint Victor *Liber Excerptionum* i.iv (*PL*, CLXXVI, 195) and the *brano* revision of William of Conches *De philosophia mundi* (Ottaviano, ed., pp. 22–3), where, however, "eloquence" is bracketed with "wisdom" as a twofold remedy against ignorance. Cf. the fourfold scheme of Bernardus Silvestris *Commentum super sex libros Eneidos Virgilii* (Riedel, ed., p. 36): "There are four evils which beset human nature: ignorance, vice, lack of skill in speaking, material want. To these four evils, four goods are opposed: to ignorance, wisdom; to vice, virtue; to lack of skill in speaking, eloquence; to material want, sufficiency."

APPENDIX B

1. With the material of this chapter, cf. Isidore *Etymologiae* viii.ix.1 ff.; Rhabanus Maurus *De magicis artibus* (*PL*, CX, 1095 ff.); and the *brano* revision of William of Conches *De philosophia mundi* (Ottaviano, ed., p. 35).

APPENDIX C

1. Buttimer's text (p. 134) has here been repunctuated as follows: "Ideo omnis motus et conversio creaturae rationalis esse debet ad mentem divinam, sicut omnis motus et conversio creaturae visibilis est ad rationalem creaturam." On the created universe as a network of hierarchically arranged causes deriving ultimately from the primordial causes or exemplars in God (eternal and invisible; causes only, not effects; rooted in the divine Will, ordered by the divine Wisdom, made fruitful by the divine Power), see *De sacramentis* i.ii.22 (*PL*, CLXXVI, 216C; Deferrari, p. 41) and i.ii.2 (*PL*, CLXXVI, 206D f.; Deferrari, pp. 29 ff.); on the creative extension of the primordial causes through three orders of created being, (1) temporal and invisible (angels), (2) temporal and partly invisible, partly visible (men), (3) temporal and visible only, down to the *ultima et postrema universorum* (effects only, causes to nothing below themselves), see *ibid.*, i.iv.26 (*PL*, CLXXVI, 246A–C; Deferrari, pp. 73–4). The term "rational creature" Hugh some-

times restricts to angels alone, created with primordial matter in the first instant of time (*ibid.*, 1.i.5 [*PL*, CLXXVI, 189D f.; Deferrari, p. 10]; cf. *Adnotationes elucidatoriae in Pentateuchon* v [*PL*, CLXXV, 34A]), sometimes extends to man, like the angels created prior to the rest of creation not in time but in dignity, and, before the fall, directly illuminated by God with knowledge of the natures of all beings (*De sacramentis* 1.vi.1, 5, 12–15 [*PL*, CLXXVI, 263B f., 266B f., 270C ff.; Deferrari, pp. 94, 97, 102–4]). The orientation or "conversion" of every being is properly toward that for which it was created, its "final cause"; in man's case, this is God; in the world's, man (*ibid.*, 1.ii.1 [*PL*, CLXXVI, 205B f.; Deferrari, pp. 28–9]).

2. Buttimer's text (p. 134) here repunctuated as follows: "Sicut homo, cum quid mente conceperit, ut aliis etiam patere possit quod sibi soli notum est, foris exemplum eius depingit, postea etiam ad maiorem evidentiam, quomodo id quod ad exemplum propositum est cum ratione eius concordat, verbis exponit; ita Deus, volens ostendere invisibilem sapientiam suam, exemplum eius in mente creaturae rationalis depinxit, ac deinde corpoream creaturam faciens, foris illi quid intus haberet ostendit."

3. Cf. *De tribus diebus* xxv (*PL*, CLXXVI, 835B); *De sacramentis* 1.v.2–5 (*PL*, CLXXVI, 247A–9B; Deferrari, pp. 75–7). According to Hugh, divine ideas, communicated to the angelic intellect, provided the exemplars according to which primordial chaos was ordered by God in the works of the six days. Underlying this view is Hugh's repeated insistence, as against criticism by William of Conches, upon the didactic purpose of the mode of creation and upon the literal, not merely figurative, import of the hexaemeron. A series of texts of varying date give the impression of a debate between William and Hugh on this point: (1) William, in his commentary on the *De consolatione philosophiae* (Parent, *Doctrine de la création*, p. 129), declares it heresy against the divine goodness to affirm that God created original confusion or chaos; (2) Hugh, in *Adnotationes elucidatoriae in Pentateuchon* iii (*PL*, CLXXV, 33A ff.), observes: "It is neither wrong nor unsuitable to say that God created something imperfect or unformed; ... daily he makes children who are imperfect with respect to the growth that is to follow, but perfect in the number of parts, that is, feet, hands, and the like"; God created initial chaos and ordered it through six days "not because he lacked power to do differently (hardly true), but because he intended an example and lesson for the rational creature. Just as he first conferred being, and then beautiful being, upon things, so upon angels and men, to whom he first gave rational being, he would afterward have given blessed being, if they had remained faithful"; (3) William, in *De philosophia mundi* 1.xxi (*PL*, CLXXII, 53A–D) and in his commentary on the Timaeus (Parent, *Doctrine de la création*, pp. 158 ff.), remarks that angels did not need external instruction since they knew all things from within, and men did not exist to be instructed at the time of creation; (4) Hugh, in the *De sacramentis* 1.i.3 (*PL*, CLXXVI, 188C–9B; Deferrari, p. 9) reaffirms his belief that both angels and men learn from the ordering of initial chaos not to be satisfied with mere existence, and adds: "But if anyone asks what rational creature existed in the very beginning of the universe, to whom this example and lesson could be proposed, one can

easily reply that the angels were already created and that they were admonished by this fact to know themselves, and that to the end of time men would be created, who, although they did not see creation when it was accomplished, nonetheless, taught by the Scriptures, could not fail to know that it was accomplished" (Deferrari's translation altered). If anyone wishes still to disagree with Hugh's reasons for his belief, let him, in all friendliness "seek out some better and more subtle idea," Hugh adds.

4. Gen. 1:3.

5. For example, Gen. 1:14–16: "And God said: Let there be lights made in the firmament of heaven, to divide the day and the night. ...And it was so done. And God made two great lights...."

6. Cf. Augustine *De Genesi ad litteram* ii.vi–viii (*PL*, XXXIV, 268–70): "When, therefore, we hear, 'And God said: Let it be,' let us understand what existed in the Word of God. ...But when we hear, 'And it was so,' let us understand the rational creature's knowledge of the thing destined for creation and foreseen in the idea of the Word of God; for God first 'creates,' so to speak, in the rational creature those things which, by a prior movement in the Word of God, he knew to be destined for creation. Finally, when we hear it said, 'God made,' let us understand that the created object itself has been brought forth according to its kind." Cf. Abaelard *Theologia christiana* (*PL*, CLXXVIII, 1129C) and Thierry of Chartres *De sex dierum operibus* (Häring, ed., p. 185).

BIBLIOGRAPHY

The following list is restricted to the more important primary works cited in the notes to the translation of the *Didascalicon*, and to secondary materials which the translator has found particularly useful for understanding the sources of the text, the text itself, and the intellectual and historical milieu in which the text first appeared. Recent editions of primary works are listed under the editor's name only.

PRIMARY WORKS

Abaelard, Peter. Introductio in theologiam. PL, CLXXVIII, 979–1114.
—— Theologia christiana. PL, CLXXVIII, 1123–1330.
Alanus de Insulis. De planctu naturae. PL, CCX, 431–82.
—— Theologiae regulae. PL, CCX, 617–84.
Alcuin. Dialogus de rhetorica et virtutibus. PL, CI, 919–50.
—— De dialectica. PL, CI, 951–76.
Alonso, Manuel, ed. Hermann de Carintia: De essentiis. Comillas [Santander], Universidad Pontificia, 1946.
Articella. Venice, Baptista de Tortes, 1487.
Augustine. Contra academicos. PL, XXXII, 905–58.
—— Contra Faustum manichaeum. PL, XLII, 207–518.
—— De civitate Dei. PL, XLI, 13–804.
—— De diversis quaestionibus. PL, XL, 11–100.
—— De Genesi ad litteram. PL, XXXIV, 245–486.
—— De Trinitate. PL, XLII, 819–1098.
—— Retractationes. PL, XXXII, 583–656.
Barach, Carl Sigmund, and Wrobel, Johann, eds. Bernardi Silvestris De mundi universitate libri duo sive megacosmus et microcosmus. Innsbruck, 1876.
Baron, Roger, ed. "Hugonis de Sancto Victore Epitome Dindimi in philosophiam: introduction, texte critique et notes," Trad. XI (1955), 91–148.
—— ed. "Hugonis de Sancto Victore Practica geometriae: introduction, texte," Osiris, XII (1956), 176–224.
Baur, Ludwig, ed. Gundissalinus, De divisione philosophiae. BGPM, Band IV, Heft II–III. Münster, 1906.
Bode, Georgius Henricus, ed., Scriptores rerum mythicarum latini tres Romae nuper reperti. Cellis, Impensis E. G. C. Schulze, 1834.
Boethius, Anicius Manlius Severinus. De arithmetica. PL, LXIII, 1079–1168.
—— Commentaria in Porphyrium a se translatum. PL, LXIV, 71–158.

—— In Porphyrium dialogi. PL, LXIV, 9–70.

Bossuat, R., ed., Alain de Lille, Anticlaudianus. Texte critique avec une introduction et des tables. Paris, Librairie Philosophique J. Vrin, 1955.

Bovo of Corvey. Commentary on the De consolatione philosophiae iii.m.ix of Boethius. PL, LXVI, 1239–46.

Bubnov, Nicolaus, ed., Gerberti opera mathematica. Berlin, 1899.

Bülow, G., ed., Des Dominicus Gundissalinus Schrift de processione mundi herausgegeben und auf ihre Quellen untersucht. BGPM, Band XXIV, Heft iv. Münster, 1925.

Burkhard, Carolus, ed., Nemesii episcopi Premnon physicon. Leipzig, B. G. Teubner, 1917.

Buttimer, Charles Henry, ed., Hugonis de Sancto Victore Didascalicon de studio legendi. A critical text. Studies in Medieval and Renaissance Latin, X. Washington, Catholic University of America Press, 1939.

Cousin, Victor, ed., Ouvrages inédits d'Abélard. Paris, 1836.

—— ed., Petri Abaelardi opera. Paris, 1849.

De Rijk, L. M., ed., Petrus Abaelardus: Dialectica. Assen, 1956.

Dick, Adolphus, ed., Martiani Minnei Felicis Capellae De nuptiis Philologiae et Mercurii libri VIIII. Leipzig, B. G. Teubner, 1925.

Dobschütz, E. von, ed., Decretum pseudo-Gelasianum. Texte und Unter- suchungen, XXXVIII. Leipzig, 1912.

Eyssenhardt, Franciscus, ed., Macrobius. Leipzig, B. G. Teubner, 1893.

—— ed., Martiani Minnei Felicis Capellae De nuptiis Philologiae et Mer- curii libri VIIII. Leipzig, B. G. Teubner, 1866.

Freundgen, Joseph, tr., "Hugo von St. Viktor, Das Lehrbuch." Sammlung der Bedeutendsten pädagogischen Schriften aus alter und neuer Zeit. Band XXIII. Paderborn, Ferdinand Schöningh, 1896.

Gibb, John, and Montgomery, William, eds., The Confessions of Augustine. Cambridge Patristic Texts. Ed. by A. J. Mason, Cambridge, Cambridge University Press, 1927.

Green, William M., ed., "Hugh of St. Victor, De tribus maximus circum- stantiis gestorum," Spec., XVIII (1943), 484–93.

Gregory the Great. Moralium libri, sive expositio in librum Job. PL, LXXV, 509–1162.

Halm, Carolus, ed., Rhetores latini minores. Leipzig, B. G. Teubner, 1863.

Häring, Nicholas M. "The Creation and Creator of the World according to Thierry of Chartres and Clarenbaldus of Arras." Introductory study and texts of the De sex dierum operibus of Thierry of Chartres and the Liber de eodem secundus of Clarenbaldus of Arras. AHDL, XXII (1955), 137–216.

Honorius Augustodunensis. De animae exsilio et patria. PL, CLXXII, 1241–6.

—— De imagine mundi. PL, CLXXII, 115–88.

Hugh of St. Victor. De arca Noe morali. PL, CLXXVI, 617–80.

—— De arca Noe mystica. PL, CLXXVI, 681–712.

—— De sacramentis christianae fidei. PL, CLXXVI, 173–618.

—— De sapientia animae Christi. PL, CLXXVI, 845–56.

—— De scripturis et scriptoribus sacris praenotatiunculae. PL, CLXXV, 9–28.

—— De tribus diebus. PL, CLXXVI, 811–38.

—— De unione corporis et spiritus. PL, CLXXVII, 285–94.

—— Expositio in Hierarchiam coelestem. PL, CLXXV, 923–1154.

—— In Ecclesiasten homiliae. PL, CLXXV, 113–256.

Huygens, R. B. C., ed., Conradus de Hirsau, Dialogus super auctores. Collection Latomus, XVII. Brussels, 1955.

—— "Mittelalterliche Kommentar zum O qui perpetua," SE, VI (1954), 373–427.

Jansen, Wilhelm, ed., Der Kommentar des Clarenbaldus von Arras zu Boethius De Trinitate. Breslauer Studien zur historischen Theologie. Band VII. Breslau, 1926.

Jean de Toulouse. Annales. Bibliothèque Nationale, MS Latin 14368.

Jerome. Commentariorum in Isaiam prophetam libri XVIII. PL, XXIV, 17–678.

—— Praefatio in Ecclesiasten. PL, XXIII, 1009–16.

—— Praefatio in Evangelia. PL, XXIX, 515–30.

—— Praefatio in libros Samuel et Malachim. PL, XXVIII, 547–58.

—— Praefatio in Pentateuchum. PL, XXVIII, 147–52.

—— Praefatio in Salamonem. PL, XXVIII, 1241–4.

—— Translatio homiliarum Origenis in visiones Isaiae. PL, XXIV, 901–36.

John of Salisbury. De septem septenis. PL, CXCIX, 945–64.

—— Entheticus de dogmate philosophorum. PL, CXCIX, 965–1004.

John the Scot. De divisione naturae. PL, CXXII, 441–1022.

Jones, Leslie Webber, tr. An Introduction to Divine and Human Readings by Cassiodorus Senator. New York, Columbia University Press, 1946.

Jourdain, Charles. "Des commentaires inédits de Guillaume de Conches et de Nicolas Triveth sur la Consolation de la philosophie de Boèce." Notices et extraits des manuscrits de la Bibliothèque Impériale et autres bibliothèques. Vol. XX. Paris, 1862. Pp. 40–82.

Keil, Heinrich, ed., Grammatici latini. Vols. II–IV. Leipzig, B. G. Teubner, 1858–64.

Kroll, W., and Skutsch, F., eds., Firmicus Maternus, Matheseos libri VIII. Leipzig, B. G. Teubner, 1897.

Laistner, M. L. W., ed., "Notes on Greek from the Lectures of a Ninth Century Monastery Teacher," Bulletin of the John Rylands Library, VII (1922–3), 421–56.

Leclercq, Jean, ed., "Le 'De grammatica' de Hugues de Saint-Victor," AHDL, XV (1943–5), 263–322.

Liebeschütz, Hans, ed., Joannes Ridevallus, Fulgentius metaforalis. Ein Beitrag zur Geschichte der antiken Mythologie im Mittelalter. Leipzig, B. G. Teubner, 1926.

Lindsay, W. M., ed., Isidori Hispalensis episcopi Etymologiarum sive originum libri XX. 2 vols. Oxford, The Clarendon Press, 1911.

Lutz, Cora E., ed., Glossae in Martianum [by Dunchad]. Lancaster, Pa., Lancaster Press, Inc., 1944.

—— Iohannis Scotti annotationes in Marcianum. Cambridge, Mass., The Mediaeval Academy of America, 1939.

McGarry, Daniel D., tr., The Metalogicon of John of Salisbury. Berkeley, The University of California Press, 1955.

McKeon, Richard Peter. Selections from Medieval Philosophers. 2 vols. New York, Charles Scribner's Sons, 1929.

Meyer, P. Gabriel, tr., "Hugo von Sankt Viktors Lehrbuch." Ausgewählte Schriften von Columban, Alkuin, Dodana, Jonas, Hrabanus Maurus, Notker Balbulus, Hugo von Sankt Viktor, und Peraldus. Freiburg im Breisgau, Herder'sche Verlagshandlung, 1890. Pp. 150–211.

Michaud-Quantin, Pierre, ed., Le Fons philosophiae de Godefroy de Saint-Victor. Analecta mediaevalia Namurcensia, VIII. Namur, Editions Godenne, 1956.

Mommsen, Theodore, ed., Gestorum pontificum romanorum liber pontificalis. MGH, Gesta pontificum romanorum, I. Berlin, 1898.

Muckle, J. T., ed., "Abelard's Letter of Consolation to a Friend [Historia calamitatum mearum]," MS, XII (1950), 163–213.

Mullach, F., ed., Fragmenta philosophorum graecorum. 2 vols. Paris, Firmin-Didot, 1928.

Müller, Karl, ed., Hugo von St. Victor, Soliloquium de arrha animae und De vanitate mundi. Kleine Texte für Vorlesungen und Übungen. Ed. by Hans Lietzmann. Vol. CXXIII. Bonn, 1913.

Müller, Martin, ed., Die Quaestiones naturales des Adelardus von Bath. BGPM, Band XXXI, Heft II. Münster, 1934.

Mynors, R. A. B., ed., Cassiodori Senatoris Institutiones. Oxford, The Clarendon Press, 1937.

Nock, A. D., ed., and Festugière, A. J., tr., Corpus Hermeticum. 2 vols. Société d'édition "Les Belles Lettres," 1945.

Ostlender, H., ed., Peter Abaelards Theologia "Summi Boni." BGPM, Band XXXV, Heft II-III. Münster, 1939.

Ottaviano, Carmelo, ed., Un brano inedito della "Philosophia" di Guglielmo di Conches. Naples, Alberto Morano, 1935.

Peiper, Rudolfus, ed., Anicii Manlii Severini Boetii Philosophiae consolationis libri quinque et eiusdem atque incertorum opuscula sacra. Leipzig, B. G. Teubner, 1871.

Remigii Autissiodorensis in Martiani Capellae De nuptiis commentarius. Bibliothèque Nationale, MS Latin 14764. Fols. 1ʳ–93bis.

Richard of Saint Victor. Excerptiones priores. PL, CLXXVII, 194–286.

Riedel, Guilielmus, ed., Commentum Bernardi Silvestris super sex libros Eneidos Virgilii. Greifswald, 1924.

Schmid, Toni, ed., "Ein Timaioskommentar in Sigtuna," CM, X (1949), 220–66.

Scott, Walter, ed., Hermetica. 2 vols. Oxford, The Clarendon Press, 1924–1926.

Silk, E. T., ed., "Pseudo-Johannes Scottus, Adalbold of Utrecht, and the Early Commentaries on Boethius," MRS, III (1954), 1–40.

—— ed., Saeculi noni auctoris in Boetii consolationem philosophiae

commentarius. Papers and Monographs of the American Academy in Rome, IX. Rome, American Academy, 1935.

Silverstein, Theodore, ed., "Liber Hermetis Mercurii Triplicis de VI rerum principiis," AHDL, XXII (1955), 217–302.

Silvestre, Hubert, ed., "Le commentaire inédit de Jean Scot Erigène au mètre IX du livre III du 'De consolatione philosophiae' de Boèce," RHE, XLVII (1952), 44–122.

Stahl, William Harris, tr., Macrobius' Commentary on the Dream of Scipio. New York, Columbia University Press, 1952.

Stewart, H. F., ed., "A Commentary of Remigius Autissiodorensis on the De Consolatione Philosophiae of Boethius," JTS, XVII (1916), 22–42.

Stölzle, Remigius, ed., Abaelards 1121 zu Soissons verurtheilter Tractatus de unitate et trinitate divina. Freiburg im Breisgau, 1891.

Webb, C. C. J., ed., Joannis Saresberiensis Metalogicon. Oxford, The Clarendon Press, 1924.

—— ed., Joannis Saresberiensis Policraticus. 2 vols. Oxford, The Clarendon Press, 1909.

William of Conches. Commentarius in Timaeum Platonis. PL, CLXXII, 245–52.

—— De philosophia mundi. PL, CLXXII, 39–102.

William of St. Thierry. De erroribus Guillelmi de Conchis. PL, CLXXX, 334–40.

Willner, Hans, ed., Des Adelard von Bath Traktat De eodem et diverso. BGPM, Band IV, Heft 1. Münster, 1904.

Wrobel, Johannes, ed., Platonis Timaeus interprete Chalcidio cum eiusdem commentario. Leipzig, B. G. Teubner, 1876.

SECONDARY WORKS

Baltus, Urbain. "Dieu d'après Hugues de Saint-Victor," RB, XV (1898), 109–23, 200–14.

Baron, Roger. "L'Influence de Hugues de Saint-Victor," RTAM, XXII (1955), 56–71.

—— Science et sagesse chez Hugues de Saint-Victor. Paris, P. Lethielleux, 1957.

Bischoff, Bernhard. "Aus der Schule Hugos von St. Viktor." Aus der Geisteswelt des Mittelalters. BGPM, Supplementband III, Halfband I, pp. 246–50. Ed. by Albert Lang, Joseph Lechner, and Michael Schmaus. Münster, 1935.

Bliemetzrieder, Franz. Adelhard von Bath: eine kulturgeschichtliche Studie. Munich, Max Hueber Verlag, 1935.

Bonnard, Fourier. Histoire de l'abbaye royale et de l'ordre des chanoines régulier de St-Victor de Paris. 2 vols. Paris, Arthur Savaète, [n.d.].

Cappuyns, Maïeul. Jean Scot Erigène, sa vie, son oeuvre, sa pensée. Louvain, Abbaye de Mont Césare, 1933.

Chatillon, Jean. "De Guillaume de Champeaux à Thomas Gallus: chronique d'histoire littéraire et doctrinale de l'école de Saint-Victor," RMAL, VIII (1952), 139–62.

—— "Le Contenu, l'authenticité et la date du Liber exceptionum et des Sermones centum de Richard de Saint-Victor," RMAL, IV (1948), 23–51, 342–64.

Chenu, Marie-Dominigue. "Arts 'mécaniques' et oeuvres serviles," RSPT, XXIX (1940), 313–15.

—— "Conscience de l'histoire et théologie au XIIe siècle," AHDL, XXI (1954), 107–33.

—— "Cur homo? Le sous-sol d'une controverse au XIIe siècle," MSR, X (1953), 195–204.

—— "Involucrum: le mythe selon les théologiens médiévaux," AHDL, XXII (1955), 75–9.

—— La théologie au XIIe siècle. Etudes de philosophie médiévale, XLV. ed. by Etienne Gilson. Paris, Librairie Philosophique J. Vrin, 1957.

—— "L'Homme et la nature: perspectives sur la renaissance du XIIe siècle," AHDL, XIX (1952), 39–66.

—— "Moines, clercs, et laïcs au carrefour de la vie évangélique (XIIe siècle)," RHE, XLIX (1954), 59–94.

—— "Nature ou histoire? Une controverse éxégétique sur la création au XIIe siècle," AHDL, XX (1953), 25–30.

—— "Platon à Citeaux," AHDL, XXI (1954), 99–106.

Chroust, Anton-Hermann. "The Definitions of Philosophy in the De divisione philosophiae of Dominicus Gundissalinus," NS, XXV (1951), 253–81.

Courcelle, Pierre. "Etude critique sur les commentaires de la Consolation de Boèce (IXe–XVe siècles)," AHDL, XII (1939), 6–140.

—— Les Lettres grecques en occident de Macrobe è Cassiodore. Paris, E. de Boccard, 1948.

—— "Les Pères devant les enfers virgiliens," AHDL, XXII (1955), 5–74.

Croydon, F. C. "Abbot Laurence of Westminster and Hugh of St. Victor," MRS, II (1950), 169–71.

d'Alverny, Marie-Thérèse. "Le Cosmos symbolique du XIIe siècle," AHDL, XX (1953), 31–81.

—— "La Sagesse et ses sept filles. Recherches sur les allégories de la philosophie et des arts libéraux du IXe au XIIe siècle," Mélanges F. Grat. Vol. I. Paris, 1946. Pp. 245–78.

de Ghellinck, Joseph. Le Mouvement théologique du XIIe siècle. Bruges, Editions 'De Tempel,' 1948.

De Lage, G. Raynaud. Alain de Lille. Montréal, Institut d'Etudes Médiévales, 1951.

Duhem, Pierre. Le système du monde: l'histoire des doctrines cosmologiques de Platon à Copernic. Vol. III, L'Astronomie au moyen âge (suite). Paris, 1915.

Flatten, Heinrich. Die Philosophie des Wilhelm von Conches. Coblenz, Görres-Druckerei, 1929.

Gilson, Etienne. A History of Christian Philosophy in the Middle Ages. New York, Random House, 1955.

—— "La Cosmogonie de Bernardus Silvestris," AHDL, III (1928), 1–28.

Grabmann, Martin. Die Geschichte der scholastischen Methode. 2 vols. Freiburg im Breisgau: Herder'sche Verlagshandlung, 1911; reprinted, Graz, Akademische Druck- und Verlagsanstalt, 1957.

Gregory, Tullio. Anima mundi: La filosofia di Guglielmo di Conches e la scuola di Chartres. Publicazioni dell'Università di Roma, III. Florence, G. C. Sansoni, 1955.

—— "L'anima mundi nella filosofia del XII secolo," GCFI, XXX (1951), 494–508.

—— "Sull'attribuzione a Guglielmo di Conches di un rimaneggiamento della Philosophia Mundi," GCFI, XXX (1951), 119–25.

Gwynn, Aubrey. Roman Education from Cicero to Quintilian. Oxford: The Clarendon Press, 1926.

Haskins, Charles Homer. Studies in the History of Mediaeval Science. Cambridge, Mass., Harvard University Press, 1927.

Hauréau, Barthélemy. Histoire de la philosophie scolastique. Vol. I. Paris, 1872.

—— Hugues de Saint-Victor: nouvel examen de l'édition de ses oeuvres. Paris, 1859.

Jaeger, Werner. Paideia: the Ideals of Greek Culture. Tr. Gilbert Highet. Oxford, Basil Blackwell, 1939.

Jeauneau, Edouard. "L'Usage de la notion d'integumentum à travers les gloses de Guillaume de Conches," AHDL, XXIV (1957), 35–100.

—— "Simples Notes sur la cosmogonie de Thierry de Chartres," Sophia, XXIII (1955), 172–83.

Kleinz, John P. The Theory of Knowledge of Hugh of Saint Victor. Washington, Catholic University of America Press, 1944.

Kilgenstein, Jacob. Die Gotteslehre des Hugo von St. Viktor. Würzburg, 1898.

Klibansky, Raymond. "The Rock of Parmenides: Mediaeval Views on the Origin of Dialectic," MRS, I (1941–43), 178–86.

Lasić, Dionysius. "Hugo de S. Victore auctor operis 'De contemplatione et eius speciebus,'" Antonianum, XXVIII (1953), 377–88.

—— Hugonis de S. Victore theologia perfectiva: eius fundamentum philosophicum ac theologicum. Studia Antoniana, VIII. Romae, Pontificium Athenaeum, 1956.

Liebeschütz, Hans. "Kosmologische Motive in der Bildungswelt der Frühscholastik." Vorträge der Bibliothek Warburg, 1923–4. Ed. by Fritz Saxl. Pp. 82–148.

Lutz, Cora E. "Remigius' Ideas on the Origin of the Seven Liberal Arts," MH, X (1956), 32–49.

Manitius, Max. Geschichte der lateinischen Literatur des Mittelalters. 3 vols. Munich, 1931.

Mariétan, Josèphe. Le Problème de la classification des sciences d'Aristote à St.-Thomas. Paris, Felix Alcan, 1901.

Marrou, Henri-Irénée. Saint Augustin et la fin de la culture antique. Paris, E. de Boccard, 1949.

McKeon, Richard Peter. "Poetry and Philosophy in the Twelfth Century: the Renaissance of Rhetoric," MP, XLIII (1945–6), 217–34.

—— "Rhetoric in the Middle Ages," Spec., XVII (1942), 1–32.

Mignon, A. Les Origines de la scholastique et Hugues de Saint-Victor. 2 vols. Paris, 1868.

Ott, Ludwig. "Hugo von St. Viktor und die Kirchenväter," Divus Thomas (Fribourg), ser. 3, XXVII (1949), 180–200, 293–332.

Paré, G., Brunet, A., and Tremblay, P. La Renaissance du XIIe siècle: les écoles et l'enseignement. Paris, Librairie Philosophique J. Vrin, 1933.

Parent, Joseph-Marie. La Doctrine de la création dans l'école de Chartres. Paris, Librairie Philosophique J. Vrin, 1938.

Pedersen, Jørgen. "La Recherche de la sagesse d'après Hugues de Saint-Victor," CM, XVI (1955), 91–133.

Silverstein, Theodore. "Adelard, Aristotle, and the De natura deorum," CP, XLVII (1952), 82–6.

—— "The Fabulous Cosmogony of Bernardus Silvestris," MP, XLVI (1948–9), 92–116.

Smalley, Beryl. The Study of the Bible in the Middle Ages. New York, Philosophical Library, 1952.

Thorndyke, Lynn. A History of Magic and Experimental Science. Vol. II. New York, The Macmillan Co., 1929.

Vernet, F. "Hugues de Saint-Victor," DTC, VII, Part I, 1927.

Vernet, A. "Un Remaniement de la Philosophie de Guillaume de Conches," Script., I (1946–7), 243–59.

Weisweiler, Heinrich. "Die Arbeitsmethode Hugos von St. Viktor, ein Beitrag zum Entstehen seines Hauptwerkes De sacramentis," Schol., XX–XXIV (1949), 59–87, 232–67.

—— "Die Pseudo-Dionysiuskommentare 'In coelestem hierarchiam' des Skotus Eriugena und Hugos von St. Viktor," RTAM, XIX (1952), 26–47.

Werner, Karl. "Kosmologie und Naturlehre des scholastischen Mittelalters mit specieller Beziehung auf Wilhelm von Conches." Sitzungsberichte der kaiserliche Akademie der Wissenschaften. Philosophische-historische Klasse. Vol. LXXXV. Wien, 1873. Pp. 309–403.

INDEX

Aaron, 139

Abaelard, Peter, xii, 4, 6, 158n2, 217n3; on the classic philosophers, 13, 167n84, 182n26, 192n69; disputations of, 16, 18, 19, 23, 166n72, 215n68; on the world soul, 25, 28, 178n8, 179n10
 De dialectica, 179n10
 Expositio in Hexaemeron, 202n44
 Historia calamitatum mearum, 158n2, 166n 67, 215n68
 Introductio in theologiam, 179n10
 Logica ingredientibus, 207n88
 Theologia christiana, 167n84, 179n10, 190 n56, 192n69, 197n9, 228n6
 De unitate et trinitate divina, 179n10, 215n68

Abdias, 104

Abelard, *see* Abaelard, Peter

Abisag, 98,99

Abraham, 84, 86, 210n34

Action: philosophy and, 9, 10, 15, 48, 54, 132-33, 161n21; divine and human, 55, 190n59; for the perfect (student), 130-31

Acts of the Apostles (N.T.), 103, 104, 107, 114-15, 137

Actuality: Divine Wisdom and, 14, 15, 164n42, 156; powers of the soul and, 50; change and, 53-54; reason and, 58-59, 73, 156

Adalbold of Utrecht, 168n93, 185n35, 192 n69, 198n25

Adam of Saint Victor, 5,37

Adelard of Bath: on the arts, 18, 195nn76, 2; 212n46
 De eodem et diverso, 166n71, 169n118, 178n8, 189n53, 193n71, 195nn76, 2; 202n47, 212n46
 Quaestiones naturales, 188n45, 191n66, 203n56, 204n60

Aemilian, 84

Aesculapius, 85

Agathocles, King, 215n63

Aggeus, 105

Agriculture: among the arts, 33, 74, 83, 153; provinces of, 51, 77; origins 84, 85

Alanus de Insulis, x, xi, 189n53
 De planctu naturae, 179n10
 Theologiae regulae, 182n26

Alcabitius, 20

Alcmon of Crotona, 86

Alcuin, 3, 161n21
 De dialectica, 183n27

Alexander, 106

Alexandria, 106

Allegory: in Scripture, 35, 120, 121, 127, 135, 136, 138, 214n54, 219n1, 220n25, 222nn2, 3, 4; 223nn7, 9; the study of, 139-44, 145-46; *see also* Involucrum (integumentum)

Alphabets: origin of, 85-86, 210n31; Hebrew, 105-106, 108-109, 111

Ambrose, Saint, 104, 115
 Sermo ii in Ps. cxviii, 177n4
 Sermo x, 177n4

Ammonius of Alexandria, 112, 161n21

Amos, 104

Amphio, 84

Analecta Mediaevalia Namurcensia, 173n174

Andrew of Saint Victor, 4

Angels: nature of, 14, 27-28, 156, 170n127, 184n31, 185n38, 186n42, 190n59; the Devil as, 125; as rational beings, 226n1, 227n3; *see Ousiai*

Animals, distinguished from man, 51

Anima mundi, *see* World soul

Anselm of Havelberg: *Epistula ad Abbatem Ecbertum*, 216n81

Anselm of Laon, 215n68

Apicius, 85

Apocalypse (N.T.), 104, 107, 111, 115, 144, 145

Apocrypha, 103; defined, 107-108; listed, 116-18

Apollo, Tripod of, 46, 177n4; as author of medicine, 85

Apostles, Acts of the (N.T.), 104, 107, 114-15, 137

Aptitude, for study, 43-44, 91, 93; *see also* Students

Apuleius, 84

Aquila, 106

Arabic tradition, 6, 159n11, 203n53

Archetypal essences, *see Ousiai*

Architecture, 62, 84; typifying the study of Scripture, 140-42, 222n3, 223n9

Argument, theory of, 81-82, 83, 153, 207 nn87-88

Aristotle, 3, 21, 160n14, 167n85, 172n160; on logic, 6, 86; division of philosophy by, 8, 19, 36, 62, 159n11, 161n21, 207n 88, 208n3; entelechy and, 26, 178n7; on Zoroaster, 154; Mariétan on, 160n13
 De interpretatione, 207n88

INDEX

Ousiai, 9, 14, 53, 152, 186*nn*39, 42
Ovid, 173*n*174, 182*n*26
 Epistulae ex Ponto, 216*n*85
 Metamorphoses, 176*n*3

Paganism, 21, 22, 167*n*85, 168*n*91; "worldly theology" of, 34-35, 173*nn*167-68; Augustine's outline of pagan knowledge, 131-32
Palladius: *On Agriculture*, 84
 Paradisus seu historica lausiaca, 221*n*31
Pallas (Minerva-deity), 73, 85, 204*n*63
Pamphilus, 106, 115
Paper, origin of, 119
Paralipomenon (O.T.), 103, 106, 110, 137
Paré, Gérard: *Les idées et les lettres au XIIe siècle: Le Roman de la rose*, 189*n*53; *see also Renaissance du XIIe siècle* (Paré, Brunet, Tremblay)
Parent, Joseph-Marie: *Doctrine de la création dans l'école de Chartres*, 28, 162*n*23, 166*nn*72, 81; 168*n*98, 169*nn*108, 109; 172*n*160, 175*n*1, 179*n*10, 180*n*11, 185*nn* 35, 38, 186*n*42, 190*n*59, 192*n*69, 193*n*71, 207*n*84, 227*n*3
Paris, Judgment of, 204*n*63
Parmenides, 86, 97, 98, 211*n*35
Parsimony, 100, 131
Patriotism, in the philosopher, 101
"Pattern," *see* Wisdom, Divine
Paul, Saint, 104, 107, 144, 147, 224*n*21
Paul (4th century ascetic), 130, 221*n*31
Pedersen, Jørgen: "Recherche de la sagesse d'après Hugues de Saint-Victor," 175*n*1, 181*n*19
Pelasgians, 85
Pentateuch (O.T.), 103, 104, 108
Performance, *see* Action
Persians, 155
Persius, 20: *Saturae*, 188*n*49
Peter, Saint, canonical epistles of, 107, 220*n*8
Pherecydes, 86
Philo Judaeus of Alexandria, 105, 111, 219*n*1, 223*n*14
Philology, 100, 215*n*79, 216*n*80
Philosophy: defined by Hugh, x, 9, 10, 33-34, 48, 51, 172*n*160, 181*n*19, 196*n*6; fourfold division of, xi, 7-19, 28, 60, 61-62, 83, 152-54, 160*n*16, 161*nn*19, 21; 182*n*24; relation to Divine Wisdom, xi, 9, 11-19, 22, 24, 29-32, 33-34, 36, 47, 48, 61, 164*n*42, 167*n*85, 172*nn*162, 165; 177

*nn*4-5; schematizations of, 5-6, 159*n*13; threefold division of, 8, 10; origins of, 12; Scripture and, 30, 32, 33, 35, 44-45, 103, 173*n*172; as pursuit of wisdom, 48, 50-51, 61; stages of, 130-31, 132-33, 177*n*5; *see also* Arts and sciences, The; *and see specific schools or aspects of philosophy, e.g.,* Neoplatonism
Phrygians, 155
Physics: in philosophy, 8, 17, 33, 62, 110, 153; Scripture and, 35; defined, 71, 203*n*57; function of, 72-73, 203*n*57, 204 *nn*61-62; origin of, 83
Pilumnus, 85, 210*n*24
Pindar, 109
Pisistratus, 106, 115
Plato, 3, 11, 95, 98, 167*n*85, 175*n*1; division of philosophy and, 8, 62, 203*n*58; cosmology of, 19, 166*n*73; trinitarianism and, 19; on justice, 84, 209*n*15, 224*n*22; Socrates and, 86, 211*n*36; Abaelard on, 167*n*84, 178*n*8, 179*n*10
 Parmenides, 202*n*41
 Phaedo, 197*n*9
 Republic, 84, 224*n*22
 Timaeus, i-x, 8, 13, 19, 22, 161*n*23, 166*n* 73; Chalcidius on, 13, 161*n*21, 179*n*9, 180*n*13, 184*n*34, 185*n*35, 186*n*42, 187*nn* 43, 52; 190*n*59, 192*n*69, 193*n*71, 199*n* 26, 200*n*29, 209*n*15; William of Conches on, 20, 21, 25, 27, 162*n*23, 163*n*31, 166*n*61, 169*nn*107, 108; 178*n*8, 179*n* 10, 182*n*26, 184*n*34, 185*n*35, 190*n*59, 196*n*7, 198*n*25, 199*nn*26-27, 200*n*28, 203*n*57, 209*n*15, 214*n*58, 218*n*55, 224*n* 22, 225*n*2, 227*n*3; on the world soul, 24-25, 26, 28, 46, 169*n*118, 178*nn*6-8, 179*nn*9-10, 192*n*69; arts represented in, 212*n*48
Platonism, 13, 19, 23-24
Pliny, 83: *Historia naturalis*, 208*n*5
Poetry, 21, 167*nn*83, 85; 211*nn*44-45, 48; Scriptural use of, 108-109
Politics, 74, 205*n*65
Porphyry: Boethius on, 10-11, 161*n*21, 181*n*21, 182*nn*22-24, 195*nn*75, 1; 197*n*15, 198*n*20, 203*n*57, 205*n*66, 206*nn*75-78, 81; 208*n*88
 Life of Pythagoras, 195*n*79
Poverty (parsimony), 100, 131
Practical arts: virtue and, 10, 152, 182*n*24, 183*nn*27, 30; in philosophy, 33, 51-52,

RECORDS OF WESTERN CIVILIZATION

The Art of Courtly Love, by Andreas Capellanus. Translated with an introduction and notes by John Jay Parry.

The Correspondence of Pope Gregory VII: Selected Letters from the Registrum. Translated with an introduction by Ephraim Emerton.

Medieval Handbooks of Penance: The Principal Libri Poenitentiales and Selections from Related Documents. Translated by John T. McNeill and Helena M. G. Editingamer.

Macrobius: Commentary on The Dream of Scipio. Translated with an introduction by William Harris Stahl.

Medieval Trade in the Mediterranean World: Illustrative Documents. Translated with introductions and notes by Robert S. Lopez and Irving W. Raymond, with a foreword and bibliography by Olivia Remie Constable.

The Cosmographia *of Bernardus Silvestris.* Translated with an introduction by Winthrop Wetherbee.

Heresies of the High Middle Ages. Translated and annotated by Walker L. Wakefield and Austin P. Evans.

The Didascalicon *of Hugh of Saint Victor: A Medieval Guide to the Arts.* Translated with an introduction by Jerome Taylor.

Martianus Capella and the Seven Liberal Arts.

> Vol. I: *The Quadrivium of Martianus Capella: Latin Traditions in the Mathematical Sciences,* by William Harris Stahl with Richard Johnson and E. L. Burge.

> Vol. II: *The Marriage of Philology and Mercury,* by Martianus Capella. Translated by William Harris Stahl and Richard Johnson with E. L. Burge.

The See of Peter, by James T. Shotwell and Louise Ropes Loomis.

Two Renaissance Book Hunters: The Letters of Poggius Bracciolini to Nicolaus de Niccolis. Translated and annotated by Phyllis Walter Goodhart Gordan.

Guillaume d'Orange: Four Twelfth-Century Epics. Translated with an introduction by Joan M. Ferrante.

Visions of the End: Apocalyptic Traditions in the Middle Ages, by Bernard McGinn, with a new preface and expanded bibliography.

The Letters of Saint Boniface. Translated by Ephraim Emerton, with a new introduction and bibliography by Thomas F. X. Noble.

Imperial Lives and Letters of the Eleventh Century. Translated by Theodor E. Mommsen and Karl F. Morrison, with a historical introduction and new suggested readings by Karl F. Morrison.

An Arab-Syrian Gentleman and Warrior in the Period of the Crusades: Memoirs of Usāmah ibn-Munqidh. Translated by Philip K. Hitti, with a new foreword by Richard W. Bulliet.

De expugnatione Lyxbonensi (The Conquest of Lisbon). Edited and translated by Charles Wendell David, with a new foreword and bibliography by Jonathan Phillips.

Defensor pacis. Translated with an introduction by Alan Gewirth, with an afterword and updated bibliography by Cary J. Nederman.

History of the Archbishops of Hamburg-Bremen. Translated with an introduction and notes by Francis J. Tschan, with a new introduction and bibliography by Timothy Reuter.

The Two Cities: A Chronicle of Universal History to the Year 1146, by Otto, Bishop of Freising. Translated in full with an introduction and notes by Charles Christopher Mierow, with a foreword and updated bibliography by Karl F. Morrison.

The Choronicle of Henry of Livonia, by Henricus Lettus. Translated and with a new introduction and notes by James A. Brundage.

Lanzelet, by Ulrich von Zatzikhoven. Translated with a new introduction by Thomas Kerth, with additional notes by Kenneth G. T. Webster and Roger Sherman Loomis.

The Deeds of Frederick Barbarossa, by Otto of Freising. Translated and annotated with an introduction by Charles Christopher Mierow with the collaboration of Richard Emery.

Giles of Rome's On Ecclesiastical Power: *A Medieval Theory of World Government.* A Critical edition and translation by R. W. Dyson.